SEQUOIA

SEQUOIA

The Heralded Tree
in American Art and Culture

LORI VERMAAS

SMITHSONIAN BOOKS
Washington and London

Copy editor: Debbie K. Hardin
Production editor: E. Anne Bolen
Designer: Janice Wheeler

Library of Congress Cataloging-in-Publication Data

Vermaas, Lori.
 Sequoia : the heralded tree in American art and culture / Lori Vermaas.
 p. cm.
 Includes bibliographical references and index.
 ISBN 1-58834-140-2 (alk. paper)
 1. Coast redwood in art. 2. National characteristics, American, in art. 3. Symbol-
ism in art—United States. 4. Arts, American—19th century. 5. Arts, American—20th cen-
tury. I. Title.

NX650.T74V47 2003
929.6—dc21 2003045693

British Library Cataloging-in-Publication Data are available

Manufactured in the United States of America

10 09 08 07 06 05 04 03 1 2 3 4 5

∞The paper used in this publication meets the minimum requirements of the American
National Standard for Information Sciences—Permanence of Paper for Printed Library
Materials ANSI Z39.48-1984.

TO MENTORS LARGE AND SMALL,
OF THE AIR AND OF THE EARTH

CONTENTS

PREFACE

I wish I could tell you that I have been fascinated with the big trees since I was a young girl and that I once led a group of Amazon ruffians through their groves, where we claimed them as our own imagined realm, and, from atop a fallen giant, dared the rest of the world to take us on. I wish I could tell you that I had an incredible bonding experience with them— or any tree, for that matter—one that involved ecofeministic acts of heroism and sacrifice. And I wish I could tell you that I climbed trees throughout my childhood because they offered me vital refuge when other places and people failed to fill that void. But those are not my stories. Mine involve realizing that trees are symbols, and you do not climb symbols.

Symbols are concentrated narratives. They are tales that attract us because they express that intangible something about ourselves—a wish, a hope, a desire, a belief—with presumed clarity, precision, definition, substance. And to a large extent, that is what this book is about: that a tree's idealization, recorded in all kinds of imagery, discloses many things about its celebrants, particularly the qualities that we imagine we are lacking and

subsequently those we crave. This self-revelation operated throughout the history of the sequoias' visual representation in American culture.

I have to admit that I have developed some pretty esoteric ideas about trees in the past ten years. I associate them with many things: death, the consequences of living, audacious human will, and, of course, nationalism. Yet I did not always feel this way. I had never even seen the sequoias until I embarked on this project as a dissertation. In between visits to archives, I hiked the main trails at Sequoia, Kings Canyon, and Yosemite National Parks and there observed the visage and pondered the allure of the General Sherman and General Grant trees and the infamous Grizzly Giant (my favorite), along with numerous lesser known sequoias. About four years later I made it out to Muir Woods National Monument near San Francisco and witnessed the nobly serene Coast redwoods on an early February morning. Each visit and all the research let me indulge my interest in tracing out how a person's or a society's concerns influence perception. And that's the hook for me with any subject—the ways we use objects to symbolize something else, usually something strongly felt, usually as sign posts indicating purpose or substance or direction.

Although I argue in this book that the big trees collectively symbolized a powerful American destiny during the first one hundred years of their celebration, they, and all old trees, for that matter, mean to me something strikingly less optimistic. Their presence signifies the fragility of memory and how caught up we can be with its recovery, even to the point of embodying it in landmarks. Much as William Cullen Bryant wrote in his 1869 poem "Among the Trees," when I see an old tree now, I sense that "an unremembered Past/Broods"—mostly my own past, but also one that I imagine can disable an old tree along with its admirers. I will let Bryant elaborate. Ancient trees improbably "have no history," he persistently cautions in this post–Civil War poem, because they cannot convey who planted them or who may have spared them from the ax or other human danger; they are impotent living beings unable to speak of their own past. Such wounded silence rests "like a presence, mid the long gray boughs/Of this old tree," the New England poet exhorts, leaving it mute and unable to help or comfort humankind through any pain or loss or even joy. What trees signify is thus something only we can imagine—and the results, even when they include the heralded sequoias, are not always reassuring.

It may be obvious that I have a clear tendency to anthropomorphize objects to make sense of the world—or orient myself to it—and trees are no exception. Trees embody the human struggle for expression and its comprehension, a kind of tale in itself, which reminds me of a poster I made when I neared my dissertation's completion. An illustration from the back cover of a remaindered book so inspired me that I enlarged, laminated, and framed it and put it on my wall. It seemed to express directly what I had come to learn and most value about trees. Above a simple silhouette of a fully foliated tree are these words: "to know something about trees—about even one tree—is to know something important, something fundamental, something profound about the nature of the world and our place in it."

There are many ways to take such a statement, but for me it means that trees are storytellers. Or, rather, they bring out the storyteller in us. And that is what I have come to recognize—that trees, that nature, reflect us. The tales about us that I notice, the ones I use in this book, are those that involve people's reactions to trees, primarily the big trees, and the hidden anxieties and values they expose. Whether as effusive ruminations about the religious uplift inspired by a walk through a grove, or triumphant fantasies of conquest and other derring-do, or conflicted concern for a sequoia's desecration, or enthusiastic promotions of its physical alteration— all of these responses reveal our insecurities about our place in the world—our significance—and our anguished and oftentimes remorseful recognition that we have little say in its control.

Before all of this—before I realized that trees were part of human culture—I was an American studies graduate student at the University of Iowa, and I luckily stumbled on this topic by chance in an art history course in 1993. At the time I was more intrigued by the fact that, regardless of the big trees' fame, scholars had not written that much about them. After delving through additional research, I discovered that the sheer volume of cultural artifacts related to the trees was staggering. The sizable body of literature that built and sustained their celebrity (travel writing, scientific accounts, plays, poetry, short stories, and novels) made up only part of the motherlode. Traveling exhibitions, along with photographs, paintings, drawings, and other promotional ephemera, added a ponderous amount of material evidence, yet I found very little cultural analysis

of these representations.[1] The seminar paper I completed, a cultural analysis of two of Albert Bierstadt's big tree paintings, expanded into a dissertation and now has become a book.

The work that follows links the sequoias' visual culture—the way in which Americans saw them—to national identity. Although I trace their celebrity to a tradition of historic trees in America, Americans' regard for the sequoias intensified during a time of national growth and expansion, when many Americans became mindful of the costs and benefits of such rapid development. Ancient trees embodied these concerns, especially in the nineteenth century. How the sequoias' discovery, reception, and depiction served cultural needs—sometimes hesitantly, sometimes exuberantly—characterized their iconography during their first hundred years as famous natural objects in America.

I approach cultural analysis with the assumption that objects serve cultural needs—they are convenient symbols expressive of social or cultural concerns. My methodology first involves becoming familiar with an object's public reception. I seek out and identify the key words, issues, or qualities that writers and artists repeat, invoke, or incorporate in their work. Then I look for explanations by considering the larger context for clues about the anxieties such reactions attempted to assuage. These main issues function as conceptual anchors, and the interpretations and readings in subsequent chapters rely heavily on them. Each chapter also observes the twists and turns in national identity and destiny that the sequoias' depiction always seemed to express. Thus my approach is to work from the object and image outward to larger cultural issues. This process might include the significance of each element in an image (like a specific big tree or a visitor's stance), an artist's history, where and why the image was displayed, and larger national events (such as the Civil War, the Great Depression, or World War II). By linking case study readings of the sequoias' representation to shifting beliefs about national identity, I conclude that these celebrated trees repeatedly served as national icons—symbolic proof of the nation's durability during crises or as triumphant evidence assuring American superiority.

I hope that my analysis of these narratives will change the way you look at trees and what we call "nature." I hope that you will see trees as more than landscape elements, climate regulators, flood controls, or global oxy-

genators (though, obviously, these qualities are important). They are much more than incredible botanical wonders. Trees are living objects, characters, storytellers, and symbols. They reveal us to ourselves, sometimes loudly and largely (like the sequoias), but more often than not in powerfully personal and quiet ways. And these revelations enrich us all, especially those of us long past the tree-climbing age.

ACKNOWLEDGMENTS

I have been blessed with all kinds of special assistance during this project's research and writing stages, and for that I am deeply grateful. My family is spread out all over the country, yet their support from the Rio Grande Valley in Texas; Las Vegas, Nevada; and Sacramento, California, made this project's completion possible. In fact, without my parents' help, I would never have been able to even get started. A huge thanks to them first and foremost. More thanks are owed to the following individuals who aided my progress, sometimes in small but crucial ways. Although this is not an exhaustive list, they include Tammy Green, interlibrary loan library assistant, Ellis Library, University of Missouri–Columbia; Jim Snyder, historian, Yosemite National Park; Deborah Barlow Smedstad, head librarian, Los Angeles County Museum of Art; Jennifer Watts, curator of photographs, Huntington Library; Melanie Ruesch and Ward Eldredge, museum technicians, Sequoia National Park; and Tammy Lau, head archivist, Sanoian Special Collections Library, Henry Madden Library, California State University–Fresno. Special thanks go to the document

delivery staff at the University of Iowa: Without their efficient service, I could not have conducted a study of this California topic way out here in Iowa (and proven a lot of Western natives wrong); archivist Ellen Halteman of the California State Railroad Museum Library and senior librarian John Gonzales of the California State Library, both in Sacramento, for all the substantive time and help they offered during a crucial research visit; *Iowa Heritage Illustrated* editor Ginalie Swaim, who gave my preface a careful and beneficial review; American art history associate professor Janice Simon, University of Georgia, for providing an incredibly insightful and helpful reading of my manuscript while I prepared it for publication; American art history associate professor Joni Kinsey, University of Iowa, for her astute editorial eye and grasp of my project's larger picture; and last, I owe a particular debt of gratitude to American studies professor John Raeburn from the University of Iowa. His exceptional editorial enthusiasm and continued support helped to sharpen my writing immeasurably—especially when I was struggling—and his commentary often times made many passages read much more eloquently than I could ever have imagined. He is truly one of the good ones.

1

NATIVE TALISMANS

It was not a bear. Having shot and wounded one, Augustus T. Dowd was tracking the beast and surveying the forest at ground level. But the objects in front of him disoriented him—defied his normal vision. Only when he tipped his head back, and then more, and then a little more did he begin to comprehend the sheer magnitude of what he saw. For a moment he felt as if he were dreaming: The world was confusedly out of scale, and he had, without warning, shrunk to insectlike insignificance. Awestruck, Dowd hurried back to camp to tell his companions about his extraordinary discovery.

What overwhelmed Dowd was Sierra redwoods, conifers that grow more than 300 feet high and 30 feet in diameter. Unlike the equally massive but generally thinner Coast redwoods, which thrive in misty forests along northern California's littoral, Sierra redwoods (for clarity's sake, subsequently referred to as big trees or sequoias) flourish only in small groves in the Sierra Nevada mountains of California. Dowd's experience of viewing what came to be known as the Discovery Tree in the spring of 1852

became the mythical Euroamerican discovery story of these trees, even though indigenous groups had observed them much earlier.[1]

Along with their gargantuan size, generous estimates of the sequoias' remarkable venerability added an even more astounding element to their public reception. Even those who attempted careful study of the trees during the nineteenth century unwittingly contributed to the hype. After counting a sequoia stump's rings in 1894, naturalist John Muir—founder of the Sierra Club and an early leader of the American conservation movement—concluded that the tree was 4,000 years old before being felled. Subsequent study, however, found that he had overcalcuated by at least 500 years. Using more precise core-sample and ring-counting techniques, modern scientists have indeed leavened such eager claims. The accepted age range for mature sequoias spans anywhere from 200 to 3,500 years old (the most popular big tree specimens being more than 2,000 years old), with sequoias more than 1,000 years old the most abundant.

Given the difficulty and expense of travel to the Sierras, Americans' interest in sequoias began to emerge only after parts of their massive trunks were sent on promotional tours, beginning in 1853. In preparation for its exhibition, one of the trees had its bark stripped in sections.[2] These tours mark the beginning of the sequoias' cultural construction in tourist accounts and visual culture as myth, monument, commodity, spectacle, and national tree in America—all of which were entangled in Americans' fascination with the trees in the century after their Euroamerican discovery.

Because they were ancient, the sequoias acquired cultural meaning as historic landmarks—as artifacts of living history whose exclusive existence on native soil bolstered American pretensions about the nation's cultural wealth. The most common tourist reaction even today is to note that these trees existed contemporaneously with ancient turning points in human history—the birth of Jesus or Rome's fall—covertly expressing the young nation's historical insecurity. In the mid–nineteenth century the United States was still an adolescent and culturally undeveloped: It lacked distinction in this regard, or even a coherent national identity. Henry James reflected on this youthfulness, which he astutely linked to an "exaggerated [and] painful . . . national consciousness." "Americans," he continued, are conscious of being the youngest of the great nations, of not being of the European family." They understood themselves to be "placed on

the circumference of the circle of civilisation rather than at the centre" largely because their country did not possess any castles, ancient temples, or other architectural ruins—storied artifacts emblematic of an enduring cultural tradition. Nathaniel Hawthorne, for one, regretfully conceded in his preface to *The Marble Faun* (1860) that "there is no shadow, no antiquity . . .[in] my dear native land."[3]

Reacting to this lack of history, Americans turned to nature. Taking possession of endless forests, breathtaking western vistas, and unrivaled marvels such as Niagara Falls and the Grand Canyon encouraged them to regard their country as more than Europe's equal. Impressed by what they perceived as its pristine and ancient character, many artists such as Hawthorne held up American nature as a superior surrogate for antiquity and national identity.

Trees played a significant role in this dynamic. Unlike other natural forms, such as mountains or rivers, trees are accessible resources in that they are self-contained objects that more easily invite personal interaction and visitation and whose ages are visible and tangible. But when Americans viewed their nation's trees and forests, they filtered their patriotic appreciation of them through European standards. Timberland and other resources were less bountiful overseas, a condition that influenced which natural elements Americans most highly emphasized and treasured at home, such as old, gigantic trees. Eager to appraise their nation's worth, many nineteenth-century Americans, particularly the comfortable classes, cultivated an "imperial" eye. They saw nature primarily as a resource, perceiving either its lucrative market potential overseas or the esteem its incomparable grandeur would likely encourage in foreign tourists.[4] The sequoias' celebrity during the mid–nineteenth century thus provides a rich example of nature-becoming-culture. The nation interpreted these natural objects as the apotheosis of its identity, an exceptional nation divinely blessed because of a remarkable natural inheritance. Finding its roots in one of its most prominent natural forms further empowered the young country's boast of a national culture distinct from Europe's.[5]

As tensions between the American North and South intensified around mid-century, old trees strongly began to entrance Americans as emblems of national destiny.[6] Not only were such hoary patriarchs a legitimate type of antiquity, they were organic symbols whose vitality or degradation

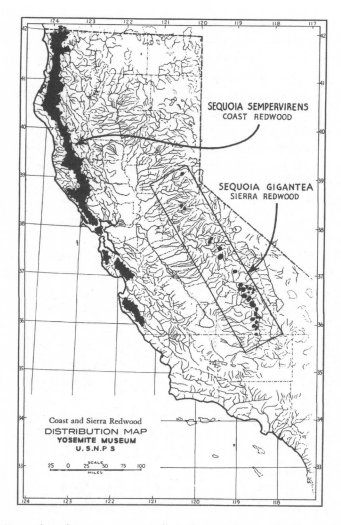

Figure 1. Two redwood strains grow naturally in the United States. The Sierra redwoods or big trees reign in small groves in the Sierra Nevadas, and Coast redwood forests line the northern California coast up into Oregon's southwest corner. From H. Johnston, *They Felled the Redwoods,* 1996.

could augur America's future—a tree's physical robustness indicated national prosperity, or, alternately, its deterioration portended national tragedy. Benson John Lossing, a pictorial historian and illustrator, was mindful of such symbolism when he began in the late 1840s to study some of the oldest known trees. Most, if not all, of his sketches were of trees intimately connected with the nation's founding, of importance to Lossing because the nation was struggling to maintain the political origins of its ideals. These included the Washington Elm at the Commons in old Cambridge, which marked the site where George Washington assumed leadership of the revolutionary forces on July 3, 1775. Four years later, Wayne's Black Walnut, south of West Point on the Hudson River in New York, consecrated the spot where "Mad" Anthony Wayne had ordered the successful recapture of the fort at Stony Point. And the Rhode Island Sycamore, located off the Eastern Channel between Newport and Providence, was the only tree left standing in 1779 following a bitter salvo by defeated British forces after "dashing exploits" by Capt. Silas Talbot ended their three-year occupation of the colony. The "solitary survivor" not only witnessed Britain's humiliation but also other epochal historical events, including the pilgrims' landing and Roger Williams's leadership. These trees were "not numerous," a troubling circumstance that stirred him to emphasize that their scarcity ought to "command the reverence of every American." Updating his survey during the Civil War's early years, he discovered to his dismay that many of the eighteen "Chroniclers" he had visited, such as the Rhode Island Sycamore and Washington Elm, were either dead or severely damaged. He regarded their disturbing deterioration as a potentially damning forecast of the nation's future.[7]

Lossing also visited Hartford's Charter Oak. One of the most famous historical trees, the oak gained notoriety when colonists used its trunk in 1687 to hide the original Connecticut charter after the English king had revoked it. Although King James II ruled for two years afterward, the tree soon became a revered symbol of resistance to tyranny. It secured its greatest fame, however, in the late–eighteenth century, when Americans venerated the tree for its historical associations, regarding it as a patriotic shrine prefiguring and asserting the new national identity.[8]

Americans became even more fascinated with the Charter Oak as a historic site and sacred relic in the 1850s when old age and the elements

HARPER'S
NEW MONTHLY MAGAZINE.

No. CXLIV.—MAY, 1862.—VOL. XXIV.

AMERICAN HISTORICAL TREES.

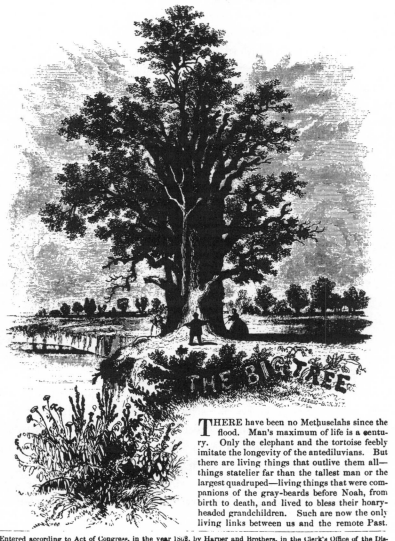

THE BIG TREE

THERE have been no Methuselahs since the flood. Man's maximum of life is a century. Only the elephant and the tortoise feebly imitate the longevity of the antediluvians. But there are living things that outlive them all—things statelier far than the tallest man or the largest quadruped—living things that were companions of the gray-beards before Noah, from birth to death, and lived to bless their hoary-headed grandchildren. Such are now the only living links between us and the remote Past.

began to stagger it. By this time, the 1848 democratic uprisings in Europe had been crushed, filling Americans with the swaggering realization that the United States was democracy's sole asylum. But by the time the oak fell during a violent storm in the early morning hours of August 21, 1856, it had become clear that the nation's political landscape was ominously changing as well. As it had throughout the decade, the estrangement of the North and South was accelerating. The violent conflict over Kansas's right to self-determination—"Bloody Kansas"—convulsed the nation. It also was an election year, and debates over the economic effects of slave versus free states dominated party platforms. The fallen oak stirred up anxious questions about the nation's continuing endurance as a democracy. Curtis Guild, a Boston poet, explicitly imagined the tree as a national portent. The oak was like a flag, he mused five days after the tree's demise, with "mighty limbs [that] like banners wave." But the sound of a coming storm disturbed its equanimity, whose clamor and chaos Guild initially mistook for marching troops and fallen flags.

> But hark! is it the rattling rain,
> Or measured tramp of troops again?
> No! 'tis the tempest's sounding roar,
> That wrestles with the oak once more!
> It yields! and with a rushing sound
> Like a great banner, to the ground
> It comes at last.

With the tree destroyed, Guild perceived a horrifying omen—the nation laid low—and challenged Americans to learn from its example. The oak would live on in sacred memory, and if humanity could not quell the natural storms that felled it, with determination they could still the political ones that threatened the union.

> Freemen all, the warning heed—
> Let UNION be our only creed.

Figure 2. Calling it the most ancient living link with America's past, Benson John Lossing visited and sketched the Big Tree in the summer of 1857, just weeks before its demise on the Genessee riverbank near the village of Geneseo, New York. An oak entwined by an opportunistic elm, the imperiled thousand-year-old historic tree—reputedly so revered by the Senecas that they named both a nearby village and a Seneca chief in its honor—slowly suffocated in the elm's "treacherous grasp" until it was finally swept away in a great flood later that November. Some writers imagined that its form and demise tragically embodied the destructive history of Native–Caucasian relations. From *Harper's New Monthly Magazine* 24 (May 1862): 721, 722.

XIV.—THE RHODE ISLAND SYCAMORE.

The voyager up Narraganset Bay from Newport to Providence will observe the bald appearance of Rhode Island. The absence of forests, or large trees singly or in groups, excites curiosity and commands remark. Doubtless few travelers are aware that this baldness is the effect of the desolation wrought by the British, while for three years they occupied Rhode Island. Necessity and wantonness went hand in hand in the work of demolition; and when, in October, 1779, they left the Island one solitary tree, an aged Sycamore, was all they had left of the stately groves and patches of fine forest that had beautified the Island. That venerable tree was yet standing when I visited Rhode Island, late in autumn several years ago. The coast storms had then defoliated it. It stood upon the estate of Vaucluse, the property of Thomas R. Hazzard, between his fine mansion and the Seaconnet or Eastern Channel. It was thirty-two feet in circumference within twelve inches of the ground. The storms had riven its trunks and topmost branches, and it was the picture of a desolated Anak of the woods; yet it seemed to be filled with vigor that promised it life for centuries to come.

Seaconnet Channel, just below Vaucluse, was the scene of one of the most dashing exploits of the Revolutionary war. The British had blocked it up with a floating battery, the *Pigot*, armed with twelve 8-pounders and ten swivels. Captain Silas Talbot undertook the capture of the *Pigot*. Embarking sixty men on the *Hawk*, a coasting schooner, armed, besides small arms, only with three 3-pounders, he sailed down under cover of darkness, grappled the enemy, boarded, drove the crew below, coiled the cables over the hatchway to secure his prisoners, and carried off his prize to Stonington.

The destruction of wood on Rhode Island at that time was the cause of great distress to the loyal inhabitants who returned at the opening of the severely cold winter of 1780. Fuel was so scarce that wood sold in Newport for twenty dollars a cord.

That majestic Sycamore, if it still lives, is doubtless many hundred years old. It may have been there when the Scandinavian sea-kings trod the forests around it, and reared the old Tower at Newport. It was there when the Pilgrims landed at Plymouth, and when Roger Williams seated himself at Providence, that he might enjoy perfect freedom in the wilderness. No doubt the eyes of Philip of Mount Hope and Canonchet of Canonicut, of Witamo, and Miantonōmoh of the beautiful Aquiday have looked upon that patriarch, which stood, and may still stand, upon that gentle eastern slope of the Island, a solitary survivor of the primeval forest.

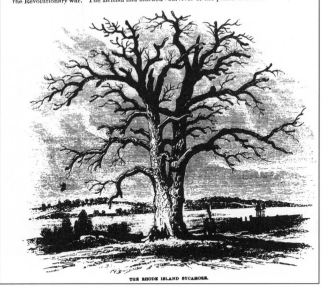

THE RHODE ISLAND SYCAMORE.

Figure 3. The British intentionally spared the Rhode Island Sycamore after their terroristic pillage of Rhode Island's forests during the Revolutionary War. It appeared "a desolated Anak of the woods" to Lossing by the 1840s. According to biblical folk tradition, Anak was an ancestor of a tribe of giants that was nearly eradicated. Because the sycamore had witnessed other vital events in American history, some admirers came to regard it as a historic tree, one whose yet vigorous condition exemplified American endurance and fortitude. From *Harper's New Monthly Magazine* 24 (May 1862): 736.

Let not our mighty nation now,
That stands with starry circled brow
The admiration of the world,
From its far height by us be hurled;
Nor by fierce discords tempest blast,
In ruin dashed to earth at last.
But linked in chain, no blow can sever—
Shine Union's clustering stars forever.[9]

An old tree's ability—as with the Charter Oak—to endure the ravages of war, time, and the elements fueled Americans' appreciation of them as national historical monuments. Americans saw these trees as sturdy ancestors that connected them tangibly to their national roots. For such a young nation, which in the first half of the nineteenth century showed little interest in erecting commemorative monuments, trees became important living landmarks to foster reflections about national history and identity. With the coming of the Civil War, the fate of the nation itself hung in the balance, and what Americans believed about their nation's destiny—its political, economic, and social progress—had been cast into doubt. Much like the oak, which had decayed during the 1850s from age and even vandalism,[10] the nation was beginning to weaken from within, and many read the Connecticut tree's death as tragically resonant. Old historical trees thus figured as dependable though mortal representatives of the vulnerable yet resilient nation throughout this tumultuous period.[11]

Amid the disruption of the Civil War in 1864, President Abraham Lincoln also endorsed the potent symbolism of old trees. He signed a bill to preserve the sequoias near Yosemite, specifically protecting those in the Mariposa Grove "for public use, resort, and recreation." The bill, which included Yosemite Valley, was the federal government's first legislative act of preservation. The iconic status of old trees made the creation and signing of the bill during that time of national distress all the more poignant. The same passionate reverence for historical trees such as the Charter Oak would sustain the sequoias as permanent and protected living monuments unique to America. Seen as the largest and oldest living organisms on earth, the sequoias were certified as enduring historic trees and representations of cultural wealth, writ large.[12]

"We have great facts in California that must be believed, sooner or

later," enthused popular travel writer Nathaniel Parker Willis in 1859 after viewing the big trees in the Calaveras Grove, north of Yosemite Valley. The grove, the first of several discovered in the Sierras during the previous seven years, had been converted into a tourist site, complete with a hotel and trail. Very few tourists, perhaps fewer than 200, had visited the groves before Willis, although within five years tourist numbers would steadily increase, achieving "the status of a 'must'" for the nation's cultural elite.[13]

The trees overwhelmingly impressed Willis, but equally so did the worshipful behavior of those lucky few who had visited them. "The intelligent and devout worshippers" who visited this grove, gloated Willis, appeared much more inspired than those he had observed entering Mohammed's tomb at Mecca, deliriously racing alongside the Juggernaut of Hindostan, or viewing other "reputed" and "superstitious objects" overseas, such as a robe Jesus may have worn. Years before the popularity of the big trees peaked in the 1870s and 1880s, Willis asserted that a journey to view them surpassed any other sacred pilgrimages, especially for "intelligent" American travelers, because, according to Willis, the trees were an authentic revelation: astounding natural forms that grew and thrived in native soil. They were not false idols dragged through the streets or humanmade artifacts trapped under glass: They were the real thing and the direct result of God's cultivation, according to Willis, validating Ralph Waldo Emerson's 1836 declaration that in the nation's woodlands "we return to reason and faith." American nature bested Europe, because its gargantuan tree groves were the truest sacred places whose purity not only impressed but would ultimately benefit devout Europeans.[14]

As did Willis, other Americans embraced the big trees' patriotic symbolism in quasi-religious terms. When "a large eagle came and perched upon [one of them]," an early observer piously interpreted the occurrence as "emblematical of the grandeur of this forest as well as that of our country," a sign of God's blessing. Unconsciously expressing national anxieties and aspirations, Americans championed the massive trees' antiquity and nativeness as reverential proof of America's historical and cultural wealth.[15]

Among the most heralded of America's ageless natural wonders, these native trees redeemed America's lack of an ancient past. Their gargantuan size and venerability made them natural royalty, a talisman whose history

stretched further back than European royal ancestral lines. Clarence King, a geologist who helped Josiah Dwight Whitney complete a survey of California during the 1860s—and supervised his own great survey by the end of the same decade—claimed that the sequoias were American antiquities far superior to any humanmade relic of the Old World. Somewhat like Willis, he favorably compared them to time-worn landmarks and Roman architecture, finding that none of these others "link the past and to-day with anything like the power of these monuments of living antiquity . . . of green old age, still bid fair to grow broad and high for centuries to come." These were ancient links to the past, more than a match for Europe's because they were living and, like the nation, had many more years of growth and development ahead. America may still have been culturally thin in the 1860s when compared to Europe's past, but the superiority of American nature imaginatively compensated for the perceived imbalance.[16]

As compared to the Charter Oak—linked to a single event in the nation's past—the big trees seemed to embody all of human history, both subsuming and evoking it. In scientific and travel accounts from the 1850s to the 1880s, Americans identified them as American possessions—huge living artifacts that transcended the history of past civilizations and whose presence in America presaged the next long-lived empire. Such writers championed their size, age, and mythic aura as uniquely American. These old trees vitally consecrated America as a nation of centennial and even millennial endurance and significance.

Scientists attempting to classify the sequoias also turned to national metaphors. During the first decade after the big trees' Euroamerican discovery in 1852, botanists waged a heated battle over their scientific name. These disputants essentially fought over the privilege of asserting nationality: British botanists claimed a British name, and their native adversaries offered American alternatives. These scholarly disagreements even provoked the popular press's involvement. That British botanists would dare to attach a foreign name to such a "superstitious object" in America as the big trees was seen by many, both scientists and others, as an invasive act of professional trespass and an attempt at imperial repossession.[17]

The debate began after Dr. John Lindley, an English botanist, evaluated and named a big tree specimen sent to him in Great Britain in late 1853. Earlier Albert Kellogg, one of the founders of California's Academy of

Sciences, had examined the tree's botanical markers and unofficially named it Washington Cedar, thus making Lindley's naming of the tree especially grating. Kellogg subsequently forwarded his samples to the esteemed American botanists Asa Gray and John Torrey, an American botanist from Columbia College in New York. However, Kellogg had also generously showed the specimens to William Lobb, a prodigious botanical collector for Veitch & Sons, a well-respected British nursery. Years later, Kellogg recalled that he "took Mr. Lobb to the California Academy of Sciences, and showed him the first specimens he ever saw of this marvelous, now world-renowned" tree. Their dispatch to American botanists, as well as knowledge of the sequoias' sales potential, motivated Lobb to "seize . . . the day" and hastily bring home leaves, cones, and other wood samples for Lindley's analysis in Britain. The British botanist triumphantly concluded that the tree was unlike any other, even compared to the Coast redwood (*Sequoia sempervirens*, 1847) and therefore required a new name for its genus and species. On Christmas Eve, 1853, Lindley beat the Americans to the punch and published his evaluation in *The Gardeners' Chronicle*, a London-based publication. Calling the tree "a prodigious acquisition," Lindley proclaimed it "the most gigantic tree" comparable to "the greatest of modern heroes." Lindley then proudly turned to a British hero, Wellington, to inspire its naming. "Let it then bear henceforward the name of WELLINGTONIA GIGANTEA. Emperors and kings and princes have their plants, and we must not forget to place in the highest rank among them our own great warrior."[18]

American botanists as well as the American public were incensed. But because of taxonomic protocol, any name offered first had precedence, unless proven scientifically inaccurate. Even the California Academy agreed, conceding in March 1854 that because Kellogg had waited "for further information respecting [the] described species, we have lost it." They respected Lindley's publication as "substantial evidence of priority of discovery." The British name would thus remain until another botanist proved that Lindley's *Wellingtonia* had characteristics consistent with some other genus. American botanists' frustration was made even more poignant when they found out that Dr. Torrey never received Kellogg's specimen. The sample was lost in transit, as was the opportunity for an American to name the giant indigenous tree.[19]

Not long afterward, however, botanists began to discredit Lindley's conclusions by more carefully inspecting the species' markers, especially its cone. A respected French scientist, Joseph Decaisne, took issue with Lindley's conclusions and corroborated Torrey's eventual and yet unpublished analysis by identifying the tree as *Sequoia gigantea* at a meeting of the French Botanical Society in July 1854. Gray immediately concurred, saying that its cones were essentially similar to the genus *Sequoia* (which Stephen Endlicher established in his 1847 scientific study and naming of Coast redwoods) and thus ruled that "the so-called *Wellingtonia* will hereafter bear the name imposed by Dr. Torrey, namely that of *Sequoia gigantea*."[20]

Disregarding these developments, however, the British refused to concede the name. Although Decaisne had publicly confirmed the accuracy of *Sequoia gigantea* the year before, Berthold Seemann published an 1855 big tree taxonomy wherein he confidently listed *Sequoia Wellingtonia* first in its synonymy. Four years later, Seemann persisted in questioning the tree's naming. After much investigation, including interviewing Torrey, Seemann contended that because Torrey had not published his findings about the new name until 1857—fully two years after Seemann had published his own—the new name, *Sequoia gigantea,* was illegitimate. Buoyed by his taxonomic work's "right of priority," and perhaps seeking that justice be served, Seemann rechristened this sequoia for Britain in his article, even though the mystery surrounding the tree's scientific name had already been solved for many other, non–British botanists.[21]

The controversy over the tree's naming would not be resolved until the twentieth century. In 1938, John Buchholz, an American botanist, completed a careful study of the differences between Coast redwoods and Sierra redwoods. He offered a new scientific name, *Sequoiadendron giganteum,* which has become the tree's official designation, even though it remains popularly known today in Great Britain as *Wellingtonia.*

The American press soon weighed in on the international debate. They reacted to claims such as Seemann's by lobbying to reclaim the trees as American. According to travel writer Willis, "some good and laudably patriotic souls" named the trees "Washingtonia Gigantea," an act that others dramatically endorsed. Defensively denouncing foreigners who continued "to rechristen them after this or that European celebrity," a

Harper's Weekly writer argued that because "American frontiersmen" had discovered these trees, "all who write or speak of them should avoid being thus led, and perpetuate the glorious name given them shortly after their discovery—the WASHINGTONIA GIGANTEA."[22]

One of the "patriotic souls" to whom Willis had referred was C. F. Winslow, a scientist who had entered the naming debate in August 1854. Probably unaware of Gray's public statement the month before, he defended two alternative names in a missive to *The California Farmer*, a San Francisco-based agricultural journal. The letter was rife with national pride and professional disdain. Literally writing on the stump of Dowd's Discovery Tree, Winslow accused Lindley of intentionally baiting American naturalists by applying the British name. "A name so worthy of immortal honor and renown as that of WASHINGTON," Winslow affirmed, "would strike the mind of the world as far more suitable to the most gigantic and remarkable vegetable wonder, indigenous to a country, where his name is the most distinguished ornament."

After this broadside, Winslow then added his own jingoistic twist to the *Washingtonia* name. He labeled the British scientific community's handling of the tree's naming as a "stamp act," and envisioned American naturalists participating in an updated version of the Boston Tea Party. Claiming "respectful dissent" from British authority, Winslow argued that only an American name was appropriate (he offered *Washingtonia Californica*) and that any British names should be thrown overboard forever. Delivering the final salvo, Winslow eagerly encouraged American scientists to vindicate their honor "from foreign indelicacy by boldly discarding the name now applied to it."[23]

Winslow's comments were more than just a professional disagreement. Just as American colonists had regarded Hartford's oak as an unimpeachable symbol of independent resolve, Winslow's plea to associate the big trees imaginatively with Washington demanded respect for America's separate and distinct status as a nation. That British scientists refused the tree an American name only confirmed American cultural anxieties, because it revealed foreigners' disrespect for both American naturalists and the nation itself. Indeed, Andrew Murray, a respected British botanist and collector whose specialty was conifers, ridiculed Winslow in 1860, almost six years after Gray confirmed the tree was not a *Wellingtonia*. He said

that Winslow's argument was "more like a speech concocted by Dickens for Mr. Jefferson Brick than a real true *bona fide* speech."[24]

At the same time botanists were insulting each other over the tree's scientific name, European nurseries were successfully selling big tree seeds and seedlings. These American trees were now being transplanted quite readily to foreign soil. After Lobb's arrival with cuttings and seeds in 1853, big-tree mania swept England. According to tree folklorist and writer Thomas Pakenham, they "were planted everywhere: on suburban lawns, on great estates, in triumphal [urban] avenues." They were so popular that nurseries could not keep up with the demand. Alfred Lord Tennyson's son wrote that in 1864 one of "the great event[s] of [that] year was the visit of Garibaldi to the Tennysons, an incident of which was the planting of a Wellingtonia by the great Italian and ceremonies connected with it." Their popularity may be explained by the fact that they grew readily in the cool moist British climate, at a rate of 2 feet a year, an impressive accomplishment because many concerned American nurserymen, such as Pennsylvania-born Josiah Hoopes, advised that the sequoia was "exceedingly difficult to transplant."[25] Despite these challenges, many of the early transplants to Europe have survived, from as far south as southern Spain to as far north as Germany. A seedling reputedly nursed for two years by German naturalist Alexander von Humboldt and then planted in 1858 still stands, and French nurseries have developed many sequoia cultivars, including pygmy and weeping varieties, that endure today. In fact, sequoias are such a common sight in Great Britain that a Royal Forestry Commission member has claimed that specimens likely inhabit any hilltop or mountain viewed there.

Some of the same critics of American naturalists wrote enthusiastically of their *Wellingtonias'* growth rates, thus adding insult to injury. Murray triumphed that "it is perfectly hardy in Britain, and has already reached the height of 14 feet at Martyr Castle, near Cork, and not much short of this both in England and Scotland, and has borne ripe fruit at Thetford in England." Because of these developments, the British were becoming less dependent on the United States for a supply of big-tree seeds, the English transplants becoming more fruitful with each passing year. Soon markets opened up in other European nations such as France and Germany, prompting the British Seemann to revel in their European vitality. He ea-

gerly hoped that "the Mammoth-tree [would] continue to flourish, and display in the gardens and pleasure-grounds of Europe the same gigantic proportions that render it an object of wonder and amazement in its native valleys of America!" An inaccessible and remote wonder in the American wilderness, the sequoia in Britain was being civilized—made into an object of cultivation—further suggestive of American inferiority. Whereas Americans could only gawk at the trees in their native habitat or greedily remove trunk or bark sections for exhibition elsewhere, Europeans were successfully growing them to enhance their estates and city streets.[26]

Even if some Americans might have felt pride in the transatlantic transplantation of their native wonder, the naming debates raised disturbing questions about the pillage of the national patrimony. Foreigners were now confiscating these trees literally and figuratively as their own. Nurserymen in Kirkcaldy appropriated them both in name and as an arboreal fact for England, boasting that Americans had lost their national claim to them. Because the young country's attempt to appropriate the trees as "a memorial for *their* great man," George Washington, "ha[d] failed," the British cultivators predicted that

in a few years the name *Washingtonia* will have passed from the memories of men, except as a scientific, or rather *unscientific*, synonym. These nurserymen reimagined the Wellingtonias, so named, as a British possession, as if the originals had never existed.[27]

When the New York *Herald* in late 1854 voiced concern about the trees' extinction, its editors were especially alarmed by "the rapacity of unscrupulous speculators," not only those Americans who sought to exhibit desecrated sequoia specimens for profit but also Europeans, such as Lobb, who foraged for seeds and seedlings. Their efforts, usually sponsored by British nurseries, were often destructive. Murray's brother, for example, tried different ways to secure seeds, all of them questionable. At one point he tried to shoot down cones with a rifle. When this proved futile, he recruited three or four men and chopped down four big trees, the largest of which was 42 feet in circumference, before the local authorities stopped them.[28]

For Americans the sequoias' confiscation and successful transplantation overseas fueled fears of their extinction at home and tarnished their

mystique as indigenous wonders. They worried that the symbolic capital the trees provided the nation was being radically diminished. Although the federal government secured Mariposa Grove as a state park in 1864, countless other sequoia sites remained unprotected. As sequoia groves became more accessible in the 1860s, American tourists wasted no time recuperating their patrimony by rechristening these indigenous trees with all manner of American names. During the botanical naming debates of the 1850s, some individual big trees had inspired descriptive nicknames, such as The Old Maid or Grizzly Giant, and others drew on names from Greek mythology, such as Hercules, one of the largest sequoias until its fall in an 1862 storm. But when tourism increased in the 1860s, especially after the Civil War, tourists began to nickname the trees after eminent Americans. These were acts of creative fantasizing, made more significant after British botanists' refusal to concede the trees' Americanness. Tourists imaginatively Americanized them with these nicknames. The main groves, Calaveras and the protected Mariposa, became American sacred spaces filled with towering monuments to Americans both past and present.

The record of big-tree nicknames is fairly sketchy for this period, but tourist accounts and guidebooks suggest the main trends. The most detailed source is George W. Pine's 1873 guide, which lists many nicknames given to the trees as well as their presentation. At the Calaveras Grove, "all the trees named have a small slab of white marble, with the name engraven thereon, fastened to the trunk about twenty feet from the ground." Tourists nicknamed the trees after states (Keystone State, Vermont, Empire State, for example), writers (William Cullen Bryant, Henry Wadsworth Longfellow), clergymen (Henry Ward Beecher, Thomas Starr King), politicians (George Washington, Abraham Lincoln, Andrew Johnson, Daniel Webster, Henry Clay), generals (Ulysses S. Grant, William Tecumseh Sherman, J. B. McPherson, all named in 1865), and symbols or ideals (Uncle Sam, Union).[29]

Often tourists would attach creative narratives to the sequoias based on their nicknames. Pine commented that one tree, which a San Francisco woman decided to call America, was "a very healthy young tree 280 feet high, [and] its constitution appears vigorous and healthy. It has been well named." One Scottish tourist referenced the botanical naming debates when she commented on the tree nicknamed after George Washington. It

"is well named," she said, "and possibly the ever-green memory of some great naturalists is happily commemorated." Sometimes tourists attached an emblematic political narrative to nicknamed trees. Alonzo Clark, son of Mariposa guardian Galen Clark, observed in 1871 that the tree nicknamed "'Andy Johnson,' which [had] been inclining gradually for a year or two to the *South*, [had] lost its balance . . . and [had fallen] with a fearful crash . . . distinctly heard five miles away."[30]

Tourists who visited the big trees throughout this period thus entered groves of massive trees labeled with American nicknames. The practice quickly became unwieldy. Journalist Isaac Bromley complained in 1872 that "everybody who has visited the [Mariposa] grove has named one or more trees in honor of themselves or some ambitious friend," which left few trees for others to nickname. However, the joke was on the tourists. So thoroughly did they enjoy naming sequoias that Mariposa guides would hand out cards for tourist parties to fill out and attach to trees; after the tourists left the guides would dispose of the cards. Unbeknownst to the tourists, said Bromley, "most of the names given the trees last while the christening party is in the grove, and are never heard of afterward, though the guides promise every one that the name shall be registered, and recorded, and perpetuated." Only names with national prominence would ever "stick to the giants," such as Lincoln, Grant, and Sherman. Aware of the game, Bromley's party "christened" one of the trees after a friend's newborn "as quickly as possible after we got there, for fear [an incoming] Chicago party would hear of it and come back and get ahead of us with one of their everlasting cards."[31]

Bayard Taylor, one of the best-known writers of early California, also noticed that the nicknaming practices were getting out of hand. Coming on a grouping of big trees while visiting the Calaveras Grove in 1859, he charged that "some lovesick blockhead . . . has fastened upon three of the trees marble tablets, inscribed severally, in letters of gold, 'The Marble Heart (!),' 'The Nightingale,' and 'The Salem Witch.'" He immediately asked the host for a ladder and a hammer, explaining that "if I were to remain here tonight, you would find those things smashed tomorrow morning." Taylor eventually enjoyed some satisfaction when he discovered that the expensive marble tablet that Miss Avonia Jones, an actress, had commissioned for placement on one of the trees, had been destroyed in a for-

est fire while en route to the grove. "Fancy one of those grand and awful trees bearing the name of 'Avonia Jones!'" Taylor exclaimed. "Even Senator Gwinn, as I was informed, had his name cast on an iron plate, and sent to the Mariposa Grove, to be placed on one of the largest trees. Oh! the pitiful vanity of our race!"[32]

Minor nicknames, such as The Marble Heart, rarely stuck. But with the prominent names American tourists imaginatively repossessed the sequoias and repopulated the groves with indisputably American wonders. Groves full of trees named the Abraham Lincoln and George Washington firmly announced that these were historical American shrines. In 1884 Constance Frederica Gordon-Cummings, a popular Scottish travel writer, conceded that a big-tree grove was a uniquely American place. Coming on the Father of the Forest, a massive, nearly 400-foot tree 90 feet in circumference lying on the ground, she admitted that "it is as if, having looked at a European forest through the wrong end of your opera-glasses, you suddenly turn them, and lo! you behold a Californian forest." It is a striking perceptual transformation, especially after the vehement refusal of botanists and nurserymen to concede the sequoia's national origins in the 1850s. In fact, only after sequoia tourism increased did the cult of the trees in British nurseries, much as the intense naming debates, begin to die down, a casualty of Americans' reclaiming practices.[33]

Likewise Americans' imaginative repossession of the big trees involved a patriotic discourse that scripted them as providential talismans—their native presence only in America prophesied a grand future for the nation. Countless tourists referred to them as "monarchs of the earth" equal to world leaders, a collective chant that contributed to a mythology about the nation's preeminence. The guidebook writer Pine romanticized their millenial presence in the New World, maintaining that they had been growing only for this time and place.

> Perhaps before Old Rome was planted on the hills, certainly long before any man imagined this Continent, these youthful trees were lifting their noble forms in these faraway mountain solitudes, to be ready for eyes that would appreciate them in the Nineteenth Century.[34]

Other celebrants went even further, linking their grand and royal provenance to a prosperous American future. Mrs. S. C. Conner's play, "The

Three Brothers; or, the Mammoth Grove of Calaveras: A Legend of California" (late 1850s), which may have been performed on the massive stump of Dowd's Discovery Tree, described the perceptual effect that overcame a sequoia spectator. "Into what depths of time/Might Fancy wander sportively," she wrote, a view that prefigured the trees as time's patriarchs, with human history, both past and future, as its progeny. "Some Monarch-Father of this grove set forth/His tiny shoot when the primeval flood/Receded from the old and changed earth," and its growth paralleled that of human culture.

> Perhaps coeval with Assyrian kings
> His branches in dominion spread; from age
> to age, his sapling heirs with empires grew.
> When Time those patriarchs' leafy tresses strewed
> Upon the earth, while Art and Science slept,
> And ruthless hordes drove back Improvement's stream,
> Their sturdy oaklings throve, and in their turn
> Rose when Columbus gave to Spain a world.[35]

The trees prospered, according to Conner, thriving while the prospects of civilization slumbered and ignorance impeded its progress. However, when Columbus discovered the New World, the trees rose up, because their magnificent growth had all been to meet that moment—the dawning of a new empire, this one the crowning achievement of human history. The trees were talismans of prosperous empires, Conner fantasized, perhaps harbingers of powerful cities in their native lands. She concluded by contemplating the wondrous possibilities signified by their presence in the nineteenth century, again positing them as venerable parents nurturing impressive developments to come in human history.

> Who shall say,
> (If hands irreverent molest them not,)
> But they may shadow mighty cities, reared
> E'en at their roots, in centuries to come.[36]

Such prophetic fantasies infected other writers as well, such as Walt Whitman, who blustered in 1874 that the obliteration of the Coast redwoods (*Sequoia sempervirens*) heralded the advancement of civilization. Whitman's redwoods accepted their destruction because their pass-

ing would allow Americans to assume their role, he thought, as an annointed nation. "Murmuring out of its myriad leaves," these sequoias sang a song whereby they rapturously conceded defeat to their American conquerors.

Nor yield we mournfully majestic brothers,
We who have grandly fill'd our time;
With Nature's calm content, with tacit
 huge delight,
We welcome what we wrought for through the past,
And leave the field for them.

For them predicted long ago,
For a superber race, they too to grandly fill
 their time,
For them we abdicate, in them ourselves ye forest kings!

The trees, so Whitman believed, embraced their abdication because they were designed for that moment—they were "wrought for" it. As the "superber race" Americans were the trees' evolutionary superiors, an inevitable and improved generation of world leaders. The loggers were giants too, according to Whitman, and heroes, because they cleared "the ground for broad humanity, the true America, heir of the past so grand,/To build a grander future." The national confidence assumed by Whitman ironically was all the more plausible despite the historical and personal context in which he wrote the poem. The nation was enduring one of its most severe depressions when Whitman originally penned it in late 1873. Earlier in that same year, personal tragedy had devastated him when he suffered permanent partial paralysis from a stroke in January followed by the loss of his dearly beloved mother four months later. Impressed by trees whose ancient and massive presence he never saw, Whitman recovered enough from these personal and national disasters to exult in their symbolism as patriotic oracles, thus bolstering himself and his readers.[37]

Americans imaginatively sympathized with the big trees as coeval brothers whose lineage bespoke only great things. Along with these fantasies, they found evidence of their nation's cultural ascendancy during a tumultuous time of internal change and political firestorms. Yet regardless of the braggadocio inherent in these patriotic effusions, most Americans were uncertain about the prophecies imagined via the sequoias. The

nation was still young and for the most part not influential on a world scale. Eager for international respect, those who visited these prophetic trees recorded tentative and anxiety-filled pilgrimages, reflective of a nation still culturally and politically insecure.

By the late 1860s, embracing the mythology of the sequoias as ancient indigenous chroniclers of the nation had become conventional in tourist accounts. Much of this was a result of the phenomenal amount of attention the trees had received. Marveled by their journalistic coverage in "innumerable articles in popular [and scientific] periodicals and [international] books of travel," Josiah Dwight Whitney, state geologist of the California survey team, concluded in 1870 that "no other plant [has] ever attracted so much attention or attained such a celebrity within so short a period." Most visitors were thus well-read on the subject and expected to be awed, overwhelmed, and maybe even changed when in the sequoias' presence, moved perhaps to contemplate the whole of human history.[38]

However, the two most common visitor reactions starkly countered the trees' patriotic reputation of national grandeur. Many felt overwhelming insignificance in the presence of such age and size, perceiving the trees less as positive portents than disdainful monuments, scornful of humanity's evanescent mortality. Novelists and short story writers were especially drawn to the theme of human insignificance. In an anonymous 1886 short story, "A Romance of South Dome," a young San Francisco woman visits the Calaveras Grove. Her party's late arrival to the grove's hotel postpones a sequoia tour until the following morning. But after settling into her room, the character, Frank, cannot wait any longer. She admits to a friend that she "can't sleep, and it would be a waste of time to sleep in this place that I have dreamed about for years. Walking at midnight among these creatures will be a new sensation." She ventures out with two friends and perceives the trees as ominous and disconcerting figures. Looking at the Fallen Monarch, Frank admits to a feeling of unworthiness. She senses that "we modern creatures seem out of place here. I feel like apologizing." Besides the fascinating novelty of viewing the trees at night, however, the short scene was loaded with anxieties related to the big trees' symbolic presence as providential sentinels.[39]

The Californian Bret Harte elaborated on this theme in his novel, *In the Carquinez Woods* (1883). Fearful that the law would find her after

a supposed crime of passion, the main character Teresa hides out with a botanist named Low Dorman in a sequoia trunk. Its chamber is "irregular-shaped [and] vaulted," and contains enough room for a sleeping area, a table, a cupboard, and an informal pile of supplies. Hanging bark makes it the perfect hideout, as well as an easy and silent escape passage. Frustrated with her isolation and feeling as though "she was acting to viewless space," Teresa decides to challenge the big tree forest. She rips the bark aside, leaps to the ground, runs forward wildly, stops, and cries out "Hallo! . . . Look, 'tis I, Teresa!" When she senses no reaction, "she stretche[s] out her clenched fists as if to defy the pillared austerities of the vaults around her" and shouts, "come and take me if you dare!" The trees' silence makes Teresa feel a deep sense of insignificance and panic. She trembles and is struck breathless "by the compact, embattled solitude that encompassed her" in the grove. The fact that "impressing these cold and passive vaults" was hopeless "filled her with a vague fear." She creeps back to her hiding place, a retreat "less awful than the crushing presence of these mute and monstrous witnesses of her weakness."[40]

In these tales of darkness and judgment, the trees caused viewers' self-importance to fall away, the opposite of Whitman's personification of them as compliant victims. In Teresa's imagination, the sequoias offered visitors no inviting welcome—they even disdained her presence. Women were the main actors in these two tales, and their gender may explain why the writers at that time emphasized their insecurity in the face of nature, especially when one of them challenged the trees. However, in other descriptive passages Harte referred to the sequoias as places of doom and death, with "aisles [that] might have been tombs; the fallen trees, enormous mummies; the silence, the solitude of the forgotten past." Harte thus may have coincidentally chosen a woman to experience and express general insecurities any typical viewer would feel in the sequoias' presence. As Teresa later told Low, these were "supercilious trees" that "browbeat . . . and look . . . down upon" you.[41]

The trees' presence as scornful antagonists made for powerfully humbling literary scenes, but it did not represent all tourists' visitation experiences. The second general reaction—much more common—was that the great trees failed to impress viewers, inspiring only disappointment, even boredom. Thus tourists felt either too much or nothing at all in their pres-

ence. Eli Perkins, a *New York Times* correspondent, found visitors' tastes to be fickle and fleeting during a trip to the Calaveras Grove in 1877. He noticed how quickly travelers tired of the sequoias' appearance and subsequently compensated by mocking the unique giants. A "sentimental young gentleman" and the trail guide loudly agreed that the Keystone, one of the largest trees in the grove, would be a fine "place to live in," except that "it lacks running ice-water and good company." The shouted critique abruptly interrupted Perkins's private enjoyment of the grove, causing him to point out Americans' inability to appreciate the trees' sublime novelty. Americans, he disparagingly concluded, found the urban environment much more entertaining and thus meaningful, "the great City of New-York ha[ving] in it a perpetual lodestone, 10 times more attractive to some other wandering soul than the sublimest waterfall or the most gorgeous sun-gilded mountain peak of the [sic] Yo Semite."[42]

Perkins saw Americans' short attention span as only part of the problem facing unimpressed big-tree tourists. Travel writers had created such a mythology about the sequoias that it led the uninitiated to build up huge expectations before even reaching the groves. When on first glance the trees failed to overawe them, the tourists moved on to the next great view. But in many other accounts, tourists, disturbed by their disappointment, lingered a little longer in hopes of perceiving the trees' true character. This tourist ritual of recovered perception revealed Americans' tentative desire to embrace the historical magnificence of the sequoias and that which they predicted for the nation by association.[43]

The graphic artist James Smillie, who both wrote the text and contributed drawings of the sequoias and Yosemite Valley for a chapter in William Cullen Bryant's *Picturesque America* (1872), captured the typical tourist's ritual. Filled with the mythology of the trees, Smillie experienced all the stages of big tree viewing in his account: high expectations, disappointment, and recovery. Having familiarized himself with scientific articles and surveys of the trees, Smillie practically burst with anticipation. Admitting that "it would be useless to attempt to describe the confusion of sentiment and impatience that possessed me" as the party neared the groves, he began to imagine what he would perceive. Predictably, Smillie anticipated feeling the trees' sublime historical presence through memories of ascendant races and past empires whispered through weary

branches. "Peering anxiously through the labyrinth of the wood for the first glimpse into the . . . grand old grove," he fancied, would be like entering a time portal. He imagined being in the presence of the "lore of dead ages" and "the sad history of centuries past," with the trees telling lurid tales of "Goths and Vandals," "King Arthur and 'his table round,'" and "Mohammed and his wars." For the trees, "Columbus would be a matter of yesterday," he fancied, "and our dear Revolutionary War a scarce noticeable thing of to-day."[44]

When the guide finally announced the sequoias, Smillie was caught by surprise. The atmosphere was all wrong and the scene before him uninspiring. "I was ready to shout, and, spurring my prosaic beast, to rush with the rest in a graceless scramble to be first to reach his majesty's foot." However, "the charm was broken." Smillie "had built an ideal grove, and at first sight it was demolished." All the sublime elements—a dark aged atmosphere, with eerie whistling breezes suffocatingly bound by grand, titanic silhouettes—were absent, for "there was no gloomily grand grove, there were no profound recesses; the great trees stood widely apart. . . . I wandered about, sorely disappointed that they did not look bigger, and yet every sense told me that they were vast beyond any thing that I had ever seen."[45]

Only later, after he had been "among them for hours, and had sketched two or three, [did] their true proportions loom . . . among [his] understanding." Smillie's expectations were thus dashed by the misleading reality of their actual height. Instead of an ideal grove, whose members would eloquently breathe history and trumpet prophetic claims, all Smillie initially could see were trees that, without any other referents of size or even drama, looked just like common trees he had seen before. Such a perceptual ritual called on tourists to readjust their lenses to see what they wanted to see—mammoth-sized trees and imaginative historical referents. Smillie's recovery of his expectations happened as a storm neared, which effectively broke up the tour group. With the boom of the rapidly nearing storm "roll[ing] through the pillared forest," Smillie, all alone now, gathered his materials and looked back on the groves with "a last hungry, devouring look." Here was the sublimity he craved as a big tree tourist, and finally recovered, admitting that because of that moment "now there is pictured in memory a mighty shadowed forest, its branches moving un-

easily, and sighing as the storm swe[pt] torrent-like through it." Consumed with visions of the mood created by these huge trees, Smillie finally saw what he expected to see—magnificently sublime giants—a vision that filled him with extreme relief and overwhelming satisfaction.[46]

Smillie's despair was not just an artistic concern, because other tourists labored to recover their high expectations as well. Rev. Thomas Starr King was moved to "confess" that on scanning his first big tree he felt "intense disappointment" before he was able to assess their historical value fully. Journalist Isaac Bromley, as well, needed time and a little sustenance before he could appreciate the historical continuity their age and size signified. After taking time out for repose and lunch, Bromley was more able to remark of one of the fallen trees that "the great space it had filled was nothing to the ages it had bridged over." The visual ritual soon became part of the travel description lore of the big trees. A writer for *Overland Monthly* in 1870 initially questioned "were they so very tall? Were they *really* the big trees? . . . I was disappointed." He discussed his experience with a landlady of distinctly lower class, who informed him that "folks are always disappointed at first," but that "you'll call 'em big enough to-morrow."

> I've seen quite as large in other States, and no one thought of making them celebrated. This is Fame, is it?. . . .To-morrow you'll give up comparin' of 'em, and by to-morrow night you'll think there's never been half enough said about 'em.[47]

These reactions were so common that tourist guides even warned of the possibility of a letdown. In Yosemite's first guidebook, John S. Hittell advised in 1868 that most tourists were "generally disappointed on first visiting either grove," because "many of those who look at the Big Trees, if not previously informed, would ride through a grove of them and not imagine that they . . . differed much in size from other trees about them, or were very remarkable in any respect." Whitney, finding that many viewers overestimated their age (one claimed a tree was nearly 6,000 years old), miscalculated their size (the Starr King tree at 366 feet instead of the actual 283 feet high), and even panicked about their abundance and range, concluded that "the Big Tree is not that wonderfully exceptional thing which popular writers have almost always described it as being."[48]

Grace Greenwood, a well-known travel writer, kept the faith, offering strategies that would enhance tourists' proper appreciation of the big trees. After maneuvering in and among the trees for a while and describing a few viewing angles and experiences, she finally found the most effective vantage point. She suggested "lying on your back and looking up to its huge, immovable lower limbs, up, up, to where its tapering bole and highest branches stand above the ordinary green level of the forest tree-tops." Whichever view a tourist chose, the most important element was time. Greenwood reassured readers that "grander and grander they [will] grow to you, these sombre, Titanic shapes, the longer you linger and look, and you [will] feel that you shall never quite pass out from their solemnizing shadow of the great past." Tour proprietors also tried to prevent dissatisfaction from developing among their clientele. At Calaveras Grove they set up ladders, allowing tourists access to fallen trees—an experiential vantage point that aided appreciation of their magnitude.[49]

Thus all manner of tourists labored to see an "ideal grove" of ancient big trees, the kind that would enhance America's connection to the historical past and thus solidify its reputation abroad. Some of Perkins's comments illustrate the extent of Americans' efforts at imaginative recovery. By insisting that the trees were active participants in world history as well as its eyewitnesses, he championed the trees' significance as historical royalty in America.

> When Rome was founded this tree was a vigorous sapling, larger than the big oak on Boston Commons, and when Solomon sent to Lebanon for cedars, and Hiram rafted his curious woods from Tyre, this tree would have made a pillar of the temple. [It] saw the deluge; saw the crucifixion; saw the first Pope; saw Luther, and was here to receive Columbus. When Balboa discovered the Pacific Ocean the Methuselah of the forest had gone to rest. A sapling when Adam was a stripling, and only half grown when Methuselah died of old age.[50]

Figured as part of the "pillars" of ascendant empires, the big trees imaginatively buttressed national hopes and fears. These were the world's biggest trees in a nation many believed was manifestly destined to be the world's biggest as well. Americans could never question the trees' nativeness or downplay their size and significance, because either would mock

27

the nation's divinely sanctioned uniqueness as a land of plenty and perpetual progress. Those to whom international leadership and respect meant anything, and to whom its responsibility would likely fall, often found in these trees what they needed to celebrate. As huge living historic trees, the big trees sustained the mythology of an enduring nation in the post-Civil War era and stably functioned as American monuments of antiquity and distinction for the remainder of the late–nineteenth century.

2

FIRST VIEWS

Although many Americans interpreted the sequoias' American uniqueness as evidence of the nation's cultural and scientific ascendancy, some early artists did not invoke these ideas. Rather, the most popular of image-makers at the time—stereographers—emphasized the trees' eccentricities. The sequoias' inimitable size and bulk provided optical thrills of their own, but the new medium's ocular effect intensified the visual experience. The trees' visual spectacle, along with the stereograph's mass popularity and centrality to a growing tourist market, more strongly influenced these initial portrayals. Growing out of investigations into perception that began earlier in the nineteenth century, stereography was arguably the brainchild of British natural philosopher Charles Wheatstone in the 1830s. Experimenting with a portable viewing device whose lenses forced each eye simultaneously to behold one of two identical hand-drawn im-ages, Wheatstone discovered that the eyes' optical axes (or lines of sight) converge when perceiving nearby objects. The proximity creates distinctly dissimilar views that trigger the eyes' sense of depth perception to recon-cile them into one image.[1]

Wheatstone's examination of binocular vision's intense experience quickly became a lucrative parlor game by the 1850s, especially as photographic technologies improved. Produced by a special camera, the stereograph consisted of two identical 4″ × 7″ photographs mounted side by side on one stiff card. Users inserted the card into a stereoscope's holder, which faced two adjustable viewing lenses installed in the front of the device. When Oliver Wendell Holmes constructed his unpatented stereoscope model in the early 1860s, the device so dazzled patrons that it became the standard viewer, even though companies soon created slightly different versions. Looking through the device's viewing lenses, users surrendered to a vivid experience of tunnel vision, one made more acute by the absence of any personal frames of reference. One's entire world of perception essentially became the paired images that pulled the eyes into a scene's imagined space.

Such surrender, which Holmes regarded as a visual and mental exercise, was exhausting. Scanning the image from left to right required that each eye incessantly refocus and unceasingly readjust to the disorienting feeling of moving through real planes of space while remaining motionless. Users typically did not rush while viewing the images because processing all the visual information was so time-consuming and could cause much eye fatigue.[2]

The device became a commonplace item in American homes between 1870 and 1910.[3] With its exaggerated perspectives and sense of immediacy, stereography thrilled urban Victorian viewers. However, because photography was not yet a high art form—and because patrons had to peer through bulky equipment—many considered looking at such images a guilty pleasure. Using the device in the privacy of their own parlors, eastern viewers were especially drawn to scenes of the American West, particularly those that depicted tourist sites. In fact, the medium excelled at presenting the nation's natural splendor and famous locations overseas, scenes whose composition eerily and intentionally simulated the tourist experience.

Although a poor substitute for actually viewing distant landscapes, the stereograph's magnifying effect vividly allowed it to present an object's proximity and tangibility. This capability catered to American travelers' interest in inspecting the nation's growing list of singular sights or land-

marks. Image-makers who produced the most visually successful images typically framed their subjects centrally in the foreground, surrounding them with secondary objects or figures. Any other compositional approach risked the subject being overlooked or lost amid a confusing array of receding planes. However, technical constraints also influenced their compositions. Stereography usually involved the use of a special camera (one with twin lenses, placed side by side) that enabled its operator to capture the same view twice in one shot (a single-lens camera could be used, although it required extremely careful placement and planning). This meant that stereographers had to choose perspectives or scenes that either lens could reliably replicate—either lens's view could not be blocked, in other words. Framing their subjects in the foreground thus let image-makers avoid any further compositional hazards. The resultant images allowed viewers an intensive close-up examination—a surrogate for the actual experience of viewing it in reality. Highly conscious of the medium's optical strengths, many big-tree stereographers composed views that emphasized their immense height and bulk.[4]

By 1879 big-tree stereographic views numbered at least four or five thousand.[5] Their producers found the trees ideal stereographic subjects. As singular natural phenomena, the sequoias were amazingly powerful centers of attention that a stereographer could use to manage the medium's visual illusion. The most prominent of these image-makers during the mid-1860s and early 1870s, photographers such as Carleton Watkins, Eadward Muybridge, J. J. Reilly, and Thomas Houseworth applied such compositional practices in their work, resulting in aggrandized explorations of the sequoias' quirky forms and massive dimensions.[6]

In series after series, big-tree stereography approximated a visit to a P. T. Barnum show—they presented the trees as visual entertainment for would-be tourists. Incredibly massive trunks easily miniaturized their visitors; large excavated boles playfully contained see-through views of others; or a giant tree's branches appeared to soar to infinity—all courtesy of stereography's exaggerated optical effect. Views of fallen trunks were the most ubiquitous subjects. In *Fallen Tree Hercules* (1866) (Figure 4), Houseworth centered the trunk remains of a massive Calaveras Grove big-tree in between smaller, upright trunks in the frame's middle ground. He captured three human figures standing and sitting atop Hercules in the

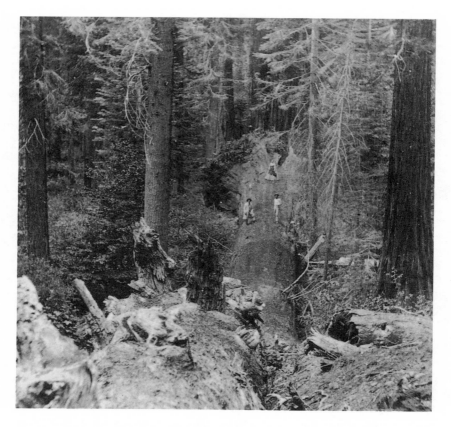

Figure 4. Thomas Houseworth, *Fallen Tree Hercules, 325 ft. long, 97 ft. in circumference from a point 250 ft. high from the base, Calaveras Co.,* 1866, stereograph. Courtesy of the Bancroft Library, University of California, Berkeley.

background. Houseworth's organization of such elements not only effectively heightened viewers' sensation of being pulled into the site's space, but his placement of the human figures tantalizingly reinforced the fact of the trunk's immense size. Reilly provided a more intense example of fallen trunk stereography in *Father of the Forest, Calaveras Grove, Cal.* (ca. 1875, Figure 5). He created an immediate vantage point on top of Father of the Forest's trunk, with a single human figure sitting halfway down the trunk. Such framing effectively mounted viewers on the stereograph's primary and irresistibly receding element—rather than removing them from it as in the Houseworth image—thus impressively magnifying the up-close novelty of the grainy trunk's size and ancient, pock-marked decay.

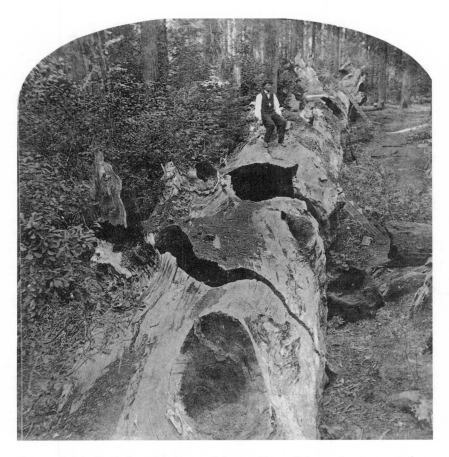

Figure 5. J. J. Reilly, *Father of the Forest, Calaveras Grove, Cal.*, ca. 1875, stereograph. Courtesy of the Bancroft Library, University of California, Berkeley.

Another common strategy centered on a standing trunk's massive bulk, often from middle-distance, with visitors gathered around the base. But other images reinforced the drama of the sequoias' length and bulk in more creative ways. Some recorded a standing trunk's dramatic ascendance, such as Houseworth's *Under the Dome of the Forest* (1866, Figure 6). The upward view of numerous treetops circulating high above created a multitude of lines that triggered the vertigo travelers often experienced while viewing the trees' height. With more compositional balance, Watkins replicated the same angle in an oval-shaped albumen print, *Among the Treetops, Calaveras Grove* (1878, Figure 7). Stereographers

Figure 6. Thomas Houseworth, *Under the Dome of the Forest, Mammoth Grove, Calaveras County*, 1866, stereograph. Courtesy of the Bancroft Library, University of California, Berkeley.

generally used albumen-treated paper, and it remained the most prevalent type of print photographers used until around 1890. Coated with egg white and then sensitized with silver nitrate, and sold dry, the paper produced an image after being put in a frame that positioned it in contact with the film negative and exposing it to the sun. In this image, Watkins exploited the print's round-hole shape to signal the stereograph's dizzying zoom.

Views from inside a burned out and excavated trunk were the most complex of the conventional big-tree stereographs. Scanning down a massive trunk's interior to an exterior object required the viewer to perform

Figure 7. Carleton E. Watkins, *Among the Treetops, Calaveras Grove*, 1878, 12.9 × 8.9 cm. The J. Paul Getty Museum, Los Angeles.

Figure 8. Thomas Houseworth, *Uncle Tom's Cabin, from a Point 40 Feet in the Interior of the Big Tree Eagle Wing*, ca. 1866, stereograph. Courtesy of the Bancroft Library, University of California, Berkeley.

an intense amount of refocusing. Houseworth's *Uncle Tom's Cabin* (ca. 1866) (Figure 8) is a powerfully somber example. Within the tree's darkened recesses, Houseworth conveyed the trunk's immense bulk by using the contrast of its opening to frame and encircle Uncle Tom's Cabin's massive base, the latter an undeniable stereographic visual aid that optically induced movement through the tunnel. Sometimes, as in Watkins's *In the Mariposa Grove, Mariposa County, Cal.* (ca. 1867, Figure 9), stereographers simulated a tourist's examination of a trunk's bulk by reversing the camera's position, enticing the viewer's gaze into one of these natural caves. *In the Mariposa Grove* not only coerced the viewer into a trunk's

Figure 9. Carleton E. Watkins, *In the Mariposa Grove, Mariposa County, Cal.*, ca. 1867, stereograph. Courtesy of the Bancroft Library, University of California, Berkeley.

tunnel, but then also out of it. Framed by the hollow's outer edge, a sitting human figure inexorably draws the gaze into, and out of, the trunk cavity—simulating the awe-inspiring experience of actually beholding a massive trunk. It is not clear if these artists were mindful of the irony of using tree tunnels as stereographic subject matter, because such inside-out trunk views formed visual puns. They focused on actual tunnels, which duplicated the stereograph's optical illusion.

Big-tree stereography provided armchair tourists with views that approximated those experienced by actual visitors. They also served as souvenirs for those wealthy enough to travel to the Sierras and who desired some kind of visual record of their experience. That stereographers tended

37

to document as many named sequoias in each grove as possible—as well as other big-tree oddities, such as trunk sections and exposed roots—reinforced their usefulness as tourism substitutes.[7] The compositional style of the stereographs thus emphasized appreciation of the trees as objects of incredible height and heft. Constrained by the medium's compositional constraints and guided by market considerations, stereographers presented the sequoias as lowbrow eye candy for the eager urban leisure classes. (Stereographs were considered lowbrow because they were not high art. They were made to thrill and appeal to the visceral—they were a parlor game, not a serious exhibit or command performance.) But such a commercial focus (Yosemite stereographs were second to Niagara Falls, the most popular of all subjects) substantially ignored the trees' meaning as prophetic and historic beings, the dominant interpretation of them through at least the late 1870s. Stereographs thus previewed the contradiction about how the trees were viewed and valued throughout the latter 1800s—either as national symbols or amusing novelties. But the latter view would not prevail until the end of the nineteenth century.

In the interim, other contemporary artists, motivated by powerful metaphorical goals, produced more symbolically rich depictions. One of these artists, Watkins, a stereographer himself, inscribed these larger concerns in huge-format photographic explorations of the trees' indominatability. The cruel reality of the Civil War and its residual effects motivated Watkins's and other artists' interest in the trees' invincible character. As the nation endured the divisive war and strained to reach its first centennial intact, these artists expressed Americans' anxious attraction to the sequoias' durability, finding in these living monuments evidence of the nation's survival. Portraits of single trees dominated such artists' compositions during this period, an approach that invited careful scrutiny of the trees' health and, by extension, the nation's. From these early artists' perspectives, the big trees were national vanity mirrors, whose bold and healthful or withered and sickly reflection foretold American prospects.

Three artists who worked in different media—photography, lithography, and oil painting—created portraits that captured these national concerns. The nation was weathering damaging storms, and the trees' perseverance inspired portrayals expressive of national hopes and fears. Later in the century, as the nation rebounded from both the physical and polit-

ical assaults the war had incurred, fewer and fewer artists attempted such nationally revealing images, which gave the advantage to tree views whose commercial focus recalled the stereograph's. In fact, sequoia portraits would not resurface until the next significant national crises—the Great Depression and World War II. But during the first period of the trees' celebration, Americans were captivated by the heroic and indomitable character of the sequoias. They were national monuments for a war-torn nation, whose mythic stature artists consistently highlighted in their work.

On April 13, 1862, tree connoisseur and poet Holmes asked a favor of the popular Unitarian minister of San Francisco, Rev. Thomas Starr King. He "wonder[ed] if you could for love or money procure me a stereoptic view of the great pines?" Word had spread about the fine photographs of the Mariposa Grove and Yosemite Valley that Carleton Watkins had recently produced, a collection that would receive wider attention later that year at New York's prestigious Goupil's Gallery. Watkins made the thirty mammoth prints (averaging 21″ × 16″) on a trip to the grove and valley in July 1861 with the mining magnate Trenor Park and his family, who likely covered much of the trip's logistical expenses. Watkins also produced one hundred stereograph views, inserted into glass and ivory card mounts. Watkins eventually sent twelve of them to Holmes at King's request, two of them of the big tree the Grizzly Giant of Mariposa. Holmes gratefully described them as "admirable views."[8]

Watkins also printed two mammoth plate versions of the Grizzly Giant for exhibition at Goupil's. The sequoias were a national marvel, and, given their successful transplantation overseas, an international sensation. Watkins's large-format photography preceded that of most big-tree stereography, the latter of which did not begin to proliferate until the mid–1860s. Although newspapers and minor artists had printed wood engravings of the trees, stereographers had yet to exploit them, and thus Watkins's images provided the national public's first photographic view of them. Bolstered by photography's reputation for verisimilitude, the large-sized tree portraits allowed the ambitious photographer to advertise his work's high quality by taking advantage of the trees' national symbolism.[9]

He did not have a commission, and thus Watkins's 1861 trip involved notable professional and personal risk. Before embarking, he methodically

gathered experimental photographic equipment to take with him. By this time, he was familiar with Charles Leander Weed's Yosemite work, and was struggling to provide clients with, as he put it, "the best view" (or the most all-encompassing perspective) of expansive plots of land. Weed—a junior partner in Robert Vance's prominent San Francisco gallery—had photographed the valley and the Mariposa Grove in 1859 and was Watkins's constant competitor throughout the 1860s. Although Weed's Yosemite work received glowing reviews from California newspapers, it never attracted national attention. Nevertheless, his efforts provided the first views of the area's scenery and highlighted what compositional difficulties lay ahead for other photographers. Challenged by Weed's work and the perspective problems of his own recent photographic assignments, Watkins constructed a special mammoth-sized camera. Thirty inches square when compact and even larger when fully extended, this device allowed him to surpass in spectacle and clarity Weed's views of Yosemite's towering domes and trees.[10]

Watkins took an enormous amount of gear in addition to the large camera. Along with a stereographic camera and basic camping supplies, Watkins's pack train hauled at least thirty glass-plate negatives (each of which weighed 4 pounds) and one hundred stereograph glass plates, a good supply of 21″ × 16″ print sheets, tripods, processing chemicals and trays, and a tent to be used as a dark room. One misstep by the pack animals could mean the erasure of hours or days of work if the equipment were dropped. Because of the primitive state of photographic technologies in the early 1860s, developing a large negative and print could take up to an hour, a process that could extend into many more if dust (for which Yosemite was famous) or any other unfortunate accident ruined the negative.[11] So time-consuming and potentially wasteful was the procedure that some historians have surmised that Watkins used his stereograph camera much as a present-day photographer might use a Polaroid or digital camera—to test out the best views. After being satisfied with an image's composition, Watkins more than likely rephotographed the same or similar view with the heavy and unwieldy camera. It is a credit to his persistence and ambition that Watkins averaged about four finished prints a day.[12]

Such a methodical approach allowed him to plan out and sequence well-ordered and impeccably composed over-sized pictures. Opening with

long establishing shots, he followed with medium views of the dominant objects in a given landscape, and then completed the sequence with close-ups that highlighted smaller details. He deftly experimented with the zoom technique for the first time during the 1861 trip. This approach was timely and appealing because it produced compositions compatible with a world view that regarded nature as ordered and comprehensible. In his first exhibition of his sequoia photography, however, Watkins did not exploit his method's full potential. He showed just two images, a long shot of a tree's full height and a close-up of its trunk's massive bulk. But even if in exhibiting these two pictures he failed to reflect the coherent three-step sequence he had developed—a failing he would later correct—these two pictures foreshadowed his continuing project of making a discrete portrait series that concentrated on individual trees, as he was urged to do by Harvard botanist Asa Gray and which he initiated in 1865.[13]

One of the trees included in the series was an especially notable big tree, the Grizzly Giant, which "sat" for him on several occasions. Copyright law did not cover images until after 1865, and Watkins lost considerable royalties to those who pirated his images. The most notorious was D. Appleton and Company, which rephotographed his 1861 originals, reduced their size, and, without acknowledging his authorship, included them as illustration inserts in its *Album of the Yosemite Valley, California* (1866).[14] Watkins's loss was posterity's gain, because it inspired him to produce at least two versions of the full-size Grizzly Giant portrait and four of the close-up view of its trunk during the decade. Watkins made the second one either in 1865 or 1866, while serving as Josiah Dwight Whitney's photographer for the California Geological Survey. Although this last portrait resembled the 1861 image, there were slight differences between the two. Because Watkins repositioned his camera in the later Grizzly Giant portrait, certain objects surrounding Grizzly receded into its background. This strategy created a bolder, less provisional view of the aged tree from 1865 to 1866, one that connoted more optimism about the nation's plight at war's end. Instead of presenting a sequoia whose condition appeared more questionable because of its pairing with another tree's unhealthy remains, Watkins's second composition showed the same sequoia, this time independent of the damaged other tree, thus heralding the big tree's unfettered survival at mid-decade.

As impressive as these images were—their mammoth format imitating the trees' extraordinary size—most Americans were preoccupied during this period by Civil War news and the Union's health. After a period when American newspapers were crowded with battle maps and reports, Watkins's 1865 to 1866 views of the celebrated historic trees were a reassuring distraction for the war-torn nation. The photographs addressed cultural anxieties, assuaging them by analogy. Much like the decaying but defiant historic trees by which Benson John Lossing charted the nation's historical viability, Watkins depicted the big trees as bold survivors that endured despite clear evidence of destructive storms and fire.

When Watkins photographed the big trees, he faced a dilemma common to every sequoia artist: accurately conveying their massiveness. For the sketch artist or lithographer, altering a big tree's surroundings or exaggerating comparative human dimensions could facilitate an impressive representation. For example, in 1853 Joseph M. Lapham, brother of the first proprietor of the Calaveras Grove, made (via lithographers Britton and Rey) what the *Daily Alta California* inaccurately identified as "a finely executed lithograph of an *arbor vitae*(?)"[15] It was possibly the first rendering of the sequoias. In *Mammoth Arbor Vitae [redwood]: Standing on the Headwaters of the Stanislaus & San Antoine Rivers, in Calaveras County, California* (Figure 10), Lapham eliminated surrounding trees and diminished others' scale, thus solving the problem of conveying the sequoia's size by indisputably giving it center stage. Lacking these compositional aids, however, most onsite visitors found it difficult to appreciate the trees' actual appearance. They struggled to gauge a grove's proportions, especially given its diversity. The Sierras not only contained sequoias of differing sizes and ages but also other immense conifers, such as Douglas fir, which skewed even more visitors' comprehension of any tree's magnitude. Bayard Taylor, writing of his trip to Calaveras Grove in 1859, noticed the perceptual phenomenon and shook himself out of it by reminding himself that "the slender saplings (apparently) behind the Trees, were in themselves enormous trees. In dwarfing everything around them, [the big trees] had also dwarfed themselves." By placing the big tree in imaginary isolation, Lapham captured its mythology as an object that dominates its surroundings, though he hardly captured the reality of its habitat and actual appearance.[16]

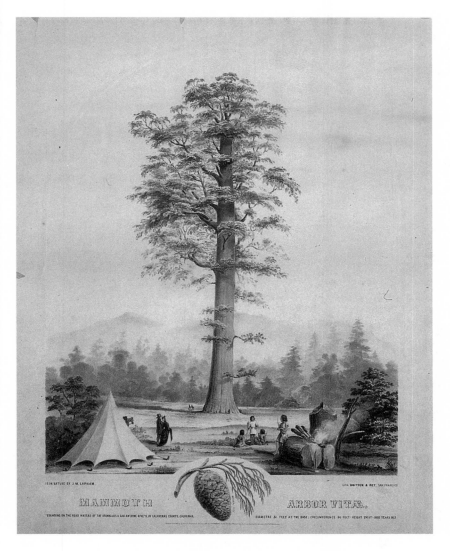

Figure 10. Joseph M. Lapham, *Mammoth Arbor Vitae [redwood]: Standing on the Headwaters of the Stanislaus & San Antoine Rivers, in Calaveras County, California,* 1853, color lithograph. Courtesy of the Bancroft Library, University of California, Berkeley.

As a photographer, Watkins had considerably less artistic license than Lapham. Given the novelty of his camera and the strict requirements of wet-plate processing, his main choices were the camera's placement and angle, the use of lighting, and the posing of human figures or other props. But even these options were fairly limited, given the grove's somewhat shadowy recesses and crowded spacing. Perhaps because of these contingencies, Watkins's big-tree views were frontal portraits, because he chose no odd angles (such as looking up from its base) and did not elevate his camera position.

Even though the big-tree discourse during the early 1860s largely focused on asserting the sequoias as American possessions, Watkins starkly omitted any reference to the naming debates in the titles to his two sequoia views. This is somewhat surprising, given his preference for botanical nomenclature in titles of other tree portraits. His composition of the 1861 sequoia views also differed from other tree portraiture he later produced. Indeed, his subsequent studies of other trees tended to be scientific examinations of a tree's abstract form. Watkins portrayed them as facts—with their size, shape, and environment all depicted in one shot—because Gray had requested unembellished scientific documentation.[17] But Watkins embedded more anecdotal and personal views in the large-sized portraits, his earliest tree studies. He emphasized the celebrity of the Grizzly Giant. Preceding the more scientific work he would complete for Gray and others, Watkins did not merely document Grizzly Giant's form, although he certainly recorded an uncluttered view of its shape and size. Examining this sequoia's appearance without exaggeration or patriotic props enabled Watkins to emphasize the sequoias' overall visual majesty and to contemplate their relevance as large old trees to a nation at war.

The two photographs provide views of the sequoias' height and mass, the two main characteristics that overwhelmed their viewers. *Grizzly Giant, Mariposa Grove, 33 ft. Diameter* (1861, Figure 12) is a full portrait of the oldest living tree in any of the then-known groves. Four unidentified men stand at its base, providing scale. As Rev. H. J. Morton, a writer and lecturer on photography, noted in 1866, the picture's composition ultimately had "a magical" effect on the viewer. "The tree rose and rose as we followed up its trunk . . . till at last the eye, almost wea-

Figure 11. *Sequoia, Mariposa Grove* reveals Watkins's classic approach to tree portraiture. Although a simple record, it also shows photographers' tendency to emphasize the sequoias' dominating presence. A healthy and richly foliated young tree singularly dwarfs the lesser-sized pines standing behind it. No wind disturbs its posture, and none of the other trees interrupt the full-length record of an anonymous sequoia. Carleton E. Watkins, *Sequoia, Mariposa Grove*, 1865–1866. Courtesy of the Department of Special Collections, Stanford University Libraries.

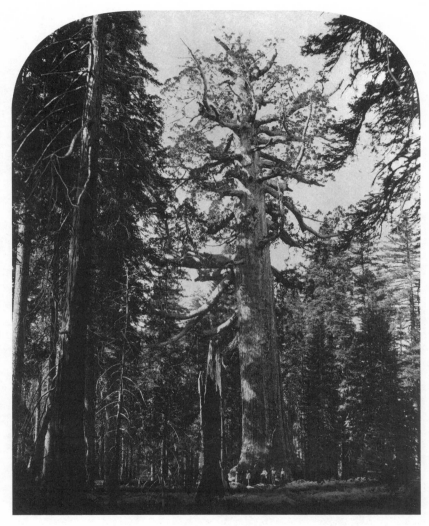

Figure 12. Carleton E. Watkins, *Grizzly Giant, Mariposa Grove, 33 ft. Diameter*, 1861. Courtesy of Fraenkel Gallery, San Francisco.

ried with the work of following its solemn shaft, took in the whole stupendous growth, and we felt that we looked indeed upon a grizzly *giant*."[18]

It is a glorious portrait, with the tree's topmost branches lifting up effusively to the heavens. Watkins captures the tree's full height and extension, thus enhancing its grandeur. Rising beyond the canopy of surrounding trees, the sky nearly opening for it, Grizzly Giant easily and with little exaggeration diminishes the trees that form its background perimeter. The two trees on the right and left edge incline inward, as though bowing, but also serve as dark framing elements to focus attention on the sunlit central object. Although the technical limitations of his camera created parallax, an optical distortion that strongly misrepresented Grizzly Giant's and the flanking trees' posture, such warping only reinforced Watkins's announcement of the Grizzly Giant as the king of the forest, with no other tree worthy of such singular attention.[19]

As much as Watkins heralds the sequoias' dominating presence in the portrait, he also implies their mortality. This is highly suggestive, given the equation of these special trees with the national condition just after the advent of the Civil War, when Watkins took this photograph. A shattered trunk stands just in front of Grizzly Giant, a companion to the old tree. It is a hollowed out and exposed shell, about a third of Grizzly Giant's height, suggesting the ultimate fate of these long-lived trees. Watkins was fascinated with the trunk, because in a second exposure he made of the same view he moved his camera slightly closer in, thus enlarging the shard to half the tree's height (Figure 13). The tree fragment's position serves as an effective intervening element—thanks to Watkins's training as a stereographer—its damaged presence strongly encouraging close observation of the large tree's injuries.[20] Insistently highlighting the shattered trunk's presence, the photograph becomes a study of deterioration as much as a celebration of the old indigenous ruin. The Grizzly Giant possesses spare foliage for a tree in mid-summer, which accentuates its overall skeletal appearance. Its crown is cracked off, no doubt the victim of a lightning strike, and shadows zigzag down its trunk, intermittently highlighting its pits and small burls, the results of a lifetime's worth of climatical buffeting. There were other trees Watkins could have photographed to represent the big trees, but he chose the oldest one—the one

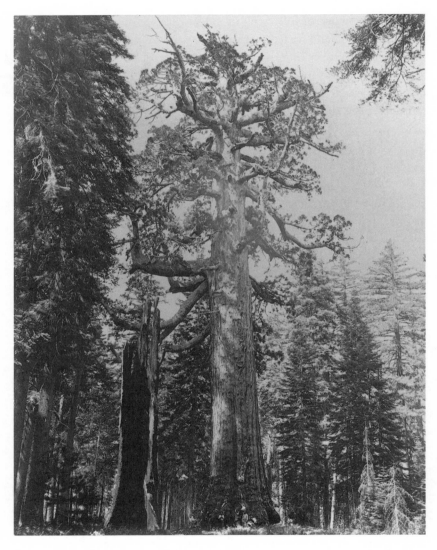

Figure 13. Carleton E. Watkins, *Grizzly Giant, Mariposa Grove, 33 ft. Diameter*, 1861. Courtesy the Department of Special Collections, Stanford University Libraries.

that had endured the most abuse—as *the* tree to see. Weathered and worn, it had outlived lesser trees, represented by the shard.

Depictions by sketch artists of other famous sequoias, especially the Mother of the Forest, however, represented them as more vibrant organisms. A distant neighbor about 100 miles to the northwest, Mother of the Forest in the Calaveras Grove had arguably been the most famous big tree before Watkins's 1861 portraits. Its bark had been stripped and successfully exhibited in the mid-1850s in New York and London. Illustrations in popular magazines often depicted the half-girdled Mother of the Forest with scaffolding around its trunk but still in full foliage, a defiant survivor thriving despite the horrendous human abuse.[21] In comparison, the skeletal Grizzly Giant in Watkins's portrait looked much more haggard, even though it had suffered less human-inflicted trauma than Mother of the Forest. Portraying Grizzly Giant standing imperiously above the severely damaged shard, the 1861 full-length portrait symbolized a weather-beaten yet rebellious America at the onset of its most divisive conflict. It presented a big tree that had outlasted countless storms yet continued to remain vulnerable, as the fragile shadow tree's condition urgently reminded.[22]

Having established a long view of the sequoia, Watkins completed his big tree photography by moving in to detail their massive girth and condition. In *Part of the Trunk of the "Grizzly Giant,"* (negative from 1861) (Figure 14), he provides a close-up view of the tree's bole with Galen Clark, the Mariposa Grove guardian, posing with it. Clark leans on a rifle in his left hand and holds a sprig of big tree cones in his right, testimony to his position as a protector of the trees. Large barkless branches lay in front of both the bole and Clark, casualties of time. Functioning somewhat like Watkins's inclusion of the tree shard in the long shot, Clark's grizzled frontiersman appearance corresponds to the tree's. The Grizzly Giant's trunk is much more shaggy in this near view, as contrasted with the longer one, with gouges and exposed weather-beaten strips, and its base is pitted and worn.

Yet the photograph is less about comparisons with the stereotypical frontiersman than the massiveness of the tree. Clark is its servant, its guardian, holding its cones and looking off camera as though to scan or survey the grove for poachers and souvenir hunters. His appearance draws

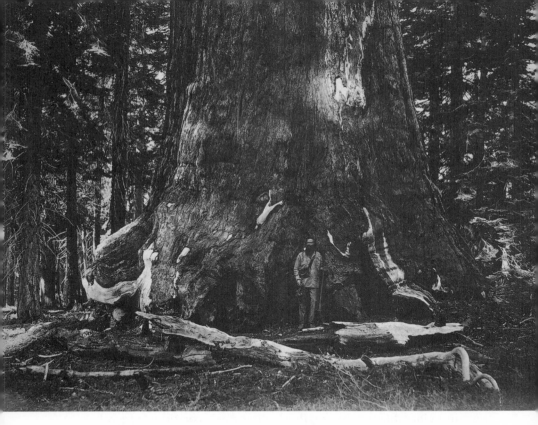

Figure 14. Carleton E. Watkins, *Part of the Trunk of the "Grizzly Giant" [with?] Clark— Mariposa Grove—33 feet diameter—California 1866* (negative from 1861). The J. Paul Getty Museum, Los Angeles.

out the gargantuan size of the trunk that Watkins could only hint at in the previous photograph. Clark stands in an indentation between the deep gouges in its base, a grizzled human veteran of the forest made nearly inconsequential by the ageless tree's presence.

The two big-tree images emphasized the groves' indomitability, although the shard's looming figure suggested Watkins's ambivalence about the nation's indomitability. Given their reputation as grand historic trees, such visual proof suggested the same for America at the onset of the war. Vulnerable amid signs of its own destruction yet overwhelmingly dominant, Watkins's depictions of the Grizzly Giant as a hoary survivor portended a battle-scarred nation that would prevail.

In 1865 to 1866, Watkins again produced nearly the same views of the Grizzly Giant. He was working for the California Geological Survey, which allowed him the opportunity to rephotograph many of his 1861 views. Many photo historians regard the quality and composition of these

images as superior to the earlier ones. Having photographed Yosemite before, Watkins had a better eye for the most stunning views. His improved equipment, including the more versatile Dallmeyer lens—a recently patented single wide-angle lens—helped him avoid some of the blurry patches and optical distortions that somewhat marred the 1861 images. He also had as many as six assistants helping him with the four different cameras he brought with him to produce multi-sized images. It was an ambitious undertaking for Watkins, because he produced images in four sizes, 18″ × 22″ views; 9 1/2″ × 13″ for album photographs; 6 1/2″ × 8 1/2″ for the survey's publication; and stereographs. With all of these cameras trained on Yosemite's trees, he ultimately hoped to best Weed, who, after Watkins's success at Goupil's, had rephotographed Yosemite in 1864, this time using his own giant camera. The market was quickly flooding with Yosemite views, vendors continued to profit from the sale of Watkins's uncopyrighted 1861 images, and Weed's mammoth rephotographs only crowded the market more, diminishing what little profit Watkins was making.

Although Watkins used the four differently sized cameras to photograph the big trees in 1865 and 1866, he only published two 6 1/2″ × 8 1/2″ views of them in Whitney's *Yosemite Book* (1868). A hefty 12 1/4″ × 10″ book elegantly protected in a drop-spine box, Whitney's *Book* tastefully and uniquely publicized the park's wonders with factual descriptions and twenty-eight breathtaking photographic plates, twenty-four done by Watkins. According to Whitney, "there has been little of accuracy, and almost nothing of permanent value" written about Yosemite. Whitney hoped to redress those deficiencies with his huge gift book: "The object of this volume," he said, "is to call the attention of the public to the scenery of California, and to furnish a reliable guide to some of its most interesting features." After the oversized edition, in a run of 250 copies, Whitney published a smaller, compact guidebook edition two years later. Both editions were well-received, the *North American Review* exclaiming that "in no other guide-book have we seen so charming a combination of scientific accuracy with poetic sensibility." Its "thrilling narrative" and variety of maps made it "rise . . . out of the class of mere guide-books, and take a high place among the contributions to American science." Watkins thus photographed Yosemite in 1865 to 1866 for a project whose goals

included accuracy and scientific entertainment. He was accompanied by geologists, Whitney and one of his assistants, Clarence King, while at the same time having already agreed to furnish Gray with photographic studies of trees. Amid this professional atmosphere, Watkins altered his version of the full-sized Grizzly Giant portrait, choosing a more reassuring view of the grove's oldest survivor.[23]

The main difference in the rephotograph (Figure 15) is the near elimination of the tree shard. Whereas the shard had prominently accompanied Grizzly Giant in the 1861 portrait, it now stood in the background. Watkins often altered views, or cleaned them up, to improve a photograph. For example, in an act indicating his competitive spirit as an artist, he rephotographed Weed's 1864 view of *Yo-semite Valley, from the Mariposa Trail./Mariposa County, CAL.* for the survey. After physically removing a tree branch that nearly blocked Half Dome in Weed's earlier version, he lowered the camera, thus cropping the top of the same tree that Weed had chosen to depict more fully. Watkins's tidying efforts and compositional choices earned it the title *From the "Best General View," Mariposa Trail.* Rather than interfering or blocking the perspective, the cropped tree more compellingly encouraged the viewer to look beyond it and into the breathtaking vista, making it indeed the "best" view.[24]

In Watkins's rephotograph of the Grizzly Giant, he only had his earlier work to compete with. He moved his camera closer in and to the right, a repositioning that relegated the shard into the forest, if not into the weathered tree's shadow. Viewers would probably not notice the shard's near absence at all in this version or its refiguring as insignificant kin, unless they had seen the original 1861 portrait. Presenting a slightly more cluttered and cramped view—the framing trees on the left and right edges crowding in more on Grizzly Giant—the 1866 version factually recorded the tree's size and its weathered antiquity, the shard's virtual absence a triumphant editorial about national survival.

Watkins's post–Civil War tree portrait heroicized the sequoias even more and glorified the nation by association. Like the nation, the Grizzly Giant had survived a recent threat to its survival when a fire raged through Mariposa Grove in July 1864. Harriet Errington, an amateur botanist who was collecting seeds and specimens to send to her sister in England, reported that "the big trees are on fire, and I am in a great fidget lest they

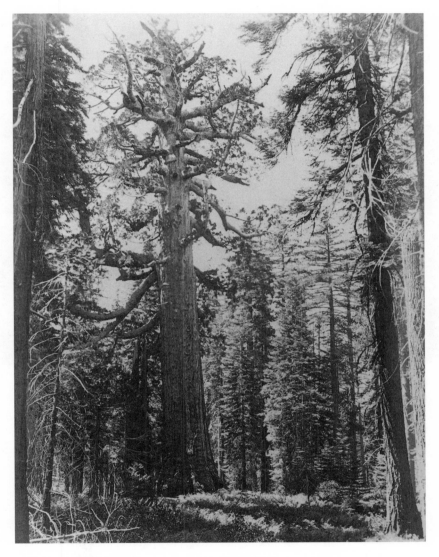

Figure 15. Carleton E. Watkins, *Plate 23. The Grizzly Giant, Mariposa Grove,*
1865–1866. From *The Yosemite Book* (1868).

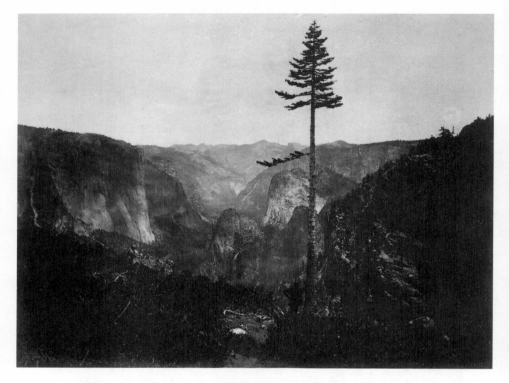

Figure 16. Charles L. Weed, *Yo-semite Valley, from the Mariposa Trail./Mariposa County, CAL.,* 1864. The J. Paul Getty Museum, Los Angeles.

burn up before I see them." One year later, she described the damage Grizzly Giant had sustained. "The Grizzly Giant, close to the ground, now measures ninety-one feet in circumference but it has suffered from fire and allowing for the loss of rotundity where it has been consumed, the tree would measure one hundred and two feet round."[25]

Watkins had to be keenly aware of the damage Grizzly Giant had sustained and the destruction of other sequoias when he began the first of two photographic shoots for the survey in the summer of 1865. It may have lent his efforts at scientific tree portraiture more urgency. However, the Grizzly Giant portrait did not reveal the damage Errington reported. Watkins's camera placement did not allow for a clear view of the large fire scar that Grizzly Giant sustained. In making this decision, and by relegating the shard to the dark background, Watkins created a portrait of an

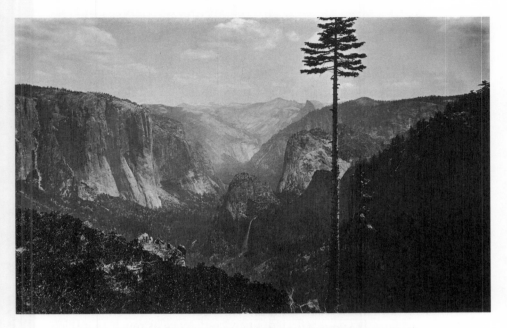

Figure 17. Carleton E. Watkins, *From the "Best General View," Mariposa Trail*, 1865–1866. The J. Paul Getty Museum, Los Angeles.

invincible ancient American tree, one that had overcome any hint of its vulnerability, and, by extension, of the nation's.

Reviewers emphasized the triumphant attitude more clearly evinced by the 1865 to 1866 portrait. *The Art-Journal* celebrated the tree's indomitable presence, one so powerful that it had its own agency. The "lofty coniferous tree . . . shoots up to the height of six times that of the hunter standing by its roots, sheer off the page; and seems, at that point, to be only shaking itself clear of the ground." *The Philadelphia Photographer* said that Grizzly Giant's indomitability was so evident in the portrait that storms could only be trifling nuisances. Unlike the storms that Curtis Guild analogized as war troops when lamenting the Charter Oak's passage, viewers of a big tree could barely perceive such danger while standing at its foot. "Storms of centuries had torn its topmost bough, . . . decapitated it. . . . [and] shorn [it] of its original and just proportions," but any future "tempest might be tearing at the topmost boughs of this majestic Monarch of the West, yet the traveller sitting down by its roots, [can]

hear only a far-away murmur." The imperturbable solidity of the tree induced feelings of serenity and security in its viewers—in its photographic representation no less than in actuality. As an emblem of the enduring grandeur of American nature, it was not too farfetched to see the Grizzly Giant as representing the nation's annealment after a reign of fire, the now-concluded tempest only a "far-away murmur."[26]

Produced after the Civil War's end, Watkins's 1865 to 1866 portrait of what Whitney referred to as a "battered and war-worn" tree no longer invoked the tree's mortality—and the nation's by association. The sequoias' existence was now a confident scientific fact, and the Union's survival was largely unquestioned. Watkins was so satisfied with these new versions that he took two of them and twenty-eight other views to the Paris International Exposition in 1867. He won the only medal awarded for landscape photography.[27] Displaying them in dome-shaped mattes and redwood frames with an American eagle decorating their top edge, he patriotically asserted the singularity of the sequoias and the nation's recovery. The Union had emerged from the war intact, and Watkins's altered portrait of Grizzly Giant reflected a new confidence as much as it scientifically documented and marketed Mariposa Grove's protected trees to scientists and tourists as a lasting fact in California.[28]

3

VISCHER'S VIEWS

During 1862, the same year that Carleton Watkins exhibited his large-format sequoia portraits in New York, Edward Vischer (1809–1879), a San Francisco merchant and artist during California's gold rush years, published a number of big-tree portraits in *Vischer's Views of California. The Mammoth Tree Grove and Its Avenues*. This visual guide predated by six years the publication of the first official Yosemite guidebook, John S. Hittell's *Yosemite: Its Wonders and Its Beauties*. Providing much more than textual descriptions, the graphically oriented portfolio contained color lithographs that focused on the trees' quirky physiognomy and the tourism and industrial activity surrounding the state's northernmost grove, Calaveras. As the war raged on, Vischer reassured himself of the grove's restorative effect. He felt "the turmoil of earthly strife . . . vanish" while touring the secluded 50-acre grove of ninety-three mature sequoias.[1]

Although appreciative of the grove's isolation, Vischer was equally interested in its regional connections, especially its relation to California's (or the West's) commercial development. The Calaveras or Mammoth

Grove was already a commercial draw by the early 1860s—"the only one of easy access . . . [for] visitors to roam"—and stereographers were just beginning to produce the site's photographic inventory. Unlike other groves, especially Mariposa, Calaveras provided domestic comforts for sightseers and other "pleasure-seeking parties," including a hotel and well-constructed road that connected daily lines of stages originating from Sacramento and Stockton.[2]

As a businessperson as well as an artist, Vischer was interested in the grove's commercial promise. In fact, such development made the big trees and their national allure that much more meaningful to him. The entire region was bustling with commercial activity, primarily mining enterprises. Although Vischer regarded the development as evidence of the state's inevitable prosperity, his portfolio belied concerns over the implications of their proximity to the grove. For much of his career, he was an advocate of progress, often championing developments such as those he witnessed in the mining industry while surveying the state during the 1840s and 1850s. Yet when he depicted the sequoias in the summer of 1861, he was unable to ignore the contrast between their cultural value as national symbols and the fast-changing developments that were beginning to characterize the region.

He touched on such concerns when he briefly identified the grove as a "quiet [Edenic] retirement[,] . . . a resting place on a tour through the California mining region, where waste and destruction in every form is the prevailing characteristic, bearing mute testimony to the demoniac power of Mammon."[3] A visit to the trees may have imaginatively figured as a haven in his portfolio—where "earthly turmoil" vanished, an Emersonian reunion with reason and faith—but the evil and destructive activity incurred by the mines' presence always intruded, especially in many of his tree portraits. He included six separate mining scenes in his book and alluded to the mines' presence in views otherwise devoted to the grove by showing damaged and decayed trees, whose wasted condition paralleled the destruction evident at the mines. The contradiction between his intention to celebrate the region's development and his latent dismay at the trees' damaged appearance expressed Vischer's fundamental ambivalence about the successful coexistence of industrial progress and nature's sublimity. Although he never publicly acknowledged such an attitude, it

seemed to grow with each image. In fact, one of the tree portraits became Vischer's most overt expression of ambivalence, an image around which the entire portfolio's contradictory theme developed. Much more power-fully than had Watkins, Vischer inscribed in this tree portrait a more caustic warning about the prevailing national condition.

Vischer's Views, which contains twenty-five engravings on twelve plates—plus the frontispiece—was essentially a commercial guidebook to Calaveras County. It provided a visual itinerary and textual description of the business and industrial development visitors would encounter en route to the Calaveras Grove. Given that it was a guidebook, the plates are mod-estly sized at 10″ × 13 1/2″. Vischer no doubt personally paid for its pub-lication, and it may have been his first attempt at publishing his own work. *Views* more than likely did not sell well, given that its run "was sud-denly brought to an end by the breaking of the stone on which the prin-cipal plates were drawn." Eight years later, Vischer was still promoting its sale, hawking that anyone "desirous to obtaining [it] can be accommo-dated, on application to the author, a few surplus copies yet remaining on hand from the limited number saved before the accident to the stone." The portfolio's layout was amateurish—the four pages of descriptive text that precede the plates repeat information, change format, and describe plates out of chronological order.[4]

Calaveras Grove was a prescient choice for the visual survey. Although Mariposa would soon capture the nation's fancy, Calaveras was the grove where the sequoias' celebrity began. It contained Augustus T. Dowd's original Discovery Tree and the Mother of the Forest, whose revelation and consequent trunk and bark tour circuit ironically came about because of the region's industrial activity. Given that the Union Water Company, one of the outfits that constructed aqueducts, employed Dowd, the min-ing industry was largely responsible for the trees' discovery. "It is deserv-ing of record," James Hutchings, hotel owner at Mariposa Grove, asserted in 1888, "that the discovery of those enormous trees must be credited, in a degree, to the business men of Murphy's [a mining company], through whose enterprise, incidentally, they were first seen." Vischer thus chose to render graphically the grove whose trees had inspired national pride and that owed its popular discovery to the mines.[5]

But he also emphasized the grove as a tourist enterprise by including

visitors in every tree scene and by remarking on tourists' accommodations in the portfolio's brief text. He advised visitors that ready-made views awaited their consumption as "delightful horseback or buggy rides [will] conduct the visitor to many interesting points of scenery or objects of curiosity." Plentiful game abounded, offering inducements to hunters or fishermen, and it all was surrounded, he continued, by mining enterprises that likewise engaged in their own hunting and extraction activities. Nodding at all of these connections, he chose mining scenes for the portfolio's first plate, indicating that the mines should be part of the big-tree tour.[6]

Vischer organized the portfolio into four categories: mining scenes, portraits of healthy sequoias, scenes of the grove's proprietary development, and portraits of big-tree ruins and oddities. Although he somewhat favored the healthy trees—especially the Three Graces and the Orphans—because they were "unmarred" and "slender" as well as "gracefully entwining," he delayed their introduction.[7] Instead, the first five plates introduced the region's, grove's, and trees' development and exploitation. The first image, the frontispiece (Figure 18), consolidated all of these themes by condensing the grove tour in one view, thus foreshadowing Vischer's valuing of the trees as tourist commodities. He announced that the central oval-shaped image was "a fanciful representation of the Grove," because he had rearranged "the principal groupings of the giant trees, irrespective of their relative position," because "the obstruction of the dense pine forest and undergrowth [prevented] the possibility of any general view of the Sequoias."[8]

Right from the beginning, Vischer created a more consumable view of the trees, one more pleasing to general tourists and one that nature had denied them. Playing landscape architect, he imaginatively altered the grove's actual layout, editing out much of the natural scenery that, from the point of view of a tourist, functioned as an "obstruction." The tree groupings included in the sanitized view offered an interesting array of wounded victims and vibrant monuments: seven or eight healthy trees surrounding a haggard specimen, encased in scaffolding; a stump, dotted with ant-sized tourists; a couple of severed trunks, including a hollowed-out trunk section; and exposed roots that resembled an exhumation. Like a pit of mastodon bones, which fascinated as well as horrified Americans earlier in the century, the "fanciful representation" presented an unsettling

Figure 18. Edward Vischer, *The Mammoth Tree Grove*, frontispiece, 1862. From *Vischer's Views* (1862). Courtesy of the Bancroft Library, University of California, Berkeley.

amalgamation of fecundity, abuse, and decay.[9] Drawings of sequoia cones and foliage decorated the bottom half of the oval vignette, providing a nest for the image and an up-close view of the tree's foliage.

The frontispiece's imagined scene of destroyed and still-standing trees was followed by six mining scenes arranged in two rows on Plate 1, *Approaches to the Grove* (Figure 19). Three of them, the bottom row, provided a glimpse of the mountain scenery tourists would view while on the big tree route. But the upper row, underlined by a banner that announced Murphy's as "the starting place for the grove," focused on the mines' immediate surroundings. In one of the scenes, Vischer identified a symbiotic relationship between the grove and the mines by framing three sides of one of the mining images—*Sperry's Hotel at Murphy's*—with sequoia cones and foliage. By doing so, Vischer linked the frontispiece's tree-pit

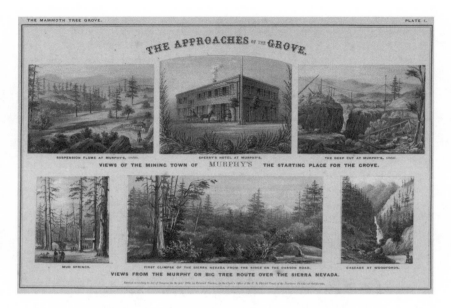

Figure 19. Edward Vischer, *Approaches to the Grove*, 1862. Plate I in *Vischer's Views* (1862). Courtesy of the Bancroft Library, University of California, Berkeley.

scene with the mines, specifically its tourist accommodations. These were the only two scenes framed by sequoia foliage.

The other mining scenes, *The Deep Cut at Murphy's, 1859* and *Suspension Flume at Murphy's, 1859,* implicitly continued the equation of the mines with the grove. They flanked the Sperry's image, "commemorat[ing] some monuments of the enterprise of the mining community at Murphy's." Although described as commemorative, *Deep Cut at Murphy's* also detailed the latest in hydraulic mining techniques. The cut, a 1.5-mile channel, had been blasted through solid rock to provide drainage for the mining claims above Murphy's. Complete with large rock masses, wooden framework, and the cut itself, the excavation approximated the scene of the trees' waste and destruction evident in the frontispiece. A massive chunk of rock lay to the left of the chasm, resembling some of the prone sequoia giants, whose remains lay scattered in the frontispiece's foreground. Suspension cables and poles rising in the vignette's background recalled the trees that encircled and hovered over those that lay wasted and abused.[10]

Expressive of his admiration for both the trees' appearance and the progress occurring in the nearby mines, the two images also showed Vischer's ambivalence about their interconnection. The fecundity and death apparent in the frontispiece did not harmonize well with the productivity suggested in the mining scene: The main connection between the two was waste and destruction. He awkwardly reconciled these poles in the descriptive notes by regarding the aqueduct's constant presence as a sublimely pleasurable companion while on a pilgrimage to the grove. The carriage road between Murphy's and the Mammoth Grove put tourists "mostly in sight of the extensive Aqueduct of the Union Water Company," a technological feat whose appearance impressed, maybe even obsessed, Vischer. "The airy tracery of its scaffolding over deep gullies, the mad rush of torrent, as seen foaming through the ditch races"—paired with "glimpses of a placid sheet of water, a natural reservoir"—only improved a visitor's appreciation of the natural landscape, according to Vischer. During a previous visit to the region in 1859, he explained how it created new vistas, claiming that it broke "the monotony of the interminable forests," forming clearings that "show[ed] the trees to better advantage."[11]

When Vischer depicted the tourist atmosphere in Plates 2, 7, 8, and 9, he could not as easily ignore the human abuse of the grove that was foreshadowed in the images illustrating its approach. Each of the plates provided different views of the grove's entrance and tourist facilities. All of the images featured the integration of big tree fragments into the tourist compound, with Plate 2 exhibiting "the original" big tree's transformation into a pavilion and bowling alley. Vischer aptly described the sight as a "monstrous tree emerging from its own housing." Dowd's Discovery Tree, originally 302 feet high, had been felled in 1853, the leftover stump initially used as a cotillion dance floor and even the site of a local newspaper press before its conversion into the covered pavilion. Proprietors had also turned a small portion of its severed trunk into a tourist display. Plate 7 presented a closer view of the log's transformation into such a spectacle, complete with a staircase ascending up its bulk and tourists posing on top for a photograph.[12]

These scenes only began to hint at tourists' eagerness to convert the trees into keepsakes or other tourist objects, an interest that big tree stereography also served. *Overland Monthly* described one "industrious"

tourist's eagerness to take home as many authentic mementos of her grove trip as she could. Two hours late for breakfast after her tour group "'did' the whole grove," she had "lumber[ed] [the] room with a miscellaneous collection of big-tree bark, big-tree wood, big-tree cones, big-tree branches, and big-tree curiosities in general."[13]

Yet Vischer's images of the trees' use as tourist commodities revealed much more than visitors' formulaic fascination with the trees' curious forms or their conversion into promotional objects. Partly an endorsement of the region's commercial splendor, some of these scenes forecast industrial progressivism's cost to the landscape, both natural and political. The last image, a panorama of the grove's farm, hotel, and grounds (Figure 20), recorded the extent of the grove's development. At the left edge was a two-story hotel, its smoking chimneys evidence of its successful approximation as a domestic hearth. A fenced park, including ornamental shrubbery and a water fountain, accented the sentiment that the "settlement [is] an oasis in the apparently boundless forest." The final exotic element was the Bactrian camels that enter the scene on the right. Their appearance in 1861, however, also served as a contextual reminder of the region's business energy. They were imported from the Amur region in Mongolia for use as pack animals at the Washoe mines. The camels simultaneously served as both tourist attraction (captured in lithography and, likely, stereography) and industrial pack animal. As a "counterpart to Plate II" (which showed a slightly elevated view of the grove's entrance), the entire scene in Plate 9 displayed constant commercial activity.[14]

Although Vischer's inclusion of the camels reinforced the notion of the region as a bustling center of enterprise, Plate 9 also revealed some ambivalence about such interconnectedness. Obviously the grove was a tourist site, which largely accounted for its exclusive development in the mountainous wilderness. However, Vischer made an effort, albeit inconsistent, to highlight the grove's separation from the wilderness, which he acknowledged both in the image and text. The curving carriage road created a boundary between the hoary wilderness and the grove's development, one that visitors never crossed. The wilderness contained bears and other wild animals, dead trees, and artifacts of indigenous peoples. These natural elements were not a part of the grove, yet, like the nearby mines, they bordered it and affected the trees. A skeletal tree spiking through the

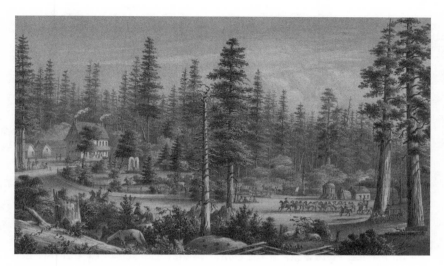

Figure 20. Edward Vischer, *The Mammoth Grove Hotel, Grounds, and General View of the Forest*, 1862. Plate IX in *Vischer's Views* (1862). Courtesy of the Bancroft Library, University of California, Berkeley.

middle of the drawing was the main anomaly in Vischer's careful separation of the wild and domesticated. Its resemblance to one of the grove's most famous sequoias, Mother of the Forest, depicted by Vischer in the portfolio's most compelling plate, would seem to indicate its inclusion in the grove. It thus was a prominent reminder of the grove's and region's troubling interconnectedness that Vischer otherwise worked to deny in Plate 9.

The tree it resembled, in Plate 4, was among the portfolio's third category, the plates that presented damaged sequoias. Plate 3 introduced the new category, whose subject matter and perspective recalled the stereograph's. Containing a sampler of six natural big tree oddities, the plate included depictions of hollowed-out trunks tourists could ride through on horseback, burned trunk cavities the size of a room, exposed roots and trunk shards, and the unconventional upward-viewing perspectives their visitation may have inspired. Plates 7 and 10 documented the largest fallen trees, the 450-foot Father of the Forest and 320-foot Hercules, the latter of which had only recently been felled by a December 1861 storm. Vischer found such prone giants admirable, saying after his 1859 visit that "their partial concealment speaks more to our imagination [because] they will

serve coming generations as monuments of past millenniums." Hercules was an especially instructive fallen sequoia, according to Vischer, who found that the "modern relic . . . explains much of the history of so many other fallen trees; and by ascending the trunk and following it up to the broken limbs, the fragments of which resemble full-grown cedars, there is a fine opportunity for close . . . examin[ation]." There were lessons to be learned from the trees' destruction, which Vischer did not ignore in Plate 4, *Mother of the Forest, (1855 and 1861,) and Other Groups* (Figure 21). Up to this point, Vischer had somewhat problematically labored to present the mines and the trees as congenial neighbors. But he was unable to reconcile either in this image, the most important one in the portfolio, because in it he most completely expressed his ambivalence about industrial progress. If the entire portfolio placed the trees within the tourist and mining industries, Plate 4 lay at the center of all these activities and revealed their consequences: a standing but dying big tree surrounded by other sequoia attractions, some of them also irreversibly injured.[15]

Vischer conceived of the image to solve the problem of the trees' representation. "This representation," he admitted, "is adopted not only from the impossibility of showing separately so many trees . . . but to convey the character of the forest, and the proportions of the *Sequoias* to the surrounding forest, which could not be given in any other way." His solution entailed combining views of big trees already included in other plates in one master family portrait of the grove. In the foreground rested the Discovery Tree stump and log and the tunneled Horseback Ride, while the Three Graces, Pride of the Forest, and others surrounded the prominent figures, two side-by-side views of Mother of the Forest.[16]

Vischer wanted to highlight and comment on the trees' celebrity and the resultant damage Mother of the Forest had sustained. The "two" Mothers of the Forest, surrounded by relatives and other victims of invasive tourism, afforded him the opportunity. Mother of the Forest was a special example of a mined or excavated sequoia, its bark stripped and softwood exposed. As a quasi-historian, Vischer presented time-lapse views of the tree, carefully etching dates into each version's trunk. The version on the right showed the tree a year after it had been girdled to a height of 116 feet. This rendering, dated 1855, resembled many others of the tree published during the late 1850s. Its trunk skinned, the tree's

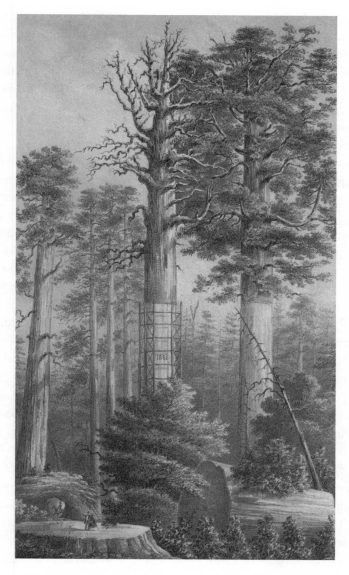

Figure 21. Edward Vischer, *Mother of the Forest, (1865 and 1861,) and Other Groups,* 1862. Plate IV in *Vischer's Views* (1862). Courtesy of the Bancroft Library, University of California, Berkeley.

foliage nevertheless indicated a still-living big tree, though certainly one that would inevitably decay. The central image, by stark contrast, showed the condition of the tree in 1861. Its appearance recalled the spiking tree in Plate 9, but now assumed center stage, a prominent element through which Vischer could convey the entire grove's character. Contained within scaffolding, the tree, which Vischer commented was a "mere skeleton," was dying, if not dead already.[17]

The year 1861 presumably marked the sketch's date, but it was also the year of the Civil War's outbreak. Once again, the sequoias' cultural meaning as prophetic national trees intruded, providing telling commentary about the nation's health and promise. Mother of the Forest, its bark half stripped, evoked a nation divided, an estranged political condition whose cumulative damage was considerable by 1861. Indeed, instead of a defiant botanical Sumter, as was Watkins's Grizzly Giant, Vischer's view indicated the progress of the nation's division and its decay, even foreboding its demise. He could have chosen to omit the dates, but he affirmed the trees' historicity by inscribing the years into their trunks. Vischer was seriously concerned about the war's consequences, publishing a broadside on the war and its effects on California the following year. But his portrait of Mother of the Forest served as first draft. Surrounded by other exploited victims, such as Dowd's Discovery Tree stump, Vischer's Mother of the Forest documented the fragile lifespan and tragic national resonance of one of America's proudest possessions, a clear victim of the "power of Mammon" that so characterized the region's progressive development.

Vischer's biography as a graphic artist is crucial to identifying the disparity between the portfolio's ideological intent and its images. He was a businessperson, with a talent for drawing. His work as an independent merchant, importer, and real estate agent from the 1840s through the 1860s thus influenced his choice of subject matter, because it gave him many unique opportunities to document admiringly the history and commercial development of California. A native of Bavaria, he sailed the world on various business trips, some of them highly adventurous, for an enterprise headquartered in Acapulco, Mexico. On many of these trips he made sketches, which years later he began to publish in a series of portfolios. According to historian Francis P. Farquhar,

he developed great facility in making a rapid draft of outlines which he would fill in with greater detail at leisure. He could thus make notes for a sketch while stage-coach horses were being changed, or on other such occasions. He used all manner of media—whatever came to hand. . . . He used pencil and quill pen and sometimes water-colors or crayon and a soft leather blender.[18]

After initially surveying California at the urging of his employer in 1842, Vischer returned seven years later during the Gold Rush, settled permanently in San Francisco, and established his own firm primarily as an importer, though he pursued diverse interests.[19]

Although drawn to the natural beauty of the state, particularly its trees, he was equally fascinated by the technological progress he witnessed while carrying out such surveys, especially those occurring in the mining region. On a visit to the mining region in 1859, which he recounted in a German-language pamphlet, *Californischer Staats-Kalender* (1860), he remarked that all the new innovations, especially those in hydraulic mining, such as aqueducts, were ingenious miracles, made more admirable because they were the product of humankind's practicality and creativity in the face of challenging terrain. Aqueducts carry water—usually by the pull of gravity—from remote water sources, such as mountain streams and rivers, to a specific location. Miners would blast the transported water from hoses in powerful jets, washing away the topsoil and rock strata more quickly, accurately, and cheaply than conventional pick-ax methods or dynamite. Viewing on this visit "how a handful of men readily took out the very heart of a mountain with their water hose," Vischer concluded that "based on the great principle of economy of labor there can be no more striking argument advanced to convince one of the importance of this truly Californian invention."[20]

With the new technology, Vischer felt that the atmosphere in the mining settlements had improved as well, becoming more professional and family-oriented. "Although it is new to most of them," he observed, "the workers follow their calling . . . with the seriousness and constancy of pursuing their life goals." He found that "family life, which is gaining more and more," largely accounted for this development. "Homesteads, many of which may be called real farms, have risen in almost every corner of the mining region that is fit for cultivation," as had "pleasant residences,

surrounded by beautiful gardens." "All of this," he concluded, "forms a pleasant contrast to the chaotic upheaval which generally characterizes most mining districts."[21]

Vischer investigated other features of California life throughout the 1860s, including the conditions of the state's agricultural development and the character of its native peoples, thus functioning as a documentarian of the state. Although as Farquhar has put it, Vischer's "aim was to be graphic rather than artistic," he mingled in the art world, and sometimes collaborated with local artists such as Watkins and Thomas Hill, the latter of whom he referred to as a "well-beloved friend." On occasion he solicited artists, such as Watkins, to contribute images to be reproduced in his publications. He was not a professional artist—it was his avocation, which he later admitted was an "expensive luxury."[22]

In championing the technological developments he witnessed in the mining regions, Vischer equated them with the nation's inevitable progress. His last two publications, published eight and ten years, respectively, after *Vischer's Views*, most fully expressed his optimism about the state's industrial development. The *Pictorial of California* (1870) was his magnum opus and included images and textual descriptions of the state, and *Missions of Upper California* (1872) included no images and served as a textual supplement to some of the images originally included in the *Pictorial of California*.

In *Pictorial of California*, Vischer combined his love of the state's natural features and enthusiasm for its industrial progress in a sweeping collection of about 150 bird's-eye views of the state's natural landscape, its changes over time, and the progress of commerce and industry. Although somewhat wistful about the obliteration of "the landmarks of the California of olden times," he was captivated by "the indomitable spirit of enterprise of its present inhabitants, and the advent of new comers," which he sought to convey in his study of "the natural characteristics of this favored country." Vischer, who originally planned to include only sixty drawings, quickly expanded the book. For example, he added five plates of big-tree views, different from those he published in 1862, at the beginning of a section titled, "Trees and Forest Scenes." Sprawlingly divided into four other sections, the complete *Pictorial of California* lavishly celebrated the state's progressive development.[23]

His descriptions of the early history of Californians and the state's missions in the 1872 supplement seemed an odd companion to his study of California's technological advancement, especially because he lamented the missions' "extinction" and admitted to "feeling sad on beholding their crumbling walls." However, by stressing that the missions were of a by-gone era and their deteriorating condition "pre-ordained," he considered their ruins as useful comparative reference points indicative of California's advancement. Indeed, the missions had "outlived their usefulness." Easily overwhelmed by the "undaunted" efforts "of a more practical people," they would soon be replaced by more cheerful structures and significant natural resource development. He thus concluded that as casualties of "the irresistible march of progress" the missions were part of the state's "Past[,] . . . [and thus] constitute all the romance that is left us in this (prosaic utilitarian) *the progressive era.*"[24]

The first image that Vischer used to exemplify such progress in the supplement was *Ruins of the Mission of San Carlos* (Figure 22). The first plate in the *Pictorial of California, Ruins of the Missions of San Carlos* dramatized the state's development by showing the crumbling remnants of the mission while hints of future improvements dotted the horizon. Because San Carlos was one of the first missions built in the territory, its political status marked the beginnings of California's progressive emergence. Rendered by Vischer in 1861, when it was still standing, the "stately ruin" that was San Carlos had disappeared by the time of *Missions of Upper California*'s publication eleven years later. He found that "with its steeples picturesquely defined against the ocean background, . . . surrounded by crumbling adobe buildings, with broken roofs," the mission clearly symbolized "by-gone days." As the sun set

> yonder seaward, the sailing craft, bending under a stiffening breeze, and the smoke of the steamer of the distant horizon, in significant contrast, betoken the infusion of new elements, the stir and activity of progress which, gradually obliterating the monuments of the past, and its pleasing associations, initiate the era of California's great future.[25]

Because they provided celebratory accounts of the state's progressive development, both publications garnered favorable reviews, especially for their usefulness to historical museums and libraries. One local newspaper regarded the *Pictorial of California* as a "welcome addition . . . deserv-

Figure 22. Edward Vischer, *Ruins of the Mission of San Carlos*, 1868. Plate I in *Pictorial of California* (1870). Yale Collection of Western Americana, Beinecke Rare Book & Manuscript Library.

ing our warmest recommendations." Vischer was so satisfied with his latest studies that he made plans to detail the more technical advances occurring in the state's mining, agricultural, and other industries, a study he intended to title *Review of California's Progress*. He did not have financial support for this project, however, and never completed it.[26]

Vischer was thus an advocate of progress, an illustrator of its "irresistible march," even amid scenes of destruction, such as crumbling mission ruins. However, unlike his interpretation of the missions' condition, Vischer did not so boldly regard the deterioration of some of the Calaveras sequoias as evidence of progress—although by including mining scenes in the portfolio he attempted to associate them with something of the same. Couching them in the surrounding region's and grove's development, Vischer primarily depicted the trees as examples of decay and exploitation, of "waste and destruction," whether they were standing up or lying prostrate on the ground. Although in the accompanying text he

showed no such careful awareness of the portfolio's inherent contradictions, Vischer presented a complex account of the big trees and their national resonance. In this way he expressed his underlying ambivalence about the progress that otherwise dominated his life's work as an illustrator.[27]

Given its "contrary undertone," Vischer's portfolio is an example of what historians Bernard Bowron, Leo Marx, and Arnold Rose have labeled "covert culture." Such a cultural phenomenon "results from the impulse to adhere (simultaneously) to logically incompatible values," like fear amid confidence. Self-repression of the contradiction is crucial in its expression—indeed, denial energizes the process. Many nineteenth-century Americans exhibited covertness when confronted with scientific advances. Writers and artists often professed undying admiration for the progress signified by all manner of technological developments while at the same time associating machines with horrifying imagery or describing them as menaces.[28]

Mark Twain's *A Connecticut Yankee in King Arthur's Court* (1889) may be the most eloquent example of cultural covertness, and its dire ending has parallels with Vischer's depictions of the grove's industrial atmosphere. The novel begins as a swaggering celebration of the superior progress evident in American industrial society, but it ends with its severe questioning, because the Yankee's quickly modernized English subjects instead became its victims. Vischer could only hint at such an outcome with his Mother of the Forest portrait. Twain bluntly asserted it. In Twain's book, the new industrial order collapsed quickly and violently at the Battle of the Sand Belt, with mass electrocution and extermination via the Gatling gun. The novel's final scene of 25,000 rotting corpses was tellingly reminiscent of Civil War battle sites littered with war dead. The cluttered scene was similar to Vischer's frontispiece, which surveyed the grove's wounded and abused trees.[29]

The narrative arc of Vischer's portfolio, however, was less dramatic than would be Twain's novel. The lithographer recorded the trees' damaged condition, but largely did not decry it, even though such an attitude conflicted with his professed regard for the grove as an Edenic haven. His knowledge of the mining region complicated the covertness evident in the portfolio. Vischer had spent at least a decade studying the mining region's development by 1862, both for pleasure and business purposes. He was keenly aware, probably more than any other California artist of his era,

of its role in the history of the region. But by including views of nearby mines and of the grove's proprietary exploitation, he implicitly equated them. Like ore from the mines, the trees were also commodities, extracting specie from tourists, and whose depredation was as equally fascinating. Far from censoring such commercial exploitation, his portfolio suggested that mining and providing entertainment for tourists were actually complementary activities. With the trees as his muses, Vischer attempted to reconcile his admiration for both the sequoias and progress, ultimately evincing a disguised discomfort about the latter's national implications. Such an effort, part of a "pattern of inconsistency" characteristic of nineteenth-century covert culture, combined the trees' contrary meanings as novelties and prophesiers. Unlike their portrayal by stereographers and formal photographers, who tended to depict them as one or the other, Vischer upheld the contradictions in his portrayals. In his view, they were tourist objects and national metaphors, commodities and symbols, both for viewing and reflection—and thus he produced the most comprehensive consideration of the sequoias' iconography and celebrity during the 1860s.[30]

Both Vischer and Watkins visited different big-tree groves in the summer of 1861, thus marking a significant cultural moment in the history of the trees' celebrity as prophetic national icons. Each artist constructed his portraits differently, but both portraits inevitably commented on the nation's mood or condition. Watkins certainly benefited from the novelty and fascination surrounding photographic technology, but his choice to portray an isolated ageless sequoia, withstanding any threats or hints of its destruction, likewise suggested a nation of indomitable will. The wondrous image displayed a tree of whose possession Americans could be proud. However, Vischer's time-lapse portrayal of a dying sequoia, located in a site that included mined and abused trees, suggested something more insidious—national sabotage or betrayal. Much like gold scoured out of pay dirt, sections of these trees had been extracted and put on display both far from and inside the grove itself. As Hutchings pointed out in his travel memoir, *In the Heart of the Sierras*, Americans' treatment of Mother of the Forest was not a distant memory even by 1888. The matriarch, "dismantled of her once proud beauty," was still "a reproving . . . ruin," instructive of a nation disconnected from nature especially because it accepted the "evils" of manifest destiny. Hutchings referred to the ax as

being the instigator for the tree's demise, an object nineteenth-century Americans used to refer to the nation's expansive ambitions. "Even the elements seemed to have sympathized with her," he lamented, a problematic commiseration, given the final outcome. He regretfully noted that "the snows and storms of recent winters have kept hastening her dismemberment, the sooner to cover up the wrong." The nation's possession of Mother of the Forest was thus an embarrassment, because its condition exposed the grove's damaged character and, by association, the nation's.[31]

The overwhelming popularity of Watkins's images as well suggests something about what either grove offered Americans as sites for national trees. The Mariposa Grove Watkins depicted was pristine and undeveloped in 1861, thus confirming the fantasy of America as an unsullied nation whose destiny, even in the midst of a divisive war, was as expansive as its land. The Calaveras Grove Vischer depicted, however, was part of a degraded region, whose abused appearance was part of the region's tradition of land development. As a site that included wasted and abused trees, Calaveras Grove did not satisfy the prophetic and optimistic fantasies of the nation that Mariposa so well served. Eden really was not Calaveras, it was Mariposa, and Vischer's inclusion of the mines as part of any visitor's trip to the big trees succinctly exposed the contradictions inherent in the sequoias' national symbolism. His 1861 portrait, belying his professed beliefs in the nation's progress, covertly linked it with a national tradition of abuse and decay.[32]

Vischer made one last portrait of Mother of the Forest after 1862, one that also provided a conflicting vision of the nation's progress. He was so captivated and provoked by the tree's appearance that he included a new drawing of it in the 1870 *Pictorial of California* (Figure 23). The drawing was practically a visual quotation of Watkins's 1861 stereograph version of Grizzly Giant, thus invoking the trees' national symbolism as embattled survivors in his celebration of the progressive era in California. Flanking it with other sequoias and showing it still encased in scaffolding, Vischer recessed Mother of the Forest into the background to capture its full height.

In contrast to the 1862 version, where he accounted for the tree's condition with etched-in dates, Vischer traced out the tree's demise and editorialized about it in the 1870 text. His bitter eulogy railed against a

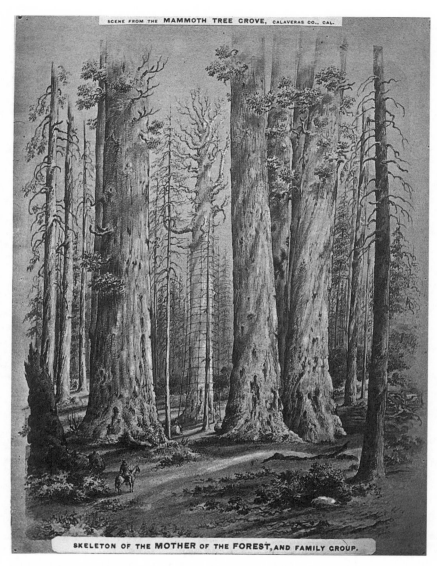

SCENE FROM THE MAMMOTH TREE GROVE, CALAVERAS CO., CAL.

SKELETON OF THE MOTHER OF THE FOREST, AND FAMILY GROUP.

Figure 23. Edward Vischer, *Skeleton of the Mother of the Forest, and Family Group*, 1868. From *Pictorial of California* (1870). Yale Collection of Western Americana, Beinecke Rare Book & Manuscript Library.

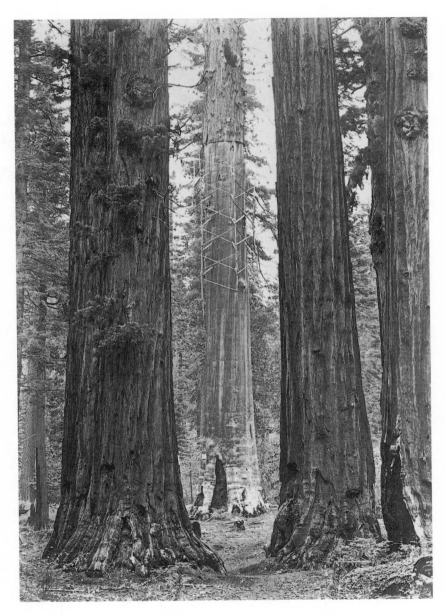

Figure 24. Carleton E. Watkins, *Sequoia Grove, Calaveras County. One of 73 Images from an Album Entitled: "California Tourists Association, San Francisco."* ca. 1872, albumen print, 30.5 × 21 cm. The J. Paul Getty Museum. Gift in memory of Leona Naef Merrill, and in honor of her sister, Gladys Porterfield.

mindset at odds with the progress he otherwise celebrated throughout the *Pictorial of California.* "For several years it yet stood in full vigor until . . . summer, 1861, one solitary tuft of green, just visible at one of the extremities, was the last vestige of its vitality." The once proud ornament— the "proudest . . . of the grove," according to Vischer and many other admirers—could only stand as "a colossal skeleton, holding up its withering arms as in silent accusation against the vandalism of its executioners." Even dead, Mother of the Forest still suffered vandals. Hutchings wrote of visitors who had inscribed "numerous dates and [their] names" into her trunk "at different distances upward, especially at the top." Another visitor noted in 1870 that she had secured a piece of Mother of the Forest along with "a lot of cones, actually picked from her venerable partner, the 'Father of the Forest.'" Although such actions no doubt troubled Vischer, he held no reservations about commodifying Father, a "colossal chronological monument" whose gargantuan size inspired him to think of its lumber value in the *Pictorial of California.* "Nearly a million of square feet in one-inch boards," he marveled, a sentiment never once raised in any of his commentary concerning Mother of the Forest, the most obvious victim of sequoia vandalism in any of the groves.[33]

Vischer's 1870 Mother of the Forest portrait may also have inspired a subsequent one that Watkins produced in the same decade. *Sequoia Grove, Calaveras County* (ca. 1872) (Figure 24) presented almost the same tree-framed view of Mother of the Forest, differing only by its omission of the tree's upper stem. California photo historian Peter Palmquist has argued that it is Watkins's meditation on humanity's abusive relationship with nature, noting that Watkins "organized [it] so as to make a direct comparison between the brutalized redwood and its still-living mates. This makes him one of the first photographers who consciously recorded the harmful impact of man on nature." Although Watkins may have been the first environmentally minded photographer, Vischer certainly was the first such illustrator, even given his efforts at promoting the imagined virtues of industrial progress. His 1862 and 1870 portraits of Mother of the Forest expressed these latent concerns, allowing him to present a tree whose feminine archetypal name modestly questioned the exploitative masculine triumphs he recorded in his otherwise celebratory views of the state's progress during the 1860s.[34]

4

THE CENTENNIAL VERSION

In mid-September 1874, the Utica *Morning Herald and Daily Gazette* reported on the activities of the famed landscape artist Albert Bierstadt. A New York resident, he had been developing numerous sketches after a two-and-a-half-year sojourn on the West Coast, the second of two trips he had made within a ten-year span, which included Yosemite visits. Dazzled by the Sierra trees' superior beauty and size, Bierstadt made copious tree studies, including "groups and single specimens of the famous *Seguoia gigantea* [sic], and of many other trees of that wonderful country." One of them was no doubt *California Redwoods* (n.d.), a hasty off-center rendering of two redwood trees (probably Coast redwoods), standing side by side (Figure 25). The pair slightly dwarfed the three young and spindly Sugar pines to their right, while an unimaginably tall redwood bordered and exceeded the limits of the left edge. Studies such as these were valuable references for Bierstadt. He turned to them for inspiration to complete formal paintings. A record of the sequoias' primary characteristics— their vibrant color and unequaled height—*California Redwoods* was one

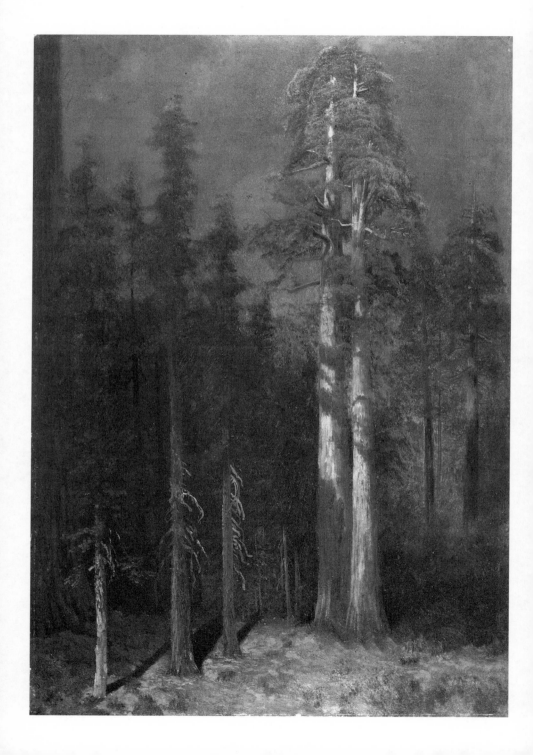

of an unknown number of big tree sketches Bierstadt completed after his second Yosemite visit.[1]

During the early to mid-1870s, Bierstadt developed at least two paintings for formal exhibition from these studies. The big trees had gained in popularity since 1862, when Watkins and Vischer had produced their images, with Watkins's inarguably receiving the most notice and acclaim. Bierstadt had seen Watkins's work at Goupil's Gallery and was so impressed that he sought it out when he arrived in San Francisco in 1863. He then proceeded to make an even more celebrated career out of Yosemite than had the photographer. Yet the painter, whose signature was large-sized canvases, allowed about ten years to pass before he began to exhibit his depictions of the world's largest trees.

When he began in the early 1870s to focus intensely on the sequoias, critics had already begun to turn on him, heavily criticizing any work he produced, regardless of its mass appeal. In fact, his popularity only frustrated commentators even more. Because Bierstadt unabashedly and successfully marketed his depictions of popular subjects, such as Yosemite and the big trees, to mass audiences, his work had clearly violated cultural hierarchies. His work did not inspire aesthetic and spiritual elevation, according to such critics—it was mere entertainment—which incurred the repeated wrath of reviewers.[2]

For example, when Bierstadt exhibited his initial sequoia painting at the Century Association in February and then the National Academy of Design in April of 1874, reviewers were unimpressed. The painting, which he blandly titled *Landscape* and then later changed to *California Forest*, was, to make things even more complicated, sometime later retitled *Giant Redwood Trees of California* (Figure 26). His examination of a Coast redwood forest's interior, luminously swathed in red light, included a Native American family in quiet habitation. Sitting near a rocky precipice, the father and son survey the area, while the mother, carrying a basket on her back, prepares to forage for food. Three large redwoods repeat and recede into the background, the foremost one a huge fire-scarred tree whose charred hollow base forms an open teepee-shaped cave. Strewn baskets litter its opening, and a small snuffed-out campfire complete the peaceful

Figure 25. Albert Bierstadt, *California Redwoods*, n.d., 28″ × 19″. Private Collection. Provided by Alexander Gallery.

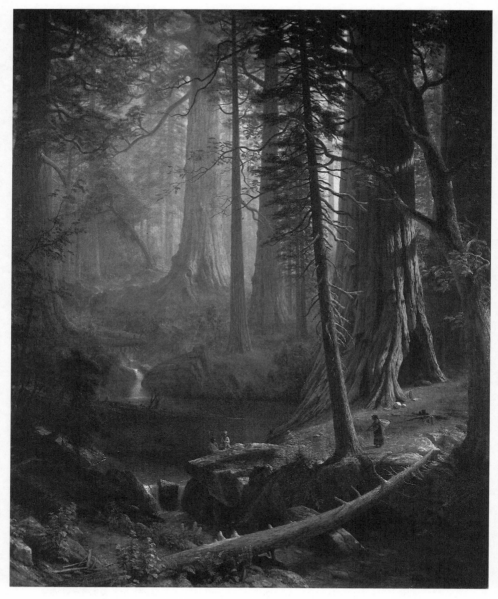

Figure 26. Albert Bierstadt, *Giant Redwood Trees of California*, 1874, oil on canvas,
52 1/2″ × 43″. Courtesy The Berkshire Museum, Pittsfield, Massachusetts, USA.

scene, which art historian Geald L. Carr has "interpreted as a belated homage to Asher B. Durand," then president of the academy.[3]

The sparse settlement of the few surviving Native Americans amid the ageless redwoods was an ominous pairing. By the 1870s, numerous California tribes and Coast redwoods had been decimated, but Bierstadt's calm inclusion of them seemed to ignore either subject's actual condition. Although he was not a student of California's redwood logging industry, he clearly was not ignorant of indigenous tribes throughout America. Fascinated by native culture and history early in his career, he made copious studies and stereographs of various tribes, their dress and tools, and even the bison (buffalo) so vital to the Natives living in the plains. In his formal paintings Native American campsites were places thriving with activity. Although in this work its presence could be just a colorful provider of scale for the trees, the single family's isolation in the redwood forest scene—accompanied by a snuffed-out fire—strongly contrasts with Bierstadt's previous depictions of native settlements.

Exhibiting such a difference, the painting merits an alternate reading, one informed by the trees' promise as recently heralded national emblems. Ensconced within the redwood's cathedral grove, the native family's peaceful isolation in *Giant Redwoods* draws on the vanishing Indian theme, a notion Americans accepted throughout the nineteenth century because it allowed for westward expansion and thus national progress. Bierstadt's pairing of the two iconic figures laments the quiet passing of a noble race with the reassurance that the trees—equally "natural" western elements—would in the future serve as the Indian's surrogate. Bierstadt would revisit such a theme fifteen years later in *The Last of the Buffalo* (1888), in which his central placement of an Indian spearing a charging bison, surrounded by skulls and a bison herd, equated the destructive demise of the animal with that of the Native Americans, as well as it commented on a culture in denial about such an equation.[4]

Critics ignored the complex implications of Bierstadt's juxtaposition of the two western subjects, instead regarding the composition of the work "ugly," its subject matter passé, and evidence of Bierstadt's "fading talent." Countless articles about the big trees, complete with illustrations, had been published by the early 1870s, as well as stereographs developed for a general public eager to view these distant wonders, which seemed to

justify their disappointment with Bierstadt and his big tree painting.[5] The profusion of promotional material, as well as a recent resurgence of sequoia exhibitions, began to give the trees a sideshow reputation in eastern highbrow circles, although visitors continued to glean exalted patriotic meaning when they viewed them in the Sierras. Because they appealed to popular tastes, the sequoias were not refined high-art subjects—perhaps explaining why most nationally respected painters ignored them—and Bierstadt's 1874 depiction of them fueled critics' disregard for him.[6]

The New York *Evening Mail* led the critical ambush, demeaning Bierstadt's painting as part of an excuse to insult him even more.

> This artist has justified his right to be called the "Big Painter of America," by sending in a pretty big picture of the big trees of California, and putting a very big value on his work. To tell the truth, we have had plenty of the Yosemite and the Big Trees, and we don't want any more.

The New York *Times* and *Evening Post* were just as unimpressed. The *Times* described the work as an example of Bierstadt's "careless[ness]," bluntly concluding without explanation that it was "the most unsatisfactory work of his we have ever seen." The *Post*, perhaps weary of the trees' visual splendor after sections were exhibited both near Central Park and at the former site of the Crystal Palace in 1871, followed up by describing it as another "collection of big-tree trunks" and thus "not equal to the demands of his reputation." The artist's professional practices and subject matter thus made him a popularist of little value to critics by the early 1870s. By their standards, he was an artist who merely capitalized on public trends or fancies, such as the sacred and mythic Far Western trees, rather than one who focused on quieter or smaller subjects whose subtlety would in theory reveal a more advanced artistic sensibility.[7]

Ignoring their near-unanimous professional disdain, Bierstadt completed one other formal big-tree composition, one that began as a small study of a 300-foot sequoia whose trunk was 42 feet in diameter. Here he changed his approach by using a different style—that of portraiture—and described the new direction six months later in a letter he sent to George Bancroft, a personal friend and famous historian who was the American minister to Germany. Ever attuned to cultivating contacts and encouraging patrons, Bierstadt wished to give his most recent tree sketch

to the German Kaiser as a gift. Because Bancroft had written a multivolume and pro–westward-expansion history of the United States, Bierstadt expected Bancroft would be receptive to the painting and might present it to the Kaiser for him. The painter boasted that the 3′ × 4′ "upright" was "a portrait of the largest tree in California if not in the world, and they have named it there, 'The King of the Mountains.'" Unfortunately, scholars have been unable to confirm the Kaiser's reception of the work or its exhibition history, although art historian Gordon Hendricks claims that Bierstadt sent a "large picture" to Berlin for exhibition. Based on catalog listings and exhibition reviews, Bierstadt may have exhibited it at London's Royal Academy that summer as *The Big Tree of California*, but most scholars consider it lost.[8]

As a study, the lost work could hardly capture the grand character most Americans associated with the sequoias, though it ultimately prepared Bierstadt for his final and most prolific portrayal of them. The following year, the New York *World*, although confused about the tree's genus and location, reported that Bierstadt was completing work on a big-tree portrait, one of two "great canvases [that] look[ed] Centennialsward."

> One of them is an upright, whose most salient feature is the Grizzly Giant, which is to say, one of the great trees of Calaveras County, Cal., a cedar, and it is to be presumed in all essential features a portrait, so that the artistic value of the painting will not be the only element of interest in the work.

Six months later, Bierstadt did indeed exhibit this version at the Centennial Exhibition in Philadelphia. It was the largest nineteenth-century big tree portrait any artist or photographer had ever made, a 10′ × 5′ image with a dominating subject poised to withstand any sneering criticism. His portrayal of these national historic trees, much as the *World* suggested, richly complemented the painting's placement at such a landmark national anniversary. The massive size and appearance of *The Great Trees, Mariposa Grove, California* (1876, Figure 27) ambitiously capitalized on the big trees' celebrity as emblems of the nation, this time embodying a more hopeful vision of the nation's condition after the war. The last nineteenth-century big tree portrait to equate the sequoias with the nation, *Great Trees* was Bierstadt's emboldened response to Watkins's heralded 1861 version.[9]

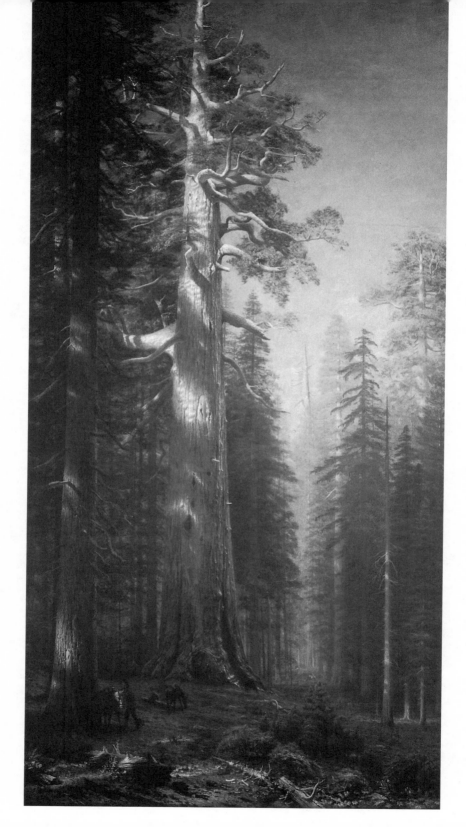

The 1876 American art exhibition in the Renaissance-style Memorial Hall and its adjoining annex at the exposition in Philadelphia gave Bierstadt yet another chance to promote his work, but it also presented the best evidence for America's cultural development—the latter of which was its organizers' primary agenda. The venue, which afforded much of the general public with their first comprehensive view of American art, contained the finest American art collection ever assembled, comprising more than one thousand paintings and sculptures, and its pedagogical promise genuinely encouraged the cultural community. As *The Nation* boasted of the display, "with all its shortcomings, [it is] by far the best illustration that has ever been made of this country's talent in its completeness, the range being from Boston to San Francisco, in geographical source, and, in time, from Smybert's [sic] day to our own." Not only did the exhibit provide an overview of contemporary American art, including works from Thomas Moran (six etchings, four oil paintings, one watercolor), Eastman Johnson (ten oil paintings on canvas), and Winslow Homer (four watercolors and two oil paintings)—some of which were for sale—it also presented a survey of the best of America's past one hundred years. Works by Jonathan Copley, Benjamin West, John Trumbull, Gilbert Stuart, Washington Allston, Thomas Cole, and William Sydney Mount helped to fill the nine galleries, two corridors, and one large hall devoted to the U.S. display. No other country's art collection took up as much exhibition space.[10]

Although the exhibition's overall aim was pedagogical—to assess America's cultural development—the memory of the Civil War influenced the advisory committee's selections of individual paintings. Themes of reconciliation and loyalty predominated, and Civil War subjects were specifically prohibited because they encouraged divisiveness. Despite the prohibition, one of the most popular exhibits was Peter Rothermel's huge *The Battle of Gettysburg* (1870), which William Dean Howells found "cover[ed] the whole end of one room." Rothermel's position on the selection committee probably accounted for the inclusion of this work. The chief of the art bureau was John Sartain, a respected Philadelphia engraver. His election, along with the fact that most of the committee were

Figure 27. Albert Bierstadt, *The Great Trees, Mariposa Grove, California,* 1876, oil on canvas, 10′ × 5′. From a private collection.

from Philadelphia, initially enraged New Yorkers, who felt that their city was the nation's cultural center and could thus more purposively choose edifying exhibits for Americans to view. But the committee did include members from New York and Boston, among them artists such as Worthington Whittredge and critic William J. Hoppin, and the exhibit proved to be a smashing success. The Memorial Hall art exhibition was a close second only to the wondrous Corliss Engine (a massive yet silent generator, which drew the largest crowds), steam-driven contraptions, printing machinery, and power looms displayed in Machinery Hall. *Scribner's* described the attention the art exhibit received, finding that "however rapidly other departments may be skimmed over, here the crowd lingers." Howells noted the same, saying that although the crowd throughout the fair increased each day, "it never struck one as a crowd . . . except perhaps in the narrow corridors of the Art Hall, and the like passages of the Annex to that building; these were at times really thronged."[11]

Regardless of its inclusion in the popular venue, critics were still deeply unimpressed with Bierstadt's *Great Trees,* and predictably they vented more professional objections at the artist than the work itself. American art and culture was on international display at the fair, and such scrutiny likely sensitized the highbrow community's cultural insecurities even more, to the extent that popularists' work, such as Bierstadt's, elicited severe upbraiding. Although the centennial commission bestowed on him an award of eminence, one of its judges balked at such high regard. Yale Fine Arts School director John Ferguson Weir, who wrote the official report of the art exhibition, bluntly dismissed Bierstadt's work with little explanation, regarding all six of his entries as indicative of "a lapse into sensational and meretricious effects, and a loss of true artistic aim." The elder Weir, brother of American artist Julian Alden Weir, concluded that "they are vast illustrations of scenery, carelessly and crudely executed." The New York *Times*, referring to *Great Trees*, vented that "the immense upright picture" lacked "any artistic qualities," and vilified Bierstadt's talent as vastly overrated. "I am sadly afraid that Mr. Bierstadt never was equal to his reputation," the *Times* writer opined, adding "that he acquired the latter mainly by a judicious system of advertising."[12]

Critics abhorred Bierstadt because of what they regarded as his "sacrilegious" professional practices, the kind that embarrassingly under-

scored their sense of the nation's low artistic ranking. His involvement in the dramatic marketing of his works and his penchant for high living had antagonized many of them. They felt he was turning artists into showmen and reducing art to lowbrow trade. Furthermore, he had gained popularity during an era when art tastes were quickly shifting away from the panoramic realism so evident in Bierstadt's work toward a more personal landscape vision—such as that of the French Barbizon School, whose techniques influenced American impressionism.[13] The nation's art, as the centennial show would confirm, may have been progressing, but the American public's tastes still lacked expert refinement. Bierstadt's large-sized landscapes, the most noted ones such as *Great Trees* averaging around 10' × 5', decidedly did not encourage the intimacy or reflection required by highbrow taste-makers who created more exclusionary definitions of proper art in America. They were proud, boastful landscapes that announced the beauty and majesty of the Rocky Mountains and Yosemite, sights that in the 1860s had yet to be fully revealed to an American public eager for more information about them. Thus the 1876 big tree portrait's negative reception had more to do with shifting art tastes, the formation of strict cultural hierarchies, and Bierstadt's negative professional persona than with its subject matter. Indeed, the largest canvas painter depicting the largest living organisms, both of whose reputations were often overhyped, seemed a perfect match—an ironic comment, perhaps, on self-promotion by Bierstadt. His choice to place the portrait at the nation's Centennial Exhibition, however, was an attempt to herald the nation's longevity. By 1876, the nation was in recovery from the war and nearing the end of a contentious reconstruction program. Bierstadt's use of the biggest trees to make a towering portrait, resonant of the nation's historical endurance and promise, was thus as much a celebratory gesture of faith about the nation as it was part of another attempt to resurrect his career as the grand American landscape painter.

Bierstadt thus placed *Great Trees* in an exhibition that boasted of the nation's recovery and ongoing cultural improvement. Given his fading reputation, his participation likely piqued some cultural arbiters. However, no debate about his inclusion arose, probably because of the surveylike quality of the entire American exhibition. Critics could not ignore the fact that Bierstadt had played a major role in American art history. His

popularity with the public was mostly the result of his enormously successful earlier work, which sold well as chromolithographs and engravings, and the fact that he produced landscapes. Because they were the most representative and popular American subject matter, landscapes dominated the U.S. exhibit, numbering about 240 paintings. Bierstadt contributed six of them: Along with *Great Trees* were *California Spring* (1875), *Settlement of California, Bay of Monterey, 1770* (1876), *Mount Hood, Oregon* (1865), *Western Kansas* (1875), and *Yosemite Valley, Glacier Point Trail* (ca. 1873).[14]

Although Bierstadt's exhibition choices seem a disparate sampling of subject matter and geographical location, there is one common thread among four of them. *Spring*, *Settlement*, and *Western Kansas* also display scenes whose visual organization centers on trees. Bierstadt often depicted tree scenes throughout his career, and the centennial collection was the culmination of a lifetime studying their character in and spiritual impact on the landscape. According to art historian Simon Schama, while Bierstadt trained in Germany in the 1850s, he produced landscapes "in which great trees (usually oaks) figure[d] as both heroic and spiritual actors in the scenery." In the early 1860s he crafted quieter forest scenes, such as *White Mountains, New Hampshire* (1863), and *The Mountain Brook* (1863), whose intimacy clearly relied on Durand's cathedral grove renderings. With others, such as *Pioneers of the Woods* (ca. 1863–1873), he quietly examined their branching and foliage, both in sunlight and shadow. By the early 1870s, he produced additional solemn tree studies, including *View in Yosemite* (c. 1870), *Wooded Glade* (c. 1870), and *Landscape, Rockland County, California* (c. 1872), the first two suggestive of the artist in the "fertile forest interior" and the third a perception exercise in which the trees' arrangement guides the viewer through the landscape.[15]

He revised all these themes and approaches for the centennial display, where he recorded trees' solemn and historical presence in the American landscape. Two of them attracted special commendation from observers and critics. The sun breaks through storm clouds in *Spring*, suffusing two main trees and creating the picture's division of storm and calm. One of them, the central tree, stands nearest the storm's borderline, absorbing the brunt of the sun's rays. *Settlement*, which one writer noted "attract[ed] much attention," depicts one of missionary father Junípero Serra's first

masses at Monterey. The congregation gathers around a large central oak tree whose extensive branching frames the entire ceremony. *Western Kansas* displays three or four large trees whose recession echoes that of bison drinking water at the left. Earl Shinn, a fellow painter who, under the pseudonym Edward Strahan, was an art critic, held out special praise for Bierstadt's rendering of the Kansas grouping's foremost tree.

> [Here] spreads an umbrageous and symmetrical tree—no spindling stem from the forest, but a well-rounded, broad, shadowy "park" tree. . . . Worship is the natural impulse in the presence of one of these gigantic overshadowers of the earth. . . . Mr. Bierstadt's magnificent specimen makes a felicitous foreground incident for him; and others, only diminished by distance, spread far toward the horizon.[16]

Completed during a final period of intense tree study, Bierstadt's centennial selections examined the beauty of American trees and allowed him to explore their iconographical significance to the nation. Much as trees had served as national talismans as well as signifiers of time's passage throughout the nineteenth century, centennial celebrations, especially including the Philadelphia exposition, inspired reflection on the nation's past and consequent progress. Although some historians have suggested that the focus on trees may have been part of his interest in "broadening the scope of his subject matter" between 1870 and the early 1880s—something in which his contemporaries were engaged as well—its timely collection for the 1876 celebration may have been his way of acknowledging their national and historic symbolism, with *Great Trees* serving as an ambitious focal point.[17]

Tracing the 1876 portrait from a series of sketches to its final version as his headliner for the centennial art exhibition is nearly impossible, because Bierstadt did not methodically date those sketches that survive nor did he carefully record his tree-viewing experiences. In fact, it is not clear whether Bierstadt made more big tree sketches during his first trip to Yosemite in 1863 or during the last trip in the early 1870s. However, it is clear that the first Yosemite sights that overwhelmingly impressed Bierstadt and others in his traveling party in 1863 were Sierra trees, particularly live oaks, pines, and firs. The party, which included two other painters—Virgil Williams of San Francisco (1830–1886) and Enoch Wood

Perry (1831–1915)—found their beauty and dimensions "superior to the finest white-oaks of the East" and could not resist sketching them. Fitz Hugh Ludlow, writer and Bierstadt's travel partner, affirmed the trees' graceful form was such that they "lingered long among their shadows with book and pencil, and [I] look for a desirable acquaintance with new Dryads when they grow into the life of color from our artists' hands." Art historian Ralph A. Britsch has argued that from these studies Bierstadt later completed *Pioneers of the Woods*. This portrait displays two huge oak trees, whose gnarled, skeletal, and broken branches create a "weeping [effect] at their extremities," a tree visage that characterizes those that appear in many of Bierstadt's other tree studies and mountain landscapes.[18]

The party's astonishment over the Sierra trees' size continued as they neared Mariposa Grove. "We had been astonished at the dimensions of the ordinary pines and firs," Ludlow marveled, "our trail for miles at a time running through forests where trees one hundred and fifty feet high were very common and trees of two hundred feet by no means rare, while some of the very largest must have considerably surpassed the latter measurement." When they reached Clark's station, home of the big trees' guardian, their astonishment turned to near incredulity. All previous trees paled in comparison, the pines and firs "in their turn dwarfed by the Big Trees proper, as thoroughly as themselves would have dwarfed a common Green-Mountain forest." To convince themselves further of their size, "our whole cavalcade charged at full trot for a distance of one hundred and fifty feet" through one of the hollow prostrate trees, the hollow base of one of the standing ones "easily shelter[ing] ourselves and [the] horses."[19]

The Grizzly Giant, which Ludlow called "the monarch of them all," overwhelmed the party. "A glorious monster," Ludlow effused, "as most of those measured are still living, while *the* tree is to some extent barked and charred." It was a stupendous ruin, the one sequoia that inspired the writer to litanize over the trees' historical value, the kind that easily trumped that of the sacred oak of Connecticut. Its size was such that he imagined "their tender saplings were running up just as the gates of Troy were tumbling down, and some of them had fulfilled the lifetime of the late Hartford Charter-Oak when Solomon called his master-masons to refreshment from the building of the Temple." Their age stymied Ludlow,

and they remained to him "an incomprehensible fact, though with my mind's eye I continue to see how mountain-massy they look, and how dwarfed is the man who leans against them."[20]

Bierstadt and the other artists "lingered among them half a day . . . making color-studies of the most picturesque." Challenged by the trees' size and antiquity, they eventually gave up on making "a realizing picture of the groves" and focused on rendering other aspects accurately in their studies. Ludlow reported that "what our artists did do was to get a capital transcript of the Big Trees' color—a beautifully bright cinnamon-brown . . . [and the trees'] typical figure." He described the latter as "a very lofty, straight, and branchless trunk, crowned almost at the summit by a mass of colossal gnarled boughs, slender plumy fronds, delicate thin leaves, and smooth cones scarce larger than a plover's egg." Displaying a combination of all the aforementioned characteristics, *Cathedral Grove* (n.d.) may have been an early study, because it presumably included the hollow big tree through which the party rode. At the end of their seven-week Yosemite trip, Ludlow surmised that from these numerous color studies done "on the spot" the artists had "learned more and gained greater material for future triumphs than they had gotten in all their lives before at the feet of the greatest masters."[21]

Bierstadt began to incorporate the sequoias' image in subsequent Yosemite landscapes, particularly *The Domes of Yosemite* (1868) and one other that succeeded the 1876 tree portrait, *Mount Whitney* (1877), which critics panned for its clear resemblance to his earlier and highly successful *Among the Sierra Nevada Mountains, California* (1868). In *Rocky Mountains, Longs Peak* (1877), Bierstadt incorporated big trees, too, even though the location of the scene is Colorado. The trees he included in all of these canvases resembled one another, especially the skeletal tree foregrounding the more healthy ones in *Domes of Yosemite* and *Mount Whitney*. He often recycled tree figures, most glaringly evident in *The Wolf River, Kansas* (ca. 1859) and *Indian Encampment, Shoshone Village* (1860), as well as the central tree he used in two of the centennial exhibits, *California Spring* and *Settlement of California*, because he used his *plein air* sketches as inspirational references for use in all his landscapes. More than likely, such a practice partly explains the redundancy evident in many of his formal landscapes.[22]

Similarly, *Great Trees* contained echoes from earlier images. *The Grizzly Giant Sequoia, Mariposa Grove, California* (a.k.a. *Redwood Trees*; 1872–1873, an oil-on-paper study mounted on board, was one such precedent. Although leaning noticeably to its right, the Grizzly Giant figure clearly resembled the more solidly upright version Bierstadt rendered in the 1876 portrait. His off-center placement of the tree and bifurcated grouping of the forest background in this smaller study strongly echoed the centennial work's appearance as well. *Cathedral Grove's* layout also closely resembled *Great Trees*, with a central trail penetrating a strikingly similar forest-alley background.[23]

Even as Bierstadt based his work on such studies, *Great Trees* was equally reminiscent of Watkins's 1861 portrait.[24] Bierstadt had viewed the photographer's large-format photographs in both New York and San Francisco and was inspired to visit Yosemite largely because of them. He may even have had Watkins's *Grizzly Giant* in mind, because he chose the same tree as his subject. However, because he was a painter, Bierstadt had more discretion and could imagine and include almost anything in his scenes. He used human figures to achieve perspective on the tree's height, but instead of grouping them at the trunk's base, he spread them out, almost in time-lapse records of arriving, viewing, posing, and departing. He also accentuated Grizzly Giant's skeletal appearance more carefully. He painted the tree's trunk uncluttered by foliage, recalling the spiking skeletal tree included in *Domes of Yosemite* and later in *Mount Whitney*, and displayed the trunk's wounds more prominently. Large dotted burn scars, as well as stripped bark, documented the damage the tree had sustained since Watkins photographed it. As depicted by Bierstadt, the tree was truly weathered and tired, which he emphasized by draining it of its signature cinnamon color. Yet Bierstadt still rendered the Grizzly Giant as the forest's true king by placing it in a grove of smaller trees with the sky opening above. As one reviewer described it, the lifespan of the surrounding trees "are as a span compared with the Methuselah of [sic] Calaveras."[25]

Not only did Bierstadt have Watkins's version in mind when he composed the portrait, he also responded to it by placing young tree seedlings in the right foreground. Unlike Watkins, who chose to include the tree shard as a cautionary metaphor, Bierstadt inserted signs of rebirth and

regrowth near the big tree. These were baby trees thriving in their own thick Lilliputian grove, a youthful sprouting amid the supercilious decay and age displayed by the renowned Mariposa tree. As others had discovered, sequoias were the product of fire—they relied on its heat to open their cones and thus allow for seed germination. Bierstadt's inclusion of young sequoias suggested that, amid the fire-scarred, skeletal, but still healthy remains of the old weathered giant, lay the seeds of the trees' rebirth. Indeed, Bierstadt titled the portrait, *Great Trees* (using the plural form), thus using Grizzly's overwhelming celebrity to comment on the trees' national relevance both large and small.[26]

This was not the first time Bierstadt used trees to comment on the national condition. As historian Robert McGrath has pointed out, while en route to Yosemite in the early 1860s, Bierstadt traveled through Civil War zones, completing one of the few live action scenes of the war, *Guerrilla Warfare (Picket Duty in Virginia)* (1862). He also completed a small study of northeastern flora before he left on the trip. *Maple Leaves, New Hampshire* (1862) shows a tree stump "yielding" to leaves and moss, a scene representative, argues McGrath, of "death and regeneration . . . an emblem of hope at a time when the union was seriously imperiled."[27] *Great Trees* developed this theme even more. Presented at the nation's Centennial Exhibition, Bierstadt's portrayal of the sequoia as the forest's immemorial patriarch poignantly served as a hopeful and celebratory portrait of the nation at one hundred years, whose enduring qualities had been tested but not vanquished as it neared the end of a trying reconstruction period.

5

CONSUMING VIEWS

Albert Bierstadt's uncelebrated depiction of an intact historic tree asserted the nation's centennial health and maturity, but it was not the only big-tree display intended for the 1876 Philadelphia fairgrounds. California's Tulare County, located near the southern Sierras, proudly exhibited two large tree specimens, an 18-inch-thick bark piece and a cored-out 16-foot trunk section.[1] Although both the tree samples and Bierstadt's sequoia portrait attracted only minor notice, their inclusion at the 1876 fair marked another significant cultural moment. Unlike in 1861, when Carleton Watkins's and Edward Vischer's tree portraits expressed reservations about the nation's fate and the trees' exploitation, the sequoias' presentation as object and image at the centennial celebration instead underscored Americans' embrace of both the trees' commercial value and of their metaphorical meaning. Indeed, the trees' promotional use in Philadelphia revealed the comfortable coexistence of contradictory discourses, one fascinated with the trees' potential as a lumber resource, the other holding them up as national totems. Throughout the latter nineteenth cen-

tury, many Americans held such seemingly antagonistic viewpoints because they sought to substantiate their claims of the young nation's future as promising and undeniably powerful. As a primary example of these sentiments, the 1876 fair exhibitions demonstrated that no strict division existed between the two views.[2]

Yet to some degree there was a division, especially for artists. As the nation's reconstruction reached its official end (with the 1877 removal of federal troops from the South), the big trees' usefulness in embodying the nation lost its artistic currency and mass appeal. Painters virtually abandoned using the trees as national muses. However, photography soon became the dominant medium for the trees' portrayal, and along with romanticizing their heroic presence it celebrated their conversion into lumber.

By the late 1870s, many Americans had become less interested in viewing their battered yet intact condition than in imagining their sizeable commercial promise. Some Americans acted on these fantasies by seizing tree sections for exhibition throughout the country, most prominently at the 1893 World's Fair, a marketing spectacle abetted by the federal government. Although the display of their utility was not unprecedented, especially given the proliferation of similar exhibitions immediately after the sequoias' formal discovery in 1852, the exultant promotion of the trees' size and lumber was not matched by their transformation into raw materials until the 1880s and 1890s. At that time lumber companies moved into the Sierras in greater numbers. These enterprises logged the trees' largest stands for more than twenty years, and the corresponding photographic coverage was a celebration less of the mighty sequoias than the power of American companies who decided their fate and the labor of the men who worked for them.[3]

While tramping the big trees' southern Sierran range and studying its ecology in 1875, John Muir "heard the sound of axes" penetrating the solemnity of the "cool glens and hollows." Muir was walking through the "magnificent groves of King Sequoias" south of Fresno County's Kings River. The trees were "irrepressibly exuberant," gushed Muir while he was discovering some of the region's largest and healthiest groves. When he returned sixteen years later in 1891, however, he was profoundly disappointed. Standing disconsolately among "stumps, logs, and the smashed ruins of . . . trees cumber[ing] the ground," Muir then heard a threaten-

ing "scream of saws" rather than the unremarkable hum of the five or so small independent mills whose operations merited slight mention in 1875. "Sixteen years ago," he recalled, "I saw five mills on or near the sequoia belt, all of which were cutting more or less of 'big-tree' lumber. Now, as I am told, the number of mills . . . [has] doubled, and the capacity more than doubled." He noted that the mills were "devoted to the destruction of the sequoia groves." In their haste to elude any legislative restrictions, the mills prioritized the sequoias' felling, ordering loggers to hunt them down and "get them made into lumber and money before steps [could] be taken to save them."[4]

As sacred as the sequoias had been for Americans during the Civil War, they became expendable afterward, gigantic resources bespeaking a profitable future. Although early conservationists such as Muir lobbied for and secured some of the groves' protection—most prominently in the 1890 bill that established Yosemite, Sequoia, and the General Grant Grove as national parks—lumber enterprises continued to develop "sore, sad center[s] of destruction" unhindered in the Sierras, many of them based on illegal mass purchases.[5] At one point, such speculation even threatened the Calaveras Grove, the historic site of the trees' discovery, until the federal government intervened around 1900.

The Kings River Lumber Company, renamed Sanger Lumber Company in 1894, was the most notorious. Beginning production in 1888, the company logged the region's best stands, including in 1897 the Converse Basin, "a sort of elongated bowl, nearly 1000 feet deep, four miles long," that was studded with massive fir, pine, and cedar, and what timber experts claimed were "the finest examples of Sierra redwoods to be found anywhere on earth." The basin's logging produced a yearly average of 7 to 10.5 million board feet, which in quick order devastated the grove. By 1905, the company's last year of production, Sanger had cut down an estimated 8,000 sequoias. By comparison, the pristine Giant Forest, Sequoia National Park's central grove and the basin's nearest equivalent, contained about 3,500 mature trees.[6]

During Sanger's eight-year occupation of the basin, the company's Sierran logging activity inspired images of human mastery over the trees. Indeed, when the lumber industry expanded into the Pacific Northwest, a new genre of forest photography was born: company logging shots of

large trees. For prospective photographers, there were plenty of forest stands to document. Washington's and Oregon's Cascade Range contained old-growth trees of enormous height and girth, including Douglas firs whose size occasionally equaled that of the sequoias. Other large trees, such as the Ponderosa pine and Sitka spruce, reached 200 feet and added variety to these companies' lumber prospects.

Such a valuable cache tantalized lumber barons, especially those from the Great Lakes states, an area whose denuded White pine forests had created an industry crisis by the 1880s. The prospect of western forests with trees that each contained up to half a million board feet of lumber, as the Sierra redwoods did, galvanized the industry. By the time Frederick Weyerhaeuser, heading a Great Lakes states' coalition of timber interests, purchased a patchwork of 900,000 acres around Puget Sound as the new century dawned, the boom was on. Numerous articles, especially from *Scientific American*, saw western lumber's "wonderful" and "remarkable" growth as evidence that "civilization in its most progressive form" was finally spreading to the nation's last frontier.[7]

Lumbermen, particularly "choppers," as they were called, were the central heroes of these ventures, and stories of their derring-do were the backdrop for the visual rhetoric of the logging images. The chopper's audacious confrontation with the venerable sequoias, including the region's other large Douglas firs and Sugar pines, may have been despairingly discordant to Muir, but for much of the latter part of the nineteenth century writers romanticized the forest exploits of lumbermen as a stirring component of empire building. Although Henry David Thoreau, like Muir, expressed horror, vilifying "Mr. Sawyer" (a referent to a lumberman in general) as a "busy demon" and forest ransacker in his posthumously published *The Maine Woods* (1864), magazines generally popularized lumbermen as part of a muscular front line advancing national destiny. In 1904 *The Outlook* magazine summarized their role, calling lumbermen "the first skirmishers of the army of invasion . . . to conquer the pinery . . . [an] advance guard of an army of soldiers," who laid out "the lines of attack" for "doomed timber."[8]

Such an attack began with the timber cruiser or woods surveyor who, much "like the 'look-out' from the mast-head of a whaler . . . scan[ned] the vast sea of forest." When autumn arrived, swampers, choppers,

sawyers, and skidders felled trees, prepared fall beds, cleared trails, and built skidroads, the last referring to tracks made of logs closely laid cross-wise in a corduroy pattern whose oiling eased the timber's hauling through the dense forest. During the winter, teamsters transported the crop of skid-ded and stacked logs to a river, although by the latter half of the nine-teenth century western lumber companies relied more on railroads or flumes. In the spring, river drivers directed the logs' brisk and often explo-sive travel to the mills. Although many writers regarded the river driver's job as the most dangerous and thus heroic, choppers were the most com-pelling lumbermen, brawny pioneer figures whose feats of strength se-cured the nation's ambitious growth.[9]

Walt Whitman expressed such a regard in 1856 when he extolled chop-ping as a musical performance announcing an empire's arrival, consider-ing it a much more pleasing and reassuring sound than Muir did forty years later. In "Song of the Broad-Axe," he described the broad-ax as a specialized instrument fully capable of "fluid utterances," a powerful ring-ing that sang of great cities with mighty "shapes of factories, arsenals, foundries, markets"—part of an empire's chorusing of "Democracy total." "Wooded flesh and metal bone," Whitman's living artifact was "the mighty and friendly emblem of the power of my own race, the newest, largest race"—the promised "result of centuries"—whose sonorous im-pact relied on the chopper. The sound they created together hypnotized other writers, who found the ax-chiming irresistible. "From the evergreen depths" near a Washington logging camp, Louise Herrick Wall's 1894 party heard "the pleasant resonance of axes," a strain that "called us." As they drew nearer, other sounds intruded, mostly monotonous rhythmic sawing noises, but the brash staccato of chopping did not yield. "More clearly than all else," she enthusiastically recalled, was the sound of "the finely timed alternate strokes of two choppers, as the ringing impact of their blows thrilled up the great length of a standing tree."[10]

If the ax was the instrument expressive of the nation's prolific future, the chopper was the artist who controlled its powerful performance. His mastery of his tool was seen as a patriotic act. The ax, commented *The Cos-mopolitan* in 1887, was the choppers' handmaiden, because the choppers handled such "heavy, keen-edged axes as though they were mere trifles, chop[ping] swiftly into the heart of their helpless victim, [while]. . . . white

chips fly fast and thick." After the tree gave its "warning crack," the huge mass ceremoniously crashed to earth "with the sudden sweep of an eagle."[11] Although celebrated for possessing an aura that radiated national pride in masculine work, choppers lived a coarse and rude life, whose distasteful-ness writers constantly addressed. However, they tended to excuse their living habits to emphasize the men's brawny physique. They were fasci-nated by the chopper's strength, mastery, and bravery—favorable quali-ties more in line with their nationalistic duties.[12] Choppers were "no puny impersonations of men," they were active figures with "sun-baked hairy chest[s]," who easily skinned a tree's bark off "with a quick careless mo-tion . . . swung in fearful proximity to the logger just behind." Such "lusty vigor" and "bold skirmish[ing]" could even entrance potential critics, causing them to submerge their negative preconceptions. The "sharp strokes" and "roaring profanity" of some Coast redwood choppers ini-tially offended a *Harper's New Monthly Magazine* writer in 1883 until he witnessed their felling of one of the massive trees. Impressed by their com-petence in predicting "where she'll lay," he was also captivated by their sturdy masculinity, made more imposing in the presence of the massive and ancient coastal giants. Describing their motions as "muscularly grace-ful," he thrilled to the sight of "these stalwart men perched upon their strips of springy board, hurling their axe-heads deep into the gaping wound, and never missing the precise point at which they aimed." Wit-nessing their defeat of a giant tree only enhanced the chopper's favorable reputation as the brawny ground troops of a conquering empire. By 1890, photographers began to exploit such regard by producing celebratory im-ages of the choppers' subjugation of large trees, including the sequoias. Highlighting scenes of the big trees' vanquishing, such logging photo-graphs celebrated masculine dominance and heroically portrayed human authority over nature.[13]

Darius Kinsey was the most prolific large-tree logging photographer of his era. Kinsey, who from the 1890s to 1940 photographed the Washing-ton state logging industry, reputedly claimed that "you aren't a logger until you've bought a dollar watch and had your picture taken with a tree." For almost half a century, he enhanced the logger's triumphant nationalistic role through his imagery. A dedication to photographing "anything, any-where, any time except on Sunday" enabled him to record the logging of

some of the nation's largest old-growth trees, thus creating prototypical large-tree logging images. They were so well-regarded that in 1900 *Scientific American* illustrated one of its celebratory accounts of the Far Western logging industry with five of Kinsey's images. Kinsey secured his reputation, however, by selling his work directly to the lumbermen. Charging his subjects 50¢ per print, he produced thousands of images, reinforcing a formula used by scores of contemporaries, most of them unknown, who copiously documented the felling of large western trees, including the Sierra redwoods.[14]

Although he occasionally produced images for railroad companies, such as the Seattle and Lake Shore Railroad Company, Kinsey worked independently, primarily producing individual, wedding, and family portraits from his Sedro-Woolley, Washington, studio. He opened the photo studio around 1896. So enchanted was he with the region's forest scenery, however, that by 1906 he produced exclusively logging images and other outdoor scenes from his new Seattle studio. Having been invited to exhibit his coverage of the state's trees and logging industry at the 1900 Paris Exposition and at Saint Louis's 1904 World's Fair, the well-respected photographer began to focus less on family portraits and more on the lumber industry. During the century's first decade, he produced countless images of choppers posed underneath a large tree's undercut.[15]

Such stylized portraits revealed his strengths as an image-maker. Although most industry photographers also recorded basic scenes of machinery or camp buildings—the kind that glorified a lumber companies' enterprise—Kinsey, who cut his teeth on portraiture, focused almost exclusively on individuals. Fulfilling thousands of requests, Kinsey largely supported his family with these individual sales, and they became such a common transaction that the loggers often arranged payment through salary deductions. More interested in pleasing himself and the loggers than the lumber barons—who never commissioned work from him—Kinsey enjoyed the admiration and trust of his chosen subjects. They were his primary audience, patrons, and abiding interest. Not hemmed in by industry requests, he tirelessly indulged his fascination with the logger and his methods.

Much as Watkins had while initially photographing Yosemite and the sequoias, Kinsey used trial-and-error procedures and makeshift equipment

to craft the desired compositions. Working in eleven different formats throughout his career, including stereoptics, he used a variety of cameras and other photographic equipment, but mostly relied on extremely heavy Empire State cameras. One of them, the 20″ × 24″ Empire State, weighed nearly 150 pounds, including the equipment; the other, a smaller but still bulky 11″ × 14″ version, he used to produce his most famous work. The cameras had no exposure meters, so Kinsey learned to estimate light intensity, becoming a master at using what little illumination the dense forests offered.

Accounts of his incredible patience amid dark forests underscore the self-taught photographer's obsessive dedication, an attitude that helped to secure the logger's respect. One logger admiringly noted that although it could "take two or three days before you [could] get light enough. . . . he would set there until things was the way he wanted it. Sometimes he would go clear up on a high stump, take a ladder to get up there. Stick around there for hours. Maybe sun would come down through a hole in the timber and he'd take it."[16]

Lighting was not Kinsey's only concern. The camp was a dangerous obstacle course. It was littered with stumps, logs, heavy falling debris, and whiplike boom cords, the last being high wire lines that lumbermen alternately tightened or slackened to swing logs around trees and other obstructions. Jumping from log to log while carrying the heavy equipment, Kinsey wore caulk shoes to maneuver safely on the unstable ground as he searched for an effective camera position. Because most choppers began their cuts about 10 feet above ground, he often constructed scaffolds onto which he would hoist the heavy camera to portray working loggers. He also custom built his own 12-foot tripod to avoid the construction labor involved in such preproduction, although sometimes he was able to use stumps for elevation, especially if they were about 20 feet away. No matter what procedure he used, lifting such heavy equipment was extremely hazardous. During what would prove to be his last shoot in 1940, Kinsey fell while climbing a stump with his camera and broke several ribs. His photography of the loggers' brawny masculinity thus were both studies of and acts of physical exertion.

After setting up the equipment, Kinsey motivated his subjects for the shoot, which was made easier by the loggers' respect for him. They

perceived him as "a logger's man," a fearless picture taker because he integrated himself into the camp. "His procedure when arriving in a lumber camp," recalled Mollie Dowdle, who was raised in one of the state's logging communities, "was to find the camp bull cook and locate himself a bed. Then he'd get up early in the morning and have breakfast in the cookhouse with the guys, and ride out on the flatcar as they went to the woods." Many camp foremen, respecting his fearless enthusiasm, regarded him as an unofficial camp member. After turning away one overzealous "Mr. Photographer" who had photographed fires and machinery, one foreman mandated that he would never "let no more photographers into this camp except Mr. Darius Kinsey."[17]

Such intrepid enthusiasm for logging, prefaced by years of manipulating portraiture subjects, aided Kinsey's posing of loggers during a shoot. According to Palmer Lewis, who was eighteen years old when he first met Kinsey, the photographer had a talent for inspiring men about their work's significance. "He evidently had a considerable understanding of human nature," Lewis recalled in 1972, because it was clear that he "knew how to handle people." While observing him during a shoot, he remarked on Kinsey's decisiveness, which ultimately relaxed his subjects and easily coaxed them into the position Kinsey desired. With the crew "anxious" to head home for lunch that day, Lewis noticed that Kinsey did not waste time "pondering over the best location." Instead, he worked with the men by "kidd[ing] them a bit" before redirecting them. With this friendly approach, "he got off several exposures and had his pictures. No commotion . . . and everyone jovial and happy." Lewis's observations indicated that Kinsey's "contagious enthusiasm" was the decisive element that made the loggers "feel important" and that motivated their poses in such "classic" big-tree portraits.[18]

Infusing his sometimes camera-conscious subjects with such self-importance enhanced his ability to capture the dauntless spirit he discovered in the choppers. Two images from the early 1900s, one a stereopticon print (a small transparency or slide that was projected as an enlarged image by an optical lantern), recorded one such shoot. *Thunderings of a Fallen Monarch Soon to Echo through the Woods* (ca. 1906, Figure 28) showed Kinsey on a teetering scaffold with his Empire State camera while he considered his composition. Two men on spring boards, one leaning

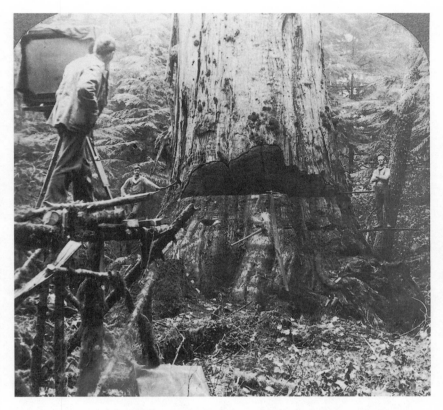

Figure 28. Darius Kinsey, *Thunderings of a Fellen Monarch Soon to Echo through the Woods*, stereopticon print, ca. 1906. Image #11600, Darius Kinsey Collection, Whatcom Museum of History & Art, Bellingham, WA.

on the trunk, the other standing with arms crossed, flanked the incised trunk of one of the most frequently photographed large trees of the period. This cedar, reputedly the state's largest tree, famously possessed a circumference measuring 76 feet.

After reconfiguring the men's position and other significant props, Kinsey produced a large-sized print that emphasized the choppers' swaggering confidence and relationship to the massive tree. In *Three Loggers Falling a Cedar with Crosscut Saws and Falling Axes* (1906, Figure 29), Kinsey added a third man, thus enabling him to move one of the others into the trunk's undercut and still maintain the scene's organizational

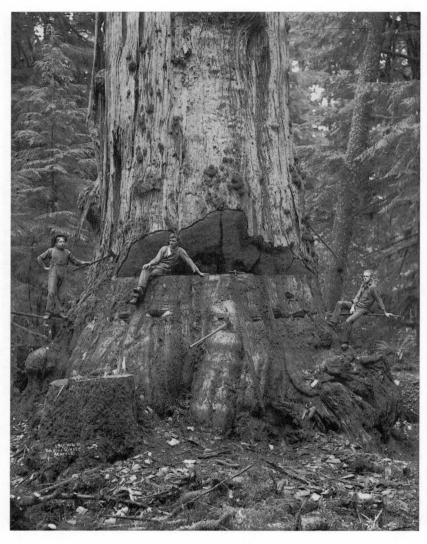

Figure 29. Darius Kinsey, *Three Loggers Falling a Cedar with Crosscut Saws and Falling Axes*, 1906. Image #20150, Darius Kinsey Collection, Whatcom Museum of History & Art, Bellingham, WA.

balance. The three men surround the trunk, the leftmost grasping the long handle of an ax whose blade is still embedded in the trunk. On the frame's right edge, underneath a dangling ax handle, a second chopper reclines on his springboard, staring confidently into the camera, while in the middle, inside the trunk's gaping wound, the last chopper leisurely sits with crossed legs, staring off camera, unconcerned about the immense weight hovering over him. Their repositioning formed a more compelling composition, because it eloquently affirmed the heralded cedar's conquest by these fearless choppers as a grand epic, a perspective that so captivated Kinsey that he created countless other chopper portraits like it.[19]

Much as did other logging photographers of the period, especially photographers of the sequoias, Kinsey admired and spotlighted the chopper's courageous dominance over the large trees. Logging photographers such as Kinsey produced unapologetic celebrations of the choppers' triumph, not the trees' death. In fact, death was a subject photographers sedulously avoided, especially Kinsey, who never photographed accidents because he felt they "discredited logging." Although Kinsey never photographed the Sierra big trees' logging, he was part of a long unheralded group of active photographers who produced similarly celebratory logging images—the kind that regarded the chopper's victory as fearless expressions of the American empire's triumph over nature at the end of the nineteenth century.[20]

Although logging photographers did record other scenes, such as sawmill production and flume transport (referring to a wooden chute conveying logs over mountainous terrain to a mill for processing), the most prevalent composition types displayed either confident choppers in triumphal possession or proud logging camps posing with their kill. The magnitude of these scenes of masculine domination was heightened when the photographer's lens focused on the sequoias. Mature sequoias had gained a reputation as examples of "the rugged virility of manhood." Making the undercut—a V-shaped gouge into which the trunk collapsed on its way down—thus was not only the chopper's first encounter with a tree, it was a rite of masculine prowess. The undercut's velvety smooth plane also vividly expressed his expert technique. Sometimes requiring a week or more of continual ax-swinging, the labor-intensive conquest expressed the chopper's strength and endurance, and the larger the tree, the

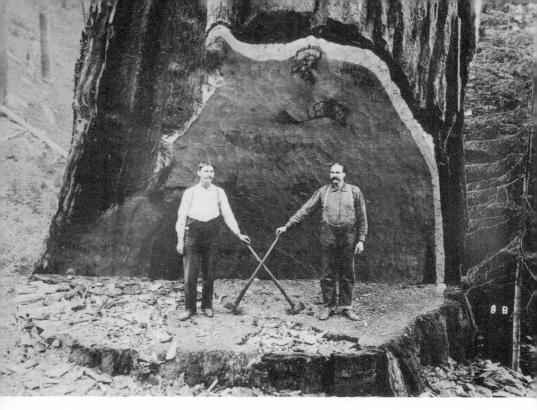

Figure 30. Portraits of the sequoia's choppers closely resembled Kinsey's big tree compositions. Sometimes depicting one man in a large tree's undercut, sometimes more than one, the composition type clearly celebrated the chopper's strength and bravery. Photographer unknown, untitled, n.d. Harold G. Schutt Collection, Special Collections Library, California State University, Fresno.

more impressive its photographic image. The diagonal cut, which exposed the trunk's softwood and formed an overhang, was the perfect dramatic backdrop before which choppers could deign to stop their assault and pose.[21]

So interchangeable were Washington State's picture trees that sometimes they were used to illustrate articles on the Sierra's big trees. In 1902, the magazine *World's Work* headed off a report on the Calaveras Grove with a Puget Sound Red fir photograph. The portrait by Everett Kirk showed two men, tightly fitted into the fir's undercut, lying down sideways with their hands lazily propped under their heads and their feet barely overhanging the stump's edges. As much as Kirk's image highlighted the chopper's quirky boldness, one of Kinsey's portraits—"*19. A Close in View of a Ten-Foot Fir Showing Man Lying in the Completed Undercut*" (n.d., Figure 31)—most fully expressed such confidence, as one crew mem-

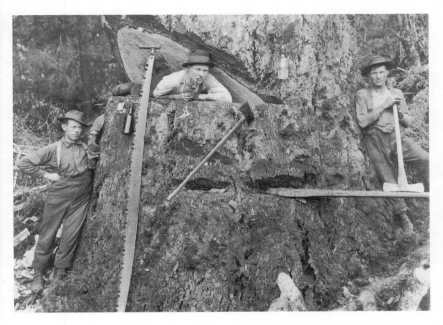

Figure 31. Darius Kinsey, *19. A Close in View of a Ten-Foot Fir Showing Man Lying in the Completed Undercut*, n.d. Image #10019. Darius Kinsey Collection, Whatcom Museum of History & Art, Bellingham, WA.

ber, pipe in mouth, defiantly lay beneath a low undercut. The Sierra big trees especially were referred to as "monsters" or "whales," whose size, as Muir observed in 1901, "would have been more in keeping" with the age that produced the "mastodon or megatherium." Such compositions not only substantiated the wondrous tales about these trees' dimensions but also that they were valuable commodities over which American choppers exercised domination, no matter how massive their size. Picture trees, especially of the Sierra redwoods, recorded the moment before a large tree's felling, a decisive scene heralding the potency of their new masters, the choppers, who, posing within their proud victims, defied the ancient stems to swallow them up.[22]

The stance was boldly ironic given that the large trees were actually the objects being devoured. The value of these large trees lay in their usage, an attitude the other composition type, labeled as group portraits, asserted in scenes of a tree after its fall. These images celebrated the nation's

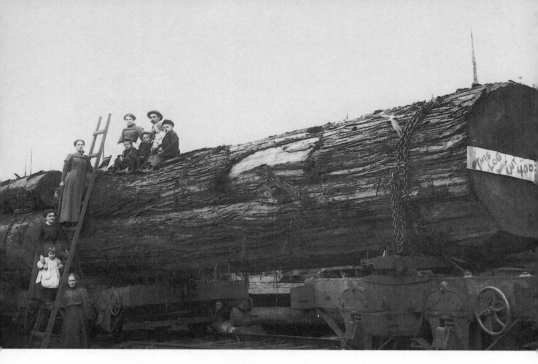

Figure 32. Darius Kinsey, *This Log Will Cut 40,000 Shingles,* 1899. Image #10060(b), Darius Kinsey Collection, Whatcom Museum of History & Art, Bellingham, WA.

dominance of its large trees and put forward an unqualified endorsement of their lumber value. They generally showed a logging crew, sometimes including an ox or horse team, sitting or standing on a prostrate trunk, often with other crew members posing with axes or crosscut saws draped across the log's exposed diameter. A crewman's family sometimes participated, their presence suggesting that the trees' felling would enhance a dazzling future for the nation's families, measured in board feet. Indeed, photographers often highlighted a fallen tree's lumber prowess by including board-foot estimates etched in or pasted on its butt end, one of Kinsey's even titled, *"This Log Will Cut 40,000 Shingles"* (1899, Figure 32).[23]

Appreciating a large tree's usefulness was such a common attitude that even Muir, who galvanized the early environmental movement, once endorsed the use of big tree logs for housing. Calling them "almost absolutely unperishable," Muir asserted in 1901 that a house built of "Big Tree logs on granite . . . will last about as long as its foundation." When the Southern Pacific railroad advertised in 1900 San Joaquin Valley's scenic and commercial beauty in *Sunset,* its travel magazine, it was no surprise that, along with descriptions of the Mariposa Grove's scenic beauty it included a collage of logging scenes that traced the logs' conversion in a

Figure 33. Artist unknown, *From Giant Trees to Matches*. From *Sunset* 4 (February 1900): 144.

nearby Madera logging camp "from giant trees to matches" (Figure 33).[24] Perhaps the strongest example of such regard for a large tree's lumber value was an untitled group portrait by A. R. Moore that documented a Sierra big tree's demise (Figure 34).[25] The entire lumber camp, including horses and two women—the loggers' wives or daughters, perhaps— surrounded the fallen giant, skinned of its bark and ready for processing

at the mill. The log's diameter was sizeable, underscored by multiple bunched groups of two and three men haphazardly spread out from bottom to top in sitting and standing positions around its butt end. The party exuded a sense of composed triumph over the tree. The men confidently faced the camera, one of its members brandishing a rifle, others insouciantly reclining on a ladder or leaning on the trunk's side, while one man, at the head of a team of horses, imperiously scanned the distance from atop the trunk. The intent of these images, with the men always dominant, confidently reclining against the tree or sometimes bracing themselves with an ax protruding from the trunk's side, was to show off their mastery of the trees and the trees' lumber value. These images that, like Moore's photograph, recorded the sequoias' subjugation, verified the prophecy Whitman had made about the big trees' cordial abdication as a sign indicative of the next great empire's rise. Indeed, by the late nineteenth century, the sequoias had become more culturally meaningful as defeated giants than as reassuring national survivors. Ironically, only in their consumption of astonishing quantities of board feet of lumber did late-nineteenth-century Americans link the trees with the national destiny. They found proof of the nation's virility and indomitability after the war in representations of the trees' conquest and commodification.

Although the logging photographs triumphantly presented masculine celebrations of the sequoias' defeat, their attitude was just as duplicitous as many other previous big-tree exhibits had appeared to eastern viewers. Regardless of the regal symbolism of their size and unique geographic location, the trees were not the magnificent cash cows many had assumed. The depression of the early 1890s slowed lumber sales; but, more important, the trees' felling, as heroically stirring as it might have appeared in the photographs, was ruinous and wasteful, ultimately leaving the lumber companies, primarily Sanger, financial wrecks.

Choppers began their undercuts about 10 to 12 feet up on a sequoia's trunk, given its enormous girth and the incidence of butt defects at its base. While this aided choppers, it wasted potential lumber, because the stumps remained unused. The most waste, however, occurred after a big tree's felling. Not only did the massive trunks tend to explode into fragments, they often shattered while being split for processing in the mills. Because the trees' diameter was so huge, loggers used explosives to split

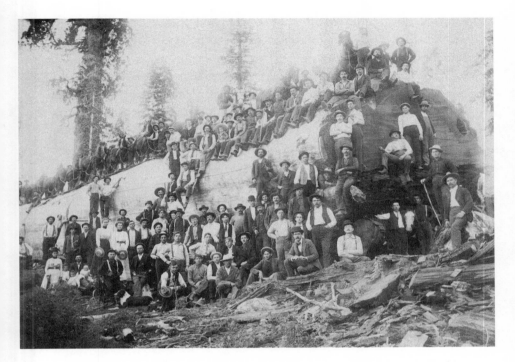

Figure 34. A. R. Moore, untitled, n.d. Harold G. Schutt Collection, Special Collections Library, California State University, Fresno.

them into more reasonably sized log sections, even though such a procedure could destroy much of the wood. The result, according to the lumber scholar Howard Brett Melendy, was that the big trees had "a waste of forty-five to fifty percent"; others have estimated it as high as two thirds.[26] Dazzled by the spectacle of the sequoias' extraordinary size but unmindful of the practical difficulties of converting it into usable lumber, Sanger never cleared a profit. The felling of thousands of tons of unusable wood incurred massive overhead costs from which the company never recovered.

The stalwart choppers and other lumbermen so triumphantly captured by big tree logging photographers thus never really completely conquered the trees. The sequoias had trumped them. Their massive trunks and twisted limbs lay prone in quieter meadows and wasted in motionless mill chutes and trestles up to twenty-five years after Sanger's demise. The basin's "speedy destruction" was an object lesson about the limits of human de-

signs. Nature was not as amenable to commodification as had been sur-
mised earlier, a powerful refutation of the nation's cultural belief in an ir-
resistible national destiny.[27]

Such moralized destruction never attracted as much photographic at-
tention, however, as had the posture of the men moments before creating
such tragic scenes. The sequoias' defeat and domestication as lumber were
too enthralling for a nation captivated by its own powerful promise. Their
true death was too damning for close photo documentation. Although the
logging photographs asserted the masculine might driving such destruc-
tive ambition, the trees' display as commodities thousands of miles away
at Chicago's 1893 World's Fair advertised the expansive empire's illim-
itable progress. Indeed, the venue presented an even more thorough ex-
ample of the big trees' value and significance as defeated giants for late-
nineteenth-century America.

6

NATIONAL COMMODITIES

Although the panoramic spectacle of the basin's financial ruin lay unphotographed, in August 1892 Charles C. Curtis, using 8″ × 10″ glass negatives and a monstrous 45-pound camera, fully documented one of its titans' demise and subsequent conversion into a trunk exhibit. The eighteen images—recording the choppers on scaffolding platforms, the giant's towering fall, the hollowing out and sectioning of the display segment, and the hauling of its carefully packaged parts out of the Sierras—verified the subduing of this "monarch of the hills" for those who visited the curiosity at the 1893 Chicago World's Columbian Exposition. Curtis underscored the analogy in one of his images, which depicted the lumberjacks posing with a slain American black bear and the tree's nearly cored-out section (Figure 35). Housed in the Government Building, the General Noble Tree trunk display (the tree was named after Interior Secretary John W. Noble) illustrated the legitimacy of the sequoias as a consumable and lucrative national resource. This characteristic was echoed more strongly by the presence of redwood displays elsewhere at the event, including a second towering redwood trunk exhibit in the Horticultural Building.[1]

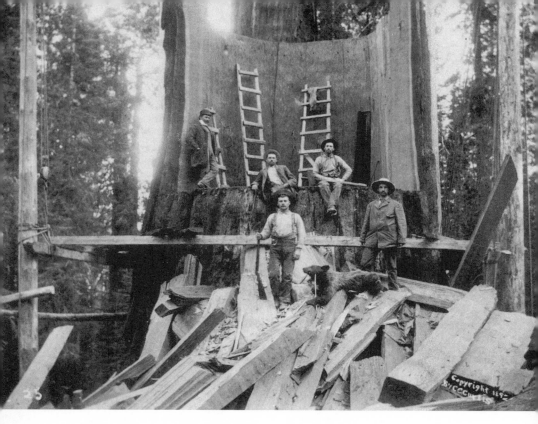

Figure 35. Charles C. Curtis, untitled photograph, 1892. Harold G. Schutt Collection, Special Collections Library, California State University, Fresno.

As much as the logging photographs trumpeted the chopper's pioneering front-line dominance of the big trees, the huge trunk displays publicized America's mastery of the gargantuan species, serving the world notice that the young nation had evolved into a deserving heir apparent to empire. Not only did the federal government and California exhibitors dramatically display the trees' defeat with the two trunk specimens but also their domestication as lumber and other commodities in numerous exhibits that impressed American and international visitors. Evidence of the imposing prospect and bountiful supply of America's resources, such redwood displays reinforced the fair's overall promotion of national progress and imperial development since Columbus's arrival.

All world's fairs illustrate nationalism. But the Columbian exposition in Chicago was an especially rich example, given the complex cultural significance of its consumer-oriented exhibits. The displays of redwood products, along with vibrant presentations of the nation's agricultural pleni-

tude and technological inventiveness, expressed the rapid emergence of a commercial culture whose values of abundance and desire would—by the early twentieth century—supersede older standards of scarcity and sacrifice. The commercial exhibits' presentation of the nation's natural wealth in regally imposing architectural structures linked the nation's imperial ambitions with its consumer appetites, initiating the period when America's hosting of the international extravaganzas "pivoted on dreams of empire." The profusion of goods—particularly California's lavish forestry and agricultural contributions—and the latest gadgetry thus predominated because they confirmed the equation of abundance with empire.[2]

Regarding the two as comfortably entwined, however, belies their inherent contradictions. Plenitude suggests desire and submission, whereas imperialism denotes power and control. Thus although the dominating tree-trunk sections reinforced the fair's imperial theme, copious displays of redwood handicrafts and woodwork endorsed consumerism, a primary example of the complex mediation and interweaving of clashing cultural values symptomatic of the entire fair. Indeed, the fair was a balancing act of competing cultural values: the majestic unity of the White City (the southern section of the fair whose pure white Beaux Arts exhibition buildings, surrounding a humanmade lagoon, expressed an idealized vision of American civilization) contrasted with the carnivalesque chaos of the midway (an avenue that included many ethnological exhibits and thrilling rides); the stately formality of neoclassical exteriors overlay exposed interior metal skeleton frameworks, whose floors were festooned with consumer products flogged by eager sales representatives; Ignace Jan Paderewski's stirring performances of Chopin in the Court of Honor clashed with Scott Joplin's ragtime out on the midway; and an electrically illuminated "ideal vision of the new urban West" competed with the rowdy popularity of Buffalo Bill's Wild West Show.[3]

Ultimately, the most compelling example emerged in the main entrance designs. Planners originally intended local railways to shuttle visitors into the grand White City, but because of a railway rate dispute, the deal fell through. As a consequence, more visitors than organizers had intended entered through the midway, where instead of first viewing the Administration Building's golden dome, whose "unity, grandeur, and order" signified cultural "authority and solidity," visitors saw "the enormous Ferris wheel—

the epitome of mechanized money-making entertainment." At a venue where Frederick Jackson Turner announced the closing of the frontier and worried about the meaning of the century's end, the fair's confusing dialectic of themes and symbols (order/chaos, unity/diversity, permanence/consumption) bespoke deep cultural insecurities about national progress. The contrast between the traditional trappings of highbrow culture (especially the staid Beaux Arts architecture) and frenzied lowbrow commercialism hedged that the latter could indeed sustain America's predicted rise.[4]

California organizers planned their state building and grounds to underscore the themes of material progress and abundance. Instead of making it a "semi-club house, with a view to receiving friends and guests rather than displaying products," as some other states did (to their ultimate regret), the commissioners displayed all of California's products in organized exhibits. In this way "visitors might there see California in miniature." The plan enabled commercial exhibitors "to represent different eras of the State's progress."[5]

Visitors who walked through the landscaped grounds, viewing the building's exterior and then entering its interior, were transported through a progressive survey of California's development as a commercial empire. Perhaps wanting to confound dominant geopolitical assumptions that contrasted northern or nordic energy with southern lassitude, state commissioners had their grounds carefully landscaped into a tropical paradise, full of transplanted native trees and shrubs. Orange, lemon, olive, and banana trees, along with sago palms and a 35-foot date palm, all blossomed and bore fruit, showcasing the state's natural abundance even amid an environment often regarded as primitive.

The state building's mission architecture likewise suggested an earlier stage of human development, one centered on piety rather than progress. With eight 80-foot bays, or towers, surrounding a large 113-foot central dome, the mission-style building contained a combination of distinctive features from three missions, Santa Barbara, San Luis Rey, and San Luis Obispo. As the second phase of the commissioners' presentation of the state's advancement, the state building's architecture functioned much like that of the White City's, given that it contrasted distinctively with the displays housed within its interior.

Only when visitors entered the building was the disparity revealed—a

vast array of natural plenitude advertising the state's commercial progress. Visitors encountered a "lavish profusion" of colorful displays stuffed into every inch of space, some of them whimsically formed into geometric shapes. Globes of oranges, heroic statues, olive oil towers, marmalade and raisin pyramids, prune sculptures, luxuriant flora—in pots both on the floor and hanging from the ceiling—"and above all the towering palm tree under the center of the dome, with fountains playing about its base," created "a bewildering display." Leaves, moss, and tree branches entwined pillars and railings, beams and trusses suspended baskets filled with flowers, palm leaves, eucalyptus in seed, and pampas plumes—some baskets hanging from roof-garden windows—and potted plants filled any remaining exhibition space. Some pillars were so extensively decorated that visitors commented on their resemblance to palms, bamboo, or pampas grass. Summer birds even found the decorations suitable for building nests.[6]

Even more impressive than the 35-foot tall date palm located on the grounds outside was the specimen visitors could not overlook inside the state building. The gigantic 50-foot date palm, weighing about 45,000 pounds, symbolized the theme of progress, because it grew from a seed planted by Father Junípero Serra about 1770, the beginning of California's progressive emergence from the mission era. The commissioners' intent "to give an impression wholly different from that . . .[of] any other State building" resulted in vigorous displays of fecundity that were not only the product of the state's natural abundance but equally or more so of human energy and organization and of the scientific management of California's potential. Thus California could be presented as both a tropical paradise and an untapped commercial opportunity.[7]

Reviewers admired the expansiveness and fertility of the California displays. A leading illustrated eastern journal enthusiastically commented that "the general impression of the visitor upon entering California's great building at the fair is one of tropical luxuriance and vastness," and the Chicago *Times* was entranced by the "air of prosperity and abundance about it all," one

> that is seen in no other State building. Great palms waved their green plumes against the roof beams, and the sweet perfume of flowers and fruits made the air heavy with fragrance. Wines and cake were served during the afternoon, and always, before and after everything else, fruit.

It was a "big building," exclaimed the Chicago *Herald*, "heaped with barrels of sparkling wine, tons of delicious fruit, grain, vegetables," a veritable cornucopia, suggested the *Survey Graphic*, signifying the state's "boundless resources, energy, and enterprise." Visitors, as many as 40,000 per day, were enthralled, the Oakland *Times* noting that "people appear to be in a state of excitement as they stand around and descant on the things displayed in the California Building."[8]

The aroma of citrus, the fecundity of the landscaping, and the prodigious bounty inside the pavilion all bolstered California's reputation as a place of illimitable progress. A Florida correspondent sank with embarrassment at how the California exhibit made his state look like a feeble competitor. He delighted in the "whole orange groves, and waving palms and other plants [that] greet the eyes of the lovers of tropical scenery." He also praised the state for its ability "to advertise," "while alas! Where, oh! where are we?" Some writers so associated California with advancement in commercial agriculture that they labeled its prominence at the fair the consequence of its "usual progressiveness."[9]

The promotion of California as productive and progressive, a land of plenty, was most dramatically conveyed on California Day, September 9. Although Illinois's building was initially the most popular state building by virtue of its size and its role as the host state, California became "the chief attraction" afterward. As part of the day's celebration, organizers planned an extravagant giveaway of all kinds of native fruits. It proved to be a smashing, if somewhat perilous, success, attracting the fair's third largest attendance.

"People of all nations, classes, and colors rushed" for the free fruit, carloads of which were "thrown out in the vast throng gathered in front of the building," wrote an amazed Salt Lake City *Tribune* reporter. Organizers required "a hundred Columbian guards to maintain order and keep a passage-way in the street," as thousands "carried away bunches of grapes, and pears, peaches, oranges, and plums to the extent of eight carloads." The chaos sometimes got out of hand. "The crowd in front of the building," a Greeley *Tribune* (Colorado) correspondent reported,

> was so dense that three women fainted in the first half-hour. People, after an hour or so, became so tightly wedged together it was found impossible to pass out the fruit in original packages, and it was finally tossed out in regular

baseball fashion into the uplifted hands of thousands. It was estimated that fully 50,000 people either got some fruit or watched others get it.

Because of such attendance and fanfare, Thomas H. Brown, executive commissioner for South Dakota's World's Fair Commission, claimed that afterward "the Exposition was spoken of as the World's Fair and the California Exhibit."[10]

Although the fruit displays sealed the state exhibition's reputation as "a palace of plenty," those involving Coast redwood specimens reinforced this characterization, adding strength and might to the plenitude. County vendors relied heavily on redwood to build displays, creating a regal and sumptuous atmosphere evocative of a rising empire. Santa Clara's broad redwood counters enclosed an 80′ × 20′ space, all its entrances "spanned by redwood arches, with step-like tops," which held grain exhibits. The Agricultural Department displayed its products in cases, one made of polished Coast redwood. On three sides of the Viticultural Department's pyramid-shaped display of 600 bottles of wine, champagne, and brandy "were high partition-walls of open grillwork, built in California of native redwood, and lined with bottled wines." Its sister display in the Horticultural Building included "a very handsome redwood installation" of counters, panels, and grill-work that likewise highlighted wine. The interior walls of the California Room in the Women's Building "were wholly wainscoted with redwood, both the straight and curly grains and the burl of the wood being employed, and all so highly polished as to reflect like mirrors." San Francisco County framed its relief map of the city with "heavy redwood boards bolted to cylinder ribs or beams" and 6-foot "carved and fire-etched" redwood panels that "formed a continuous screen enclosing the space" resembling alcoves, all fronted by a redwood arch proclaiming "Art, Literature, Music, Industry." Even Ventura, outside Los Angeles and thus the area least associated with the big trees, used 7,056 pieces of redwood and 1,236 pieces of glass for its Bean Pagoda, an imperial 23 1/2-foot-high octagon house whose elaborate decorative display of nearly 2,000 pounds and 83 varieties of beans declared its status as the state's bean-producing king.[11]

Counties that were more dependent on Coast and Sierra redwood industry created exhibits dominated by either strain. Humboldt County trumpeted its "wildwood" industry by surrounding planks, logs, branches,

brush, and lumber camp photographs within "an elaborate inclosure [sic] of polished redwood . . . built of fancy shingled panels up to a height of 4 feet" (Figure 36).[12] Columns upheld "an oddly ornate entablature of redwood, with the words 'Humboldt County Exhibit' appearing in fret-work and extending entirely across each end." A sampling of redwood panels "girthed" the base of an 8′ × 12′ log wedge, on which rested a row of county forest and lumber camp photographs, while three large red-wood vases, filled with bouquets of grains and grasses, ornamented a nearby mineral water display. Along with displays of other woods, Hum-boldt's contained a hollowed-out redwood tree section 16 feet in diame-ter and a "splendid" board of redwood burl 8′ × 4′.[13]

Fresno County (Figure 37), in the southern Sierras, highlighted its ex-ploitation of the wood with display cases of *Sequoia gigantea* that sur-rounded a thatched building, "a circular installation structure, like an airy summer-house, a dozen feet in diameter," made from Sierra redwood. Amid these structures that held jars of preserved fruits and "boxes of Fresno figs, raisins, and other dried fruits of many species and varieties. . . . rose tall sequoia urns, crowned with heavy heads of durra and a lavish wealth of mounting pampas plumes," a sumptuous expression of natural abundance. "A statuette of Mercury, carved by a young Italian, from a piece of the sequoia tree known as 'General Noble'" finalized the county's exhibit, a hint of the tree's connections to imperial Rome. Indeed, the se-quoias were famous for their antiquity, their rings often counted to prove their existence preceded Rome's. Thus the statuette's apt embodiment of a Roman deity was not only an elegant reminder that the wood from which it was carved stood long before these pagan gods were worshipped but also a faint suggestion of the United States as the new Rome.[14]

San Mateo (Figure 38), just south of San Francisco, expressed such tan-talizing aspirations with the creation of a 20-foot-high pillared redwood temple, both a shrine to the wood's beautiful utility and a romantic as-sertion of *Sequoias* as the symbolic foundation of the young empire's emergence. "Fourteen grand [12-foot] columns of solid redwood, kiln-dried and turned smooth, upheld the circular entablature," supported by 4-foot smoothed and polished pedestals formed of curly redwood. At the temple's center stood another foundation, a large redwood tree cross-section that formed "a [low] base for a small greenery" stuffed with pot-

Figure 36. Photographer unknown, *Humboldt County Exhibit, Interior View—California Building*. From *Final Report of the California World's Fair Commission* (1894).

ted plants. "Projecting brackets about four feet above the floor upheld a wide circular shelf of redwood," on which paintings, stuffed birds, wildflowers, and other native specimens were placed. The original design had called for a rounded roof or dome covering made from redwood bark, but "it proved so objectionable on account of its height . . . that at the request of the Commission, the managers of the exhibit permitted its removal." The shrine's final design and decoration promoted the redwoods' admirable conversion, whose presentation as supports for other products' displays amply facilitated boastful assertions of the nation's abundant native resources.[15]

Departmental displays in other buildings outside California's fairgrounds also created an atmosphere of industrial prosperity. They showcased the trees' commodification into all kinds of products, including furniture, decorations, wood paneling, and, of course, board feet of lumber. Viewing California's display in the Women's Building, for example, an observer concluded that the "combined effect of massiveness and richness . . . demonstrat[ed] to a striking degree the possibilities of redwood in household decorations." The journalist especially praised the curly

Figure 37. Photographer unknown, *Fresno County Exhibit—Thatched Pavilion, Made of "Sequoia," or "Big Tree," in Center—California Building*. From *Final Report of the California World's Fair Commission* (1894).

redwood. A byproduct "so hard that [it] can scarcely be chopped, and so heavy that [it] will sink like stone," the variant had formerly been regarded as unusable and undesirable. However, the centerpiece of the artistic display was a redwood piano whose sounding-board, although previously thought unresponsive if made from the state's famous trees, impressed listeners and viewers alike. The exhibitor had polished the piano to showcase "the artistic effects possible in curly redwood, polished merely enough to bring out the natural grain," an effective advertisement of the wood's potential, in all of its forms, even including the difficult curly version. Another display echoed the curly variant's aesthetic utility and linked it with the dignified beauty of craft work. On an "elaborately carved mantel of curly redwood" and flanking an oval mirror rested two sets of nine carved medallions made from wood indigenous to Alameda County. Similar crafts filled the exhibit, including a collection of 128 specimens of native wood on which native flowers were painted. Most of these specimens were of Coast redwood, some of them redwood burl, "well selected and highly polished, a few of them being so beautiful in themselves that they were exhibited as natural landscapes."[16]

Figure 38. Photographer unknown, *San Mateo County Exhibit—California Building.*
From *Final Report of the California World's Fair Commission* (1894).

Figure 39. Photographer unknown, *In State Wood and Forestry Exhibit. Novel Wood Growths in Foreground—California Building*. From *Final Report of the California World's Fair Commission* (1894).

The State Wood and Forestry exhibit (Figure 39) advanced the trees' utility more systematically. It contained all kinds of native wood specimens—including foliage, cones, and barks, plus photographs of the lumber industry. The stated goal was "to illustrate the great variety of California woods and their adaptability to building purposes, as well as their wonderful beauty when used in the manufacture of furniture and other decorative woodwork." While attempting to advertise all its wood products, two of the three most popular displays, according to California's organizers, were those involving Coast and Sierra redwood. Visitors were intrigued by large Coast redwood burls, as well as big tree bark samples 2 1/2 feet in diameter and "surprised" by the curly redwood specimens, especially "the use to which slabs of [them] . . . could be put in making fancy furniture and veneers."[17]

Thomas Hatch, the collector of the state's forestry exhibits, reported that eastern manufacturers of artistic furniture and skilled veneerers were so impressed that "immediate orders were often given for different sorts,

especially for the redwood burl, the curly redwood, and the black walnut." Having worked fancy woods for thirty-three years, Hatch was amazed by the change in market prices for these special woods. "Before the collection of this exhibit had gotten well under way," he remarked, "choice burl was selling for about 10 cents a square foot of one inch in thickness." After the fair ended, demand soared, especially from "Eastern people." By the following year, San Francisco vendors began to run out of "choice specimens," causing the price of burl to rise "to nearly $1 a square foot" and the salvaging of other redwood byproducts. "Figured redwood from the body of the tree, that used to go to the fire," Hatch noted, "is now being carefully saved, and dealers are holding it at a high price." Based on Hatch's comments and market inquiries, state organizers rated the forestry exhibits a lucrative success. The commercial uses of California woods quickly increased, fueling economic growth, because "there was shown to be a wide market in the East and Europe for fancy wood. . . . thereby proving of direct benefit to all persons connected with lumber interests in the State."[18]

The state building's forestry exhibit had impressed many, but general audiences flocked to the Forestry Building exhibits in even larger numbers. Its architecture unquestionably asserted the arrival of a new empire blessed with unmatched natural wealth. Built entirely of wood and joined by wooden pegs, the unique structure embodied the nation's lumber resources. A thatched roof of tan and other barks topped a magisterial colonnade of ninety tritrunk columns, each of whose bark was retained and that flanked barkless slabs of wood forming the building's walls. The 270-trunk colonnade created vaulted interior halls whose exposed trunks resembled Greek columns complete with bark, fashioning a rustic cousin to White City architecture, whose structures also presented monumental pillared fronts. Its monumentality and imperial ambition thrilled viewers, especially the big tree and three Coast redwood trunks that served as columns to support the building's roof. Along with fifteen international exhibitors and other private displays, sixteen states from the United States—including California—installed exhibits inside the structure.

Those who viewed California's popular exhibit entered a room of more than 1,000 square feet with walls lined with different woods, polished and natural. Native pine cones, hanging much like icicles on a roof's edge,

lined its upper exterior. Visitors who thronged the venue were "often so numerous as to cause passers-by to ask if a convention was not being held within the inclosure [sic]." The Orange *Tribune* (Texas) claimed it was the "greatest exhibit" at the fair. The paper went on that "there is no time during the day when the space is not crowded with visitors, all of whom express in ohs and ahs their wonder and amazement or stand spellbound at the beauties so lavishly displayed." Both European and native visitors registered such wonderment by reportedly appreciating the "effects" of many of the wood grains, "the delicate silvery hue of the native ash, evok[ing] words of admiration from many sight-seers," whereas burls of the darker woods, especially redwood, pleased viewers with their "radiating lines flecked with cords of light." Others hurried to see "the delicate straight grains and rich, ruddy hue of the sequoia, or 'big tree,' . . . [that] were greatly admired." Seemingly no one expressed dismay about the tree's transformation from living specimens to board feet.[19]

Although commercial redwood displays were found in buildings throughout the fair, vendors installed two other sequoia exhibits, ones that showcased even more the big trees as evidence of the nation's cultural ascendance and resource-rich future. Standing alone in the rotunda of the Government Building, the General Noble Tree was an actual tree trunk section; the other, surrounded by numerous exhibits and products in the Horticultural Building, was a fake life-size trunk, specially "built up of thick redwood bark," giving it "all the appearance of a solid trunk." Its Beaux Arts architecture boldly dominating one of the fair's main entrances, the Government Building housed a surprising trunk exhibit, given the determination to choose displays that were "above criticism." Ignoring the embarrassing precedent set in 1876 when Martin Vivian displayed part of the Captain Jack in a pitched tent on Philadelphia's notorious Elm Avenue, exhibitors installed a 30-foot tree-trunk section under the building's 120-foot central dome (Figure 40). Sponsored by California's Tulare County and commissioned by the federal government, the trunk section housed two hollowed-out 14-foot rooms, one on top of the other. They were linked by an interior spiral staircase, and as viewers ascended it they viewed Curtis's photographs of the trunk's conversion into the exhibit on its inside walls.[20] Because of the photographic evidence and the expert care taken in patching the sections together, patrons did not ques-

tion the authenticity of the display, as they had with previous trunk exhibits. Nearing the end of the century, the sequoias and their multiple meanings as national monuments, tourist oddities, and national resources were accepted facts. Although three national parks had been established to protect them only three years before, the towering John W. Noble display unabashedly violated federal policies that had created the parks.[21]

Exactly why the federal government commissioned the exhibit is unclear, but it is evident that the big trees, whether intact or sectioned, still signified desirable national qualities. Trees that were hard to bring home were useful pedagogical instruments for a confident national government eager to show off its potential to the world. The Noble display's central placement strongly suggested such an attitude. Prominently situated in one of the most notable fair buildings, the trunk asserted the nation's arrival as a mighty power, one whose promise and latent riches were as massive as the tree's height and bulk. All the building's entrances led to the central rotunda, where visitors entered a "very beautiful" and lavish setting that enhanced the exhibit's majesty. Elaborate high arches, upheld by steel pillars, topped the eight entranceways, the pillars "colored to represent bases of chocolate marble streaked with white, from which r[o]se tall fluted shafts of malachite marble, capped with gilded capitals." The arch entrances were also "balustraded with ornamental iron-work," and the "pale blue" glass dome above the entire room contained side panels showing "beautiful figures representing the arts and sciences." Given the ornamental detailing and coloring, one guidebook described "the general tone of the interior of the dome [as] light brown, with a tracing of gold arabesques and other figures." Seen in such an imperial setting, the massive Noble tree was a testament to the congruity of American ambitions and the wherewithal to effect them.[22]

In its singular dominance and sheer majesty, the Noble display somberly presented one of the nation's prized resources. By contrast, in the Horticultural Building's southern pavilion stood a very different trunk exhibit, "a representation of the trunk of a mammoth redwood tree 40 feet high" (Figure 41). Located near California's many viticultural entries, the tree exhibit, a hollow structure overlaid with numerous redwood bark panels, stood at the edge of many other county wine exhibits, some of which showcased thousands of bottles on counters and in pyramid-shaped

Figure 40. Photographer unknown, *Section of Sequoia Gigantea or "Big Tree," 23 feet in diameter, from California—Government Building.* From *Final Report of the California World's Fair Commission* (1894).

displays. The redwood trunk, which neighbored the Vina pavilion whose sumptuous ornamental fountains—"one throwing jets of wine, the other brandy"—advertising Leland Stanford's Vina Vineyard, was the main feature of a private winery exhibit sponsored by three vineyards.[23]

With a "fine picture of the Golden Gate" in the background, the trunk was ornamented to assert the industry's imperious wealth and progress in

Figure 41. Photographer unknown, *California Section in Viticultural Department—Horticultural Building*. From *Final Report of the California World's Fair Commission* (1894).

the state. Heavy garlands of grapes made of staff and a deep blue banner bearing the words, "California Viticulture," draped the trunk's exterior, while between "its spreading roots" rested "bunches of grapes, vines, ferns, rocks, and grasses. . . . arranged in artistic fashion." Vases full of grapes stood on top of some of the rocks to accent the sumptuousness of the trunk's exterior. On top of all of its Bacchanalian splendor were three staff figures whose position on the trunk symbolized the state's viticultural progress: Near its base, a sitting figure of an Indian girl carrying a basket of grapes; above her a missionary holding a spade; and both of them topped by a 10-foot "queen of the vine," the last a dramatic illustration of the state's arrival at its latest and most superior phase.[24]

As with the General Noble Tree, the trunk's design encouraged interaction. "A large irregular opening, resembling a hole burned out by fire," served as the entrance to the trunk's interior, which formed "a natural grotto[,] 28 feet in diameter," and included a "winding" stairway. Inside, visitors viewed walls "covered with appropriate photographs and mottoes," no doubt winery images, and also wine bottles displayed in separate sections. After visitors ascended to the second story, the "unique

The Forestry Building.

Figure 42. Made entirely of trunk and wood samples from the nation's lumber holdings, including both redwood strains, the Forestry Building at the 1893 Chicago World's Fair confidently verified the nation's imperial arrival. "The Forestry Building." From *Rand McNally & Co.'s Handbook of the World's Columbian Exposition* (1893): 93.

structure" led to a gallery view of a "trio of California raisin exhibits from Fresno, Riverside, and San Diego counties." Because redwood was often the wine industry's wood of choice for tanks or barrels in which to age spirits, it made for a clever industry promotion.

Thus visitors to the fair were met with two views about the nation's ascendance with the two trunk exhibits. In the elaborate federal pavilion, the General Noble Tree symbolized the nation's peerless natural wonders and implied that the tree and its sponsor shared a similar august grandeur—neither one was a fraud. Yet on the other side of the lagoon, the mock redwood ironically dared to suggest something similar—that plenitude and consumerism also ensured a powerful American destiny. That the one emphasized this message via a sequoia trunk's authenticity and the other through its deceptive construction only revealed how compelling such beliefs were about America's future.[25]

After canvassing officials from other departments, the California's World's Fair commission concluded that it was "practically unanimous that no other single display possessed as many attractive and practical features combined, as did that from California." The splendor of its setting and its cornucopia of agricultural abundance advertised California's preeminence among the states, and its dazzling display of forest products trumped national and international competitors. Although some commentators found the state's promotion of plenitude redundant—Henry James contemptuously yawned that aside from "nature and climate, fruits

Ground Plan United States Government Building.

Figure 43. The Government Building's layout emphasized the symbolic significance of the big trees' promotion at the international event. All of the building's entrances led to its central rotunda, where the massive General Noble trunk exhibit proudly exemplified the nation's powerful natural inheritance. "Ground Plan United States Government Building," from *Rand McNally & Co.'s Handbook of the World's Columbian Exposition* (1893): 130.

and flowers . . . there is absolutely nothing else"—the majority of patrons regarded the exhibits with patriotic pride. One such visitor to the California exhibit, a New York teacher, exclaimed, "I feel still prouder of my country." Contributing to such nationalistic sentiments were both kinds of tree exhibits, the stately General Noble Tree in the federal pavilion and those elsewhere featuring products made from redwood that promoted their commercial value. But with the consumer ethic moving into high gear, the trees' future belonged to the latter.[26]

The sequoias were indeed no longer just intact national artifacts: They were consumable goods. With the California lumber industry logging the best big-tree stands in the Sierras, displays of lumber, redwood vases, paneling, and furniture at Chicago expressed the development of a national consumer culture by the end of the century. Rather than promote the trees' venerability—which characterized their Civil War–era celebrity—Americans found it more appealing to witness evidence of the trees' consumption, even though the fair's dialectical layout revealed complex reservations about the cultural transformation. Nothing in the Forestry Building's architecture, for example, could distract viewers from admiring its spectacle, unlike visitors a generation later to the Converse Basin who would regard the titans' rotting columns as disturbing evidence of an empire's desolation—or even a generation before, when Edward Vischer had expressed latent dismay over what such heightened faith in progress portended for the nation. Tantalized by pretensions to national greatness, Americans at the 1893 fair instead unproblematically figured the trees as the servants of progress—especially embodied in the Forestry Building—on whose brawny shoulders overzealous claims of the nation's imperial arrival could momentarily rest. Such a conceit fit the moment, because the trees' commodified remains at the fair framed and buttressed expansive American aspirations for empire that the nation regarded as synonymous with material and cultural progress.

7

WONDER TREES

Although displays of the redwoods' usage dominated their showing at the fair, another exhibit presented a competing version of the trees' standing as consumer products at the end of the nineteenth century. In the California state building's art gallery, Thomas Hill exhibited a big tree triptych portraying Mariposa Grove's most popular attractions as an alluring tourist site. Two sequoia portrait panels—*The Grizzly Giant*, with visitors observing the weathered giant, and *Big Tree, Wawona*, with tourists near the Wawona (tunnel) Tree—flanked a central landscape, *Wawona* (Figure 44).[1] Combining a long view of the tree grove's sublimely mountainous terrain with up-close portrayals of its most popular trees, Hill's triptych unapologetically advertised the big trees as sites for visual consumption—objects whose unique appearance transfixed tourists' attention. The trees were supposed to inspire silent and solitary meditation, thus most earlier painters (primarily Albert Bierstadt) tended to portray them either as single objects for viewers' contemplation or with one or two visitors present to stress their meditative effect. Such portrayals

expressed the painters' distaste for recording tourists' actual behavior, especially because most tourists came in groups, a reality that upset such idealized appreciation. But the trees had become a popular tourist stop, and Hill was the first significant painter to depict them within such a context.[2]

Indeed, by the 1890s Hill had become synonymous with Yosemite. He maintained a studio near Mariposa Grove, at Wawona, serving market demands for Yosemite scenery by producing hundreds of landscapes and tourist views.[3] *Wawona,* indigenous for "big tree," was also the name of a popular and distinguished hotel built in 1879, which had become a gateway for tourists visiting the Mariposa Grove and even Yosemite Valley, some 30 miles to the north. Hill's triptych resembled his earlier tourist views, including an 1886 composite of the hotel and two sequoias that vigorously celebrated tourism. In *Big Tree—Mariposa Station* (Figure 45), he assembled three vignettes of famous Yosemite Valley prospects and a long view of the Wawona Hotel and superimposed them over close-up portraits of both the Grizzly Giant's and Wawona (tunnel) Tree's boles. Underneath the hotel, a shield depicting hunting and fishing equipment and a mounted deer head emphatically underscored the lucrative explosion of sports activities that often accompanied a tree visit. The composition, reprinted in some Yosemite guidebooks, figured the trees' location and viewing as an impressive beginning point for other recreation— incomparable must-sees whose massive appearance undeniably enhanced the state's appeal to tourists.[4]

Hill even more explicitly commodified the sequoias as tourist objects in his other paintings. He made multiple copies of his 44" × 10" Grizzly Giant and Wawona (tunnel) Tree portrait panels during the early 1890s. The composition of these elaborate souvenirs—frontal views of either tree, with tourists at their base—more than likely inspired the tree portrait panels he eventually included in the fair triptych. More significant, however, was the medium Hill chose for these portraits. He painted his sequoia portraits on redwood panels, an equation of image with object. Certainly by the 1890s, as their treatment at the fair indicates, the big trees were valued as consumable natural resources—as board feet of lumber or furniture products. But, given their development as tourist destinations, Hill's choice also implicated their appearance as another type of commodity whose consumption relied on tourists' presence.[5]

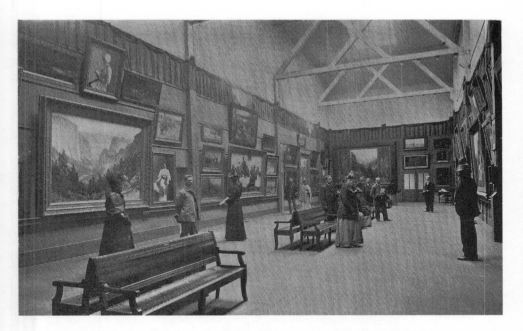

Figure 44. Hill triptych on far wall, left side. Photographer unknown, *In Art Gallery, Looking East—California Building.* From *Final Report of the California World's Fair Commission* (1894).

Despite Hill's reputation as a big-tree portraitist and Yosemite Valley landscape artist, his body of work pales in comparison to the sheer volume of photographs that were snapped in the late nineteenth and early twentieth centuries. By the 1870s, Carleton Watkins, Eadward Muybridge, J. J. Reilly, and Thomas Houseworth had photographed as many different sequoias as possible for a public feverishly interested in these national talismans. Although the intense competition inspired these early image-makers to inventory each grove thoroughly for armchair tourists, later photographers' work differed strikingly. By the end of the nineteenth century, as tourists began to photograph their own tree visits with easier to use cameras, publishers, publicists, and in-park photographers began to solicit and produce images that focused on the tourist's presence at two specific tree sites—tunnel trees and those later referred to as "auto logs." Rather than emphasizing a sequoia's overwhelming height—a compositional choice that, when it included sightseers, rendered them minuscule and insignificant—photographers and publishers instead repeatedly relied

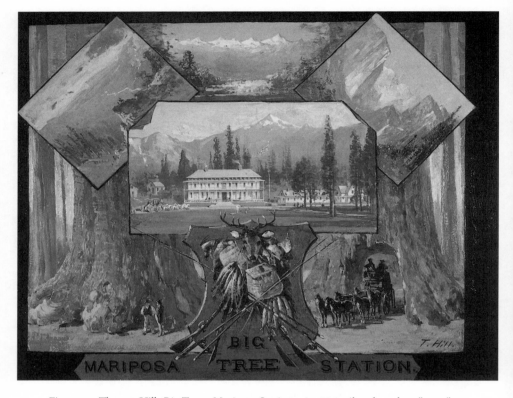

Figure 45. Thomas Hill, *Big Tree—Mariposa Station*, ca. 1886, oil on board, 22″ × 27″. Courtesy Dr. Oscar and Trudy Lemer, San Francisco.

on images of visitors in the midst of encountering the gimmicky tunnel and auto log trees to illustrate travel magazines, guidebooks, and a variety of promotional ephemera. These scenes clearly portrayed the groves as vacation stops filled with trees with which tourists could interact and play. Such tree types formed the next generation of famous big trees, whose visitation dominated the sequoias' early-twentieth-century visual culture.[6]

Tunnel trees possessed boles that had been laboriously excavated, allowing travelers entry. The most prominent one was the Wawona (tunnel) tree, so-named because its 28-foot base contained a 10′ × 10′ tunnel, carved out in 1881. The other type, often referred to as an auto log, included any fallen trunk whose planed surface allowed visitors to pose on

top of it, whether on foot, horseback, stagecoach, or automobile. Both of these tree curiosities became tourist icons because of their extreme alteration, not preservation. They were natural relics intentionally modified to enhance a tourist's tree experience.

As environmental historian Alfred Runte has discovered about late–nineteenth-century big-tree tourism, it was not enough that the trees were regarded as hoary antiquities or national totems. When the tree tourist industry formally started to develop in the 1870s and 1880s, converting the sequoias (and other sites at Yosemite) into quirky spectacles began to infect the park's development. Private businesses, especially those providing accommodations or transportation, created activities and features that flirted with converting nature into the carnivalesque, an aesthetic hazard against which landscape architect and original Yosemite commission member Frederick Law Olmsted had earlier warned. In his 1865 report of recommendations for Yosemite's management and development, he strongly stressed preservation of the park's natural scenery, conceding that some alterations—"within the narrowest limits"—were acceptable. Hoping to forestall distortions of the park's scenery and thus preserve its "dignity," Olmsted cautioned that "fixing the mind on mere matters of wonder or curiosity prevents the true and far more extraordinary character of the scenery from being appreciated." Because of ineffectual preservation policy and weak park management, however, he resigned his position in frustration in late 1865. He soon began designing New York City's Central Park, the landscaper's most famous project.[7]

But the fixation on the odd or curious, a governmental park service bias that Yosemite photographer Ansel Adams would come to criticize vehemently, nevertheless became unofficial policy at Yosemite and an approach practiced at other parks as well (such as Yellowstone). Not content to rely on the drawing power of the natural sights themselves, business entrepreneurs created spectacles out of existing sites with little resistance from national park management. In 1892 a California congressman proposed damming the creeks that fed Yosemite's waterfalls, so that during the heaviest part of the tourist season engineers could regulate its flow, enabling visitors to see more than just "a discolored streak on the dry face of the cliff." At Yellowstone, hotel proprietors aimed rooftop searchlights at the park's famous geysers, creating a dazzling exhibition of "colored

lights" dancing on powerful columns of water and steam that thrilled visitors. However, the most celebrated pageantry of all was Yosemite's fire fall. Its conception occurred at James McCauley's hotel, perched near Glacier Point in the early 1870s. The precipice's 3,200-foot drop encouraged visitors to hurl all kinds of objects, such as field glasses (early binoculars), over the edge and trace their descent. McCauley trumped them all by throwing a hen over, which, to visitors' relief, could be found "calmly picking her way home" on ground-floor trails. Such enthusiasm over the throws led to the fire fall. After waiting until the fire had burned down, McCauley pushed it over the cliff, creating an explosive cascade of falling embers specially created for the Fourth of July. By the turn of the century, David A. Curry, owner of Camp Curry (located below Glacier Point), engineered the show, making it into a yearly event that lasted until 1968.[8]

The creation of such spectacles accompanied the explosion of national park tourism and development in the early twentieth century. During this period, visitation increased remarkably, including parks with sequoias. The number of visitors increased twofold at Yosemite about every four years between 1906 and 1921, from 5,414 to 91,513. Sequoia National Park gained tourists steadily until 1919, when attendance doubled to 30,443. For the only figures available for Mariposa Grove, between 1912 and 1915, tourist figures skyrocketed more than 600 percent. Automobile usage, which was officially permitted in the parks in 1913, nurtured much of the increase. Three years later, more people arrived at Yosemite by private car than used the rail lines, whose usage declined an annual average of 29 percent over the next ten years as road building increased. By 1922, 65 percent of Yosemite tourists came by private car.[9]

Although such novelties like the fire fall performance benefited the park's development, some people found them objectionable and commercially exploitative. The *Saturday Evening Post* commented on their destructive effect on all tourists' behavior. The magazine criticized the park for nurturing a "back-alley attitude to [nature's] beauty" that only produced "vacation vandal[s]" unable to appreciate nature and whose presence only helped to damage park scenery. George Horace Latimer categorized the tourist types, distinguishing between the rare "stoppers" who stayed for longer periods to hike, fish, or camp, and the more prevalent "trippers" who only came to the parks to sightsee for a day. The lat-

ter displayed the worst of tourist behavior, driven by a voracious appetite for mere amusement. Latimer lashed out that "they gulp down their sunsets and bolt their scenery. They turn from the Grand Cañon to buy a picture postal of it[, and] they spurn the trail horse for the rubberneck wagon," which he later referred to as a "sightseeing chariot." He found especially appalling those who "turn their backs on the sunset glories of the mountains for the allurements of a curio store . . . [, and then] snap the Almighty with a two-by-four camera and pronounce the negatives good." As Latimer's derisive comments suggest, the parks prospered because of most tourists' desire to sightsee as quickly as possible. Of course, the automobile catered to this impulse, because it permitted tourists more independent access and fleeting viewpoints.[10]

Two of the park spectacles that encouraged such sightseeing practices were tunnel trees and auto logs. Some writers and guidebooks praised the stops, referring to them as "wonder trees." Although the Grizzly Giant still "chain[ed] the attention" of photographers and visitors, its photographic portrayal essentially remained the same: the oldest standing tree's full-length battered visage, alone and defiant. The view reinforced its traditional survivor symbolism. Such visual celebration may have continued to exalt the trees and overwhelm visitors, but it did not form as compelling a composition for magazine or brochure covers. Tunnel trees and auto logs instead provided the more satisfying imagery to encourage tourism. Professional photographers' use of them as theatrical tourist backdrops promoted the trees as entertaining natural phenomena, a spirited feature more attractive to the general tourist at this time than their static reputation as sacred national totems.[11]

Captured on souvenir postcards, photographs, and other promotional material, particularly the Southern Pacific Railroad's literature, such creations and their photographs confirmed the trees' conversion into tourist entertainment around the turn of the century. The depictions created an incredibly popular genre of tourist imagery that formed the aged giants' last significant iconographic transformation. Many of these images included transportation imagery, especially the automobile. As a vehicle that allowed for convenient and personalized traveling, the car widened tourists' travel choices and added an element of ownership to many of these tourist scenes. The contrast between the car as a technological

marvel with the weathered trees hinted at the nation's present superiority over their merely natural antiquity. Repeated references to the conversion of the trees into a roadway also hinted at their diminishment. These allusions both reassured tourists of the sequoias as pleasurable diversions and reinforced the trees' subsidiary status during the early beginnings of the modern machine age.[12] As historian David Nye has argued, "The construction of the tourist gaze . . . is embedded in technological structures," and the automobile was central to its construction, or reconstruction, in these photographs. The vehicle encouraged a gaze that asserted the tourist's agency because using a car made "mov[ing] into the landscape" more desirable. These promotional tree images thus collectively documented the eclipsing of nature by technology. Visitors driving to and through the trees became even more significant than the view of the trees themselves.[13]

Early-twentieth-century images thus evinced a less exalted view of the big trees, one less focused on their overwhelming physical superiority or condemnatory antiquity than on Americans' confidence in their presence. Tourists avidly participated in the sequoias' reduction to the familiar and accessible by riding through the Wawona Tree's tunnel, standing and walking on auto logs, and posing for photographers. The promotional imagery, to which one editorialist derisively referred as "insidious . . . tripper propaganda," only reinforced this behavior, because it identified such defeated and altered trees as amusing must-sees.[14] Unlike what author Bret Harte had described as his character's embarrassment and feelings of inadequacy amid the imposing sentinels, these later visitors displayed a swagger, a boldness, and even relaxation amid the trees. Such a fixation on the trees as curios asserted their imaginative dethroning. Indeed, it refigured the weathered kings as mere wilderness attractions. The trees were transformed into true handmaidens serving tourists' visual pleasure and environmental entertainment as the twentieth century dawned. Their depiction as conquered and conciliatory tourist icons was final celebratory proof of the nation's supplanting of them.[15]

Based on its prevalence in tourist accounts and promotional imagery as "the chief wonder of them all," the Wawona Tree quickly became a popular tourist stop during the late nineteenth century. Its fame eventually attained its zenith in the early part of the twentieth century.[16]

CALIFORNIA'S FAMOUS BIG TREES.

In some twenty irregular groups, extending through a distance of about two hundred miles on the western slope of the Sierra Nevadas, from Calaveras through Tulare County, California, are found what are known as the famous "big trees" of California, one of which forms the subject of our illustration, and, wonderful to relate, although a passageway has been cut through it through which stages regularly pass, the tree still lives. This tree is in the Mariposa grove, and is 28 feet in diameter. A still larger tree in the same grove is known as the "grizzly giant." It is 34 feet in diameter. The highest of these trees is in the Calaveras grove, and it is 325 feet high.

This tree, the *Sequoia gigantea*, should not be con-

than a pity, but rather a matter calling for severe criticism, that the lumbermen should be permitted to destroy, as they are doing, with a few exceptions, these groves of *Sequoia gigantea*. These trees grow nowhere else in the world, and their beauty, grandeur, and marvelous age combine to make them objects of such surpassing interest that the folly and neglect of the government in permitting their present destruction, will pass the comprehension of succeeding generations. The Calaveras grove, north of Yosemite valley, is still untouched, and the Mariposa grove, thirty-five miles south of the valley, is safe, because included in the Yosemite grant, but the Fresno Flats grove, the next one in the belt, is a scene of destruction. It belongs to the California Lumber Company, of San

on this grove for a number of years, and has turned its attention almost entirely to the sequoias.

If the big tree lumber brought higher prices than any other sort, the zeal which is shown in the destruction of the groves could be understood. But it rates no higher in the market than the sugar pine, with which the mountain slopes are densely covered. The lumber companies could have made just as much money and been at no expense for blasting powder if they had let the big trees alone and turned to the sugar pines.

In the groves further south the same scene is repeated time after time. In that portion of the sequoia belt between the north and south boundaries of Tulare County alone there are at least ten mills, every one of

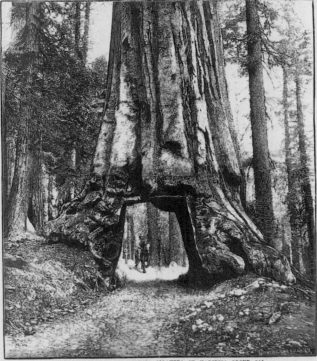

THE TREE "WAWONA" SEQUOIA GIGANTEA: IN MARIPOSA GROVE, CAL.

Figure 46. Following in the Grizzly Giant's footsteps, the Wawona Tree became the next famous big-tree celebrity near the end of the nineteenth century. More commercial artists, however, participated in its depiction. Artist unknown, *The Tree "Wawona" (Sequoia Gigantea) in Mariposa Grove, Cal.* From *Scientific American* 13 (February 1892): 103.

Although it would soon become the most popular and photographed tunnel tree of them all, it was not the first. That honor went to Tuolumne Grove's Dead Giant, a 90-foot stump whose 40-foot-wide bole contained a 12′ × 10.5′ tunnel that easily facilitated a stagecoach's passage. The original road to the tree, which passed a short distance from Dead Giant, had been diverted to connect to the excavated tree. The development made the older road "a relic of the past, untrodden and grass-grown," according to one tourist, "for no one will care to traverse it when there is the alternative of a free passage right through a 'big' tree." Located just north of Yosemite Valley, the Dead Giant immediately attracted visitors on the tunnel's creation in 1878. One of the earliest, a British tourist named Walter Gore Marshall, regarded it as "a novelty such as one does not come across every day," and enthusiastically described his experience of it as a newly developed big-tree tourist stop.

> We waited a considerable time within the tree. The tunnel had only been completed a week before our visit to the grove, the first coachful having passed through the stump on the afternoon of Tuesday, June 18th. We found the names of the parties who first performed this extraordinary feat pencilled up inside against the wood.[17]

Scottish travel writer Constance Frederica Gordon-Cummings was likewise so impressed by its appearance in the early 1880s that she sketched "a rapid drawing" while "the coachman very good-naturedly pulled up at the tree."[18] A curiosity intended both to amuse tourists and ease stagecoach travel through the grove, the Dead Giant was the first big tree site intentionally crafted for tourists.

If the Dead Giant proved a notable tourist stop, the Wawona (tunnel) Tree soon became a must-see. Three years after Dead Giant's tunneling, the Yosemite Stage and Turnpike Company commissioned the tunneling of Mariposa Grove's Wawona Tree as a contrived novelty for tourists traveling by carriage on the company's newly built road through the grove. According to Runte, the site's popularity then encouraged the 1895 tunneling of another sequoia, the California Tree, but the Wawona Tree still attracted the most acclaim.[19] Unlike with the Grizzly Giant, whose impersonal and solitary visage appealed to visitors' eyes, tunnel trees like the Wawona Tree granted a more personally moving appreciation of the trees'

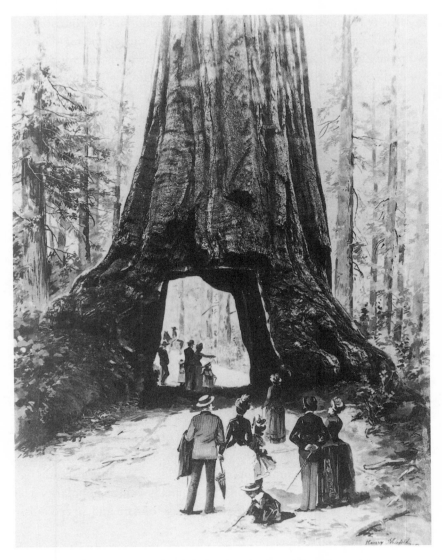

Figure 47. The Wawona Tree had become such a famous tourist icon by the late nineteenth century that even John Muir included a full-page photogravure of the gimmicky wonder tree in his large-format travel-book series, *Picturesque California* (1888, volume 2), between pages 56 and 57. From a drawing by Henry Ihlefeld, *Among the Big Trees of California (Trunk of "Wawona" Showing Opening Large Enough for Passage of Stage Coach.)*, 1887.

immensity because it allowed for tourists' interaction. One tourist could barely contain himself, thrilling that "when we reached the middle of it, we pulled up, of course, for there we were with coach and four horses standing *inside* one of the mammoth trees of California!" Sometimes the view inside inspired more contemplative reactions. As J. M. Hutchings, a Yosemite hotel proprietor, explained, the Wawona Tree is "one of the most attractive [big trees] in the grove. . . . [because] the enormous trunk through which the excavation is made is in solid heart-wood, where the concentric rings, indicating its annual growth, can be readily seen and counted . . . and thus satisfactorily settle that interesting fact beyond the least peradventure." Thus, tunnel trees dominated big-tree tourism, with the Wawona Tree the most famous of them all.[20]

By century's end, the Wawona Tree's celebrity equaled, if not outpaced, the Grizzly Giant's. Guidebooks and magazines often mentioned it along with Grizzly Giant as among the sites to see when visiting the groves, a tendency to pair the two similar to Hill's with his triptych and souvenir portraits. For example, while soberly exalting the Grizzly Giant in 1897 as "one of the largest trees in the world," *Harper's Weekly* included a description of the Wawona Tree, boastfully noting that through its base "four-horse stages are driven without difficulty." *Scientific American* included nearly a full-page woodcut of the massive tunnel tree in its 1892 report, a prominent placement not uncommon, because its image often illustrated other articles about the sequoias or ornamented book chapters, sometimes in addition to Grizzly Giant's. All of the images resembled one another in that they almost always depicted tourists riding or walking through the tunnel or standing in or just outside it. With its instantly recognizable appearance, the Wawona Tree quickly gained popularity as a tourist icon—a promotional device for big tree tourism and an arduously made stop for tourists' enjoyment.[21]

Prompted by the Wawona Tree's popularity, the Southern Pacific Railroad began to create all kinds of big-tree publications during the century's first decade, even though the company never established a direct rail link to the groves.[22] Such material, which portrayed the Wawona Tree as both a primary and accommodating tourist stop, included big-tree folders (booklets that folded in half long-wise), primers (tiny booklets with question-and-answer information on the trees), books, guidebooks, rail timeta-

bles, posters, large-size photographs, and calendars.[23] Profusely illustrated, these promotional materials contained historical and scientific information about the trees with only occasional anecdotal commentary. The books, comprising photographs, resembled photo-essays, because they contained page-sized images accompanied by one or two captions.

Although these promotional publications included photographs of many different trees, their layout resembled one another in a significant way. The Wawona Tree's image dominated the front cover art for nearly all of them, particularly the folders and photo-essay books. Each of the cover images essentially resembled one another in that they depicted stage riders entering or exiting the tree's "novel arch."[24] The big-tree folder covers usually showed both views, the front cover with passengers facing the camera person and the back cover image showing a different group riding away, a visual conceit acknowledging the beginning and ending of the publication, as well as the completion of an imagined tree grove visit. Its prominent placement and depiction in these texts, which invariably included unimpeded stages or automobiles, furthered the Wawona Tree's reputation as a gateway inviting tourism. Indeed, from its beginning as a tunnel tree, the Wawona Tree was crafted to induce and enhance a tree visit as a promotional device by the premier rail line to the big trees.

The company also used the Wawona Tree's image in its travel magazine, *Sunset*. Frequently photographed to illustrate feature articles on the sequoias, the Wawona Tree only graced the magazine's cover one time, in 1899 (Figure 48). Such a cover was highly intriguing for two reasons. First, it included a postcard-sized image, and second, the image recorded tourists' playful behavior in the trees' presence, an unusual scene given previous tree photographers' preference for more sober depictions. As souvenirs or keepsakes, postcards appealed to the general tourist and thus approached an expression of the public's regard for the sequoias.[25] Compared to the folder covers, the postcard-sized image—and *Sunset*'s prominent use of it—revealed even more deeply tourism's effect on the big trees' cultural meaning. Resembling many other tree postcards of the early twentieth century, the small promotional image portrayed the tree as a gargantuan curio, not an ancient old tree or national talisman.

Scrapbooklike, the cover image contains a small photograph of a female couple's tunnel tree visit overlaying a watercolor harbor scene. The

Figure 48. Artist unknown, *Sunset* cover. From *Sunset* 3 (October 1899).

driver of a two-horse carriage emerges from the tunnel, while two women playfully pose at the tunnel's edges, having climbed up onto the trunk's base. The composition spotlights these female tourists' assertive behavior: They have surrounded the tree—having gone through it, they now stand and lean on it. Figured as literally changed versions of Teresa, the Harte character, who ran and hid from the big trees' imposing gaze, these women now playfully challenge the sequoias. Such a representation presents the trees as prompts for tourist entertainment rather than contemplation—props for photographs or a carefree romp, rather than regally imposing and untouchable giants that command a visitor's abasement or spiritual edification.[26]

Sunset's cover image affirmed the big trees' and tourists' metamorphoses in each other's presence, but it was just an early example of the shift in the sequoias' portrayal. The sheer number of postcards of the big trees produced between 1900 and 1930 is impossible to gauge precisely, but a sampling reveals the same composition: unintimidated tourists riding carriages and cars through a massive tunneled-out trunk, almost always the Wawona Tree's, often standing boldly on the base of its trunk.[27] One typical (undated) example shows New York's Gov. Benjamin Barker Odell Jr. passing through the tunnel via a three-team carriage. Two men flank the tree's base, one of them with hands on hips, an expression of his proprietorship of the site as a tourist (Figure 49). In another scene (undated), the tunnel frames an approaching carriage, with two women and a man standing on Wawona Tree's base near the tunnel's edge (Figure 50). One of the women is smiling, and they resemble playful robbers awaiting abduction of the next stage, undistracted by the sequoias' massive presence. As souvenirs of a tourist's visit, such compositions stressed the tourist's dominating presence.

The focus on the tourists' confidence was highly ironic, because it worked to deny the tree's former characterization as a chief wonder—the very reason for tourism in the first place. Indeed, tourists largely ignored the tree in these postcard images, even though they stood in it or next to it. Unlike portrayals of the Grizzly Giant, where image-makers often depicted tourists examining the tree's immensity, nobody ever looked at this wonder, even to examine the innards of its tunneled section. Instead they always looked at the camera, or in its direction, creating a portfolio of

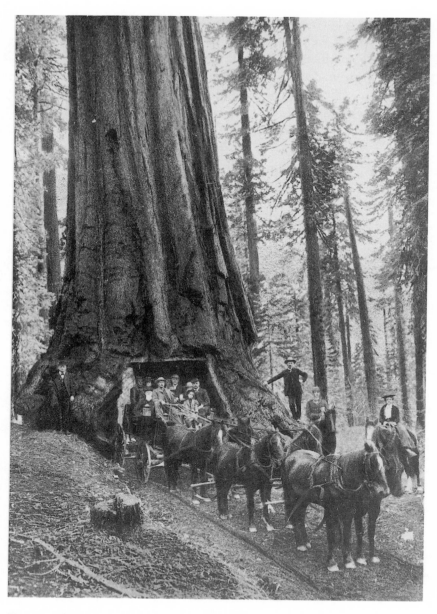

Figure 49. Photographer unknown, *Gov. Odell of New York and Party, Passing through Wawona, Mariposa Big Tree Grove, California*, n.d., postcard. Courtesy the Yosemite Museum, Yosemite National Park.

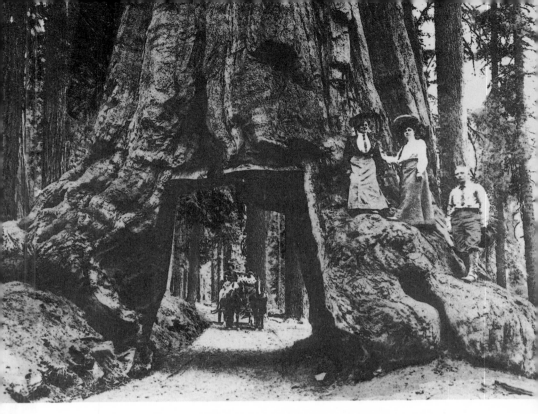

Figure 50. Photographer unknown, *Big Tree Wawona, Yosemite, Cal.*, n.d., postcard. Courtesy the Yosemite Museum, Yosemite National Park.

self-assured tourists with a curious tree as a backdrop.[28] A 1910s post-card (Figure 51) undeniably demonstrated the tourist's transformed posture. After passing through the Wawona Tree's tunnel, a woman confidently stood up in a car, a staunchly defiant posture assertively announcing the tourist's presence, one that daringly beckoned attention away from the tunneled giant. Such bravado—singularly expressed by a female and that never emerged for either sex in early big-tree photography—affirmed the invigorated superiority of the tourist.

Tunnel trees were not the only sites that indicated the tourist's and trees' metamorphosis. Auto logs attracted tourists for similar reasons. However, they formed an earlier example of a wonder tree, for practically all of them, such as the Fallen Monarch (a title attached to three fallen sequoias in three different groves), had enticed visitors and image-makers since the trees' Euroamerican discovery in the early 1850s. Resting lengthwise in the groves, these ancient relics provoked tourists' curiosity. Guidebooks explained how to interact with them, which included

mounting and then walking on the trunk, examining its exposed roots, and appreciating the elevated viewpoint. Hutchings advised that having such encounters enhanced a visitor's true comprehension, because otherwise "no one can approximately realize [their] immense proportions." Like the Wawona Tree, auto logs offered tourists an up-close experience with the massive trees, something that those still erect, such as the imposing Grizzly Giant, could never do.[29]

Gordon-Cummings also acknowledged that an auto log visit, although perhaps lowbrow, enhanced her appreciation of the trees. After being unimpressed with Grizzly Giant's Mariposa Grove, she visited Calaveras Grove. Somewhat sheepishly, she climbed one of the "tall ladders" that the grove owners had erected for tourists visiting the Father of the Forest, a massive, hollowed out, and nearly 400-foot-long prostrate sequoia. "It sounds Cockney," she grudgingly admitted, "but it is pleasant. It is not every one who could scale these red ramparts without the aid of a ladder." After "snugly ensconc[ing] [herself] among the roots of the poor old Father," however, her admiration for the trees notably increased. From "the [tree's] interlacing roots," she "let [her] eye travel along the vast stem" and gauged that "(were it but level) two carriages could run with ease" on its "broad roadway." Her experience left her convinced of the trees' royalty, particularly the Father of the Forest's, whom she afterward referred to as a "majestic tree."[30]

However, from the 1860s to 1880s photographers did not emphasize the visitor's playfulness or dominance in portraits of these proto-auto logs. Belying the experience hyped in guidebooks, their images, most of them stereographs, did not focus on tourists' mischievous curiosity amid the prone giants. Fascinated by the big trees' massive and ancient appearance, most stereographers tended to place the camera on the trunk itself, creating an angle that accentuated the fallen trunk's astonishing recession rather than one that revealed it as a tourist apparatus. Such a perspective, no doubt chosen because of the stereograph's ability to emphasize depth, produced remarkable depictions of long, flat, wooden walkways occupied by incidental visitors.

By the turn of the century, photographers began to depict fallen sequoias differently to accentuate their size and the tourists near them. Placing their camera below the trees, photographers captured visitors posing

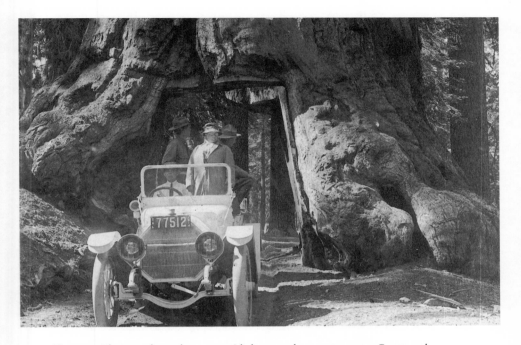

Figure 51. Photographer unknown, untitled postcard, ca. 1910–1917. Courtesy the Yosemite Museum, Yosemite National Park.

on the trunks, usually on horseback, on stagecoach, or, later, in an automobile. Such attention prompted the planing of many of these fallen trees' trunks (such as the Fallen Monarch and Father of the Forest) to ease a stagecoach's entry.[31] These images quickly became such a convention that park officials, such as Stephen Mather, first director of the National Park Service, ordered some fallen trees to be converted into photographic stops for tourists. In his 1917 annual report, he stated that "last winter a huge Sequoia tree, over 20 feet in diameter at its base, fell over during a fierce wind storm." Mather found its parallel placement near a park road fortunate, because it added another tourist diversion. He recommended that the trunk be planed to improve access, observing that now "automobiles [can] be taken upon its prostrate form with little difficulty. It has afforded much amusement for motorists during the summer. Automobiles can be operated over the tree for a distance of more than 200 feet, and 20 small cars can be driven upon the tree at the same time." Including a photograph

of tourists camping on its trunk in a pitched tent, their automobile perched nearby, Mather promoted the tree as an auto camp curiosity (Figure 52). Much like with the Wawona Tree, such fallen trees' photographic depiction as auto logs elaborated on the trees' subservience and thus American tourists' domination of their once-majestic antiquity.[32]

Auto logs showed up in a variety of promotional media, including travel magazines, tourist photography, and postcards. The most common auto log motif featured a U.S. cavalry troop (Figure 53).[33] Showing different troops on several fallen trees, the images' depiction of a line of tightly placed mounted soldiers asserted the disciplined power and might of humans over the trees while also faintly suggesting the government's commitment to their protection. One writer marveled at the troop's presence. Enthralled by the soldiers' efficient horsemanship, he gloated that the regiment's "patient effort and intelligent care" enabled the animals to "climb so high and quietly stand" on the trunk, while regarding the tree's huge size as only ancillary to such human achievement.[34] Although grand records of a big tree's massive appearance, the cavalry images instead emphasized the trees' diminishment. Depicted as pinned down, such auto log images presented the trees as being literally under military control.

Auto log images that included tourists advanced similar themes of domination. Lacking the troop's numbers, they instead asserted the tourist's lack of intimidation. Whether showing tourists standing or leaning on the big trees, these images personalized a tourist's visit, reducing the majesty of these monarchs of the forest and refiguring them as quirky tourist objects with idiosyncrasies of size and shape.

A photograph of Mather's auto log combines all the poses typical of the genre (Figure 54). Three groups of visitors surround a fallen tree: two families with two cars parked on one end of the massive trunk, some of them standing up in the car, others comfortably leaning against it; five more men at its opposite end, one of them insouciantly standing with his hands on his hips; and three men on horseback lounging below in front, all of them maintaining relaxed and confident stances. One man stands with his arms crossed, his body language expressing proprietorship. Although the tree is the impetus for the photograph, the visitors' postures overwhelm its significance.[35]

Such popular compositions as those of auto logs or tunnel trees repre-

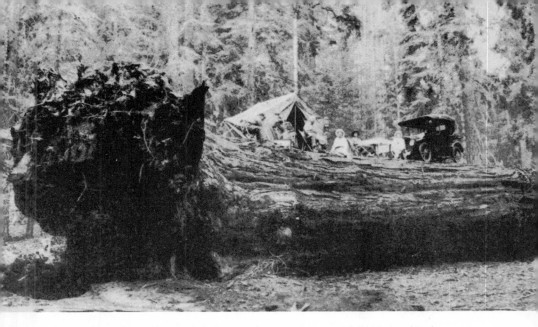

Figure 52. Lindley Eddy, untitled photograph, 1917. Courtesy of the National Park Service, Sequoia and Kings Canyon National Parks.

sented the sequoias in the early twentieth century as subservient to the tourists' presence, an iconographic transformation made more significant in that they presented only two big-tree types. Standing trees more accurately typified each grove's appearance, and although these towering examples continued to overwhelm, humble, and intimidate visitors, wonder-tree photography suggested a strikingly different experience. The promotion of deformed and defeated trees revealed a complex dynamic motivating tourist interactions with nature that typically operated in tourist accounts of the period. Historian John A. Jakle has argued that tourists reacted to the overwhelming incomprehensibility of natural forms by habitually reducing them to the familiar. Auto logs and tunnel trees became the latest expression of big-tree covert culture, and it was no surprise that tourists sought them out instead of the other tree types while visiting the groves. One imaginative account of a tourist's fallen-tree visit provides a narrative example of how this dynamic operated. A young woman delivered a melodramatic soliloquy about marriage while standing on Calaveras's Fallen Monarch. She fancied the groves as the original Garden of Eden, the site of Eve's unfortunate fall. After she lamented Eve's "Sequoialess existence," a dozen strangers began applauding the speaker's performance, a startling recognition that caused her to run along the trunk "like a squirrel, until it was low enough for her to jump down." A moment

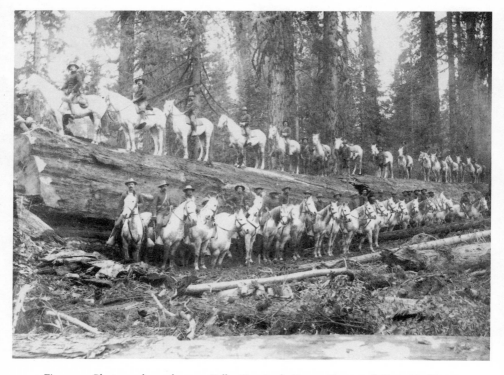

Figure 53. Photographer unknown, *Fallen Tree in the Fresno Grove*, n.d. From *Big Trees of California* (1904), unpaginated. Courtesy the California State Railroad Museum.

of childlike amusement, her behavior overlooked the trees' ageless significance and massive size. She reduced the fallen tree into a stage merely for tourists' amusement rather than what it actually was—an object with disarmingly unique botanical characteristics.[36]

Another example of imaginative reduction operated in some visitors' reactions to a big tree's name. A group of Philadelphia journalists exhibited camaraderie around a Coast redwood named Pennsylvania. The familiar name momentarily transformed the giant from an intimidating foreign entity into an invigorating assertion of their home state worthy of many "hearty cheers." Other "jolly scribe[s]" participated in the game, vainly scanning the same Santa Cruz grove for trees named after their native states. A writer observed that an Illinois native, "disgusted at his ill-luck," had to name one instead, thus recalling some of Isaac Bromley's

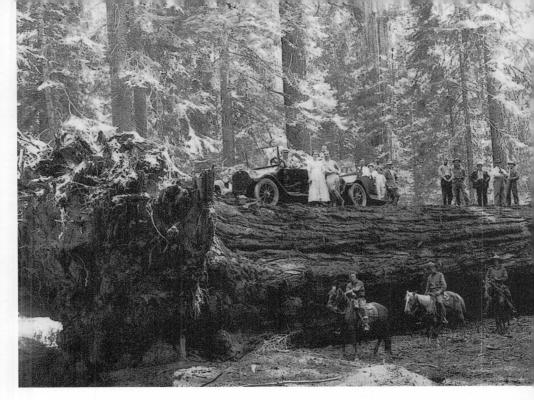

Figure 54. Lindley Eddy, *The Auto Log, Giant Forest*, ca. 1917. Courtesy of the National Park Service, Sequoia and Kings Canyon National Parks.

1872 experiences with tree-naming rituals. "He took his visiting card and pinned it to a baby sequoia sempervirens, then poetised in the following strain: You derned little runt, hold up your snoot;/Don't be so shy and cry;/I want you to root, and root, and root,/For the State of Illinois./Get a move on quick, them climb and climb;/Don't be a minute late,/Or you will have one deuce of a time/In catching the Keystone State." The baby sequoia's tongue-in-cheek christening was a humble expression of interstate competition. But it also indicated visitors' covert need to acquaint themselves playfully with the trees and assert their dominion over them— even their growth—thus overriding the solemn meditative behavior associated with previous big tree imagery and discourse.[37]

Wonder-tree photography revealed similar reductive impulses. As contrived attractions, wonder trees catered to tourists' desire for amusement and pleasure, an attitude the imagery captured and promoted. These humanizing attempts were so prevalent, however, that some photographers reacted to it in their work, especially Julius Boysen—an in-park photographer who maintained a studio in Mariposa Grove. In *The Tunnel Tree,*

Mariposa Grove (1902, Figure 55), four men in a two-team carriage posed inside the Wawona Tree. Regardless of the tree's figuration as a tourist stop, no stragglers playfully posed at the tunnel's periphery. However, the hoary giant's tunnel framed and surrounded its visitors—it contained them, an uncustomary tourist position, because most photographs either depicted tourists before entering or after emerging from the tunnel. Boysen emphasized the tourist's vulnerability, or at the very least, the tree's dignity in the image, especially because one of the passengers was Galen Clark, Mariposa Grove's guardian for half a century. Now only a reminder of the days when the big trees' cultural meaning was more exalted and precious, Clark rode through the intentionally vandalized tree, one sanctioned by the park's planners, his participation an ironic concession on the extent of the trees' dethronement. A more dignified version of the contrived attraction, Boysen's portrait grudgingly admitted the sequoias' diminishment, even as it asserted their massive dominance—a yin-and-yang commentary about trees capable of overshadowing tourists even as they themselves had been remodeled into gargantuan tourist curiosities by the early twentieth century.

One other of Boysen's wonder-tree compositions juggled similar contradictions. In *The Fallen Monarch, Mariposa Grove of Big Trees* (ca. 1903, Figure 56), he framed the auto log's exposed roots just off center, with a three-team carriage of tourists extending the length of the trunk. The framing allowed for an interesting juxtaposition of the exposed roots and the tourists—a compelling foregrounding of the tree's ancient yet vulnerable qualities that easily outsized the tour group receding to the left. The composition's right-to-left recession, which leads the eye from the massive tangled ganglion of roots back to the tourists, made the latter's presence seem irrelevant or inappropriate in the face of the dramatic antiquity of the remains. The composition allowed Boysen again to assert the irredeemable disparity between the sublimity of the trees and their absurdity as contrived tourist attractions.

Boysen's work notwithstanding, most wonder-tree iconography unreservedly asserted tourists' dominance and the trees' submission. Yet one other category of such imagery requires close analysis, because it provides more of a cultural context for the bravado and ease displayed by tourists. Such a group of images and discourse focused on confident comparisons

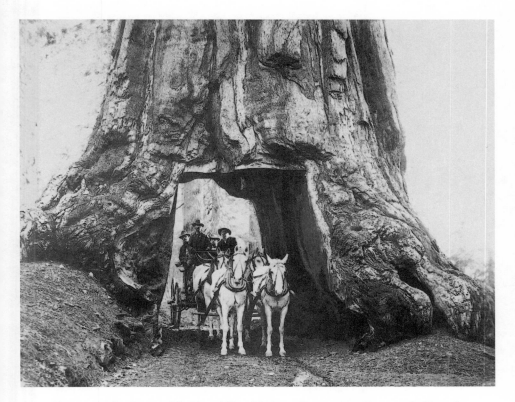

Figure 55. Julius Boysen, *The Tunnel Tree, Mariposa Grove*, 1902. Courtesy the Yosemite Museum, Yosemite National Park.

between the sequoias and modern technology, depictions that ultimately invoked the nation's dominance. Comparing them with familiar yet astounding technological wonders, two Southern Pacific advertisements presented the two big-tree types in ways that examined the trees' potency. A 1904 full-page, back-cover ad encouraging travel to California proudly identified the state as "the home of the Big Tree," with the Wawona Tree's figure placed "at the junction of [New York City's] Fifth Avenue and Broadway" (Figure 57). The placement posited the tree as the champion landmark of the West, its height easily besting the East Coast's tallest and most heralded urban monolith, the recently constructed Flatiron building. Although conceding natural antiquity's superiority to the modern and artificial, the comparison also suggested the old tree as no threat or

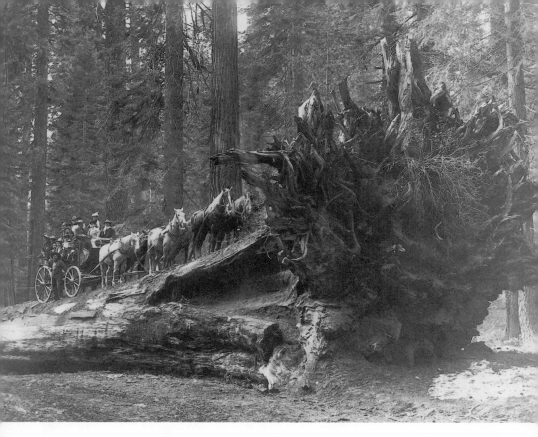

Figure 56. Julius Boysen, *The Fallen Monarch, Mariposa Grove of Big Trees*, ca. 1903.
Courtesy the Yosemite Museum, Yosemite National Park.

impediment to progress. Although the tree "would fill Broadway," the
thoroughfare's streetcars easily passed through its trademark tunnel, an
accommodation to modernity that belied the ad's promotion of nature's
supremacy.[38]

Another Southern Pacific wonder-tree promotion evinced the same con-
tradiction. A 1909 illustration paired one of the company's trains with an
auto log (Figure 58). The train heralded "the beginning of the new cen-
tury," the tree denoted "the end of the fiftieth." (Fifty centuries equals
5,000 years, thus indicating the trees' megalithic age and antiquity as their
primary highlight.) Despite the fact that the fallen sequoia easily loomed
over the train, the train embodied speed and dynamism, to which the
fallen tree was no competitor—it was uprooted, prostrate, and static, a
representation of the "old" giving way to the "new." Created by South-
ern Pacific, the ads depicted the nation's unhindered advance, regardless
of the trees' or nature's overwhelming presence. In fact, national succes-

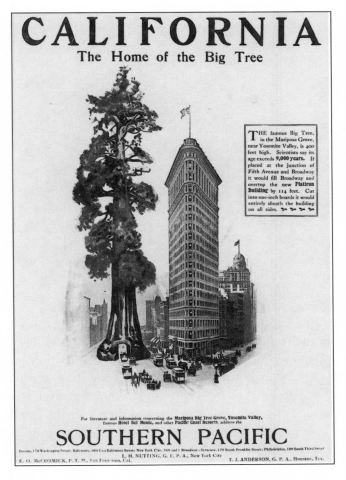

Figure 57. Artist unknown, "California: Home of the Big Tree." From *Country Life in America* 6 (January 1904): back cover.

sion only had meaning because of their aged presence. The big trees' circumvention or outpacing by American ingenuity signified such progress, an acknowledgment of national superiority that undergirded the images of confident tourists amid defeated trees so characteristic of this period.[39]

A final expression of the big trees' reduction also involved transportation. This was not so surprising, because cars, trains, and other forms of transportation were both central to the trees' emergence as a popular

Figure 58. Artist unknown, "The Old and the New—The Beginning of the New Century and the End of the Fiftieth." From *Big Trees of California* (1909), 3–4. Courtesy the California State Railroad Museum.

tourist site and their transformation into vanquished giants. The Wawona Tree was Southern Pacific's ideal cover image for big-tree tourism, but the auto log was usually positioned as its ideal pinup in these promotional publications. Depicted as trees that did not impede travel, whether by stage, streetcar, or automobile, the Wawona Tree and auto log illustrated articles about roads and conveyances, movement and progress. If the Wawona Tree was a "gateway" that invited tourism because it did not impede a tourist's visit, or even New York traffic (as with the ad featuring the Flatiron Building and a big tree), auto logs served as a bridge that accommodated such travel and visitation even more. One company publication explicitly linked the two by following a two-page spread of the Fallen Giant—the prostrate trunk topped by a stage, under which the caption stated, "They have made a new stage road"—with a photograph of "Wawona's Living Gateway." Showing one wonder tree seamlessly leading to the other, the layout figured the big trees as well-traveled roadways.[40]

The automobile became popular for tourists at the beginning of the twentieth century, and references to roads were especially thick in the auto

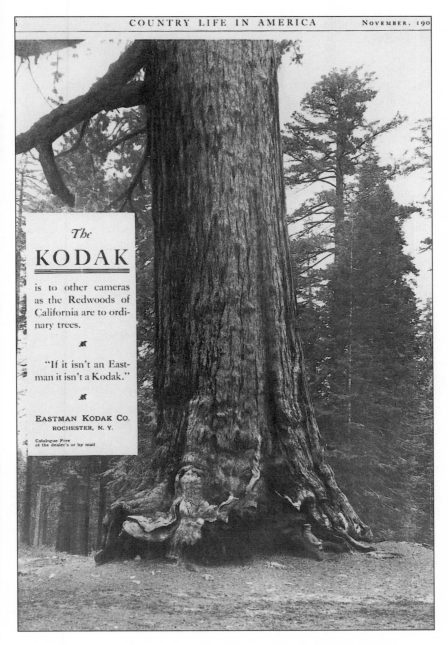

The

KODAK

is to other cameras
as the Redwoods of
California are to ordi-
nary trees.

"If it isn't an East-
man it isn't a Kodak."

EASTMAN KODAK CO.
ROCHESTER, N. Y.

Catalogue Free
at the dealer's or by mail

Figure 59. By the turn of the century, the big trees were familiar enough icons that
advertisers used tourist scenes to promote the sale of all kinds of products, such as
toothpaste or photographic film. H. C. Tibbitts, photographer. From *Country Life in
America* 1 (November 1901): vi. More recently, a 2002 California vineyard's television
commercial (for Frei Bros.™ Redwood Creek™) ends with an enlarged and close-up view
of one of its Chardonnay bottles next to a Coast redwood trunk, a wry commentary
linking the quality of aged spirits to its venerable container.

log's promotion. Southern Pacific's captioning of fallen-tree imagery in a 1909 folder, *Big Trees of California*, invoked such rhetoric directly. The caption below a photograph of an auto log's surface referred to its "broad back as a driveway for curious mortals."[41] In fact, the tree willingly conceded itself, having "lent" its bulk for such use. Pictures of auto logs, spread over two pages in many of these publications, consistently referred to fallen trees as "new stage roads." The discourse sometimes even accompanied images of the Grizzly Giant. A caption in a 1904 Southern Pacific publication capriciously evaluated the eponymous tree's inadequacies as a twentieth-century tourist stop. The writer speculated on the possibilities for its improvement or alteration, invoking both the Wawona Tree's and auto log's transformations as models for its rehabilitation. "If the stage coach could be raised to [its] first great limb," the writer imagined that "a new branch road on the 'Wawona' route might be opened, for the huge bough is broad enough to carry a Yosemite coach and its passengers."[42]

Based on such imagery and discourse, Americans had largely reduced the trees to entertaining tourist stops by the early twentieth century. An attempt to present amusing scenes of confident tourists—the kind that would encourage more visitation—their promotion also revealed a desire to express national confidence. Many of these images, especially those involving defiant tourists and comparisons of trees with recent humanmade wonders, triumphantly measured the nation's progress. Depicting their powerful size and intimidating age as no longer a true competitor to human achievement, these images collectively used defiant tourists, superior technology, and conciliatory big trees to celebrate the nation's supremacy. Unlike Grizzly Giant's celebrity, which soothed national anxieties, wonder-tree iconography pulsed with national confidence, whose expression could not be impeded by natural barriers, however grand. As defeated giants, the sequoias were at the beck and call of their visitors and thus presented no obstacle for their inimitable entry into the future. Such cultural bravado, however, did not last long. Americans would soon humbly look to the trees for inspiration, initiating an intense revival of the big trees' Civil War–era reception.

8

THE NATIONAL EQUIVALENT

In the final scene of director Raoul Walsh's *The Big Trail* (1930), the film's female lead, Ruth Cameron (played by Marguerite Churchill), newly arrived in California, enters the shadowy recesses of a big tree grove on the advice of a grizzled Oregon trail driver. Dwarfed by the tall trees, she soon notices her lover, Breck Coleman (John Wayne), walking toward her. Reunited in this hallowed spot, they embrace, and, as they walk off screen, the camera pans up, the frame never quite reaching the trees' tops, showing a transcendent ending to their Western migration experience.

Although a commercial failure at least in part because of the Depression, *The Big Trail* invoked all the mythology about nineteenth-century Western migration. From mud-caked Missouri to the fruitful Pacific coastal valleys, Walsh depicted the dangerous trip as one full of physical and mental obstacles—a pilgrimage of hardships vanquished and dreams recovered.[1]

A grand film unique in its time for its 70-mm format, the movie depicted Americans as survivors and toilsome pilgrimages as part of the

national tradition. These qualities were the settlers' heritage, established long ago, Wayne's character assured fellow emigrants fighting a driving Sierra snowstorm late in the film. The history of the nation was an unstoppable exercise in trailblazing, one that settlers "started in England" and "blazed . . . on through the wilderness of Kentucky." He exhorts his fellow travelers that "now we've picked up the trail again. And nothing can stop us—not even the snows of winter, not the peaks of the highest mountains. We're building a nation!" That this national exodus ended in a California big-tree grove instead of the Oregon coast—the trail's actual end—posited the trees in the 1930s as symbols of reunion and recovery as the darkest days of the Depression loomed ahead. Standing tall with shafts of heavenly rays of sunlight filtering through their branches, the sequoias in *The Big Trail* affirmed that hardships could be overcome.

By the time Walsh's film entered theaters, the trail of national destiny had come to a dead end, or at the very least had taken a disastrously wrong turn. In fact, the trail Americans picked up in the 1930s and followed into the 1940s was one of the most arduous in the nation's history. It involved rebuilding and recovering the nation's confidence and faith in its future, which the trees' early-twentieth-century promotional imagery had so effortlessly evoked. Americans in the 1930s and 1940s, however, responded to the big trees differently than they had only a few decades before, in terms shaped by these concerns. The public discourse about the trees and their photographic depiction toward the end of World War II by Ansel Adams, America's premier photographer of the natural scene, resurrected the trees' usefulness as icons that faithfully asserted national identity, resolve, and destiny. Less interested in the trees as subsidiary backdrops or props for tourists or loggers, Americans, especially photographers, instead spotlighted their nativeness and enduring character. They had served as a rhetorical site for ideas about nationhood and survival before and just after the Civil War, talismans of things American that now resurfaced near the mid–twentieth century. The regard for the big trees in these years expressed Americans' anxieties about the condition of their country and for what they yearned in the 1930s and 1940s—a singularly unified and confidently enduring nation.

Following a nationwide poll by the National Life Conservation Society in 1935, the big tree as a species was named the "national tree." The or-

ganization had surveyed women's clubs, patriotic organizations, churches, lodges, colleges, and public and private schools. Documenting the trees' wide-margin victory over the American elm, the vote endorsed the sequoia as a native son, an inspirational national symbol for the flagging nation. In late August, when the National Park Service officially announced the vote, many publications vigorously applauded the choice, emphasizing the trees' exclusivity and grandeur. "It grows nowhere else on earth and is therefore distinctively American," a writer for *Better Homes and Gardens* reported in December 1935, and a reporter for *Nature Magazine* noted the "memory of their majesty and immensity" as partly explaining the trees' allure as national emblems.[2]

Certifying the sequoia as the national tree, however, proved surprisingly difficult. So uncontroversial did it seem at first that Henry E. Stubbs, congressman of the Tenth California District, confidently took the House floor to propose passage of a bill affirming the tree's unique national status. Given that the bill, H.R. 10106, was endorsed by the Department of the Interior, the New York History Club, the National Society of the Daughters of 1812, the Sons and Daughters of the Pilgrims, and by countless prominent citizens, Stubbs expected no resistance. But to his chagrin, a congressman from a Great Lakes state objected. The sequoia was not "typical" enough, he said. Ironically recalling the posturing that infected the debates over the trees' scientific name during the 1850s, Rep. Jesse Paine Wolcott of Michigan turned the uniqueness argument against its proponents. He pointed out that "it is the most rare tree I know of in the United States," far less representative than "the oak, the pine, the maple, the spruce, the hemlock, the cactus, and the willow." These "are all more typical American trees than is the Sequoia." Although Wolcott agreed the big trees had dignity and joked that naming them as the national tree would not interfere with the president's financial program, he would not endorse the bill. In fact, he mocked the entire idea of a national tree, encouraging other congressmen to name trees typical of their own states. After Wolcott suggested that the "gentleman from Texas might suggest the cactus," Rep. Thomas Lindsay Blanton objected, saying "I would suggest the everlasting mesquite tree."[3] Rather than enhance the hype over the big trees, the debate only seemed to encourage the congressmen to assert the typicality of their own states' trees. Stubbs noted the same, later

admitting in a letter to Sequoia National Park superintendent Col. John Roberts White that "the boys wouldn't let me get by with it—they have trees of their own to look after, apparently."[4]

The trees may not have been typical enough for Congress to certify them as the national tree, but the National Park Service's celebration of them during the 1930s presented them otherwise, as living monuments—homegrown reminders typifying the sacred national past. Although legislators resisted singling them out as the most American of the nation's trees, by the twentieth century the sequoia had become such a national icon that its status as uniquely American, once a concern in the mid–nineteenth century, was no longer an issue. The attachment of nicknames to the trees, however, had become more official and formal, especially as Sequoia National Park developed into a popular tourist site. Whether officially sanctioned by the federal government or not, the trees were emblematic of the nation, a sentiment affirmed by these ceremonies.

Rather than the name-and-erase policy practiced tongue-in-cheek at Yosemite in the late nineteenth century, Colonel White either arranged or hosted many special tree-naming ceremonies to honor prominent Americans during the 1930s. Unfortunately, precious little information was recorded about these events. Based on what information is available (in particular, programs for the General Lee ceremony of 1937 and Susan B. Anthony's in 1938), they were elaborate affairs attended by National Park Service and government officials. They included an opening prayer, a flag advance, a tribute, the unveiling of a tablet or plaque, sometimes a play or pageant, and, always, the singing of "America, the Beautiful."[5]

As opposed to the competitive atmosphere pervading the novelty of nineteenth-century nicknaming practices, these serious attempts at memorialization bespoke a determination to assert the importance of remembering the American past and making permanent its legacy. As President Franklin D. Roosevelt affirmed of the Susan B. Anthony tree in 1938,

> in strength and stability the tree in Sequoia National Park is a symbolic tribute to all valiant souls whose effort, supplementing hers, at length gave to American women the right of equal suffrage with men in their conduct of Governmental affairs. Their labors deserve to be held in everlasting remembrance.[6]

Blessed with prayer and the national anthem, as well as veiled by the flag, the big trees signaled moments in American history. Much as citizens had of the late Charter Oak, Americans formally anthropomorphized the trees as ancient national forebears in the 1930s, the conditions of which symbolized the endurance of American ideals. Both the interest in certifying them as the national tree and the formality of the naming ceremonies were efforts at equating the nation with these native trees and their heralded qualities—permanence and stability—especially as the economic disaster of the Depression staggered the nation.

Indeed, despite the decade's economic uncertainty and the war's advent (or perhaps because of them), the discourse during these years focused on the unofficial national trees' durability and invincibility in unprecedented ways. Although many writers included the now-familiar rhetoric about the sequoias' age, the historic events of the past the trees had lived through, and their resultant grand immensity, they also began to emphasize pointedly the trees' indomitability. Writers became more fascinated with reporting whether big trees had fallen or making note of when one had fallen.[7] Instead of regaling them as curiosities or must-sees for tourists, the reports collectively focused on the trees' character, asserting that these were trees that would not or could not die or disappear. The concerns about the nation's endurance and willpower were being metaphorically addressed as writers reported on the health and strength of these powerful, American trees.

As Thomas West, a writer for *Nature Magazine*, put it in 1931, "they came, they sawed and sawed, but they did not conquer." So goes his report on a curious tree in Balch Park Grove, which was still "stand[ing] squarely on its own stump" forty years after a crew of woodsmen had chopped, wedged, and then finally exploded dynamite in the effort to take it down—all to no avail. The survival rhetoric is thick throughout the article, especially in the writer's use of the verb "refuse": "the tree refused to be conquered," it "refused to bow," and "it has refused to succumb to ax and saw." "Cut through but standing," as a caption to a U.S. Forest Service photograph states, the tree is finally and indisputably labeled, "the Big Tree that Wouldn't Fall."[8]

But big trees did fall in these years. Ironically, one named the Stable

Tree fell on August 28, 1934. The name originated from stagecoach days when the tree accommodated up to four horses. The cavity, measuring 15 feet in diameter, was more than likely caused by a great fire. The park naturalist for Yosemite National Park, C. A. Harwell, lamented the Stable Tree's passing, saying that it "seemed [to be] flourishing" before its fall. But the survival rhetoric he invoked in subsequent commentary seemed to deny the tree's passing, even as it lay on the ground. He asserted that "these *Sequoia gigantea* do not know how to die standing," predicting that the tree would live on—its durable character an inspiring lesson. Along with its great size and impressive bark, he stressed that the tree's "remarkable resistive and self-healing powers," the kind "that have made it able to live and grow in spite of tremendous injuries," would make a positive impression on visitors. The exemplary tree had many "powers of resistance," he admiringly concluded, including resisting decay.[9]

In late July 1944 writers were still reporting on fallen sequoias. The *Science News Letter* noted that the 250-foot-tall tree with an 8-foot trunk that fell in Whitaker's Forest in Tulare County was the fourth to fall in the area in the past thirty-four years. "At the present rate of fall, one tree every seven years," the report reassured readers that "it will be 1,750 years before the last one goes. By that time the present stand of seedlings will have grown up to replace them."[10] These reports reinforced the trees' reputation as undying natural phenomena, the kind that were not going to disappear even if some of them fell. Many big trees had fallen naturally in the past, but only during the 1930s and 1940s did their demise call forth national attention.

Celebrations of the trees' enduring qualities also included the Coast redwoods. *Nature Magazine* reported in April 1931 about the redwoods' restorative powers. A photograph illustrated one redwood tree growing on a fallen one, a vivid display of the species' regenerative abilities. Indeed, their scientific name indicates these properties—*Sequoia sempervirens* means "always living." As conservation groups' advocacy gained strength in this period, the public's interest in Coast redwoods began to grow, and more articles on their qualities both as living organisms and functional lumber began to increase. Articles that described Coast redwoods continuing to thrive even amid one's apparent death only enhanced the sequoias' reputation as "indestructible" national trees.[11]

Tantalized by their durability, a writer for *Harper's Magazine* in 1936 described a big tree's last stand in a dramatic account of a nineteenth-century attempt by settlers to take one down. With no more motivation than "just to see it fall!" the settlers destroyed the tree. This gratuitous assault, however, came only after the tree had survived other trials. "The violence it encounters is terrific," the article's writer, Morrow Mayo, asserted. The tree had withstood winter hurricanes, thunder and lightning storms, forest fires, and earthquakes. But even with these assaults, the trees remained. A big tree, "within itself, and of itself . . . appears to be almost immortal," Mayo stated admiringly, warning that "its existence ends only when it is killed by an outside agency, and by violence." For Mayo, this was a tree whose "organs never wear out." By dramatizing the violent realities faced by a big tree, Mayo highlighted their enduring qualities as an object lesson in survival—even though this particular big tree died a violent death.[12]

Indeed, Mayo was obsessed with the trees' immortality amid outside threats. His intense account of the tree's death reached high drama as the men began to chop and grind. Slowly but surely, tree trunk fragments "of brown and purple and pink chips" piled up around the men "until in places it was as high as the platform of the scaffolding." Eventually each man dug himself into a "vast opening" that formed "a tunnel taller than himself." After near physical exhaustion, the men's quarry finally relented, and "wine-colored juice from the tree poured out from its wounds and trickled about their feet." Its trunk bleeding to death, the tree finally fell. But in Mayo's account, "no one was near to see its death." It fell at night, when everyone was sound asleep, having been exhausted by all the tree chopping. Mayo offered all the grisly particulars of the final "tremendous shiver" that characterized its final yet private fall. He contended that, even murdered, the tree retained its dignity by dying without the presence of gawking spectators.[13]

Mayo's account of the falling of a big tree drew on the sequoias' mythic qualities. It was a tale of the wanton destruction of national resources, especially as the tree's destroyers were the first to view the prosperous and tranquil grove. Walsh's *The Big Trail* also recalled this moment of discovery, depicting the pioneers' arrival to the grove but eliding any view of subsequent abuse. In a nation recovering from the wasteful and damaging exploits of pioneer attitudes such as Mayo detailed, the kind perceived

theless slight movements occur, which have the effect that each exposure may be at a different (and unknown) tilt from the horizontal. This tilt is of very small amount—not more than a few degrees in extreme cases—but it is sufficient to distort the relation between ground surface and picture. In order to obtain usable survey data from the air pictures, then, it is necessary to determine the tilt with great accuracy, and make correction for it."

THE INDESTRUCTIBLE REDWOOD

AMONG THE OLDEST LIVING THINGS in the world to-day are the California redwood trees. Such is the generally accepted verdict of naturalists, we are told by P. M. Schmook, writing in *American Forests* (Washington); but the fact is by no means so well known, he declares, that the wood of fallen redwood trees may remain sound for hundreds of years. But how, it may be asked, can this be proved, since California has not been inhabited by record-keeping civilized man for more than three or four generations? The answer is found in observation of certain natural phenomena, which the writer thus describes:

"Recently there was discovered in the forests of Humboldt County, California, a fallen giant of some past age upon whose prone trunk there is growing a veritable small grove of living trees. The old redwood is 10 feet in diameter at the butt and 186 feet long from its upturned roots to the point where the top of the tree broke off when it crashed to the ground.

"Growing out of the dirt and debris collected on its top surface are eleven living trees—nine Western hemlocks and two Sitka spruces. The roots of these trees find their way to the ground on either side of the massive trunk of the redwood. The largest of the young trees is a Sitka spruce 61 inches in diameter and about 170 years old. A hemlock 25 inches in diameter was 180 years old.

A REDWOOD STILL SOUND AFTER THREE CENTURIES
The great tree, six and a half feet in diameter, was 400 years old when it fell, while the ages of the hemlocks growing over and around it are 340, 235 and 250 years, respectively.

This is done by examining two consecutive plates and comparing the apparent elevation of some object, say a hill, with the known elevation. Correction must thus be made for both longitudinal and transverse planes of the plate. The plate is then fixt at the angle of tilt determined (that at which it was when the negative was exposed), and re-photographed; the result of this ingenious procedure being that the new negative is just what the original one would have been had the camera been aimed in the exact perpendicular. Pairs of plates thus corrected are then placed on the stereoscope table for measurement of all desired elevations and drawing of contours. In practice, the original plates are exposed with the air-plane at the height of about 5,000 feet, and each plate (6¼ by 8¼ in size) covers a land area of about 480 acres (one mile by three-fourths of a mile). Contour mapping by this method is claimed to have the advantage of superior accuracy, speed, economy, and completeness of detail over ground surveying. Of a map made in the basin of Green River, North Carolina, it is said:

"The country is of bold relief and heavy forest cover, which would have greatly delayed ground surveys, but offered no obstacle in this process. With stereoscopic vision it was a simple matter to see between the trees and contour the ground. The flying was done late in 1923 and about 55 square miles were photographed. In all, about 40 square miles were represented on the finished contour map. Contour intervals of 25 and 50 feet were shown, to different elevations, as needed.

"In another job in an Eastern State an interesting check on the ground work was obtained. The control measurements were supplied by the engineers of the company purchasing the map. Reduction of the photographs indicated clearly an error in a linear ground measurement. The company was asked to check the distance measured and telegraphed a correction agreeing in amount with that already indicated by the stereoscopic work and plotting."

"Borings into the old redwood at different points showed its wood to be as sound and durable as the day it fell to earth, two hundred or more years ago. A ring-count gave its age as about six hundred years when the fall occurred.

NO SIGNS OF ROTTING HERE
One can notice in this photograph the soundness of the redwood log, which, after centuries, is still unaffected by time and weather.

Figure 60. Depression-era Americans were fascinated with the big trees' ability to endure all kinds of threats, an appreciation that also included the Coast redwoods. "The Indestructible Redwood," *Literary Digest* 85 (May 16, 1925): 24.

TWO GENERATIONS OF REDWOODS
BY S. J. HOLMES

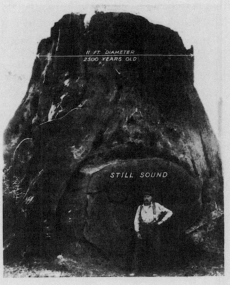

THIS picture, which was taken in a redwood forest in Del Norte County, California, does not require the deductive powers of a Sherlock Holmes in order to interpret its meaning. Since it represents one redwood tree growing upon another one, the upper tree must have started to grow after the other had fallen. The trunk of the upright tree shows about twenty-five hundred rings, and therefore must be about twenty-five hundred years old. It was a big tree when Demosthenes was delivering his fiery orations in Athens, and was a stripling of some six hundred years at the beginning of the Christian era. Twenty-five centuries ago a redwood seed germinated in the debris and humus which had accumulated upon the trunk of one of its fallen predecessors. As the young tree grew its roots formed a connection with the soil on either side of the fallen log which may have been partially buried at that time. Recently this log was sawed across, and a count of its annual rings showed its age to be over two thousand years. In all, over forty-five hundred years are represented in these two generations of redwoods.

Most of the prostrate log was sawed up and converted into lumber, a fact which is indicative of the great durability of redwood, at least under the climatic conditions prevailing in northern California. The largest part of the tree, although forty-five hundred years old, was still sound and firm. The photograph shows several plants growing on the sawed-off surface of the upper tree. Perhaps another redwood may start there, and in another two thousand years develop into a third generation of forest giants. What is human longevity compared to this?

(Image labels: II FT. DIAMETER, 2500 YEARS OLD; STILL SOUND)

Figure 61. Respectful descriptions and imagery emphasizing the Coast redwood's undying will—especially including depictions of their peculiar regenerating abilities—began to show up in national publications in the 1930s, expressive of American concerns about the nation's condition and fate. "Two Generations of Redwoods," *Nature Magazine* 17 (April 1931): 242. With permission from *Natural History*.

as stimulating the nation's economic collapse, these stories must have had cultural resonance. Much like the clenched-fist iconography in advertising that historian Roland Marchand has suggested functioned as a parable of resolve, resistance, and endurance for Americans in the Depression era, so did these tales of falling trees tell a story of dignified hardihood. As Mayo relayed it, the venerable tree fell without a witness, a narrative of strength appropriate for a humbled nation under duress from without and within.[14]

Even though the survival rhetoric concerning the big trees was fairly consistent during these years, and their status as national monuments un-contested, most creative writers and other artists largely omitted any ref-erence to the sequoias in their work. National Park photographers, how-ever, especially Yosemite's Ralph Anderson, could not afford to ignore them. Although many of Anderson's images were factual—recording de-composition or weather damage, for instance—others reflected the same high regard for the trees evident in the 1930s big tree discourse, somewhat recalling Carleton Watkins's and Albert Bierstadt's portrayal of the trees as survivors. Yosemite's official photographer from 1932 to 1952, An-derson often posed tourists and dignitaries dwarfed by a particular tree or within a towering grove. As historian David Robertson has pointed out, Anderson made the human figures "recede into anonymity, becoming little more than foils to accentuate the indomitable character of . . . [the] giant Sequoias." The most revealing example of Anderson's style during the 1930s was *President Franklin D. Roosevelt in the Mariposa Grove of Big Trees* (1938, Figure 62). Two weathered tree trunks flanked Roosevelt's con-vertible, seen deep in the background, a framing device that emphasized the trees' size and venerability even amid the presence of the most pow-erful American of the decade. Only the photograph's title gave viewers any indication of the identity of the automobile's passenger. Robertson added that "except for the title we might think that it is Everyman's car."[15]

Anderson's work notwithstanding, the Depression demanded other sorts of images and narratives. Documentary photography, as the most distinctive artistic expression during the 1930s, commonly privileged the human experience in America over nature scenes, except those of despo-liation. The relevant visual images of the Depression era thus were of people and the exhausted American landscape, not a protected national park icon.

America's involvement in World War II, however, would foreground patriotism and demand resolve, and these needs required symbols and icons for Americans to rally around. Singer Kate Smith stirringly led the charge by locating the presence of God in the pristine American landscape from sea to sea. First sung on the air in 1938, her 1941 hit recording of Irving Berlin's "God Bless America" unwaveringly visualized the United States as a divinely blessed and protected nation "from the mountains/to

the prairies/to the oceans white with foam."[16] The cultural climate shifted, creating an atmosphere more conducive to artistic expressions of the big trees.

A common sense of danger stimulated the desire for national unity during the war years. Citizens were urged to sacrifice as part of a home-front strategy. As the Office of Civilian Defense put it, "every time you decide *not* to buy something, you help to win the war." Even the Coast redwoods contributed to the war effort. Because they were much more usable, accessible, and largely unprotected by legislation, they were one of the nation's "team-mates in defense," "a strategic material" containing wood that could be processed into lumber or wood-chip insulation and bark fibers that could be converted into a wool substitute to make blankets or felts. "In service on many [wartime] fronts"—so much so that in 1944 *Business Week* declared that the "roll call" of their wartime use read "like a catalog of military procurement"—redwoods made sacrifices as well.[17]

Adams began to try to capture the nation's fears, hopes, and patriotism in his photography. No doubt other factors than the new patriotic climate inspired the new-found direction. He was at the midpoint in his career—almost 40 years old—and his earlier work had often made him defensive about his subject matter. Throughout the 1930s, his work seemed out of sync, especially by the end of the decade. After producing mostly small, tightly focused nature studies, he had begun to experiment with more masterful expressions of the natural world, especially of the Sierra Nevadas, a new approach some critics found lacking in substantive content. One of them, Alfred Barr, director of New York's Museum of Modern Art (MoMA) in the 1930s, once criticized as irrelevant an exhibit in which Adams participated, which also included images by Alfred Stieglitz, Paul Strand, and Edward Weston. "Why do all the photographers have to photograph bushes?" he complained.[18]

But Adams likewise found the images of the photodocumentarians lacking. On November 4, 1938, he evaluated Walker Evans's *American Photographs* in a personal letter to a friend. He was extremely disappointed with Evans's show, especially in his depiction of America. Although "Evans has made some beautiful pictures," Adams admitted, he had captured only a small part of the nation's character. Such inaccuracy confounded and frustrated him. "I have no idea but what Evans had a

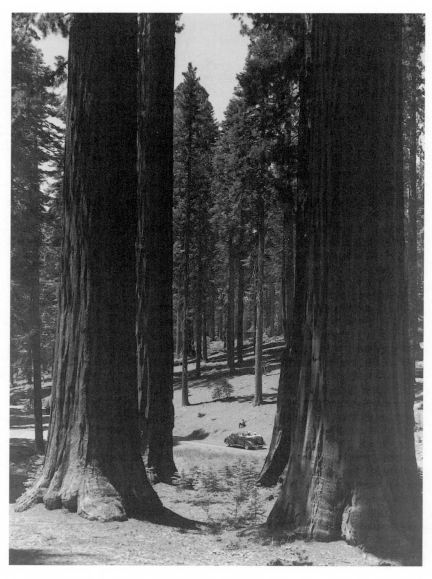

Figure 62. Ralph Anderson, *President Franklin D. Roosevelt in the Mariposa Grove of Big Trees*, 1938. Courtesy the Yosemite Museum, Yosemite National Park.

Fiber From Redwood Bark Is Wool Substitute

Now they're harvesting wool for clothing from the bark of California's giant redwood trees, oldest living things on earth. Until a decade ago this bark, which grows up to ten inches thick, was a waste product. Then research men of the Pacific Lumber company discovered the bark fibers had valuable insulating properties; they were long-lived, resisted fire and moisture, and were distasteful to vermin and insects. Redwood wool insulates cold storage and meat packing plants, quick-freeze food warehouses and the walls and ceilings of homes. The latest development is its use in textiles. Combined with natural sheep wool, the bark fibers form a strong fabric, useful in felt hats, lightweight blankets and clothing. The combinations range from 15 to 60 percent of bark fiber in the finished products.

↑
Here is a jacket made partly of fibers from redwood bark. In her hands the young lady holds redwood wool sample

← Stripping the bark from a giant redwood log. It is shredded and processed into textile fibers and wool for insulation

Figure 63. The redwoods were such an inspiring part of the national mythology by the 1940s that they were heralded as patriotic participants and advocates helping to motivate further the war effort. Reprinted from *Popular Mechanics* (May 1942). © Copyright The Hearst Corporation. All Rights Reserved.

conception that was very subtle about the whole thing," he surmised, "but it does not come through." Evans's coverage of the urban scene— particularly the industrial grime and crumbling architecture, peopled with unfriendly faces and lined with ragged fences, tattered posters, and a worn billboard advertising a movie whose female lead is an abused woman— deeply troubled Adams. His sense of the images' inaccuracy bothered him the most. "America is not that way," he worried, although "some of it is, but not all of it. And this 'some of it' loses impact when separated from its whole. Had the title been *Photo-Documents of Some Phases of the American Scene*, it all would have been more logical." "America," affirmed Adams, "is a land of joy—more than any other land," and omitting this was potentially damaging, he maintained. Conceding that he was "very far from [being] . . . 'Patriotic,'" he stressed that "I do resent untruths, exaggerations, [and] false colors in relation to the land in which I work and live." If all photographers did was to "show everything that is false and inhuman, sordid and without hope, without alleviation of the larger fact," that would encourage an "infection" that would "only widen and deepen and eventually consume us." *American Photographs* to Adams contained nothing but "petulant jabs at the social order" from a "self-conscious messenger of decay" all in a "self-conscious attempt to make . . . 'art.'"[19]

The larger fact of America for Adams was to be found in America's relationship to nature. Throughout this period, from 1938 to 1945, Adams increasingly revisited his ideas about America and nature to such an extent that it was the prologue to what most photography historians and critics agree was his most impressive and productive period of work— the Cold War era.[20] But it was during wartime when all these ideas and impulses began to crystallize. In 1944, Adams produced three images of the big trees in the Mariposa Grove. His depiction of the trees, visually unique and creative, suggested that he saw them as quintessential nationalistic symbols or markers in the twentieth century.

During the war years, project after project required Adams to focus on the task of representing America. Starting in 1940 he helped to curate a number of photographic exhibits at MoMA that centered on America. During the following year, Secretary of the Interior Harold Ickes invited Adams to create photographic murals of the national parks for the de-

partment to use in its offices. Amid many other professional commitments, this project would preoccupy Adams to the point of obsession for roughly the next year and a half. Thus began Adams's immersion in documenting the larger fact of America: the hope and redemption he found ever-present in the nation's pristine and poignantly symbolic natural landscape. By focusing on what he came to term the "natural scene" in America, Adams created grand and theatrical images reflective of a nation united in fulfilling its "divine mission" as the "hope of the world."

Adams's ideas about America and nature that came together in these years were prefigured in his philosophy of photography. His parents' strong affinity for Ralph Waldo Emerson's transcendentalist views on nature highly influenced his own thoughts about his craft. He scrutinized the natural scene for a larger meaning, the kind he could capture in a photograph. As curator Colin Westerbeck has put it, his way of photographing and seeing nature involved searching for signs of nature's "grand design" by first inspecting its small details. He would move "constantly . . . from the microcosm to the macrocosm, from the smallest detail of nature to her Grand Design, from close inspections of what was at hand to as far as the eye could see, and searching always for a relationship between the two." In fact, Westerbeck argues that Adams's career followed this way of seeing, in that his early career consisted largely of smaller nature studies and his later career, starting in the 1940s, involved the huge operatic vistas that earned him comparisons with past American artists with similar styles, such as Frederic Edwin Church and especially Bierstadt. His philosophy was not just to produce a picture of a bush or some other object or scene in nature but "fully express . . . what one feels, in the deepest sense, about what is being photographed." Ultimately, a great photograph, Adams believed, recorded "a true manifestation of what one fe[lt] about life in its entirety."[21]

A photographic vision that Adams particularly admired was Stieglitz's "equivalents." Consisting of a series of cloud studies, Stieglitz regarded equivalents as photographs whose style and subject matter represented the photographer's most intense personal mood at that moment—"they were *equivalent* to something felt deep within." In a letter to photographer Cedric Wright in 1940, Adams commented on the relevance of this approach: "Really now—isn't practically everything that we react to just

that?" Although Stieglitz's intent with these studies was to record an intensely personal moment, Adams, especially starting in his early 1940s work, tried to capture larger moments, something on a national scale. Perhaps this ambition explained the broader appeal of Adams's work during this era and his continued popularity since.[22]

Adams's affinity for the idea of equivalents quickly began to influence much of his wartime photography of nature. The compositional possibilities it offered eventually influenced his depictions of the big trees. In these years his nature photography consciously served as equivalents for the national mood. Nature's "huge vistas and [its] stern realities of sun and wind and space" were potent symbols for Adams of the "immensity and opportunity of America." These perceptions were clearly evinced in *Moonrise, Hernandez, New Mexico,* (1941, Figure 64) and *Winter Sunrise, The Sierra Nevada, from Lone Pine, California* (1944, Figure 65). Nearly the first and last images that resulted from his mural assignment, the two popular photographs fervently revealed Adams's belief in nature's permanence and its redemptive qualities—and affirmed that of the nation's by association. By depicting the moon emerging out of a huge darkened void in *Moonrise*, Adams created a tonal opposition that emphasized a church graveyard's field of crosses, a sign of God's blessing across the aging yet unvanquished southwestern landscape. He again created differing tonal planes to highlight strongly the simple presence of a lone horse calmly drinking water in *Winter Sunrise*. Even though the vast surroundings figurally dominated the animal, Adams's version powerfully presented the horse as a venerable and integral part of a vast landscape.[23]

Adams, like all Americans, was surrounded by reminders of the war and its effects—he even recorded an army cannon's placement in Yosemite Valley in 1943 and taught the GIs photography—and consequently his work during these years seemed to be leading him to an energized concept of the kind of photography appropriate for the nation at this time. Much of his work during these years, especially evident in *Moonrise* and *Winter Sunrise*, suggested that he was captivated by the idea of nature's permanence as an equivalent for the nation, and he wanted to capture that larger fact in his landscape work during these years. Letter after letter to Interior Department officials made clear Adams's intent. Writing to Newton Drury, the director of the National Park Service in late October 1941,

Adams averred that revealing the nation's grandeur with these photo-graphs would stirringly serve patriotic ends. Mary Street Alinder, Adams's assistant after 1967 and his biographer, admits that Adams "believed the photographs he was making on th[is] very trip expressed all that," and that "the scope of possibilities [beyond the mural assignment] extended before him." After Pearl Harbor, Adams's sense of purpose became even clearer. He quickly sent another letter to Drury, suggesting that he "could best serve [the nation] by making photographs to motivate Americans, im-ages that would communicate the great and pure beauty of their land, whose freedom was in serious jeopardy." He sent an additional letter in late December to E. K. Burlew, assistant to Secretary Ickes, justifying the patriotic use of his work. According to cultural biographer Jonathan Spaulding, Adams stressed "that his project contributed to the war effort by presenting the landscape of America and the values it embodied—what Americans were fighting for."[24]

All of Adams's intentions came to fruition at the end of 1944, the year in which he produced his big tree images. On Christmas Day, in a letter to Stieglitz, whose professional opinion he especially valued, he discussed having a renewed vision about his work and career, what he called "the re-emergence of an emotional stimulus." It was borne from a series of "tremendously moving experiences" he had had in the previous few years and their "reciprocals—[the] many dreary months of hoping and waiting and doing much-but-little" in the way of the war. By war's end, he con-cluded that nature was one of the only things that endured. It was clearly the proverbial "larger fact."[25]

The big tree images he produced earlier that year were part of this new "stimulus" about nature and photography. Throughout the Cold War era Adams devoted his career to promoting a conservation ethic, with ideal-ized images of unspoiled natural landscapes—scenes of what should en-dure and in what condition they should endure. But the big-tree images, much like *Moonrise* and *Winter Sunrise* before them, led him to this re-alization. Reflecting the permanence he perceived in nature and the faith and hopefulness in the nation that Americans recovered during the war, they formed the final chapter in Adams's portfolio of landscape equiva-lents of the national mood.

Adams never included the big tree images in any exhibitions, even those

Figure 64. Ansel Adams, *Moonrise, Hernandez, New Mexico*, 1941, gelatin silver print, 39.0 × 48.8 cm. © Trustees of the Ansel Adams Publishing Rights Trust. Collection Center for Creative Photography, The University of Arizona.

that he helped to curate or those that displayed his work. He also did not keep or save any notes of their making.[26] He did, however, photograph all types of trees throughout his career. Like many other artists, he used them as framing devices, but he also was interested in capturing their unique textures and odd forms. For example, he compared two differently grained boles side by side in *Trees, Illilouette Ridge* (1945, Figure 66), a sampling of smoothness and coarseness, death and vitality. The left trunk's bark had been stripped, exposing striations and marks, and the trunk's bark in the frame's right side displayed its pocks and uneven glossiness in a contemplation of texture and line. He captured the distinctive twin-ing of a pine in *Jeffrey Pine, Sentinel Dome, Yosemite National Park, Cal-*

Figure 65. Ansel Adams, *Winter Sunrise, The Sierra Nevada, from Lone Pine, California,* 1944, gelatin silver print, 38.1 × 48.8 cm. © Trustees of the Ansel Adams Publishing Rights Trust. Collection Center for Creative Photography, The University of Arizona.

ifornia, (1940, Figure 67). The pine's extreme bending and twisting complemented the horizontality of the rocks below and the spread of the mountain vista in the background. A tree's curious shape and its unusual grooves and postures created explorations in mood that attracted Adams's photographic eye.

Given their frequency in his tree photographs, it seems that Adams was fascinated with the symbolism of dying trees. In many of these images, Adams commented on the passage of time and its results—whether personal or geologic. *Dead Tree near Little Five Lakes, Sequoia National Park, California* (1932, Figure 68) was significant enough that he included a print of it in a 1936 self-portrait where he faced a camera resting to the

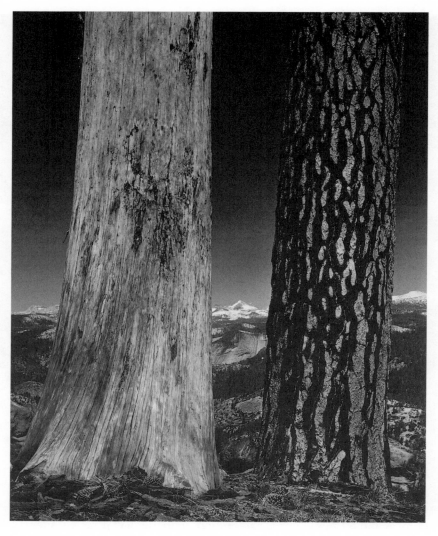

Figure 66. Ansel Adams, *Trees, Illilouette Ridge*, 1945, gelatin silver print, 33.7 × 26.3 cm. © Trustees of the Ansel Adams Publishing Rights Trust. Collection Center for Creative Photography, The University of Arizona.

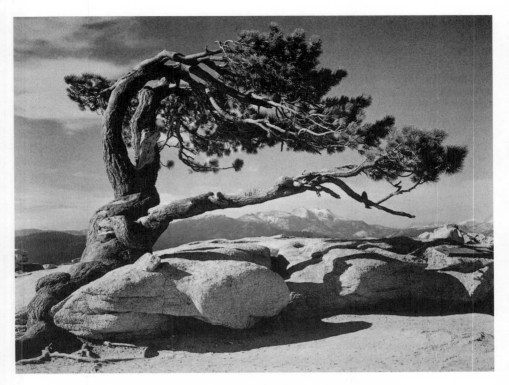

Figure 67. Ansel Adams, *Jeffrey Pine, Sentinel Dome, Yosemite National Park, California*, 1940, gelatin silver print, 18.1 × 23.5 cm. © Trustees of the Ansel Adams Publishing Rights Trust. Collection Center for Creative Photography, The University of Arizona.

viewers' left on a bookshelf. The print, positioned on a wall between Adams and the camera, presented an up-front view of a dead tree. Its central placement in the portrait presumably commented on his sense of himself as a photographer—that a dead tree literally came between Adams and his camera.

Split nearly in half vertically, the tree in *Dead Tree near Little Five Lakes* looks as delicate as Styrofoam, its branches splayed out beseechingly, like arms. Given that Sequoia National Park contained the largest number of big trees, it was interesting that this was the only photographic print of a tree that Adams made while visiting there, an examination of damaging climatical effects over time. Its inclusion in his 1936 self-

portrait reinforced the notion that Adams was interested in trees as objects expressive of time's ravages and the fragile perception of self to which that might lead.

Two other tree images reinforced these themes, but also evoked the effects of geological time. In *Mount Lassen from the Devastated Area, Lassen Volcanic National Park, California* (1949, Figure 69), Adams used a dried-out and hollow tree stump in the foreground to suggest the volcanic devastation of which Mount Lassen was capable. Finally, in *Tree, Stump and Mist, Northern Cascades, Washington,* (1958, Figure 70), Adams depicted a tree rising in the mist above and behind a pile of a stump—a moody and mystic scene suggestive of past and present, of what was and what remains—with a delicate young stripling rising up from the pile. Thus explorations of shapes, textures, the presence of death, and the passage of time formed the stylistic context of Adams's tree photography.

Given his attention to a tree's unique characteristics and its surrounding mood, when it came to depicting such icons as the sequoias Adams preferred their symbolic and lyrical qualities. He firmly believed that any interpreter ought never to emphasize them as gimmicks or tourist stops, even though he felt that the trees' appearance lent themselves to such exploitation. Indeed, he felt that even the National Park Service regarded the sequoias as "a gargantuan curio." Vehement about capturing "true spiritual and emotional values," or what he summed up as "an emotional actuality" in nature, Adams included the trees in this formulation. He argued that it would be much better not to depict them at all than to render them in "their most conventional 'tourist' aspect."[27]

Thus Adams did not portray the trees in 1944 as outsized curiosities. His images did not include an auto log or tunnel tree, and they ignored the tourist shrines of the named trees, such as the Wawona Tree or the General Sherman. Adams also omitted the presence of tourists, even though photographers often used them to solve the difficulty of conveying the trees' incredible size. The big trees he depicted were not tourist sites or props. They were something else—"emotional actualities" or equivalents evocative of the national mood while U.S. military forces mobilized throughout Europe and the Pacific.

Although Adams photographed the sequoias before and after the war, the significance of his 1944 images rests in the fact that two of them are

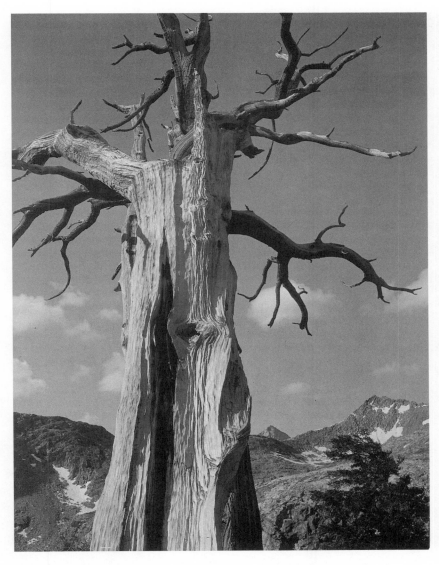

Figure 68. Ansel Adams, *Dead Tree near Little Five Lakes, Sequoia National Park California*, 1932, gelatin silver print, 21.5 × 16.0 cm. © Trustees of the Ansel Adams Publishing Rights Trust. Collection Center for Creative Photography, The University of Arizona.

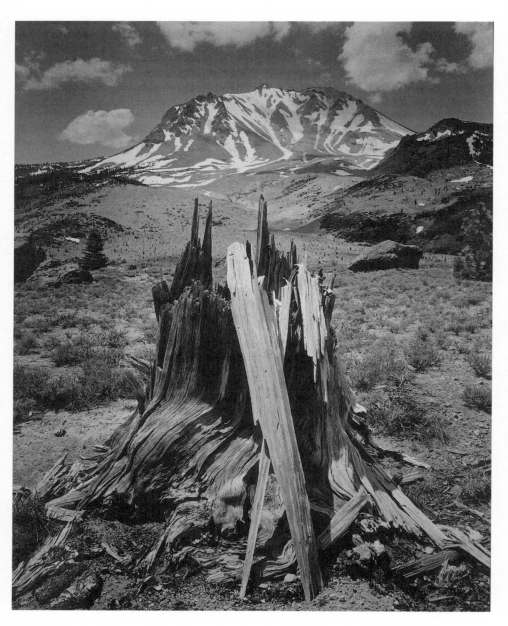

Figure 69. Ansel Adams, *Mount Lassen from the Devastated Area, Lassen Volcanic National Park, California*, 1949, gelatin silver print, 50.1 × 39.3 cm. © Trustees of the Ansel Adams Publishing Rights Trust. Collection Center for Creative Photography, The University of Arizona.

Figure 70. Ansel Adams, *Tree, Stump and Mist, Northern Cascades, Washington,* 1958, gelatin silver print, 37.2 × 48.5 cm. © Trustees of the Ansel Adams Publishing Rights Trust. Collection Center for Creative Photography, The University of Arizona.

so clearly paired, which is not so with any other of his big-tree depictions.[28] Their composition suggested the pairing: One of the trees split the frame vertically, and another horizontally. In *Giant Sequoias, Mariposa Grove, Yosemite National Park* (Figure 71), Adams divided the image and angled his camera upward, the left side thus displaying the full height of two towering trees and the right a close-up view of a massive trunk. The strategy allowed Adams to capture the trees' delicate and foliated beauty in full-length while also foregrounding their remarkable solidity. Furthermore, the close-up afforded better scrutiny of the striated bole, whose leathery and aged appearance emphasized the trees' venerability. By composing perspectives of trees that both ascend to the frame's top and fill out and move off its side, Adams underscored just how imperiously these trees

occupied their landscape. They were tall, massive, and definitely not about to fall down.

Adams used a similar strategy for *Redwood Roots and Tree, Mariposa Grove* (Figure 72). He again divided the frame, this time horizontally. In it, a medium close-up of gnarled, dried-out roots filled the lower half of the image with the bole of a young sequoia thrusting upward from them. Adams was fascinated by these roots, because he made at least one other exposure of them in 1944. He framed a vertical view for *In the Mariposa Grove of Big Trees, Yosemite National Park, California* (Figure 73). By tilting the camera up, he captured both the young tree's amazing height and the elaborately textured mass of roots encircling its base. But the angle he chose for *Redwood Roots* made for a much more satisfying composition. By leveling the camera and moving it to the tree's left, he eliminated the thin tree that leant into the redwood in the upright version and that cluttered the view of the aged trunk's ascendance. With the little tree blocked out by Adams's primary subject, *Redwood Roots* allowed him to accent more definitively the significance of the ancient tree's mortality. Indeed, the ascending view Adams chose for *In the Mariposa Grove* stressed the sequoia's dominant height instead, leaving viewers with a substantially less inviting consideration of its root system. It was evident in *Redwood Roots* that the dried, cracking, and sinuous roots were not part of the living tree shooting up and asserting itself above them in bright daylight, given the healthy and unworn look of the trunk. The root system of healthy redwood trees, although sometimes surfacing above ground, rests close to the surface and does not expose itself so profusely. In this version, a healthy trunk prevailed over a dead root system—a bold, exuberant survivor.

The comments of the *Christian Science Monitor* that same year confirmed Adams's sense of the big trees as national equivalents. In an appreciative article about the Coast redwoods, Rodney L. Brink picked up on the inspirational and redemptive qualities Adams highlighted in his tree portraits. He asserted that "their grandeur, beauty, plus their life theme of no surrender, are indeed an essential element in 'an America worth fighting for.'" Moreover, they were perfect backdrops for the war's end. Brink reported that "it has been seriously proposed on the West Coast that the coming peace conferences be held in the colonnaded natural halls of

Figure 71. Ansel Adams, *Giant Sequoias, Mariposa Grove, Yosemite National Park*, 1944 (print 1954), gelatin silver print, 32.8 × 25.8 cm. © Trustees of the Ansel Adams Publishing Rights Trust. Collection Center for Creative Photography, The University of Arizona.

Figure 72. Ansel Adams, *Redwood Roots and Tree, Mariposa Grove*, 1944. Computer scanned from Andrea Stillman, ed., *Yosemite*, New York: Little, Brown and Company, 1995, page 77, at 300 dpi using Adobe Photoshop 6.0.1, UMAX MagicScan 4.4. © Trustees of the Ansel Adams Publishing Rights Trust. Collection Center for Creative Photography, The University of Arizona.

the great redwood forests." As a natural cathedral, the redwood forest was ready-made for talks of peace, for "human beings are humbled" in their presence. They had made sacrifices as had Americans because they had "literally go[ne] to war" as lumber was in high demand, the result being that as many "will not be standing when peace comes." Thus commentators entangled the ancient trees in war rhetoric, using them to evoke America's indomitability, its soldiers' sacrifices, and as sites for redemption from the hostilities raging overseas.[29]

With his images capturing the national trees' health and vitality, Adams emphasized their endurance and staying power, even amid the presence of

Figure 73. Ansel Adams, *In the Mariposa Grove of Big Trees, Yosemite National Park, California*, 1944, gelatin silver print, 22.9 ×18.3 cm. © Trustees of the Ansel Adams Publishing Rights Trust. Collection Center for Creative Photography, The University of Arizona.

death or its own mortality, as in *Redwood Roots*. Adams's wartime am-
bition to link the unspoiled American landscape with national purpose
shaped their patriotic meaning and intent. These unofficial national trees
figured in his images as monuments to an America destined to endure as
they had endured, even amid a seething world war. This was especially
suggested in *Redwood Roots*, where the presence of death undergirded
the single redwood trunk—the roots positioned like piled up limbs or tan-
gled barbed wire, reminders of the chaos of war and its costs. Much like
Walsh's pan up the trees' heights in *The Big Trail*, Adams's depictions ren-
dered the trees as sites of reunion and recovery—places whose permanence
signified Americans' recovery of national ideals such as perseverance. In-
deed, Adams showed no dying big trees in these images. He heralded their
presence triumphantly—because their size, age, beauty, and national res-
onance demanded it.

By war's end, the big trees had been transformed into triumphant sym-
bols of the nation's power and endurance. Adams used them to celebrate
the nation as a place of permanence and regeneration amid the war's de-
structive ugliness. Their cultural resonance, however, was of such magni-
tude that it even attracted ridicule. The humor of a 1945 Disney cartoon
short about the trees' protection found inspiration in wartime concerns
about the nation's forests. The United States had extensive forest cover-
age, which many forest officials regarded as a liability as well as a bless-
ing. Old-growth forests supplied Allied forces with lumber, creating de-
structive logging practices that almost decimated forests in the Pacific
Northwest as early as 1940. As historian Frieda Knobloch argues, "the
issue of [logging] regulation would remain unsettled throughout the war,"
inspiring multiple bills aimed at pleasing the military, logging companies,
and the forest service. Obviously, concessions were made. From an origi-
nal War Department order for 2 billion board feet of timber, military con-
sumption had bulged to 119 billion board feet by 1944.[30]

In addition to concerns about lumber overconsumption, forest officials
worried about the specter of massive forest fires. Because officials saw
forests as possible sites for enemy sabotage, governmental publications
often referred to incendiary attacks as the "red demon." Such fears be-
came more justified in 1943 and 1944, when unknown assailants targeted
Oregon's Siskiyou National Forest. Thus the forest ranger became part of

America's home defense, one who would protect the nation's resources from enemy attack or natural causes. Accounts of forest fires increased, the Advertising Council created the figure of Smokey Bear, the U.S. Forest Service endorsed xenophobic Works Progress Administration posters that viciously insinuated Japanese as forest-fire saboteurs, and images of rangers keeping an eye out for any signs of flame or smoke began to emerge.[31]

Disney offered a mocking commentary on the seriousness of threats to the nation's lumber supply by saboteurs—along with the prospect of a desecrated and fallen national tree—in the cartoon short, "Old Sequoia" (1945). The short opens as two beavers deliriously take down one tree after another. The beaver twins' arch nemesis, Donald Duck, is the lone park ranger assigned to protecting this particular forest from them.

The anxiety concerning the condition of this area is evident from the beginning, in that Donald's supervisor constantly calls in for updates about the health of the stands. When Donald reassures him that all is well, his supervisor tells him to get back to work, because they've "lost too many trees!" The one tree the supervisor is most concerned about is the oldest and biggest of them all, Old Sequoia. Protected by a surrounding fence, Old Sequoia—the prize of this forest—stands for all big trees, so old a sign tacked to its bark cannot identify when it was born. As the saboteur beavers reach the sacred tree, Donald frantically tries to save it. Predictably, his supervisor's calls interrupt his every attempt.

The beavers eventually work their way inside the lower trunk and begin to destroy it from the inside out. With golden bark pulp pouring out of holes at its base, the tree loses almost all of its support, save a thin string of heartwood at its center. Donald desperately tries to save it by first holding up the entire trunk, and then shoddily restoring its appearance—he props sticks around its circumference and places bark panels over it all. The makeshift support begins to bulge when the phone rings, its sound waves so strong that they momentarily push the bulging bark back. As Donald answers the phone in the ranger's tower, the tree's support falters, and the tree comes tumbling down on the ranger's tower and into a lake, its branches reaching out as arms to take Donald with it.

Though played for laughs, the short's anxiety over sabotaged trees—even "Old Sequoia," one that is apparently immune to death—overrides

the fascination with just seeing one of these trees go down. The beavers, though seemingly playful and innocuous, are fifth columnists programmed to engage in the forest's and tree's systematic destruction. The bureaucracy, represented by the annoying phone calls that interfere with Donald's supervision of the forest and its hallowed tree, proves impotent and distracting amid the vandalism. Given that many were concerned with the durability of the nation's forests during the war, "Old Sequoia" took such paranoia even farther, because it depicted the country's most revered and protected trees as vulnerable and federal preparedness as ineffectual. Unlike most of the trees' commentators, the cartoon plotted a sequoia's destruction and death and even dared to rejoice in its final fall. Whether constructed as heroic American monuments or fallen giants, the big trees as national equivalents exposed the nation's fascination for survival and endurance throughout the 1930s and 1940s.[32]

EPILOGUE

As old trees in America—as ancient survivors—the sequoias have consistently inspired meditations about the continuum of history, especially the history of the United States. These reflections reveal Americans' affinity for nature as an apt sign of national identity—and, given Americans' celebration of the big trees, the grander the specimen, the more alluring its symbolism. Since their "discovery," the sequoias have ably functioned as national icons, objects that embody concerns about national memory, purpose, and history. Whenever the trees have entered or emerged as visual material, concerns about the nation's heritage and destiny have always arisen.

Since the Cold War era, however, the trees have attracted such symbolism less frequently. Botanical discoveries and grove acquisitions by the federal or California state governments in the 1940s and 1950s strengthened their preservation and diminished the *sequoiadendron*'s reputation as a threatened species, although such has not been the case for its sister strain, *sempervirens*. When scientists discovered a third strain, known as

the Dawn redwood *(Metasequoia glyptostroboides),* in China in the mid-1940s, the finding somewhat dampened the symbolic significance of the big trees' exclusive American existence, or, as one science writer put it, the "American monopoly."[1] The state of California, aided by the efforts of the Calaveras Grove Association and the Save-the-Redwoods League, converted the Northern and Southern Calaveras Groves into state parks in 1931 and 1954, respectively, thus obliging a decline in the trees' reputation as independent American "survivors." More parks ironically meant that the sequoias were less precious. As Newton Drury, a former National Park Service director, whose efforts helped secure both groves' protection, observed in 1952, such public acquisitions aptly formed the trees' "last chapter" nearly one hundred years after their official Euroamerican discovery and worldwide introduction.[2]

The Coast redwoods' vulnerability has indeed since dominated mainstream discussion. In the late twentieth century the discursive focus has shifted to their fate and preservation, powerfully embodied by one woman's symbolic and two-year habitation of a single redwood to protest the lumber industry's redwood clear-cutting practices.[3] Unlike the Sierra redwoods, Americans have logged the *sempervirens* from the time of their discovery and have nearly wiped them out. Their idealization and use as lumber have more severely complicated Americans' aesthetic appreciation of them throughout the twentieth century.

Interpretation of the Coast redwoods' depiction would thus require constant and detailed inclusion of conservation history.[4] For example, the one artist most associated with the Coast redwoods is Andrew Putnam Hill, a landscape artist and photographer whose political advocacy and photography was part of the intense lobbying effort to preserve the groves in the Santa Cruz mountains, a location named in 1901 as Big Basin Redwoods State Park. One of the founders of the Sempervirens Club, whose members actively sought the groves' protection, Hill took his photography repeatedly to the state capitol to persuade legislators about the importance of preserving the groves.[5]

Such political involvement was uncharacteristic of the artists who rendered the Sierra redwoods—even Ansel Adams, who infrequently used photography as a lobbying tool for conservation before World War II. The long list of other big-tree artists' work—the images produced by Carleton

Watkins, Edward Vischer, Albert Bierstadt, Charles C. Curtis, Thomas Hill, and Julius Boysen—reveals that other issues, such as the meaning of historic trees and the effects of destructive wars, national identity crises, technological progress, or tourism intruded more forcefully. Although Watkins's photographs justified and perhaps even inspired the 1864 bill to preserve Mariposa Grove, political advocacy was not part of his original intent in the summer of 1861.

There are, however, some minor exceptions worth mentioning in brief. Starting in the 1920s, Yosemite and Sequoia National Parks began to promote conservation principles, probably the direct result of the dramatic increase in tourist visitation both parks were beginning to experience. Their educational or interpretive divisions devised ways of inserting discussion about nature, humans' relationship to the natural world, and patrons' responsibility as part of a trip to the park. Guides hosted nature walks and lectured about the flowers, trees, and wildlife. Officials at Sequoia National Park repeated this information in *Nature Notes*, an educational publication started in the early 1920s that informed visitors about the proper appreciation of the park's natural wonders.

But the most elaborate conservation promotions were special outdoor pageants or plays, especially "Ersa of the Red Trees," a mythological and nearby science-fiction big-tree fantasy. The play was presented at least eight times between 1922 and 1931 at Sequoia National Park, although in 1924 it was preempted by the presentation of Washington Irving's "Rip Van Winkle." Complete with musical numbers, live accompaniment, and lighting effects, "Ersa" was such a success that it became an annual event in 1927. The story takes place in a big tree grove in an unknown time. Ersa, daughter of Mitla (the trees' guardian), is a target for invaders hoping to use the trees. Nearing death and fearful of his daughter's unprotected future, Mitla gives in to an offer to sell one thousand trees to Hau, "a visitor from the distant Karna lands." The trees themselves curse the contract before it is sealed and doom Ersa to being transformed into a golden bird "once each month for two years" and thus in danger of hunters' arrows. After a romantic plot twist involving Ersa and a prince, by some means Hau learns of the curse and threatens Mitla that he will kill his daughter unless Mitla grants him the entire grove. When Mitla refuses to concede, Hau sets fire to the giant forest in revenge, unwittingly killing himself and

eliminating the curse but fortunately not destroying the trees. As the program notes state triumphantly, by the end of the play "the trees are saved and romance has its rightful victory."[6]

Emphasizing the virtues of sacrifice over greed, Sequoia superintendent Col. John Roberts White hoped the play would influence the ways audience members behaved in the park and thus "enhance [their] respect for the age and majesty of the sequoias." His insistence that the play's presentation always occur under the General Sherman tree, the tallest sequoia in the world, underscored such an intent. Other than these few examples, however, Americans generally appropriated the trees as national symbols rather than consciousness-raising figures.[7]

After World War II the Coast redwoods became the favored object of representation. Two texts that incorporated the redwoods included a film and a work of travel writing. They collectively reinforced the same ideas that the Sierra redwoods inspired in viewers throughout their heyday— a respectful appreciation for historical legacy and stability but also a subtle questioning and even mocking of it, a turn signaling perhaps the waning of the Sierra redwoods' cultural influence.

Concerns about the historical past (or making sense of the connection between past and present) reach deep psychological dimensions in Alfred Hitchcock's film *Vertigo* (1958), in which Jimmy Stewart portrays John Ferguson, a retired detective obsessively shadowing a young wife who appears to be struggling with her identity. Although Hitchcock ingeniously meditates on issues of obsession, female identity, and the nature of performance, he briefly uses the redwoods as a setting to invoke contemplation about the nature of memory, both authentic and imagined.[8] Throughout the first half of the film, Judy (Kim Novak) portrays herself as Madeline, a woman haunted by an assumed connection to another woman who committed suicide more than a hundred years ago. At times thinking she is Carlotta Valdes, her Mexican great-grandmother, Judy/Madeline carries on a deceitful performance, along the way conducting a silent tour of San Francisco under Ferguson's professional observation. The performance includes a visit to Carlotta's grave site at Mission Dolores and another to the Palace of the Legion of Honor to view the señora's grand portrait. With the focus on her as Madeline, Hitchcock's film initially evokes concerns about a search for oneself, trying to avoid mental breakdown, a

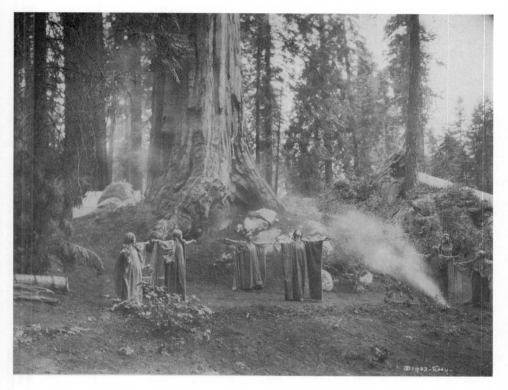

Figure 74. Lindley Eddy, Scene from "Ersa of the Red Trees," 1923. Courtesy of the National Park Service, Sequoia and Kings Canyon National Parks.

making sense of the past and its connections to the present; and perhaps it is not so surprising that one of the places Madeline seeks out is Big Basin Redwoods State Park, the site of solid, ancient Coast redwood trees—permanent, protected, and thus reliable historical landmarks.

The redwoods are easy foils to legitimize Ferguson's setup. Viewing a cross-cut section of a redwood, Madeline locates Carlotta's life span in between the trunk's outermost rings, lamenting to the relic that "it was only a moment for you, you took no notice." Yet the remainder of the dream-like scene, which film historian Dan Auller regards as "one of the [film's] most haunting [in] pace and atmosphere," finds Madeline overwhelmingly tormented by historical memories.[9] Rather than reassured by the trees' embodiment of authentic and assured antiquity, she seems painfully

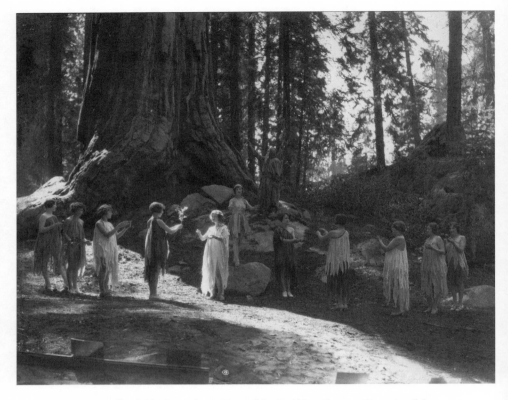

Figure 75. Lindley Eddy, Scene from "Ersa of the Red Trees," 1923. Courtesy of the National Park Service, Sequoia and Kings Canyon National Parks.

harassed by them—breathless and dizzy as she leans against one of them—the ancient grove a gloomy vault of historicity surrounding her imagined connection to Old California's past. It is almost as if, like Teresa, the Bret Harte character discussed in Chapter 1, their aged presence damningly judges her, to the point that she grows faint and weak, a historical impostor. Given the film's actual outcome, Madeline's confused terror in their presence is devastatingly comprehensible, as is Hitchcock's brilliance in choosing them as one of the film's early settings that establish Judy/ Madeline's character.

Hitchcock's conscious manipulation of the redwoods as authentic and magnificent historical entities amid deceit in *Vertigo* preceded author John

Steinbeck's embrace of and amused skepticism concerning the same. Steinbeck used his dog, Charley, as a rhetorical foil to temper his excited regard for the trees in *Travels with Charley—In Search of America* (1962). The writer first glowingly saw the trees as great "godlike thing[s]," recalling that "since my earliest childhood, [I] have lived among them, camped and slept against their warm monster bodies, and no amount of association has bred contempt in me." They have a masterfully unique effect on the viewer, for "once seen, [they] leave a mark or create a vision that stays with you always," one uncaptured by artists. "No one has ever successfully painted or photographed a redwood tree," he maintained, because "the feeling they produce is not transferable. . . . The vainest, most slap-happy and irreverent of men, in the presence of redwoods, goes under a spell of wonder and respect. Respect—that's the word. . . . Such is the impact of the sequoias on the human mind."[10]

Steinbeck ultimately mocked this heightened appreciation, however, by humorously describing his dog's rejection of them. At first worried that Charley, his Long Island black poodle, might become insane from the experience of viewing them—that he "might be set apart from other dogs" or, alternately, become a "consummate bore" or "pariah" because of the visit—Steinbeck chose to withhold from Charley any earlier discussion about them. When they came to "the grandfather, standing alone," Steinbeck opened his camper's back door and silently watched Charley for his confirmation of their majesty and beauty. But Charley first merely wandered over to a weed, then a sapling, and next a stream's edge for a drink, before sauntering off elsewhere. Steinbeck desperately tried to redirect him, pointing at the "grandfather" and enthusiastically saying, "look!" but nevertheless was unable to control Charley's attention fully. Exasperated, he grasped Charley's muzzle, pointed it upward at the tree, and interpreted the view for him, saying "look Charley. It's the tree of all trees. It's the end of the Quest." But again, Charley sauntered off uninterested. Defeated and disgraced, Steinbeck resignedly cut off a small willow branch and stuck it in the ground "so that its greenery rested against the shaggy redwood bark." After sniffing its newly cut leaves, Charley adjusted himself to gain "range and trajectory" and fired, his pissing on the redwood an ironic and amusing commentary on the trees' assumed significance as grand objects of majestic antiquity.[11]

Hitchcock's and Steinbeck's works suggest that the trees were more useful as foils to reflect on the larger issue of cultural celebrity and its influence—the trees had become so familiar as icons that their reputation could be used to comment on itself. However, although these postwar artists figured the Coast redwood groves as deceitful places—or even a humorous sham—regard for the big trees as a true sign of the nation's age and admirable character had prevailed for nearly a century. The trees had indeed captivated Americans. Representing different cultural and political issues over time, these natural relics gave America appropriate symbols around which discussion about national identity and history eagerly anchored.

NOTES

PREFACE

1. Indeed, most scholarly and popular works only generally recount Americans' reactions to the big trees, with their analysis usually veering off from cultural interpretation toward historical narrative or botanical description. A complete listing of such literature is impossible but would include coffee-table books such as Jeremy Joan Hewes's *Redwoods: The World's Largest Trees* (New York: Smithmark, 1993); and state and national park informational publications, such as Joseph H. Engbeck Jr.'s *The Enduring Giants* (Sacramento: California Department of Parks and Recreation, 1973); Lary M. Dilsaver and William C. Tweed's *Challenge of the Big Trees* (Three Rivers, CA: Sequoia Natural History Association, 1990); Tweed's *The General Sherman Tree: The World's Largest Living Thing* (Three Rivers, CA: Sequoia Natural History Association, 1988); and Tweed's *Kaweah Remembered: The Story of Kaweah Colony and the Founding of Sequoia National Park* (Three Rivers, CA: Sequoia Natural History Association, 1986). Such works only summarize the trees' discovery, their preservation history, or the cliché of their timeless, hallowed meaning. Peter Johnstone's *Giants in the Earth: The California Redwoods* (Berkeley, CA: Heyday Books, 2001), is an admirable primary collection of prose, poetry, and photography devoted to both the Coast and Sierra redwoods' appreciation—but remains a source for scholars and sequoia enthusiasts, not a synthesis.

The few works that do include cultural analysis consider the big trees' nineteenth-century imagery exclusively and also neglect extensive iconographic study of the images. Gerald L. Carr details Bierstadt's career and its relevance to the provenance and reception history of the artist's big tree portraits, but includes no

interpretations of the individual paintings. See Carr, "Albert Bierstadt, Big Trees, and the British: A Log of Many Anglo-American Ties," *Arts Magazine* 60 (Summer 1986): 60–71. Those scholars who do provide closer readings and also adopt a wider cultural lens—the connection between national identity and the sequoias—suggest an approach worth emulating. However, their analyses are brief case studies, often parts of book chapters, again relegating the trees' iconography to subsidiary status. The scholarship on the trees' visual culture is thus remarkable not only for its brevity but also for its tentative analysis of individual images. Jed Perl's article, "The Vertical Landscape: 'In the Redwood Forest Dense,'" is an exception. He focuses on compositional changes and similarities in his survey of the big trees' representation but unfortunately leaves out consideration of the cultural context that would explain the emergence of their compositions' idiosyncrasies during certain periods. The article is, however, an admirable discussion of the extent and composition of sequoia imagery. See *Art in America* 64 (January/February 1976): 59–63.

Other examples would certainly include one of John F. Sears's chapters in *Sacred Places: American Tourist Attractions in the Nineteenth Century* (New York: Oxford University Press, 1989). A study of Yosemite's cultural meaning, the section details the significance of Yosemite itself and tourists' participation there during the late nineteenth century, but it includes only a few pages of analysis of both the big trees and their iconography, the latter of which is unfortunately mainly descriptive. Nancy K. Anderson incorporates a more challenging and satisfying study of the trees' imagery by focusing on how art of the West, including that of the sequoias, both expressed cultural needs and embodied commercial functions. Nevertheless, her analyses of the big trees' visual representation are somewhat brief, perhaps because the chapter includes three other sizable case studies. The result is that she is unable to take the time to problematize thoroughly the iconographic elements in each big tree painting. Given the overall aims of each of their chapters, Sears's and Anderson's readings appear as passing interpretations. See Sears, *Sacred Places* (New York: Oxford University Press, 1989), Chap. 6; Anderson, "'The Kiss of Enterprise': The Western Landscape as Symbol and Resource," in William H. Treuttner, ed., *The West as America: Reinterpreting Images of the Frontier, 1820–1920* (Washington, D.C.: Smithsonian Institution Press, 1991), pp. 237–83.

Simon Schama, however, takes more interpretive chances in *Landscape and Memory*. His reading of Bierstadt's and Watkins's big tree portraits considers more fully the historical context of the Civil War–Reconstruction era. More important for my own interests, he interprets sequoia photographs and paintings together as expressive of national concerns. Unfortunately, he does not note the linkage between either big tree naming practices and Civil War figures or the iconographical significance of trees themselves in American culture. His subject of analysis is European perceptions of landscape, however, and not American. See Schama, *Landscape and Memory* (New York: Vintage Books, 1995), Chap. 4, especially 185–201.

CHAPTER 1. NATIVE TALISMANS

1. For the earliest and most famous publication of Dowd's story, see Nathaniel Parker Willis, "The Mammoth Trees of California," *Hutchings' California Magazine* 3 (March 1859): 385–97.

2. See Dennis G. Kruska, *Sierra Nevada Big Trees: History of the Exhibitions, 1850–1903* (Los Angeles: Dawson's Book Shop, 1985).

3. Henry James, *Hawthorne* (Ithaca, NY: Cornell University Press, 1997/1879), p. 121; Nathaniel Hawthorne, *The Marble Faun* (New York: New American Library, 1961/1860), p. vi.

4. Albert Boime has studied the frequency of elevated, panoramic landscape views in *The Magisterial Gaze: Manifest Destiny and American Landscape Painting, circa 1830–1865* (Washington, D.C.: Smithsonian Institution Press, 1991). This dominant, imperial perspective was so common in American paintings, Boime argues, that it revealed Americans' unequal regard for nature. It posited nature as valuable only for the potential prospects envisioned by a higher placed viewer, whose position assumed a divine connection and right to claim such a bounty.

 Other scholars have studied Europe's influence on American perceptions of nature, but the following provide its most focused analysis. William Cronon describes the European cultural filter and how it led to landscape's commodification in *Changes in the Land: Indians, Colonists, and the Ecology of New England* (New York: Hill and Wang, 1983). He offers an eloquently philosophical overview of the phenomenon and its current implications in "The Trouble with Wilderness; or, Getting Back to the Wrong Nature," in William Cronon, ed., *Uncommon Ground: Toward Reinventing Nature* (New York: W. W. Norton, 1995), pp. 69–90. He observes that longing forms the heart of nature-becoming-culture, because "there is nothing natural about the concept of wilderness. It is entirely a creation of the culture that holds it dear, a product of the very history it seeks to deny," and that what we behold in nature is "the reflection of our own unexamined longing and desires." In such a process wilderness ironically comes "to reflect the very civilization its devotees [seek] to escape" (pp. 69–70, 78, 79), which, in reference to nineteenth-century Americans, meant European aesthetics and land-use practices. Ralph Waldo Emerson admitted as much in "Nature" (1836), conceding that "what we are, that only can we see" [in William H. Gilman, ed., *Selected Writings of Ralph Waldo Emerson* (New York: New American Library, 1965), p. 222]. In the tradition of such insights, Ray Allen Billington advances a similar argument in *Land of Savagery, Land of Promise: The European Image of the American Frontier in the Nineteenth Century* (New York: W. W. Norton, 1981). He bases his conclusions instead on an estimable survey of nineteenth-century ephemeral material produced by European "image-makers," which included travel writers, promoters (immigration companies, real estate speculators, guidebook authors and editors, employees of state and territorial immigration agencies), and novelists. Billington convincingly maintains that Europe's promotional industry encouraged Americans to see nature as both promising and wild—willingly awaiting domestication. Such an endorsement of nature's value as commodity, he avers, depends on programmed or "learned reactions," an argument that assumes that such cultural processes are inevitable. Billington's work nevertheless strongly proves that regarding nature "we [Americans] like what we have been taught to like, and approve what we have been conditioned to approve" (p. 79).

5. Many scholars have studied nature's centrality in forming American identity. Rather than attempt an exhaustive list, I will enumerate some that are useful. Roderick Nash's seminal work, *Wilderness and the American Mind*, 3d ed. (New Haven, CT: Yale University Press, 1982/1967), firmly established the understand-

ing that Americans considered the nation's aged yet pristine landscape "a cultural and moral resource and the basis for national self-esteem" (p. 67). See Chap. 4 for his discussion of the "*American* wilderness." See also John F. Sears, *Sacred Places: American Tourist Attractions in the Nineteenth Century* (New York: Oxford University Press, 1989), especially Chaps. 1 and 8, for Niagara Falls's cultural significance as a natural site that evoked nineteenth-century American identity. For an examination of these issues and subjects in American painting, see Barbara Novak, *Nature and Culture: American Landscape and Painting, 1825–1875* (New York: Oxford University Press, 1980); and for a case study of the Grand Canyon's significance, see Stephen J. Pyne, *How the Canyon Became Grand; A Short History* (New York: Viking, 1998). Finally, for a fascinating discussion of nature-becoming-culture, or a "postwestern" analysis of "the story of a wild nature, discovered, domesticated, and transformed into something (or someone) 'productive'" (p. x), see Frieda Knobloch, *The Culture of Wilderness: Agriculture as Colonization in the American West* (Chapel Hill: North Carolina University Press, 1996).

6. More scholars have studied the impact of the forest on the American imagination than that of the nation's individual trees. For a sense of the former, see Hans Huth, *Nature and the American: Three Centuries of Changing Attitudes* (Berkeley: University of California Press, 1957), Chap. 3; Nash, *Wilderness and the American Mind*, Chap. 4; Thomas R. Cox, ed., *This Well-Wooded Land: Americans and Their Forests from Colonial Times to the Present* (Lincoln: Nebraska University Press, 1985), Chaps. 4 and 8; and Michael Williams, *Americans & Their Forests: A Historical Geography* (New York: Cambridge University Press, 1989), especially Chap. 5, pp. 120–28. Simon Schama's work on this subject is unique because he provides analysis of the cultural history of forests *and* trees in Europe in *Landscape and Memory* (1995). His work is useful to note for its analysis of Europeans' regard for forests and trees and their imaginative use of their symbology. These traditions more than likely later carried over from Europe to the United States or certainly influenced Americans' ways of regarding their trees. The few other scholars who have produced analyses of trees and their symbolism in America mostly focus on the elm tree. See Michael Kammen, *Meadows of Memory: Images of Time and Tradition in American Art and Culture* (Austin: Texas University Press, 1989), p. 134; also Howard Mansfield provides a fascinating account of late–nineteenth-century northeastern Americans' reverence for old neighborhood trees and fears over their disappearance—particularly the elm—in *In the Memory House* (Golden, CO: Fulcrum, 1993). See Howard Mansfield, "The Passing of Tall Tree America," in *In the Memory House* (Golden, CO: Fulcrum, 1993), pp. 165–92. For a more anecdotal perusal of a variety of other kinds of trees, see Gayle Brandow Samuels, *Enduring Roots: Encounters with Trees, History, and the American Landscape* (New Brunswick, NJ: Rutgers University Press, 1999).

7. Benson John Lossing, "American Historical Trees," *Harper's New Monthly Magazine* 24 (May 1862): 721, 722, 736.

8. For more in-depth case studies of the Charter Oak's cultural significance, see William Hosley, *Colt: The Making of an American Legend* (Amherst: Massachusetts University Press, 1996); Samuels, *Enduring Roots*, Chap. 1; and Lori Ann Vermaas, "The National Trees: Celebrating the Sequoias—Their Trunks, Roots, Stumps, Bark—and Their Depiction as Big Trees in America, 1852–1944," Ph.D. dissertation, University of Iowa, 2000, pp. 12–20.

9. Curtis Guild, "From the Boston *Traveller*: The Charter Oak," Hartford *Daily Times,* August 26, 1856, 2:5.

10. The most alarming example of human abuse the oak suffered occurred in the early 1850s, when some mischievous boys exploded a firecracker in its hollow, leaving only the shell of its bark and a thin crust of its main trunk to support its upper trunk and branches.

11. For additional case studies of historic trees and their cultural analysis, see Vermaas, "The National Trees," Chap. 1. Regardless of the deep reverence with which they beheld many individual trees, most Americans saw them as material resources during the nineteenth century, a fact that informs and complicates the celebration of trees for their historical qualities. Deforestation had occurred to such an extent in the Northeast that by the mid–nineteenth century more and more Americans became concerned about the fate of the nation's forests, inspiring paeans to the sacred and historic qualities of the most venerable of those trees in the Northeast that remained. For a study of the lumber industry's expansion during the first half of the nineteenth century, see Williams, *Americans & Their Forests,* Chap. 5; and for a more detailed examination of Americans' attitudes and perceptions concerning forest use and the lumber industry, see Cox, *This Well-Wooded Land,* Chap. 8.

12. The Yosemite bill is quoted in Alfred Runte, *National Parks: The American Experience,* 2d ed. (Lincoln: Nebraska University Press, 1987), p. 28.

 The big trees were apt torchbearers, given that by the end of the nineteenth century, almost all of the nation's historic trees were dead, exhumed, and—even in the case of the Charter Oak—covered by land improvements. "Nothing now remains to mark the spot where the tree that protected the Charter of Connecticut once stood," including its stump, lamented a local Hartford reporter. As soon as 1858, the spot was cut up and cleared for private development—not, as previously arranged, for the new state capitol building. See "Charter Oak Place," Hartford *Daily Times,* September 1, 1858, 2:5. Regardless of such treatment, the death of the tree did not destroy either the widespread and deeply felt feeling it evoked or its symbolic value—then or now. The brisk trade in Charter Oak artifacts after its demise and the choice of the tree to ornament one of the U.S. Mint's special edition quarters in 1999 prove its staying power as a culturally meaningful American tree.

 With less national fanfare, Boston suffered a major loss when a storm blew down its oldest historic tree, known as the Monarch or Old Elm on Boston Common, during the nation's centennial year of 1876, a symbolically distressing event. By July 1900, a Boston writer evinced concern about the increasing disappearance of many historic trees. Saying that "the number of our old trees is fast diminishing," Abbie Farwell Brown noted that it was becoming more difficult to preserve and protect those that remained. "It is a wonder," Brown states, "that Boston still preserves any of its early trees." Although no other city could "point to so many historic trees and ancient landmarks which have escaped the ax to tell us of another time long passed," the nation's history was dying and disappearing even in Boston, according to Brown. See "Notable Trees about Boston," *New England Magazine* n.s. 22: 503.

13. Willis quoted in Willis, "The Mammoth Trees of California," p. 391. For the grove's discovery, description, estimate of tourist numbers, and reputation, see Lafayette Houghton Bunnell, *Discovery of the Yosemite, and the Indian War of 1851, which Led to that Event* (Chicago: Fleming H. Revell, 1880), p. 344; and

Stanford E. Demars, *The Tourist in Yosemite, 1855–1985* (Salt Lake City: Utah University Press, 1991), p. 10.

14. Willis, "Mammoth Trees of California," p. 387. For the Emerson quote, see Ralph Waldo Emerson, "Nature," in Gilman, ed., *Selected Writings of Ralph Waldo Emerson,* p. 189.

15. Willis, "Mammoth Trees of California," p. 396.

16. Clarence King, *Mountaineering in the Sierra Nevada* (New York: W. W. Norton, 1871), p. 62.

17. The act of naming is an act of claiming, one that announces ideological and imaginative control. Historian Alan Trachtenberg has explained that something named "has been seen, known, and thereby already possessed." See *Reading American Photographs: Images as History, Mathew Brady to Walker Evans* (New York: Hill and Wang, 1989), p. 125.

18. Kellogg quoted in Joseph Ewan, *William Lobb, Plant Hunter for Veitch and Messenger of the Big Tree (University of California Publications in Botany, Volume 67)* (Berkeley: University of California Press, 1973), p. 7. For Lindley's comments, see Dr. John Lindley, untitled article, *Gardeners' Chronicle* (December 24, 1853): 820.

19. Ewan, *William Lobb,* p. 8.

20. Asa Gray, "Mammoth Trees of California," *American Journal of Science and Arts* 18(52, 2d series, July 1854): 287.

21. Lindley's passion for the name and its precedence was such that he would not relinquish it years later. In a letter to Andrew Murray, a British botanist, on January 5, 1860, he "presumed to differ from . . . [other] authorities." "I adhere to my opinion that *Wellingtonia* is necessarily distinguished from *Sequoia,*" quoted in Andrew Murray, "Notes on Californian Trees," *Edinburgh New Philosophical Journal* n.s. 11 (April 1860): 210. Regarding the chronology of American botanists' efforts to name the tree for America, accounts of both the provenance of Torrey's exam specimens and explanations regarding his findings' delay are unclear, given conflicting accounts by contemporaries such as Dr. Seemann and historians. For Berthold Seemann's account, see "On the Mammoth-Tree of Upper California," *Annals and Magazine of Natural History* 3(15, 3d series, March 1859): 164, 165. Charles Howard Shinn claimed in 1889 that Torrey did receive and examine Kellogg's transited samples in 1853, and Asa Gray suggested the same in 1854, even though most historical accounts state otherwise. See Shinn, "The Great Sequoia," *Garden and Forest* 2 (December 25, 1889): 614; and Gray, "On the Age of the Large Tree Recently Felled in California," *American Journal of Science and Arts* 17(49, 2d series, January 1854): 443. Another, although tentative, explanation for the discrepancy may be that Torrey erroneously based his original analysis on a Coast redwood trunk section that P. T. Barnum had intentionally passed off to uninformed viewers as a big tree in Philadelphia that year. Torrey notes in a letter to Gray that C. C. Parry, another American botanist, had examined redwood specimens at Philadelphia's Academy of Science in January 1854, a small sample of which Torrey forwarded in early February to Gray. Based on such a sample (which may or may not have been a Coast redwood), Torrey wondered if the *"Wellingtonia"* was "a very old state of Sequoia," an inquiry with which Gray concurred a week later, saying "is [it] not . . . a *congener* of Sequoia?" Apparently it was not until June before any account confirms that Torrey viewed an actual Sierra redwood—the Mother of the Forest at Sydenham, England. See

Ewan, *William Lobb,* p. 9. If Torrey did indeed originally examine a Coast redwood, such confusion no doubt delayed his conclusions, especially because he had conferred with Gray. Dr. Gray admits his mistaking of a Coast for a Sierra redwood in "Mammoth Trees of California," pp. 286–87.

22. Willis, "Mammoth Trees of California," p. 390; Anonymous, "The Big Trees of California," *Harper's Weekly* 2 (June 5, 1858): 357, 358.

23. C. F. Winslow, "Dr. C.F. Winslow's Letters from the Mountains. The 'Big Tree,'" *California Farmer and Journal of Useful Sciences* 2 (August 24, 1854): 58. He refers to the Calaveras Grove as "Washington Mammoth Grove."

24. Murray, "Notes on Californian Trees," p. 207; Brick was a self-important and alcoholic character in Charles Dickens's scathing *The Life and Adventures of Martin Chuzzlewit* (London: Oxford University Press, 1959/1844).

25. Thomas Pakenham, *Meetings with Remarkable Trees* (New York: Random House, 1998), p. 55. For other transplantation accounts, see Donald Culross Peattie, *A Natural History of Western Trees,* 3d ed. (Boston: Houghton Mifflin, 1953), p. 9. The Prince and Princess of Wales participated in the fanaticism for sequoias in 1868 when they each planted a young sequoia in Phoenix Park, Dublin. See Carr, "Albert Bierstadt, Big Trees, and the British," p. 64. The trees' presence in Britain has apparently become a more prideful fact a century later. See John D. U. Ward, "Sequoias Colonize Britain," *Natural History* 59 (October 1950): 383. For Hoopes, see Josiah Hoopes, *The Book of Evergreens. A Practical Treatise on the Coniferae, or Cone-Bearing Plants* (New York: Orange Judd, 1868), p. 244. The publishers proudly announced their appreciation of the big trees by embossing a gold-leaf big-tree cone on the forest green cover, the vital marker that linked the conifer to the *Sequoia* genus. Hewes, *Redwoods,* pp. 145, 146.

26. Murray, "Notes on Californian Trees," p. 219; Seemann, "On the Mammoth-Tree of Upper California," p. 175. Also see Hewes, *Redwoods,* pp. 145–47, for more about their transplantation throughout Europe. Although most prolifically transplanted overseas, some big trees were successfully replanted in the Eastern United States. According to Hoopes, "the finest specimens to be found in the Northern states" were located in the collection of Ellwanger & Barry, Rochester, New York (p. 243). However, the first big tree in the East was planted as late as 1859 by the Painter brothers at Lima, Pennsylvania, at a property that is now known as the John J. Tyler Arboretum. See Joseph Ewan, "The Philadelphia Heritage: Plants and People," in George H. M. Lawrence, ed., *America's Garden Legacy: A Taste for Pleasure* (Philadelphia: Pennsylvania Horticultural Society, 1978), pp. 1–18, especially p. 13.

27. Murray, "Notes on Californian Trees," p. 208.

28. Seemann, "On the Mammoth-Tree of Upper California," p. 172; Murray, "Notes on Californian Trees," pp. 215–17.

29. George W. Pine, *Two Wonders of the World. Yosemite, Mammoth Trees, and Bird's-Eye View of California* (New York: Herkimer, 1873), p. 45. Nelsons' Pictorial Guide-Books also lists many sequoia names, including Satan's Spear and Giant's Tower. See *The Yosemite Valley, and the Mammoth Trees and Geysers of California* (New York: T. Nelson and Sons, 1870), pp. 27–34. Nelson defends Americans' naming practices from British criticism by saying "we do not see why we should not take [the names] from contemporary history in our own country, as well as go back to 'Titus' and 'Jerusalem'" (p. 32). Sometimes British visitors did

name the trees. Nelson notes that a female British tourist named one "after the city of her residence, 'Auld Reekie,'—that is Edinburgh," an act that helped to inspire in her "a kindly recollection of American hospitality" (p. 32).

30. Pine, *Two Wonders of the World,* pp. 39–40; Constance Frederica Gordon-Cummings, *Granite Crags* (Edinburgh: W. Blackwood, 1884), p. 313; Shirley Sargent, *Galen Clark: Yosemite Guardian* (San Francisco: Sierra Club, 1964), pp. 97–98.

31. Isaac Bromley, "The Big Trees and the Yosemite," *Scribner's Monthly* 3 (January 1872): 266.

32. Bayard Taylor, *New Pictures from California* (Oakland, CA: Biobooks, 1951/ ca. 1860s), pp. 122, 123.

33. George G. MacKenzie (Lewis Stornaway), *Yosemite! Where to Go & What to Do. A Plain Guide to the Yosemite Valley, the High Sierra, & and Big Trees* (San Francisco: C. A. Murdock, 1888), p. 74; Gordon-Cummings, *Granite Crags,* p. 306.

34. Pine, *Two Wonders of the World,* pp. 45–46.

35. Conner's work quoted in Willis, "The Mammoth Trees of California," p. 389.

36. Interpretations such as these persisted well into the early twentieth century, and sometimes Europeans even promoted them. After viewing the sequoias while on a world tour in the 1910s, Count Hermann Keyserling, whose philosophical work inspired the spiritual work of thinkers such as Carl Jung and Herman Hesse, triumphed over their location as unequivocally prophetic in Hermann Graf von Keyserling, *The Travel Diary of a Philosopher* (New York: Harcourt, Brace, 1925). As the youngest of the all the continents, America was the site of the world's future redemption, Keyserling forecast, its "refuge." "The man of the New World fits into the sequoia grove, this oasis of prehistoric days, better than into the ruins of Rome," an affinity that would spark humankind's complete evolution, rather than stymie it, as had Europe's. See Johnstone, *Giants in the Earth,* pp. 216, 218.

37. Walt Whitman, "Song of the Redwood-Tree," in Lawrence Buell, ed., *Leaves of Grass and Selected Prose* (New York: Modern Library, 1980), pp. 165–69, especially p. 166. James Perrin Warren ignores the context of the redwoods' celebrity; among two other interpretations, his most compelling focuses on Whitman's affinity for evolutionary theory and how it alluded to America's progressive march via the redwood metaphor. See "Contexts for Reading 'Song of the Redwood-Tree,'" in John Tallmadge and Henry Harrington, eds., *Reading under the Sign of Nature: New Essays in Ecocriticism* (Salt Lake City: Utah University Press, 2000), pp. 165–78.

38. Josiah D. Whitney, *Geological Survey of California, the Yosemite Guide-Book: A Description of the Yosemite Valley and the Adjacent Region of the Sierra Nevada, and of the Big Trees of California,* 2d ed. (Cambridge: Welch, Bigelow, 1870), p. 141.

39. Anonymous, "A Romance at South Dome," *Overland Monthly* 8 (2d series, July 1886): 63.

40. Bret Harte, *The Writings of Bret Harte, vol. 4. In the Carquinez Woods and Other Tales* (Boston: Houghton Mifflin, 1912/1883), pp. 8, 14.

41. Ibid., 1, 35. Mary Austin similarly described the trees' powerful silence as a judgment of humans' irrelevance forty-four years later in Mary Austin, *The Lands of the Sun* (Boston: Houghton Mifflin, 1927). Commenting on the utterances of Sierra trees, she identified the sequoias as inimitable, because it was "voiceless; it speaks, no doubt, but it speaks only to the austere mountain heads, to the mindful wind

and the watching stars. It speaks as men speak to one another and are not heard by the little ants crawling over their boots." See Johnstone, *Giants in the Earth,* p. 213.

42. Eli Perkins, "California's Big Trees," *New York Times,* June 17, 1877, 5:7.

43. Sears finds that Niagara Falls's visitors in the 1830s and 1840s reacted similarly, an experiential process resembling "the pattern of religious conversion [tales] so familiar to nineteenth-century Americans" (p. 15). See Sears, *Sacred Places,* Chap. 1, "'Doing' Niagara Falls in the Nineteenth Century." For another wonderfully thorough and descriptive account of a tourist's conversion, see Henry Morford, *Morford's Scenery and Sensation Hand-Book of the Pacific Railroad and California* (New York: Charles T. Dillingham, ca. 1870s), pp. 254–62.

44. James D. Smillie, "The Yosemite," in William Cullen Bryant, ed., *Picturesque America, Volume I* (New York: D. Appleton, 1872), pp. 464–95.

45. Ibid., p. 472.

46. Ibid., pp. 472, 474. Morford commented that such a hunger to see—really *see*—the big trees was such a commonly overwhelming tourist desire that it damaged visitors' ability to appreciate the towering size characteristic of all Sierra trees encountered on their pilgrimage, not just the sequoias. "They go to look for, and at, *the* Big Trees; and, looking for *them,* they seem to lose sight of the truth that *they are riding, league upon league, through tree-growth only less gigantic than the culmination to which they proceed, and that anywhere else would be simply colossal and incredible*" (Morford, *Morford's Scenery and Sensation Hand-Book,* p. 253).

47. Thomas Starr King, "A Vacation among the Sierras—No. 4. *The Big Trees,*" *Boston Evening Transcript,* January 12, 1861, 1:2; Bromley, "The Big Trees and the Yosemite," p. 267; Anonymous, "To the Big Trees," *Overland Monthly* 5 (November 1870): 401.

48. John S. Hittell, *Yosemite: Its Wonders and Its Beauties* (San Francisco: Bancroft, 1868), p. 58; for more warnings of letdowns, see Benjamin F. Taylor, *Between the Gates* (Chicago: S. C. Griggs, 1878), p. 206, and Nelsons's Pictorial Guide-Books, p. 31. Whitney's comment in Whitney, *Geological Survey of California,* p. 154.

49. Grace Greenwood, "Notes of Travel. Going into the Yosemite," *New York Times,* July 22, 1872, 5:3; Nelsons's Pictorial Guide-Books recommends the same "mode of realizing [their] stature" from a reclining position at a sequoia's base, pp. 31–32. For an eyewitness description of the ladders, see Gordon-Cummings, *Granite Crags,* p. 307.

50. Perkins, "California's Big Trees," 5:7.

CHAPTER 2. FIRST VIEWS

1. For a discussion of the cultural and social influences in America that inspired scientific investigation into optical phenomena, see Edward W. Earle, "The Stereograph in America: Pictorial Antecedents and Cultural Perspectives," in Earle, ed., *Points of View: The Stereograph in America—A Cultural History* (New York: Visual Studies Workshop Press, 1979), pp. 9–21. Earle stresses that stereography, as a branch of photography, arose because of Americans' "curiosity in optical systems and an emerging interest in the informational content of prints produced by engraving, etching, and lithography" (p. 11). For a description of Wheatstone's

inquiries, see Jonathan Crary, *Techniques of the Observer: On Vision and Modernity in the Nineteenth Century* (Cambridge, MA: MIT University Press, 1990), pp. 118–22.

2. Oliver Wendell Holmes, "Doings of the Sunbeam," *Atlantic Monthly* 12 (July 1863): 1–15.

3. For studies of stereography's popularity, see Jib Fowles, "Stereography and the Standardization of Vision," *Journal of American Culture* 17 (Summer 1994): 89–93; and Earle, *Points of View*, especially Howard S. Becker, "Stereographs: Local, National, and International Art Worlds," pp. 89–96; and Harvey Green, "Pasteboard Masks: The Stereograph in American Culture, 1865–1910," pp. 109–15.

4. For cogent descriptions and discussion of stereographic viewing and its technological and philosophical history, see Rosalind Krauss, "Photography's Discursive Spaces: Landscape/View," *Art Journal* 42 (Winter 1982): 311–19; and Crary, *Techniques of the Observer*, pp. 122–36.

5. William Culp Darrah, *Stereo Views: A History of Stereographs in America and Their Collection* (Gettysburg, PA: Times and News, 1964), p. 75.

6. Biographies on these artists only identify the most successful and active Yosemite stereographers in the years leading up to the nation's centennial. Watkins and Muybridge repeatedly visited Yosemite in the 1860s and 1870s (Watkins made a career of its documentation), Reilly opened a photographic studio there in the 1870s, and Houseworth operated a dominant stereograph publishing house in the state during this period. For Reilly's activities at Yosemite in the early to mid–1870s, see Peter E. Palmquist, ed., *J.J. Reilly: A Stereoscopic Odyssey, 1838–1894* (Yuba City, CA: Community Memorial Museum, 1989). A sizable listing of Watkins's stereographs can be found in California State Library, *Carleton E. Watkins: A Listing of Photographs in the Collection of the California State Library* (Sacramento, CA: Author, 1984); the Bancroft Library (University of California, Berkeley) also houses a substantial collection. Mary V. Jessup Hood and Robert Bartlett Haas provide the most detailed account and description of Muybridge's two Sierra trips and Yosemite work in "Eadward Muybridge's Yosemite Valley Photographs, 1867–1872," *California Historical Society Quarterly* 42 (March 1963): 5–26. Unfortunately, they focus more on Muybridge's valley photography, with only brief mentions of those of the trees. A "mammoth tree" series of twenty-five stereograph views of Calaveras Grove, probably secured in 1867, and a group of Mariposa Grove images produced during an 1872 Yosemite trip—twenty-five stereographs, seven 5 1/2″ × 8 1/2″ photographs, and a larger (17″ × 21″) tree portrait, *William H. Seward. 85 Feet in Circumference. Mariposa Grove of Mammoth Trees. No. 51* [*Valley of the Yosemite, Sierra Nevada Mountains, and Mariposa Grove of Mammoth Trees* by Eadweard Muybridge (The Bancroft Library, University of California, Berkeley)] are the only ones mentioned. For the brief mentions, see Hood and Haas, pp. 8 and 19.

Bradley and Rulofson, owners of a prestigious San Francisco photographic gallery and supply house, published Muybridge's Yosemite work in *Catalogue of Photographic Views . . .* (San Francisco: Bradley & Rulofson, 1872), but Hood and Haas claim that no catalogue containing a "complete set" of Muybridge's output during this second trip has been found (p. 5). Contributing to such a publication quandary is the fact that Muybridge originally had an understanding to publish

this collection through Thomas Houseworth's company, whose spurning prompted Houseworth to produce a badly reproduced replica, which bore Bradley & Rulofson's imprint. For an interesting survey of stereographic history and Houseworth's early integral involvement in producing Western imagery (partnered with George Lawrence until 1868), see Peter E. Palmquist, *Lawrence & Houseworth/Thomas Houseworth & Co.: A Unique View of the West, 1860–1886* (Columbus, OH: National Stereographic Association, 1980).

Many other big-tree stereographers thrived during this period. A thorough history of their work, however, is incredibly difficult to tease out, and desperately requires a book all its own. Peter Palmquist provides a brief but helpful historical overview of California stereography in *Return to El Dorado: A Century of California Stereographs* (Riverside: California Museum of Photography, 1986). For an even shorter survey, see William C. Darrah, *The World of Stereographs* (Gettysburg, PA: Author, 1977), pp. 83–88 and 98–99. Certainly other tree stereographers existed, such as Charles Leander Weed, Martin Mason Hazeltine, Thomas C. Roche (in Yosemite from 1870 to 1871), Charles Bierstadt (painter Albert Bierstadt's brother), J. C. Scripture (1870s to 1880s), and Charles L. Pond, and sometimes they worked with one another. Pond was notorious for "signing" his sequoia portraiture by posing alongside the large specimens. See Peter Palmquist, "C.L. Pond: A Stereoscopic Gadabout Visits Yosemite," *Stereo World* 10 (January/February 1984): 18–20. A variety of publishers distributed their work, including E. & H. T. Anthony & Company of New York, John P. Soule of Boston, the Kilburn Brothers of Littleton, New Hampshire, and, later, the Keystone View Company. Roche produced a stereograph of a Mariposa Grove tree that itself bore the name "E. Anthony," the head of the successful New York stereograph publisher and Roche's sponsor. See William and Estelle Marder, *Anthony: The Man, the Company, the Cameras* (Amesbury, MA: Pine Ridge, 1982), p. 158.

Stereography enjoyed incredible popularity throughout the nineteenth century, to the point that image quality became less important to patrons—even as photographers' talents improved. By 1900 Keystone swallowed up so many other companies and their storehouses of negatives, including sequoia images, that their dating and attributive information is largely inaccurate. Most Keystone stereos dated in the 1890s were probably produced earlier and by photographers whose names are not included on the cards.

7. Big-tree stereography often followed a recipe, a lucrative and repetitive approach whose success was not unprecedented. Thomas Southall similarly argues that stereographs of the White Mountains in northern New Hampshire, roughly between 1865 and 1875, stylistically resembled one another (including titles, viewpoints, and subject matter), revealing a "collective vision" concerning nature as art. Arguing that "the idea of nature as a work of art was the underlying force behind the development of the White Mountains as a tourist attraction," Southall regards stereographs as instructional devices for prospective tourists as well as keepsakes for actual tourists who wanted to remember what they had experienced. However, the underlying force behind the sequoias' conversion into a tourist site was less the result of artistic pedagogical impulses than concerns about historical cycles and national identity. See Thomas Southall, "White Mountain Stereographs and the Development of a Collective Vision," in Earle, *Points of View*, pp. 97–108.

8. Peter E. Palmquist, *Carleton E. Watkins: Photographer of the American West*

(Albuquerque: New Mexico University Press, 1983), p. 18; Darrah, *World of Stereographs*, p. 83; Holmes, "Doings of the Sunbeam," p. 8.

9. Responses to the Yosemite prints not only benefited Watkins's career, but they also influenced American art and federal environmental policy. Watkins's social circle was the first audience for the finished Yosemite prints, and their enthusiasm ultimately led to their exhibition in New York. William H. Brewer of the Geological Survey called them "the finest I have ever seen" and bought several for his own collection. After Rev. Thomas Starr King viewed them, his endorsement encouraged other buyers, including Ralph Waldo Emerson. Soon the photographs were on display in a San Francisco art gallery. See Palmquist, *Carleton E. Watkins: Photographer,* p. 18 and n45.

When Watkins next exhibited the two big-tree images and twenty-eight others of the valley in New York, their exhibition created a stir. One writer reported that the pictures "caus[ed] exclamations of awe" as pedestrians looked in the gallery show's window. The New York *Evening Post* found them "indescribably unique and beautiful. Nothing in the way of landscape can be more impressive or picturesque." With this first eastern showing of photographic views of the Far West, Watkins publicized the region's unique botanical marvels and geographical splendors to an intensely curious audience. For pedestrians' reactions, see Fitz Hugh Ludlow, "Seven Weeks in the Great Yo-Semite," *Atlantic Monthly* 13 (June 1864): 740; and "Art Items," New York *Evening Post,* December 11, 1862, 2:4.

His work inspired other visual artists such as Edward Vischer and Albert Bierstadt to follow suit. That his Western pictures could be featured in one of New York's most prestigious galleries was an inspiration to them as well. Vischer, a California graphic artist whose work helped to publicize the trees throughout the 1860s and into the 1870s, highly regarded Watkins's big tree images, calling them examples of "the most perfect rendering of landscape we have ever seen accomplished by the instrument." See Edward Vischer, *The Forest Trees of California. Sequoia Gigantea. Calaveras Mammoth Tree Grove. Photographs, from the original drawings of Edward Vischer, with contributions from various sources* (San Francisco: Author, 1864).

The grove and valley's uniqueness and majesty, as depicted by Watkins, convinced politicians of the importance of their preservation. After Watkins had published the exhibited views in *Yo-Semite Valley: Photographic Views of the Falls and Valley* (1863), the federal government set aside the grove and valley for permanent protection. Watkins's stunning photographs so impressed landscape architect Frederick Law Olmsted, who had been appointed chair of the Yosemite Commission in 1864, that he solicited him for suggestions on how to preserve the park. Watkins's close association with Yosemite eventually led one of the mountains to be named after him in 1865.

10. For discussion of the "best view," see Palmquist, *Carleton E. Watkins: Photographer,* p. 9. Watkins's motives for constructing the mammoth camera and recording the massive trees and nearby valley, which lay 36 miles north of the Mariposa Grove, have been matters of much speculation. After the 1906 San Francisco earthquake, fire consumed the city and essentially destroyed Watkins's records and much of his photographic collection. These losses led to considerable uncertainties about his career, which historians of photography since 1975 or so have attempted to reconcile. Commissions involving an 1858 Guadalupe Quicksilver Mine land dispute

and an 1861 San Antonio Rancho boundary disagreement, however, likely pro-
voked consideration of the novel camera's design. The two commissions required
that he create comprehensive and straightforward views of the properties for use
as courtroom evidence that the court subsequently found lacking in enough refer-
ence points. Soon thereafter a chastened Watkins commissioned the construction
of a camera capable of handling large-sized negatives. He first used this camera
during his 1861 Yosemite trip.

With regard to the reasoning behind Watkins's choice to produce in 1861 a col-
lection of Yosemite views, one of the more provocative interpretations links them
to Watkins's dependence on commissions from powerful industrial patrons, such
as Trenor Park, whose enterprises Watkins often depicted. George Dimock argues
that the Yosemite views are "ideological apologetics" for such Western entrepre-
neurial capitalism, especially mining. By composing views of Yosemite in 1861 that
are largely devoid of people and thus eliding their effect on the land, Watkins con-
sciously omitted references to local economic depredation, the kind that motivated
appreciation for Yosemite and its preservation. Dimock contends that Watkins's
Yosemite views "both condoned and atoned" for the exploitation or "rape of the
land" because "they promoted an idealized image of the American landscape which
was totally disconnected from human history." They reinforced Yosemite's sym-
bolism as an Eden, "participating in an ongoing program of scenic deification."
The results are depictions of a landscape existing in "a universal, transcendent, en-
vironmental–ecological state of grace." Only a culture that valued control and
power would construct such landscape views of isolated regions whose beauty they
decided was worth preserving [see Dimock, *Exploiting the View: Photographs
of Yosemite & Mariposa by Carleton Watkins* (North Bennington, VT: Park-
McCullough House, 1984), pp. 17, 18].

Although Dimock's argument about Yosemite is compelling—and it certainly has
corollaries in the careers of other artists, such as Albert Bierstadt's—it is not as per-
suasive when interpreting Watkins's depictions of the big trees. Their cultural
celebrity as historic trees and national landmarks always intrudes. These are trees
that invoked history, inspiring its celebrants to reflect on the past and consider
predictions of the future. They had accumulated specific ideological baggage that
preceded Watkins's celebrated photographs, something less true of Yosemite Val-
ley. The trees were a cultural phenomenon throughout the 1850s, while the valley
was merely a natural wonder—although during the 1860s it would quickly become
as much, if not more, of a national phenomenon as the trees. Thus Dimock's
argument that Watkins's Yosemite views ignore history does not make as much
sense. Watkins did, however, photograph Jerome B. Ford's Mendocino lumber mills
in 1863, probably on commission. These mills processed Coast redwoods and
might serve as additional evidence for Dimock's thesis, although Watkins's por-
trayal of them followed, rather than preceded, his work at the Mariposa Grove.
However convincingly Dimock reveals broad American values, he is less com-
pelling in explaining Watkins's actual motivations to photograph the Mariposa
Grove.

Most scholars speculate that Watkins was ambitious in the early 1860s to en-
large his audience and his national reputation as a respected landscape photogra-
pher. The Mariposa Grove and Yosemite Valley were ideal subjects for such a
move. They offered towering trees and unequalled vistas whose depiction would

challenge and thus improve his photographic skills. By the time Watkins went with the Parks to visit and photograph Yosemite, his seven-year career as a photographer was beginning to come together. He was in his early 30s and had established important social and professional contacts with prominent California families, such as the Frémonts, who played a significant role in California's exploration and state politics, and also scientists, including Josiah Dwight Whitney, head of the California Geological Survey. These connections eventually introduced him to other public figures, artists, and scientists. Thomas Starr King, Ralph Waldo Emerson, Albert Bierstadt, and Asa Gray numbered among them. Watkins was becoming well-connected, which was crucial to the survival of an independent photographer.

11. Palmquist describes well the ordeal of transporting the photographic equipment. See Palmquist, *Carleton E. Watkins: Photographer*, p. 16. Developing the negatives was perhaps the most challenging part of the enterprise. The delicate wet-plate process became even more tenuous when undertaken outdoors, especially given Yosemite's formidable topography and climate. Their preparation had to be done onsite and in darkness, in a "narrow den where the deeds of darkness are done," as Holmes romantically described it in 1863. In the dark tent, the space of which was extremely limited and which by midday could become unbearably hot, Watkins would carefully coat a dust-free glass plate with collodion, a thin syrupy fluid, which allowed other light-sensitive chemicals, such as silver iodide, to adhere to the negative when subsequently applied. Next, he would place it in a shield, which allowed unexposed transference to the camera. After photographing his subject by uncapping the camera's lens, Watkins would need to carry the shield containing the negative back to the dark tent and process the negative by alternately immersing it in chemicals and water (Holmes, "Doings of the Sunbeam," p. 3). During the 1861 visit, he completed one exposure at a time, although by the mid-1860s he would develop a more efficient system of preserving multiple glass-plate negatives, which would enable him to develop prints later at his own, more comfortable, pace (Palmquist, *Carleton E. Watkins: Photographer*, p. 28). For more on the logistical problems of developing the negatives at Yosemite, see Peter E. Palmquist, *Carleton E. Watkins: Photographs, 1861–1874* (San Francisco: Fraenkel Gallery, in Association with Bedford Arts, 1989), p. 215.

12. David Robertson, *West of Eden: A History of the Art and Literature of Yosemite* (Yosemite National Park: Yosemite Natural History Association and Wilderness Press, 1984), p. 56.

13. For a description of Watkins's sequenced approach, see Palmquist, *Carleton E. Watkins: Photographer*, p. 9.

14. Pauline Grenbeaux, "Before Yosemite Art Gallery: Watkins' Early Career," *California History* (Fall 1978): 228. Correspondence verifies the nature of the reproductions in the Appleton publication, although Palmquist has identified smaller sized prints at 6 1/2" × 8 1/2," versus the Huntington Library's version, which Jennifer Watts, rare books librarian, has listed at 8" × 10".

15. "A California Tree," *Daily Alta California,* June 10, 1853, 2:2. There are at least two other exact versions of this lithograph. William Lobb, inveterate collector of tree specimens, must have been involved in the commission of *Wellingtonia Gigantea . . .(185–)*, which was introduced to England by Veitch & Son of Exeter, owners of the British nursery involved in Dr. Lindley's 1853 examination and British botanical naming of the sequoias. The other, *Mammoth Arbor Vitae* (1861),

was based on A. K. Kipps's obvious resketching of Lapham's lithographic portrait. Both of these, like Lapham's original lithograph, are housed in the Robert B. Honeyman Jr. Collection at the University of California, Berkeley. Lapham's lithograph was reprinted in national publications, including *Gleason's Pictorial Drawing-Room Companion* 5 (October 1, 1853): 217.

16. In his analysis of redwood artists' work, Jed Perl describes the compositional challenge with which all such artists have grappled, observing that "the smaller trees tend . . . to diminish the impact of the largest—one lost a sense of proportion. . . . The landscape never 'compose[s]' in the sense of providing the viewer with a proper succession of foreground, middle ground, distance" (see Perl, "The Vertical Landscape," p. 60). For Bayard Taylor's comments, see Taylor, *New Pictures from California* (Oakland, CA: Biobooks, 1951/ca. 1960s), p. 119.

17. For example, Watkins titled his recording of a strawberry tree *Arbutus Menziesii* (ca. 1872–1878, Collection of the Museum of Modern Art, New York, Purchase). His ordered composition encouraged the calm inspection of the forms of a perfectly balanced and centered strawberry tree, with the tree's umbrageous foliage fully dominating the frame. Watkins occasionally used this same empirical procedure (including the use of scientific names for a photograph's title) when depicting the sequoias. Many scholars have explored Watkins's scientific approach. Weston J. Naef mentions Watkins's affinity for examining nature's pure forms in *Era of Exploration: The Rise of Landscape Photography in the American West, 1860–1885* (Boston: Albright-Knox Art Gallery and the Metropolitan Museum of Art, 1975), p. 88, and Paul Hickman similarly notes that Watkins appreciated trees that were "regular in shape and often a cultivated variety, confirming his orderly view of nature." See "On the Life and Photographic Works of George Fiske, 1835–1918," in Paul Hickman and Terence Pitts, *George Fiske: Yosemite Photographer* (Flagstaff, AZ: Northland Press, 1980), pp. 1–37, especially 29.

 As a contrast to Watkins's Yosemite tree portraiture, consider George Fiske's. One of Watkins's assistants on and off from 1868 until the mid-1870s, Fiske became a well-respected Yosemite photographer in the 1870s and 1880s. Unlike Watkins, Hickman points out, "Fiske loved trees for their wildness. . . . He photographed trees irregular in shape and untamed by the wind [*Cedar—Erin's Harp* and *Rock and Tree Study, near Pebble Beach*], trees losing their fight for survival [*Tree Study, Yosemite Valley*], and dead trees [*Dead Oak, Yosemite Valley*], expressing his belief that nature was beyond the control of man, that all things must eventually submit to the natural cycle of living and dying" (Hickman and Pitts, *George Fiske*, p. 29). Ansel Adams believed that if much of Fiske's work had not been destroyed by fire, he "could have been revealed to-day . . . as a top photographer, a top interpretive photographer. I really can't get excited at Watkins and Muybridge—I do get excited at Fiske. I think he had the better eye" (Hickman and Pitts, *George Fiske,* p. viii). Adams cut his teeth as a Yosemite photographer by making prints from Fiske's negatives while working at Yosemite in the 1920s. Such activity no doubt influenced him, because his tree portraits closely resemble Fiske's in temperament and subject. Most of Fiske's work, such as the three mentioned earlier, is housed at the Center for Creative Photography, University of Arizona, Tucson.

18. Rev. H. J. Morton, "The Yosemite Valley," *Philadelphia Photographer* 3 (December 1866): 377.

19. Nanette Margaret Sexton explains the camera's distortions in "Carleton E. Watkins: Pioneer California Photographer (1829–1916): A Study in the Evolution of Photographic Style, during the First Decade of Wet Plate Photography," Ph.D. dissertation, Harvard University, 1982, pp. 138–39. To eliminate the worst of its effects, photographers often dome-topped or otherwise cropped their prints, as Watkins did in the 1861 portrait.

20. Although the 1861 stereograph's location remains unknown, its composition probably resembles the mammoth print's, given that Watkins likely used stereographic prints to help him compose those produced by the unwieldy new camera. No scholar has systematically studied the stereograph's influence on Watkins's (or any other nineteenth-century photographer's) compositional style, but Douglas R. Nickel suggests something of this in his discussion of Victorian Americans' perceptual desire for visual simulacra or "sheer optical spectacle." He concludes that late-nineteenth-century viewers regarded Watkins's photographs as satisfactory "exercises in ocular gratification," the same function so clearly demonstrated by stereographs. See "An Art of Perception," in Nickel, *Carleton Watkins: The Art of Perception* (New York: Harry N. Abrams,1999), p. 32. David Robertson ponders the material aspects of the stereograph's influence, finding Watkins's work an incisive "example of how style comes out of equipment. Style is not simply a function of one's vision, it's also a function of the equipment one deals with." See Naef, *In Focus*, p. 98.

21. For a brief sampling of Mother of the Forest's representation, see Nathaniel Parker Willis, "The Mammoth Trees of California." *Hutchings' California Magazine* 3 (March 1859): 395, and "The Big Trees of California," *Harper's Weekly* 2 (June 5, 1858): 357.

22. Simon Schama heads the list of art historians advocating such an interpretation. He eloquently describes Watkins's photograph as showing a tree that is "storm-racked but defiant and enduring; a perfect emblem for the American Republic on the brink of the Civil War: a botanical Fort Sumter." See Schama, *Landscape and Memory* (New York: Vintage Books, 1995), pp. 190–91.

23. J. D. Whitney, *Geological Survey of California. The Yosemite Book: A Description of the Yosemite Valley and the Adjacent Region of the Sierra Nevada, and of the Big Trees of California* (New York: J. Bien, 1868). For the Whitney quote, see the guidebook edition, Josiah D. Whitney, Geological Survey of California. *The Yosemite Guide-Book: A Description of the Yosemite Valley and the Adjacent Region of the Sierra Nevada, and the Big Trees of California,* 2d ed. (Cambridge: Welch, Bigelow, 1870), p. 2; for the smaller version's review comments, see "Whitney's Geological Survey of California," *North American Review* 110 (January 1870): 230, 232. Although Sexton dismisses the influence of Whitney's expedition on Watkins's work by flatly affirming "that the photographs were geared to the casual tourist, not the scientist" (Sexton, "Carleton E. Watkins," p. 276), the financial interests of the scientific community, especially given the expedition's dependence on congressional funding, also influenced the survey's and Watkins's approach.

24. Palmquist regards the cropped tree as an essential element for the composition's appreciation, because it "becomes a formal element that you look beyond" (see Naef, *In Focus*, p. 113).

25. Sexton, "Carleton E. Watkins," p. 246.

26. *Art-Journal* 9 n.s. (August 1, 1870): 252; Morton, "The Yosemite Valley," p. 377.

27. Whitney, *Geological Survey of California, The Yosemite Book*, p. 154. William P. Blake, Paris Exposition commissioner, recorded the number of Watkins's submission and its subject matter in the exposition's official report. See Amy Rule, ed., *Carleton Watkins: Selected Texts and Bibliography* (Boston: G.K. Hall, 1993), p. 78, n1. The next year, Thomas Houseworth and Company won a certificate of award and bronze medal (reputedly "the highest award made for photographic views") at the exposition for a submission that included twenty-six large views of Yosemite and the big trees and thirty-three stereographs of the mammoth plants. Houseworth's quality work and honorable publicity, blustered the San Francisco correspondent, has "contributed not a little to the growing interest which Europeans are now manifesting concerning all that pertains to the Pacific coast." See "California Scenery at the Paris Exposition," San Francisco *Evening Bulletin*, June 10, 1868, 3:4.

28. Some Civil War photographers used tree portraits to represent the ravaging effect of the war on the nation. George N. Barnard's *The "Hell Hole" New Hope Church, Ga.* (1866, Amon Carter Museum, Fort Worth, Texas), Plate 27 in George N. Barnard, *Photographic Views of Sherman's Campaign* (New York: Dover, 1977), of which he made at least two versions, was one of many images in the portfolio that presented a landscape of natural ruins—trees busted and broken. The central figures were trees snapped in half, powerfully evoking the destructive split caused by the war. As Keith F. Davis argues, often America's "sense of cultural identity [was] revealed in a layering of historical incident" with the use of "images of blasted trees and denuded ground." Watkins's layering in 1865–1866 involved the Grizzly Giant nearly overlaying the tree shard, an arboreal palimpsest recording the nation's reemergence from the decay and destruction caused by hostilities more strongly suggested in Barnard's onsite image. See "'A Terrible Distinctness': Photography of the Civil War Era," in Martha Sandweiss, ed., *Photography in Nineteenth-Century America* (New York: Harry N. Abrams, 1991), pp. 131–79, especially p. 170.

CHAPTER 3. VISCHER'S VIEWS

1. Although other artists had produced lithographs of Calaveras Grove, theirs were single-sheet images. Other than Lapham's, the most notable was Thomas A. Ayres's *The Mammoth Tree Grove, Calaveras County* (1855, New York Public Library, Print Collection, The Miriam and Ira D. Wallach Division of Art, Prints, and Photographs), which included a central portrait of the grove's hotel surrounded by various sequoia portraits, including those that had been sectioned, uprooted, and girdled. One other lithograph that attempted to incorporate a view of the entire grove was G. K. Stillman's *The Mammoth Trees of California, Calaveras County, Sequoia Gigantea* (ca. 1855, Robert B. Honeyman Jr., Collection of Early Californian and Western American Pictorial Material, The Bancroft Library, University of California, Berkeley), a color engraving presented to subscribers of the *Cincinnati Weekly Times*. Stillman's inclusion of each of the grove's more famous tree sites in a single view ultimately resembles Vischer's solution to representing the grove in a few of his plates. It is unclear, however, whether Vischer

had studied Stillman's or other artists' montage-like approach. For the Vischer quote, see Edward Vischer, *Vischer's Views of California. The Mammoth Tree Grove and Its Avenues* (San Francisco: Author, 1862), "Introductory Remarks." (The portfolio is unpaginated; all forthcoming citations will reference each page by its section heading. A copy of it is also located in the Honeyman, Jr., Collection.)

2. Vischer, *Vischer's Views*, "Introductory Remarks."
3. Ibid.
4. Edward Vischer, *Pictorial of California* (San Francisco: Joseph Winterburn, 1870), "Localization of Subjects."
5. James Mason Hutchings, *In the Heart of the Sierras* (Oakland, CA: Old Cabin, Yo Semite Valley, and the Pacific Press, 1888), p. 214; Horace Greeley briefly described just the opposite relationship in 1859. Instead of regarding them as subjects of the proprietary gaze, he imagined the big trees as maintaining a more magisterial position. He perceived Sierra Nevada trees as "giants [that] look down on the gold mines wherein a very large proportion of the most active population of this state must for ages be employed, while the agricultural districts lie just below them, and even the seaboard cities are but a day's ride further." See *An Overland Journey from New York to San Francisco in the Summer of 1859* (New York: Alfred A. Knopf, 1964/1860), p. 294.
6. Vischer, *Vischer's Views*, "Index."
7. Eduard Vischer, translated from the German by Ruth Frey Axe, "A Trip to the Mining Regions in the Spring of 1859: Part Two," *California Historical Society Quarterly* 11 (December 1932): 328; and Vischer, *Vischer's Views*, "Forest Scenes from Nature."
8. Vischer, *Vischer's Views*, "Description of Plates: The Frontispiece."
9. Nineteenth-century writers sometimes invoked Mesozoic-era referents to help identify the big trees as massive and aged living beings. For instance, Horace Greeley labeled them "forest mastodons." See Greeley, *An Overland Journey from New York*, p. 265.
10. Vischer, *Vischer's Views*, "Description of Plates."
11. Ibid., "Introductory Remarks"; Vischer, "A Trip: Part Two," p. 327.
12. Vischer, *Vischer's Views*, "Description of Plates."
13. *Overland Monthly*, "To the Big Trees," p. 403. It is unknown when grove proprietors or vendors began to sell official big tree souvenirs, although such trade likely began shortly after Dowd's discovery when the first lodgings opened. Constance Frederica Gordon-Cumming's 1884 travelogue offers the earliest citation. She writes that the hotel at Calaveras sold "small blocks" of sequoia bark "as memorial pin-cushions." They were "supplied from more distant trees," however, ones that were not part of Calaveras Grove [*Granite Crags* (Edinburgh: W. Blackwood, 1884), p. 309].
14. Vischer, *Vischer's Views*, "Description of Plates." For more about the use of camels in California, see A. A. Gray, "Camels in California," *California Historical Society Quarterly* 9 (December 1930): 299–317.
15. Vischer, "A Trip: Part Two," p. 328; and Vischer, *Vischer's Views*, "Forest Scenes from Nature."
16. Vischer, *Vischer's Views*, "Description of Plates."
17. Ibid.

18. Francis P. Farquhar, *Edward Vischer & His "Pictorial of California"* (San Francisco: Grabhorn Press, 1932), p. 7.
19. Farquhar lists a variety of business activities in which Vischer's firm was engaged. They include his acting "as a correspondent and agent for German [banking] firms in Mexico"; "negotiating sales of Mexican silver dollars to Chinese merchants at San Francisco for shipment to China" as a commission merchant, which attracted visitors to the city; acting as a "consignee for vessels and cargoes coming to San Francisco"; and as a real estate agent for both California residents and nonresidents. See pp. 4–5.
20. Vischer, "A Trip to the Mining Regions in the Spring of 1859: Preface," p. 234.
21. Vischer, "A Trip: Preface," p. 224.
22. Francis P. Farquhar, "Camels in the Sketches of Edward Vischer," *California Historical Society Quarterly* 9 (December 1930): 332; Vischer, *Pictorial of California*, pp. 4, 7. Vischer produced at least one formal painting, *Giant Sequoias* (oil, 44″ × 26″, according to the Smithsonian Institution Research Information System (Spring 2000), but unverified: Mr. Carl Schaefer Dentzel, Los Angeles, CA). Unfortunately, its exhibition history and date are unknown and its composition unclear. The only published reference to it is in *The American Frontier: Images and Myths* (New York: Whitney Museum of American Art, 1973), but it does not provide a helpful or clear description of its appearance. Patricia Hills observes that "with its dislocations of scale, [*Giant*] projects the awesome largeness of the thousand-year-old trees" (p. 12), which only vaguely suggests it as a study of the big trees' age and size.
23. Vischer, *Pictorial*, p. 4.
24. Edward Vischer, *Missions of Upper California, 1872* (San Francisco: Joseph Winterburn, 1872), pp. 7 and 35. His description of the missions as not useful anymore and allusions to "undaunted" and "practical people" come from unpaginated sections of the publication.
25. Vischer, *Pictorial*, pp. 10–11.
26. Ibid., p. vi.
27. Vischer, *Missions*, unpaginated.
28. Bernard Bowron, Leo Marx, and Arnold Rose, "Literature and Covert Culture," *American Quarterly* 9 (Winter 1957): 382, 385.
29. The book's sudden shift into anomie brought Twain's latent doubts about progress to the surface and seriously affected him, according to Henry Nash Smith. It paralyzed his imagination, for "henceforth," Smith claims, Twain "worked as a writer in a kind of spiritual vacuum." See Henry Nash Smith, *Mark Twain's Fable of Progress: Political and Economic Ideas in "A Connecticut Yankee"* (New Brunswick, NJ: Rutgers University Press, 1964), p. 107. An 1855 eyewitness account of a Pennsylvania tree's logging provides an example of the frequency of nineteenth-century cultural covertness, especially when it involved nature. Riding on the belly of a white pine en route to a Pennsylvania lumber mill, a *Putnam's Monthly* writer finds the journey a thrillingly sublime experience. "Seated on the stomach of one of these kings," he tremblingly boasts, "[I] went bowling down to the mill through the open valley, and saw the breathing engine clutch them, one after another, with his iron claws, and devour them with his iron teeth, and digest them into beautiful boards." His appreciation of the mill's ravenous consumption of these "great trees"—and his denial about industrial technology's sordid conse-

quences—is even more apparent when considering the writer's original intent. "I [aim] to preach" about trees, he openly admits—that they "have souls, and are worthy of salvation," so much so that he advocates reserving June 1 for tree worship—a sacred day to "be called nature's holy-day, or '*Mother's day*,' . . . [when] whole towns and villages [will] lay aside their ambitions and schemes. . . . and, in the most beautiful grove of the neighborhood, renew their youth." See "About Trees," *Putnam's Monthly* (November 1855): 518–22.

30. Bowron et. al., "Literature and Covert Culture," p. 385.

31. Hutchings, *In the Heart of the Sierras*, p. 224.

32. The meaning of either grove's Spanish names captures their differences even more compellingly. *Calaveras* is plural for skull, and *mariposa* means butterfly, accurately associating the northern grove with death and decay (a *memento mori*) and its southern neighbor with rebirth or redemption.

33. Vischer, *Pictorial*, pp. 97, 98; Hutchings, *In the Heart of the Sierras*, p. 224; *Overland Monthly*, p. 403. Mother of the Forest is now a snag, its most recent trial occurring in 1908, when a forest fire raged in the grove. See Rebecca Rupp, *Red Oaks & Black Birches: The Science and Lore of Trees* (Pownal, VT: Storey Communications, 1990), p. 257.

34. Naef, *In Focus*, p. 46. Without naming him, Claire Perry places Vischer in a group of Sequoia image-makers whose portrayals of "mammoth specimens that had been scaled, cut, stripped, pierced, or struck by lightning. . . . affirmed the dominance of humans over the natural world." But her interpretation that artists "seemed to delight in portraying the decay and dismemberment of the woodland giants"— illustrated by Vischer's frontispiece image—simplifies the entire portfolio's imagery. Perry's argument only acknowledges one side of the discursive conflict about the sequoias' value during this period, overlooking the clear signs of Vischer's ambivalence about the meaning of the trees' condition and treatment that are so evident in Plate 4. See Claire Perry, *Pacific Arcadia: Images of California, 1600–1915* (New York: Oxford University Press, 1999), pp. 119–20.

CHAPTER 4. THE CENTENNIAL VERSION

1. Clinton, "Bierstadt in His Studio," Utica *Morning Herald and Daily Gazette*, September 16, 1874, 2:4. For conjecture about *California Redwoods* as one of the studies Bierstadt produced during this period, see *Albert Bierstadt: An Exhibition of Forty Paintings*, essay by Gerald L. Carr (New York: Alexander Gallery, 1983), unpaginated. Many of Bierstadt's studies were done in oil on paper, thus lending them the formal polish of finished works. Because of their quality, some art historians have subsequently found them more satisfying than the studio paintings he targeted for exhibition. Gordon Hendricks describes Bierstadt's reliance on oil sketches in Gordon Hendricks, *Albert Bierstadt: Painter of the American West* (New York: Harrison House/Harry N. Abrams, 1988/1974), p. 240.

2. As Lawrence W. Levine has observed, cultural hierarchies intensified during the latter nineteenth century, whose distinctions between sacred highbrow and vulgar lowbrow culture expressed anxieties concerning both class differences and American cultural development. See Lawrence W. Levine, *Highbrow/Lowbrow: The Emergence of Cultural Hierarchy in America* (Cambridge, MA: Harvard University Press, 1988), especially pp. 85–168.

3. Gerald L. Carr, "Albert Bierstadt, Big Trees, and the British: A Log of Many Anglo-American Ties," *Arts Magazine* 60 (Summer 1986): 67.

4. Art historians have tended to overlook these connections or discount them. Nancy K. Anderson interprets the painting as "an Indian idyll . . .[of] the beginnings of life" in North America [see Nancy K. Anderson, "'The Kiss of Enterprise': The Western Landscape as Symbol and Resource," in *The West as America* (Washington, D.C.: Smithsonian Institution Press, 1991), p. 272], whereas Claire Perry simply regards it as Bierstadt's attempt to depict the forest primeval, with the sequoias representing nature's powerful but benevolent presence [Claire Perry, *Pacific Arcadia: Images of California, 1600–1915* (New York: Oxford University Press, 1999), p. 112]. Finally, Simon Schama refutes the idea of *Giant Redwoods* as an "inanimate elegy for the vanished redwood redskin" by contending the forest reinforces native peoples' antiquity—the painting "is sylvan-domestic: the ancient residence of the *most* indigenous Americans." See Simon Schama, *Landscape and Memory* (New York: Vintage Books, 1995), p. 197. *The Last of the Buffalo* is located at the Corcoran Gallery of Art, Washington, D.C.

5. An exhaustive list of all incidents and articles involving the sequoias before the 1870s is impossible, but for a general sampling see Chapter 1, this volume; Dennis G. Kruska, *Sierra Nevada Big Trees: History of the Exhibitions, 1850–1903* (Los Angeles: Dawson's Book Shop, 1985), Chaps. 1–5; and Anonymous, "Mammoth Tree," *Gleason's Pictorial Drawing-Room Companion* (March 11, 1854): 160.

6. Painters did depict the big trees during this early period, but most were minor local painters or amateurs; moreover, many of them tended to depict Coast redwoods. Perhaps problems of access and limited accommodations in the Sierra groves hindered painters more than photographers and dissuaded them from producing more tree canvases. Thomas Hill, William Keith, and William Hahn were the most prominent exceptions, although Keith and Hahn only depicted Coast redwoods. Keith's *California Redwoods* (n.d., oil on board, 28″ × 14″) is housed at the Akron Art Museum in Akron, Ohio. Hahn produced two logging images, *Logging in the Redwoods* (1880, Natural History Museum of Los Angeles County, according to the Smithsonian Institution Research Information System, Spring 2000, but unverified) and *Logging Redwood Trees near San Francisco* (1880, unknown). Hill's work came later in the 1880s [for example, *Among the Giant Redwoods, Yosemite* (1884, Private Collection, Spring 2000, but unverified)]. Hill was clearly the most prolific sequoia painter of the three, and his efforts included a submission at a national venue, the 1893 World's Fair in Chicago (see Chapter 6, this volume).

During this early period, however, very few, if any, nationally respected painters produced such works. Thomas Moran did not cover the subject until the early twentieth century. He produced *California Redwoods* (1914, Akron Art Museum), a watercolor portrait of Coast redwoods and an insignificant addition given its lateness in his career and its lack of fanfare or reception. Other minor late-nineteenth-century painters who depicted mostly Coast redwoods include Edwin Deakin (1838–1923), *Campfire in the Redwoods* (ca. 1878, Orange County Museum of Art, Newport Beach, CA) and *Forest Scene—Redwoods* (1888, watercolor, Restricted, Pebble Beach, CA, according to the Smithsonian Institution Research Information System, Spring 2000, but unverified); Jules Tavernier (1844–1889), *Among the Redwoods* (1883, unknown) and *Redwoods with Figure* (1884, Restricted, according to the Smithsonian Institution Research Information System,

Spring 2000, but unverified); Henry Cheever Pratt (1803–1880), *California Red-woods* (n.d., unknown); and Charles Dorman Robinson (1847–1933), who in the early 1890s created a massive 50′ × 380′ panorama of the Yosemite Valley, whose San Francisco exhibition was a financial failure. His depiction of the Coast red-woods, *Redwood Grove* (n.d., 16″ × 12″), can be found at the California State His-torical Society in San Francisco.

7. New York *Evening Mail,* April 10, 1874, p. 1, quoted in Carr, "Albert Bierstadt," 67; Anonymous, "Fine Arts. The Academy of Design," *New York Times,* April 13, 1874, p. 5:1; "National Academy of Design," New York *Evening Post,* April 25, 1874, 1:1.

8. Hendricks, *Albert Bierstadt,* pp. 240–42. *The Royal Academy of Arts,* which lists all academy exhibits from 1769 to 1904, does not identify the painting's dimen-sions, thus leaving some doubt about whether the painting Bierstadt described to Bancroft was indeed the one he exhibited at the academy. Its few reviewers did not indicate the painting's size either or the tree's dimensions that Bierstadt later listed (42 feet in diameter, 300 feet high). The *Art-Journal* particularly appreciated Bier-stadt's "effective management of the light which throws the great girth of the tree into prominence." See *Art-Journal* 36, "The Royal Academy. Concluding Notice" (August 1874): 229.

9. Anonymous, "Fine Arts. Domestic Notes," New York *World,* November 26, 1875, 5:3.

10. E. S., "The International Exhibition—VII. American Art," *The Nation* 23 (July 6, 1876): 6–7. See also James D. McCabe, *The Illustrated History of the Centennial Exhibition* (Philadelphia: National, 1876), pp. 524–26. For a description of the art exhibit, see Jean Taylor Baxter, "Burdens and Rewards: Some Issues for Ameri-can Artists, 1865–1876," Ph.D. dissertation, University of Maryland, College Park, 1988, pp. 280–327. Although Americans felt that their nation was without peer technologically, the size of the exhibit addressed extant insecurities about the na-tion's lack of cultural development. It was billed as a big classroom, and patrons were expected to take notes and learn from their nation's art and the inherently su-perior displays expected from Europe. The large survey of paintings thus aimed to teach Americans of different classes about the nation's artistic talents as well as to enable knowledgeable patrons to gauge American artistic development on a world scale. For an extensive analysis of the fair's planning, reception, and impact on art education in America, see Christine Hunter Donaldson, "The Centennial of 1876: The Exposition, and Culture for America," Ph.D. dissertation, Yale Univer-sity, 1948, pp. 88–111.

11. Rothermel's work is located at the Pennsylvania Historical and Museum Com-mission, Harrisburg, Pennsylvania. For Howells's comments, see William Dean Howells, "A Sennight of the Centennial," *Atlantic Monthly* 38 (July 1876): 93, 94. *Scribner's* quoted in Donaldson, "The Centennial of 1876," p. 104.

12. Weir quoted in Jean Taylor Baxter, "Burdens and Rewards: Some Issues for Ameri-can Artists, 1865–1876," Ph.D. dissertation, University of Maryland–College Park, 1988, p. 295 n33; *Great Trees'* review by G. A. R., "The Art of America. Its Ex-hibits at Philadelphia," *New York Times,* June 13, 1876, 1:6.

13. Anderson describes the emerging trend as "more painterly, intimate," and "influ-enced by French sources." See Linda S. Ferber, "Albert Bierstadt: The History of a Reputation," in Nancy K. Anderson and Linda Ferber, eds., *Albert Bierstadt: Art & Enterprise* (New York: Brooklyn Museum, 1990), p. 30.

14. For itemization of American landscapes at the Exposition, see Baxter, "Burdens and Rewards," p. 294. The current locations of Bierstadt's other five 1876 submissions are as follows: *Spring*, California Palace of the Legion of Honor, San Francisco; *Settlement*, Architect of the Capitol, Washington, D.C.; *Mount Hood*, Southwest Museum, Los Angeles; *Western Kansas*, unknown; *Yosemite Valley*, Yale University Art Gallery, New Haven, Connecticut.

15. Schama, *Landscape and Memory*, p. 196. "Fertile forest interior" comment in *Albert Bierstadt: An Exhibition*, unpaginated. The current locations of the paintings listed are as follows: *White Mountains*, Duke University Museum of Art, Durham, North Carolina; *Mountain Brook*, private collection; *Pioneers*, High Museum of Art, Atlanta; *View*, unknown; *Wooded Glade*, Sotheby Parke Bernet, New York, according to the Smithsonian Institution Research Information System, Spring 2000, unverified; *Landscape*, unknown.

16. For reaction to *Settlement*, see McCabe, *The Illustrated History of the Centennial Exhibition*, p. 525. For Strahan's comments, see Edward Strahan, *The Masterpieces of the Centennial International Exhibition*, Vol. 1 (New York: Garland, 1977/1876–1878), p. 42.

17. *Albert Bierstadt: An Exhibition*, unpaginated. Along with Durand's woods, Carr mentions that the professionally knowledgeable and "indefatigable" artist's tree work in the early 1870s may have been inspired by Andrew McCallum's (1821–1902) portraits of British forests, the latter of which were exhibited in London in 1868. Schama locates *Great Trees*' inspiration in fellow German Caspar David Friedrich's spiritually heroic oak-tree portraits, especially *Oak Tree in Winter* (1829), located in Berlin's National Gallery, which Bierstadt visited in the 1860s. See Schama, *Landscape and Memory*, pp. 195–96.

18. Fitz Hugh Ludlow, "Seven Weeks in the Great Yo-Semite," *Atlantic Monthly* 13 (June 1864): 743. Ralph A. Britsch, *Bierstadt and Ludlow: Painter and Writer in the West* (Salt Lake City, UT: Brigham Young University Press, 1980), pp. 43–44. Three other men traveled in Ludlow's and Bierstadt's party; two were unnamed, whom Ludlow states "had formed the original overland-party," and the last was "a highly scientific metallurgist and physicist generally, Dr. John Hewston of San Francisco" (Ludlow, "Seven Weeks in the Great Yo-Semite," p. 743).

19. Ludlow, "Seven Weeks in the Great Yo-Semite," pp. 744, 745.

20. Ibid., 745.

21. Ibid., 745, 749. The *Cathedral Grove*'s stretcher tentatively lists the grove's location as Calaveras (misspelled as "Calvars Co." and accompanied by a question mark)—likely a misidentification, because there is no record of Bierstadt visiting the northernmost Sierra redwood grove. The painting's location is unknown, but it is likely in a private collection.

22. This was a common practice with other artists of the period, especially Thomas Moran, who also reproduced tree figures in many different landscapes. See Joni Louise Kinsey, *Thomas Moran and the Surveying of the American West* (Washington, D.C.: Smithsonian Institution Press, 1992), pp. 36–39. Current locations for Bierstadt's works are as follows: *The Domes of Yosemite*, St. Johnsbury Athenaeum, St. Johnsbury, Vermont; *Mount Whitney*, The Rockwell Museum, Corning, New York; *Among the Sierra Nevada Mountains, California*, National Museum of American Art, Smithsonian Institution, Washington, D.C.; *The Rocky Mountains, Longs Peak*, Denver Public Library, Western History Department; *The*

Wolf River, Kansas, Detroit Institute of Arts; *Indian Encampment, Shoshone Village,* New York Historical Society, New York.

23. For a brief discussion of *The Grizzly Giant Sequoia,* see Ilene Susan Fort and Michael Quick, *American Art: A Catalogue of the Los Angeles County Museum of Art Collection* (Los Angeles: Los Angeles County Museum of Art, 1991), pp. 158–59. The painting is located at the Los Angeles County Museum of Art.

24. Most scholars agree about the two images' resemblance. Bierstadt may have been even more mindful of the Grizzly Giant's photography during his second trip because of photographer Eadward Muybridge's company. Such a pairing prompted the *Alta California* to assume Bierstadt's strong influence in a review of Muybridge's 1872 Yosemite portfolio. The writer based such an assumption on the fact that Bierstadt had "made several suggestions to Mr. Muybridge, while in the Valley," to the point that he had become "in fact, a patron and adviser." He predicted that "Mr. Bierstadt" would "probably" use Muybridge's photographs as Yosemite oil painting subjects. The point is not whether Bierstadt steered Muybridge at all but that Bierstadt witnessed an active photographer's portrayal of Yosemite scenery—including the sequoias—all the while he was preparing his singular towering big tree portrait. Indeed, in addition to the larger number of valley views, Muybridge produced at least thirty-three big tree images during this trip. Unfortunately, all existing copies of the 1872 portfolio are incomplete, usually containing just one of the sequoia images, a portrait of the William H. Seward tree. Thus any connection between Bierstadt's and Muybridge's tree portraiture remains highly speculative. See Mary V. Jessup Hood and Robert Bartlett Haas, "Eadward Muybridge's Yosemite Valley Photographs, 1867–1872," *California Historical Society Quarterly* 42 (March 1963): 20, 26 n25.

25. New York *World,* p. 5:3.

26. Other tree visitors also noticed signs of recovery around the tree. In his 1870 survey guidebook, J. D. Whitney admitted that one of the more memorable characteristics of the Mariposa Grove was the presence "around the base of several of the large trees . . . [of] small plantations of young *Sequoias,* of all sizes, up to six or eight inches in diameter, but only a few as large as this." Whitney, *The Yosemite Guide-Book,* p. 150.

27. Robert L. McGrath, "The Tree and the Stump: Hieroglyphics of the Sacred Forest," *Journal of Forest History* (April 1989): 67. *Maple Leaves, New Hampshire* may now have the title, *Maple Leaves, White Mountains,* based on the Smithsonian Institution's databases. In a fascinating analysis of *Mountain Brook* (1863) and *The White Mountains, New Hampshire* (1863), Janice Simon also contends that Bierstadt used forest interiors to comment on the Civil War. See "'Naked Wastes . . . Glorious Wood: The Forest View of the White Mountains," *Historical New Hampshire* 54 (Fall/Winter 1999): 92–106. For more discussion of American artists' use of forest interiors as a Civil War emblem during the 1860s, see Andrew Walker, "American Art & the Civil War," *American Art Review* 11 (September–October 1999): 126–31, and 207, especially 130–31 and 207. Current locations of the two paintings mentioned are as follows: *Guerrilla Warfare (Picket Duty in Virginia),* Century Association, New York; *Maple Leaves, New Hampshire,* Bradley Collection, Boston, according to the Smithsonian Institution Research Information System, Spring 2000, but unverified.

CHAPTER 5. CONSUMING VIEWS

1. These California showcases aimed at convincing some eastern doubters of the sequoias magnificence. Indeed, previous tree exhibits sometimes disappointed patrons, and, just as Bierstadt's tree portrait failed to impress art critics, Tulare County's did not entirely captivate fair goers. The bark specimen, accompanied by photographs of intact sequoias, garnered little if any press coverage, and the trunk exhibit's apparently fraudulent appearance deeply offended others. Americans generally regarded most of these exhibits as hoaxes, and the 1876 Captain Jack trunk exhibit was easily the worst, nearly ending the run of sequoia trunk displays for the remainder of the century.

 Because of financial or administrative problems, the trunk exhibit did not qualify for display in the fairgrounds. Martin Vivian, its proprietor, instead placed it in a tent on Elm Avenue, a street intersecting the fair's main entrance, the absolute worst location for a showcase poised to withstand sneering criticism from wisened sightseers. Vivian charged visitors 25¢ to enter from a street that possessed a vulgar carnivalesque atmosphere, complete with sideshows and saloons. Americans were already inured to hoaxes, and the captured tree, displayed among other freak shows, only confirmed visitors' doubts. The re-assembly joints, which held the eight trunk parts together, were glaringly obvious and heightened patrons' suspicions of it as a "prank," "side show," or one of many "monstrosities." The 1876 exhibit proved an embarrassing failure, an amateurish promotion to a public increasingly weary of exhibitions of the trees as oddities. It was not until 1893 before anyone truly dared to display their capture again in the celebratory atmosphere that pervaded 1876 Philadelphia. See Dennis G. Kruska, *Sierra Nevada Big Trees: History of the Exhibitions, 1850–1903* (Los Angeles: Dawson's Book Shop, 1985), pp. 46–49.

2. Anderson notes that writers often expressed contradictory evaluations of the sequoias in "'The Kiss of Enterprise': The Western Landscape as Symbol and Resource," in William H. Treuttner, ed., *The West as America* (Washington, D.C.: Smithsonian Institution Press, 1991), pp. 275–76.

3. For complete analysis of their display at the 1893 fair, please refer to Chapter 6, this volume. Minor tree exhibitions occurred in 1878 and 1885–1886, the latter a trunk slice from Dowd's Discovery Tree displayed at the American Exposition in New Orleans. In 1891 New York City's American Museum of Natural History permanently and successfully exhibited a trunk slice from the Mark Twain tree. For the latter's story and a general chronology of the trees' exhibition, see Kruska, *Sierra Nevada Big Trees*, pp. 52–58.

4. Quoted in Frederic Gunsky, ed., *Selected Writings by John Muir: South of Yosemite* (Garden City, NY: Natural History Press, 1968), p. 61; John Muir, "On the Post-Glacial History of Sequoia Gigantea," *Proceedings of the American Association for the Advancement of Science* 25 (August 1876): 243; Gunsky, *Selected Writings by John Muir*, pp. 105, 117.

5. The 1890 bill did not include the Yosemite Valley and Mariposa Grove proper—only some of the land bounding these two sites was designated as Yosemite National Park. The valley and grove's official inclusion as part of Yosemite National

Park did not occur until 1905. Until then, the two locations remained state parks. Quote from John Muir, *Our National Parks* (Madison: Wisconsin University Press, 1981/1901), p. 299. The original article was aptly titled, "Hunting Big Redwoods," *Atlantic Monthly* 88 (September 1901): 304–20. Many lumber companies made illegal mass purchases of timberland by circumventing the Timber and Stone Act of 1878, which limited individual claims to 160 acres. Their tactics were so reviled by local preservationists that when a utopian community unwittingly adopted such a strategy in 1885, a five-year investigation of their claim's legality ensued. Individual members of the Kaweah Colony bought up tracts of timberland near the Giant Forest region, an area prized by activists for its healthy sequoia groves and specimens, such as the General Sherman tree, the undisputed largest sequoia in the world. The colony's claim was made insolvent by the 1890 bill. See William Tweed, *Kaweah Remembered: The Story of the Kaweah Colony and the Founding of Sequoia National Park* (Three Rivers, CA: Sequoia Natural History Association, 1986), and Jay O'Connell, *Co-Operative Dreams: A History of the Kaweah Colony* (Van Nuys, CA: Raven River Press, 1999). Most lumber enterprises, however, were not so unfortunate. See Hank Johnston, *They Felled the Redwoods: A Saga of Flumes and Rails in the High Sierra*, 10th ed. (Fish Camp, CA: Stauffer, 1996/1966), Chap. 2.

6. Johnston, *They Felled the Redwoods*, pp. 59, 81; Walter Fry and John R. White, *Big Trees* (Stanford University, CA: Stanford University Press, 1930), p. 104.

7. Johnston, *They Felled the Redwoods*, p. 50; "Redwood Logging in California," *Scientific American* n.s. 63 (July 26, 1890): 55; J. M. Eddy, "Among the California Redwoods," *Harper's Weekly* 38 (January 6, 1894): 14.

8. Henry David Thoreau, *The Maine Woods* (New York: Penguin Books, 1988/1864), pp. 3, 4; William Davenport Hulbert, "The Lumber-Jack and His Job," *Outlook* 76 (April 2, 1904): 804. For a brief analysis of the popular romantic image of lumbermen as "dauntless knights of the wood," see Thomas R. Cox, ed., *This Well-Wooded Land: Americans and Forests from Colonial Times to the Present* (Lincoln: Nebraska University Press, 1985), pp. 85–87. Some turn-of-the-century novels furthered this macho stereotype, with Stewart Edward White's early novels, especially *The Blazed Trail* (1902), being the most blatant example. See *Blazed Trail Stories and Stories of the Wild Life* (Garden City, NY: Doubleday, Doran, 1901 and 1902).

9. Charles Hallock, "Life among the Loggers," *Harper's New Monthly Magazine* 20 (February 1860): 438, 440.

10. Walt Whitman, "Song of the Broad-Axe," in Lawrence Buell, ed. *Leaves of Grass and Selected Prose* (New York: Modern Library, 1980), pp. 147, 154, 156; Louise Herrick Wall, "Under the Far-West Greenwood Tree," *Atlantic Monthly* 71 (February 1893): 195. Nicolai Cikovsky, Jr., has correctly enumerated the many nineteenth-century artists who denigrated the ax in condemnatory renderings of stump-filled landscapes, but frequent references to its stirring voice, which composed "exhilarating music" to the many who witnessed its performance live, may have more accurately characterized its public reception. See Nicolai Cikovsky Jr., "'The Ravages of the Axe': The Meaning of the Tree Stump in Nineteenth-Century American Art," *Art Bulletin* 61 (December 1979): 611–26. "Exhilarating music" found in Hallock, "Life among the Loggers," p. 439.

11. J. Macdonald Oxley, "From Forest to Floor," *Cosmopolitan* 4 (December 1887): 315.

12. Although some scholars, most notably Andrew Mason Prouty, have argued that loggers were not romanticized figures in that they possessed "perverse morality, bad habits, and general low standards of life," a closer examination of the discourse concerning choppers reveals otherwise. See Prouty, *More Deadly than War! Pacific Coast Logging, 1827–1981* (New York: Garland, 1985), p. 5.

13. Hallock, "Life among the Loggers," p. 438; Wall, "Under the Far-West Greenwood Tree," p. 195; S. Allis, "As Seen in a Logging-Camp," *Overland Monthly* 36 (September 1900): 199; Arthur Hill, "Life in a Logging Camp," *Scribner's Magazine* 13 (June 1893): 699; Ernest Ingersoll, "In a Redwood Logging Camp," *Harper's New Monthly Magazine* 66 (January 1883): 200, 201.

14. Thomas Emerson Ripley, "Shakespeare in the Logging Camp," *American West* 4 (May 1967): 13; his dedication to a six-day work week is quoted in John Szarkowski, ed., *The Photographer and the American Landscape* (New York: Museum of Modern Art, 1963), p. 4. For the five Kinsey images, see D. A. Willey, "Logging in the Northwest," *Scientific American* 83 (December 29, 1900): 409–10.

Many photographers documented the region's lumber industry, but Kinsey was the most professionally recognized. However, scholars have slowly begun to discover other logging photographers. Two of the more well-known of them focused on coastal communities; for instance, Charles Robert Pratsch (1857–1937) photographed the Grays Harbor area near Aberdeen, Washington, roughly between 1900 and 1930, and Augustus William Ericson (1848–1927) covered the Coast redwood's logging along California's northern coast until nearly 1920. For Pratsch, see Robert A. Weinstein, "Ships and Timber," *American West* 16 (January/February 1979): 18–29; for Ericson, see Ralph W. Andrews, *Photographers of the Frontier West: Their Lives and Their Works, 1875–1915* (Seattle, WA: Superior, 1965), pp. 118–22, Peter E. Palmquist, *Fine California Views: The Photographs of A.W. Ericson* (Eureka, CA: Interface California Corporation, 1975), and Peter Johnstone, ed., *Giants in the Earth*, unpaginated portfolio section edited by Palmquist. The Washington State University Library in Pullman holds Pratsch's work, and Humboldt State University in Arcata, California, retains Ericson's. Like Kinsey, these itinerant photographers frequented logging camps. They advertised in local papers cramped with notices of others' arrival. See Palmquist, *Fine California Views*, p. 22.

Because most logging photographers freelanced, their business relationship, if any, with western logging firms is unclear. It is also not evident whether many of these firms habitually commissioned or endorsed their photographic work. For example, Charles C. Curtis, the most famous photographer of the sequoias' logging, reputedly had permission to cover the Kings River/Sanger Lumber Company's activities throughout the 1890s. Unfortunately, his career was short-lived and only sparse documentation exists about his work for Sanger, creating a sizable gap in the historic record concerning the photodocumentation of the big trees' logging. Kinsey, who produced similar kinds of lumbermen portraits, was familiar with Curtis's work, but according to his son, Darius Jr., it did not provoke him competitively. Given the comparative dearth of information about Curtis and the others, Kinsey's work more substantially typifies their photography, the kind that ex-

pressed widely shared cultural attitudes about large-tree logging, including that of the Sierra redwoods. The only analysis of Curtis's activities as a logging photographer focuses on the felling of one sequoia—a section of which became a tree trunk exhibit at the 1893 Chicago World's Fair, one of the subjects of Chapter 6, this volume. See Donald J. McGraw, "The Tree that Crossed a Continent," *California History* 61 (Summer 1982): 120–39. For Darius Jr.'s comments, see Dave Bohn and Rodolfo Petschek, *Kinsey Photographer: A Half Century of Negatives by Darius and Tabitha May Kinsey, Volume Two* (San Francisco: Prism Editions, 1978), p. 183. Another traveling photographer from this period worth mentioning is Edgar Cherry, who produced a well-illustrated book on the Coast redwood lumber industry, *Redwood and Lumbering in California Forests* (San Francisco: Book Club of California, 1983/1884). For a brief discussion of this work and a sampling of the photography, see also Johnstone, *Giants in the Earth.*

15. Dave Bohn and Rodolfo Petschek, *Volume One* (San Francisco: Prism Editions, 1978), p. 143.

16. Dave Bohn, "Kinsey Photographer," *American West* 12 (May 1975): 16; Bohn and Petschek, *Volume Two*, p. 266.

17. Bohn and Petschek, *Volume Two*, pp. 230, 246, 247.

18. Ibid., 231; Ralph W. Andrews, *"This Was Logging!" Selected Photographs of Darius Kinsey* (Seattle, WA: Superior, 1954), p. 67.

19. For more examples of such "classic" logger portrayals, see Andrews, *"This Was Logging!"*, especially pp. 41–43.

20. The choppers were the heroic central figures whose stalwart presence Kinsey famously captured, even though some art critics have claimed otherwise. Stressing a conservation ideology more characteristic of the latter twentieth century than the period in which Kinsey worked, art historian John Szarkowski argues that Kinsey's logging photographs emphasized the tree's victimization, making the loggers "subsidiary figures, like . . . donors in an altarpiece" in these "stately death portraits." By patronizingly referring to Kinsey's photographical practices as a "sport" performed "in a state of philosophical innocence," Szarkowski misses the point, I think, because they do not eulogize the trees. If they did, Kinsey more than likely would have posed the men in more subservient positions, thus exalting a tree's poignant last moments. He might have had them kneeling on one knee at the tree's base, looking up wistfully at their weathered victim or maybe even leaning exhausted against the trunk, the latter highlighting the men's vanquishing rather than true victory over the large tree. See Szarkowski, *The Photographer and the American Landscape*, p. 4. For discussion of death as a distasteful subject for logging photographers, see Prouty, *More Deadly than War!* p. xix.

It is worth pointing out that Darius relied heavily on his wife Tabitha's labor throughout his career. His work dominated her life, and he expected her to develop almost all of his images in a timely fashion. According to their youngest daughter Dorothea, it was "a partnership to the Nth degree," although other accounts record the less positive emotional and physical toll that Darius's incessant requests and career-oriented handling took on her mother. See Bohn and Petschek, *Volume One*, p. 23. Thus Kinsey's images, although proud studies of the nation's masculine exploits, owe their final appearance to a female eye.

21. For more examples of chopper portrait photography, see Johnston, *They Felled the Redwoods*, p. 90 (bottom, MOT-83) and 91 (bottom, A.R. Moore, MOT-1), both

images housed in the Harold G. Schutt Collection, Special Collections Library, California State University–Fresno. For perception of the trees as masculine objects, see Fry and White, *Big Trees,* p. 31.

22. Richard T. Fisher, "The Big Trees of California," *World's Work* 3 (February 1902): 1714; Muir, *Our National Parks,* pp. 294, 304.

23. For more photographs that highlighted board-foot estimates, see Johnston, *They Felled the Redwoods,* p. 88 (bottom photographer unknown, L-69) and p. 89, *"Admi Dewey"* (bottom, A. R. Moore, MOT-42), both in the Schutt Collection.

24. Muir, *Our National Parks,* p. 291; "A Christmas Seed and a Spring Harvest in the Valley of the San Joaquin, California," *Sunset* 4 (February 1900): 144.

25. Unfortunately, nothing is known about this photographer. Image from Johnstone, *Giants in the Earth,* pp. 56–57; also MOT-3, A.R. Moore, Schutt Collection.

26. Howard Brett Melendy, "One Hundred Years of the Redwood Lumber Industry, 1850–1950," Ph.D. dissertation, Stanford University, 1952, p. 14.

27. Fry and White, *Big Trees,* p. 17.

CHAPTER 6. NATIONAL COMMODITIES

1. See Donald J. McGraw, "The Tree that Crossed a Continent," *California History* 61 (Summer 1982): 120–39, especially pp. 127, 134. McGraw claims Curtis took eighteen photographs (Schutt Collection, California State University–Fresno), but it is unknown whether this was the shoot's entire production or only the number of images he included with the trunk exhibit. Also, which photographs were included in the display is unknown. The *Official Catalogue* refers to a photographic display of "scenery in the big tree country, and of scenes during the cutting, handling and shipping of the section on exhibition" but does not identify specific images or their photographer. Because he was the only known photographer to document the event, almost certainly the display at least included Curtis's work. See *World's Columbian Exposition 1893: Official Catalogue, United States Government Building,* Part XVI, (Chicago: W. B. Conkey, 1893), p. 123. I offer this tentative yet reasonable best guess of eighteen images based on some of their usage in promotional magazine articles on the trunk's extraction and photography, as well as the fact that Curtis so prized the ones described that he deposited them with respected Tulare County historian Harold Schutt. For promotional photographs and the source of the "monarch of the hills" comment, see Sara Delavergne Price, "How the Big Tree Was Sent to Chicago," *Frank Leslie's Popular Monthly* 35 (June 1893): 728–34.

2. For analyses of the fairs as sites of nationalism, see Robert W. Rydell, *All the World's a Fair: Visions of Empire at American International Expositions, 1876–1916* (Chicago: Chicago University Press, 1984); Merle Curti, "America at the World Fairs, 1851–1893," *American Historical Review* 55 (July 1950): 833–56; and John G. Cawelti, "America on Display: The World's Fairs of 1876, 1893, 1933," in Frederic Cople Jaher, ed., *The Age of Industrialism in America: Essays in Social Structure and Cultural Values* (New York: Free Press, 1968), pp. 317–63. Regarding the 1893 fair as evidence of a cultural shift, Warren Susman argues that all nineteenth-century world's fairs were "special ritual occasions" that speeded cultural transformation. Their planning and visitation were "rites of passage for

American society[,] which made possible the full acceptance of a new way of life, new values, and a new social organization" based on consumer principles. See Warren Susman, "Commentary: Ritual Fairs," *Chicago History* 12 (Fall 1983): 7. Robert W. Rydell goes even further, arguing that for Americans the Chicago Fair was especially precedent-setting because its imposing architecture and commercial displays symbolically linked the nation's imperial ambitions with its consumer appetites. "Displays of 'things' and people" predominated, he maintains, because they gave "visual evidence to the equation of abundance and empire." See Robert W. Rydell, "The Culture of Imperial Abundance: World's Fairs in the Making of American Culture," in Simon J. Bronner, ed., *Consuming Visions: Accumulation and Display of Goods in America, 1880–1920* (New York: W. W. Norton, 1989), pp. 192, 198; see also Rydell, *All the World's a Fair*, Chap. 2, for more about the Chicago Fair's signification of the nation's imperial aspirations. Alan Trachtenberg identifies the same imperial ambitions evinced by the fair, finding the White City an example of "consummation" (p. 209) and the fair in general appearing as a "landscape of fantasy" decorated with goods that served as "emblems of a beneficent future" (p. 217). See *The Incorporation of America: Culture & Society in the Gilded Age* (New York: Hill & Wang, 1982), Chap. 7.

3. Reid Badger emphasizes the fair's "irreconcilably dialectic" organization and atmosphere in *The Great American Fair: The World's Columbian Exposition & American Culture* (Chicago: Nelson Hall, 1979), especially pp. 120, 123.

4. Badger, *The Great American Fair*, p. 120. James Gilbert senses fewer reservations by Americans about the implications of the fair's dialectical symbolism. The "leakage" or "spill-over" of highbrow and lowbrow principles expressed in the fair's architecture and final ground plans, he argues, were less opposed. "Commerce actually defined the two cultures," he concludes, for "commercial purposes surrounded and underlay the Fair itself—to promote Chicago and its commerce." "A Contest of Cultures," *History Today* 42 (July 1992): 39.

5. California World's Fair Commission, *Final Report of the California World's Fair Commission* (Sacramento, CA: State Office, A.J. Johnston, Superintendent State Printing, 1894), pp. 9, 18.

6. Ibid., pp. 18, 108.

7. Ibid., p. 18.

8. Ibid., pp. 18, 102, 105, 108, 110, 111.

9. Ibid., pp. 102, 105.

10. Ibid., pp. 102, 103, 109, 112; for claim of "third largest attendance," see California World's Fair Commission, *Literary and Other Exercises in the California State Building, World's Columbian Exposition, Chicago, 1893* (Chicago: Rand, McNally, 1893), p. 49.

11. "Palace of plenty" quoted in Ben C. Truman, *History of the World's Fair* (Philadelphia: Syndicate, 1893), p. 505. Descriptions of exhibits in *Final Report*, pp. 31, 34, 35, 36, 77, 85.

12. The photographs included some the Excelsior Lumber Company had commissioned from A.W. Ericson. See Palmquist, *Fine California Views*, p. 9.

13. *Final Report*, p. 30.

14. Ibid., p. 43.

15. Ibid., pp. 25–26.

16. Ibid., pp. 57, 58, 59, 61.

17. Ibid., pp. 60, 61.
18. Ibid., p. 61. A year later, the *San Francisco Chronicle* verified such "wider use," reporting that "an important consignment of redwood" had been received in New York, for final shipment to London, "where it will be used to fill special orders of cabinetmakers and piano manufacturers." The writer remarked that the wood "appears to be on the eve of giving way to a popular demand, created chiefly by the magnificent exhibits of polished redwoods made at the Paris, Columbian and Midwinter Expositions." By the turn of the century, commercial use of redwood had broken out nationwide, and not only because of its decorative qualities. *The American Architect and Building News* confirmed in 1903 that it was "in great demand in the Eastern States of America" particularly for use in civil engineering. The Niagara Falls Power Company ordered three million board feet from the Redwood Association in September 1903 to be used in one of the fall's great tunnels. The company's chief engineer discovered that redwood did not corrode as destructively as steel when subjected to the high-pressure onrush of the Niagara River's water and sediment. Other northern New York electric-power houses had already found the wood "exceedingly useful in the construction of the big pipes," owing to its low cost, high durability, pliancy when kept moist, and resistance to fire. Such use had the redwoods buttressing the East's most heralded natural wonder, proving the ancient wood to be more than its equal and also more powerful than the modern alloy. Although a general history of Coast and Sierra redwood's popularity in architecture, interior decoration, or engineering projects during this period has yet to be written, reports such as the *Chronicle*'s and *American Architect*'s suggest that even during the economic depression of the 1890s redwood markets benefited from their display at Chicago. See "California Redwood," San Francisco *Chronicle* (August 20, 1894): 4:3; and "Californian Redwood as a Substitute for Steel," *American Architect and Building News* 82 (October 3, 1903): 5.
19. *Final Report*, pp. 84, 102.
20. The photographs' location is an assumption, because photographs and illustrations of the entire exhibit indicate the images were not displayed separately. They were not placed behind glass counters, for example, reasonably suggesting their installation inside the trunk section. The *Official Catalogue* does not identify the nature of their display, nor do any other sources—if they mention such photography, they merely note that images accompanied the exhibit.
21. For description of fake trunk exhibit, see "Californian Exhibits at the Fair," San Francisco *Chronicle*, April 23, 1893, 26:7. For description of the General Noble trunk's exhibition in the Government Building, see *Rand McNally & Co.'s Handbook of the World's Columbian Exposition* (Chicago: Rand, McNally, 1893), p. 127; for a description of the preparation of the Noble exhibit, see Dennis G. Kruska, *Sierra Nevada Big Trees: History of the Exhibitions, 1850–1903* (Los Angeles: Dawson's Book Shop, 1985), p. 52, and McGraw, "The Tree that Crossed a Continent," pp. 120–39.
22. *Rand, McNally & Co.'s*, p. 133.
23. *Final Report*, p. 77.
24. "Californian Exhibits," pp. 26:7, 27:1.
25. Ibid., p. 26:7; *Final Report*, p. 77.
26. *Final Report*, pp. 84, 114. Henry James quoted in Claire Perry, *Pacific Arcadia: Images of California, 1600-1915* (New York: Oxford University Press, 1999), p. 96.

CHAPTER 7. WONDER TREES

1. Unfortunately, Hill's triptych of tourists amid the trees is either lost or has been destroyed. The only known photograph of it is in the *Final Report of the California World's Fair Commission*, between pages 56 and 57. Because the tree panels appear to resemble other works Hill produced during this period, which included tourists visiting the trees, I have estimated the triptych's actual composition. Some San Francisco art collectors assume the same, one of whom years ago rejected an anonymous owner's questionable attempt to sell the triptych in separate and incomplete pieces.

2. Hill's overriding importance as a big tree tourist painter can be accounted for by the fact that his residence at Yosemite preceded other in-park painters, as well as he included tourists in many of his sequoia paintings. Christian Jorgensen and Harry Cassie Best maintained Yosemite studios beginning in 1898 and 1902, respectively, but much of their work focused on Yosemite Valley landscapes—predominately unpeopled panoramas. Jorgensen did produce many watercolor and small oil studies of the redwoods, mostly after 1900. Although an oil study of the Coast redwoods, *Redwoods* (n.d., Natural History Museum, Los Angeles County), exemplifies this pattern in that Jorgensen omitted the Bohemian Club's presence, a fraternal organization with a highly select membership that formed in the late nineteenth century in the San Francisco area. According to Katherine Mather Littel, the club maintained an encampment nearby, but the portrait offers no evidence of such visitation. Thus Hill was the first respected painter to document tourists' presence in the groves. For an account of Jorgensen's career, see Littel, *Chris Jorgensen: California Pioneer Artist* (Sonora, CA: Fine Arts Research, 1988); for more on Jorgensen's and Best's Yosemite work, see David Robertson, *West of Eden: A History of the Art and Literature of Yosemite* (Yosemite National Park: Yosemite Natural History Association and Wilderness Press, 1984), Chap. 5.

3. Hill sold most of his work to Yosemite tourists from the studio. It was built for him in 1886 by John Washburn, owner of the neighboring Wawona Hotel. Charging anywhere from $50 to $500 per painting, Hill either sold finished works directly to tourists or produced different versions of completed scenes that they ordered. For more about his business practices at the studio between 1885 and 1900, see Janice T. Driesbach, *Direct from Nature: The Oil Sketches of Thomas Hill* (Yosemite National Park, CA: Yosemite Association, in association with the Crocker Art Museum, Sacramento, CA, 1997), pp. 75–77, 83–88.

4. George G. Mackenzie (Lewis Stornaway), *Where to Go & What to Do. A Plain Guide to the Yosemite Valley, the High Sierra, & the Big Trees* (San Francisco: C. A. Murdock, 1888), p. 72 (entitled "The Wawona Hotel"). The sequoias' touristic appeal also inspired the Sanger Lumber Company in the early 1890s to use the mill's site, operations, and environs as a summer tourist lure—development that recalls the Murphy mines' association with the Calaveras Grove around midcentury (see Chapter 3, this volume). Company owners contracted with other businessmen to build a dam and artificial lake, activity that inspired the erection of at least two hotels and brief use of part of the company's heralded flume as an attraction, called the "Flumeopolis." The exciting two-mile ride, spanning the upper and lower mills, creatively promoted the lumber company's triumphant comple-

tion after thirteen months of the expensive 54-mile project. Its construction required nine million board feet of lumber that twisted and scaled arduous mountainous terrain. Attracting both female and male patrons, the outdoor venue anticipated the thrill rides usually associated only with amusement parks such as Coney Island. See Hank Johnston, *They Felled the Redwoods: A Saga of Flumes and Rails in the High Sierra*, 10th ed. (Fish Camp, CA: Stauffer, 1996/1966), pp. 27–35. For brief accounts of other late-nineteenth-century flume riding experiences in the California Sierras, see Johnston, *Thunder in the Mountains: The Life and Times of Madera Sugar Pine* (Corona del Mar, CA: Trans-Anglo Books, 1974), p. 37; and Johnston, *The Whistles Blow No More: Railroad Logging in the Sierra Nevada, 1874–1942* (Glendale, CA: Trans-Anglo Books, 1984), pp. 87–88.

5. As Nancy K. Anderson succinctly states, with Hill's panels "the image and object had become one, for in the most literal sense the subject of the painting had been consumed in the production of the image." See Nancy K. Anderson, "'The Kiss of Enterprise': The Western Landscape as Symbol and Resource," in William H. Treuthner, ed., *The West as America* (Washington, D.C.: Smithsonian Institution Press, 1991), p. 277. Hill also reportedly used wood from a Mariposa Grove sequoia to construct the frame for an 1894 landscape of the Rio Grande River. He donated the work to the San Francisco Press Club. See Driesbach, *Direct from Nature*, p. 85.

The trees' association with the business of commodities was evident enough that Theodore Dreiser used them as a metaphor for Wall Street leadership in the aptly titled novel, *The Titan* (1914). After reflecting on his achievements as a giant in the utilities industry, character Frank Algernon Cowperwood remained unsatisfied, because his reputation had not reached the highest level of his colleague's esteem. His main concern was that "he was not looked upon as a money prince. He could not rank as yet with the magnates of the East—the serried Sequoias of Wall Street." See Theodore Dreiser, *The Titan* (New York: Horace Liveright, 1925/1914), p. 439. Regarding their appearance as a tourist commodity, Daniel Boorstin similarly characterizes tourists' penchant for sightseeing as expressive of consumerist pleasure. Travel "cease[s] to be an activity—an experience, an undertaking—and instead [becomes] a commodity." See Daniel J. Boorstin, *The Image: A Guide to Pseudo-Events in America* (New York: Atheneum, 1972), p. 85.

6. For a brief discussion of "formulaic" Yosemite tourist photography during this period, see Robertson, *West of Eden*, pp. 96, 101.

7. See Alfred Runte, *National Parks: The American Experience*, 2d ed. (Lincoln: Nebraska University Press, 1987), pp. 30–31 and Chap. 8, especially pp. 161–62; also Frederick Law Olmsted, "The Yosemite Valley and the Mariposa Big Trees, A Preliminary Report (1865)," *Landscape Architecture* 43 (October 1952): 22, 17.

8. Runte, *National Parks*, pp. 164–65, 166, 168. Chris J. Magoc discusses Yellowstone's "consumer packaging" (p. 81) in guidebooks and park planning and describes tourists' attempts to amuse themselves amid the park's spectacles (like throwing laundry soap into geysers and carving names on formations), in *Yellowstone: The Creation and Selling of an American Landscape, 1870–1903* (Albuquerque: New Mexico University Press, 1999), especially Chaps. 4 and 5.

9. For visitation figures, see *Report of the Director of the National Park Service to the Secretary of the Interior* (Washington, D.C.: Government Printing Office, 1918), p. 201, and *Report of the Director of the National Park Service to the*

Secretary of the Interior (Washington, D.C.: Government Printing Office, 1918), p. 280. For the Mariposa Grove figures, see *Report of the Acting Superintendent of the Yosemite National Park to the Secretary of the Interior* (Washington, D.C.: Government Printing Office, 1912), p. 12; *Report of the Acting Superintendent of the Yosemite National Park to the Secretary of the Interior* (Washington, D.C.: Government Printing Office, 1913), p. 19; and *Report of the Superintendent of the Yosemite National Park to the Secretary of the Interior* (Washington, D.C.: Government Printing Office, 1915), p. 11. For the 1916 figures, see Alfred Runte, *Yosemite: The Embattled Wilderness* (Lincoln: Nebraska University Press, 1990), p. 241, n5; and for that of 1922, see Orvar Löfgren, *On Holiday: A History of Vacationing* (Berkeley: University of California Press, 1999), p. 61. Peter J. Blodgett and Anne F. Hyde discuss the history of Yosemite tourism and its dependence on better transportation links. Blodgett finds that only after rail lines to the valley's entrance developed did visitation increase dramatically in the late–nineteenth century, a trend intensified when the automobile was officially allowed in 1913. See "Visiting 'The Realm of Wonder': Yosemite and the Business of Tourism, 1855–1916," *California History* 69 (Summer 1990): 118–33. Hyde carefully details the automobile's effect on accommodations and other facilities the park offered during this period in "From Stagecoach to Packard Twin Six: Yosemite and the Changing Face of Tourism, 1880–1930," *California History* 69 (Summer 1990): 154–69. For a general history of the Yosemite tourist experience, see Stanford E. Demars, *The Tourist in Yosemite, 1855–1985* (Salt Lake City: Utah University Press, 1991).

10. George Horace Latimer, "Trippers and Stoppers," *Saturday Evening Post* 194 (October 8, 1921): 20. See also Paul S. Sutter, *Driven Wild: How the Fight against Automobiles Launched the Modern Wilderness Movement* (Seattle: Washington University Press, 2002); and Warren James Belasco, *Americans on the Road: From Autocamp to Motel, 1910 to 1945* (Baltimore: Johns Hopkins University Press, 1979), Chaps. 1 and 2, for a history of auto tourism and the emergence of the imperious sightseeing (or sight-collecting) autotourist. Belasco stresses that they were referred to somewhat derisively as "gypsies" or "vagabonds" (p. 8), thus carrying on some of Latimer's resentments.

11. All Yosemite artists, particularly photographers, intentionally began to create more tourist-oriented art around the turn of the century, the kind that either invoked the tourist's gaze or recorded the visitor's presence in both the groves, and, especially, the valley. Such techniques were chosen for practical reasons: In-park artists' clientele were largely tourists seeking some kind of souvenir documenting their visit. George Fiske, perhaps the most significant Yosemite photographer of the late–nineteenth century, sometimes positioned his camera on roads or walking paths when recording the park's scenery—even including a curling roadway in some of his breathtaking views, as in *El Capitan—From Milton Road* (n.d., Center for Creative Photography, Tucson, AZ)—thus simulating the everyday visitor's visual experience. See Robertson, *West of Eden,* Chap. 5. Kate Nearpass Ogden surveys nineteenth-century Yosemite art and similarly contemplates tourism's effect in "Sublime Vistas and Scenic Backdrops: Nineteenth-Century Painters and Photographers at Yosemite," *California History* 69 (Summer 1990): 134–53. For "wonder tree" references, see Rodney Sydes Ellsworth, *The Giant Sequoia: An Account of the History and Characteristics of the Big Trees of California* (Oakland, CA:

J.D. Berger, 1924), pp. 59, 63; D. J. Foley, *Foley's Yosemite Souvenir Guide*, 12th ed. (Yosemite, CA: Yosemite Falls Studio, 1912), p. 112. See also K. D. Kurutz and Gary F. Kurutz, *California Calls You: The Art of Promoting the Golden State, 1870 to 1940* (Sausalito, CA: Windgate Press, 2000), for a colorful survey and sampling of the shift in advertising. The Kurutzes briefly point out that as Yosemite tourism began to increase during the early twentieth century, its promotional ephemera reflected such "human incursion," particularly with tunnel tree imagery (p. 101).

12. According to Richard Guy Wilson, the "machine age in America" caused a profoundly optimistic transformation in Americans' regard for themselves and their international standing. He identifies the years 1918 to 1941 as a period when the machine "in all its manifestations—as an object, a process, and ultimately a symbol. . . . challenged perceptions of both self and the world. This new consciousness implied a whole new culture that could be built as readily as the machine; history seemed irrelevant, traditional styles and pieties outmoded." See "America and the Machine Age," in Dianne H. Pilgrim, Richard Guy Wilson, and Dickran Tashjian, eds., *The Machine Age in America, 1918–1941* (New York: Harry N. Abrams, 1986), p. 23.

13. David E. Nye, *Narratives and Spaces: Technology and the Construction of American Culture* (New York: Columbia University Press, 1997), pp. 21, 22, 23. Another example of technology's invocation is "Redwood Radio," a pamphleted short story written by Joseph D. Grant, one of the founders of the Save-the-Redwoods League (established in 1920). While visiting a grove, a group of scholars from a variety of disciplines discover a "crude mechanism" in a fallen sequoia's recess. They accidentally discover that it is some sort of "primitive" phonograph and loudspeaker that when connected to one of the tree's rings plays recordings from significant Western historical events, like the birth of Christ. The group conceives the "impressionable" and "sensitive" tree as a "receiver," a philosophy professor surmising that its "sensitive fibres . . . vibrated to THOUGHTS, capturing and recording them" as events occurred. Its rings, adds a radio professor, are thus the "sound waves." The group spends the entire day and night listening to the recordings, among other events hearing the stirring cries of Viking raiders and the echo of the Magna Carta's reading at Runnymede. Such a story not only repeats the discourse about the trees as historical witnesses, it imaginatively confirms it by envisioning the sequoias' compatibility with early twentieth-century communication technologies. See J. D. Grant, *Redwood Radio: A Reverie* (Berkeley: Save-the-Redwoods League, Library Building, University of California, undated), n.p.

14. Latimer, "Trippers and Stoppers," p. 20; Charles Joseph Finger noted tourists' penchant for quick visits to promoted and deformed sequoias in a 1932 tourist account. He observed that many Sequoia National Park visitors never went "far enough into the forest to see General Sherman" [the largest standing big tree], instead "many [of them] mak[ing] for the so-called Window Tree of filigreed appearance, . . . because it has been as widely advertised by picture postal cards as Niagara. Some go to the Room Tree first, which is very exciting to mild adventurers because of its chambers and stairway." See Finger, *Footloose in the West: Being the Account of a Journey to Colorado and California and Other Western States* (New York: William Morrow, 1932), p. 206. George Belden, an early Sequoia National Park photographer, named the Window Tree in 1905. The damaged tree's hollow trunk contained windowlike openings formed by fire up and out of which visitors

could look. Similarly, the Room Tree, named in 1901, contained a burned hollow in its base, complete with a window opening 6 feet above ground. According to Fern Gray, ladders enabled visitors to climb in and out of the "room," which could hold around twenty-five people. See Gray, *And the Giants Were Named* (Three Rivers, CA: Sequoia Natural History Association, 1975), pp. 3 and 5.

15. Claire Perry makes a similar argument in *Pacific Arcadia: Images of California, 1600–1915* (New York: Oxford University Press, 1999), but locates such an attitude's expression at an earlier period by arguing that stereography was part of the big trees' domestication. She regards stereography as one of "numerous strategies"—like trunk section exhibits—designed by promoters to "make audiences feel at ease" with the "vegetable monsters" (p. 118). But she fails to consider that the sequoias were exhibited in incomplete sections because it was a logistical nightmare. An entire tree specimen could not be transported without risk of damage; plus, there were no adequate facilities to showcase an entire tree. Their early "domestication" thus really had very little to do with easing audiences' minds. In fact, their initial celebrity thrived on perceptions of them as strange or incomparable curiosities. See Perry, *Pacific Arcadia*, pp. 118–21.

16. Ellsworth, *The Giant Sequoia*, p. 63.

17. Walter Gore Marshall, *Through America; or, Nine Months in the United States* (London: Sampson Low, Marston, Searle, & Rivington, 1882), pp. 341–42.

18. Constance Frederica Gordon-Cummings, *Granite* Crags (Edinburgh: W. Blackwood, 1884), p. 288.

19. Runte, *National Parks*, p. 166. The Pioneer Cabin Tree in the Calaveras Grove was also tunneled through during the 1880s. The exact date of a Santa Cruz Coast redwood's excavation is unclear, popularly known as the "driveway tree," which a writer described in 1906 as having a trunk diameter of 28 feet. See Henry Alexander MacFadden, *Rambles in the Far West* (Holidaysburg, PA: Standard Printing House, 1906), p. 128. The Wawona Tree succumbed to the elements in 1969 after a heavy snowstorm.

20. Marshall, *Through America*, p. 341; James Mason Hutchings, *In the Heart of the Sierras* (Oakland, CA: Old Cabin, Yo Semite Valley, and the Pacific Press, 1888), pp. 259, 260–61.

21. J. Franklin Bell, "Some of California's Big Trees and Their Guardians," *Harper's Weekly* 41 (May 15, 1897): 495; Anonymous, "California's Famous Big Trees," *Scientific American* n.s. 66 (February 13, 1892): 103; John Muir, ed., *Picturesque California: The Rocky Mountains and the Pacific Slope*, vol. 2 (New York: J. Dewey, 1888), photogravure between pp. 56 and 57.

22. A regional rail line, Yosemite Valley Railroad (YVR), built a link from Merced to El Portal (the western entrance to the valley) in 1907, though some independent auto transport companies existed, such as Theodore Gibson's Yosemite Auto Stage Company, which provided transport from Stockton to Yosemite Valley. Southern Pacific built a link from Los Angeles to El Portal under an arrangement with the YVR in 1909 and one from San Francisco in 1910. See Lynne Withey, *Grand Tours and Cook's Tours: A History of Leisure Travel, 1750 to 1915* (New York: William Morrow, 1997), p. 318. Once passengers reached El Portal, they had a variety of transportation options over the years. A YVR stagecoach or automobile, under the name of Yosemite Transportation Company, could carry visitors into the valley and throughout the park. However, the YVR did not monopolize in-park transporta-

tion. It is difficult to track all the different transport companies and options that existed throughout this period, but, for instance, in 1915 the Yosemite Stage and Turnpike Company offered transport from the Valley to Mariposa Grove, the Big Trees Auto Stage Company carried travelers from El Portal to the Merced and Tuolumne Groves, as well as visitors sometimes opted to use private cars. See *Report of the Superintendent of the Yosemite National Park*, 1915, p. 12. For discussion of the YVR, see Alfred Runte, "Yosemite Valley Railroad: Highway of History, Pathway to Promise," in *Trains of Discovery: Western Railroads and the National Parks* (Flagstaff, AZ: Northland Press, 1984), pp. 62–75; and for a more detailed account of all the transport linkages it offered, see Hank Johnston, *Railroads of the Yosemite Valley* (Los Angeles: Trans-Anglo Books, 1966), pp. 9–116.

23. Unfortunately, much of this material has disappeared or is lost because of the 1906 earthquake; also, Southern Pacific may have been uninterested in its collection. The posters, photographs, and calendars, consistently advertised in company publications, either have not been preserved or their location impossible to identify. Thus their exact subject matter or composition is unknown.

24. A. J. Wells, *The Yosemite Valley and the Mariposa Grove of Big Trees of California* (San Francisco: Passenger Department, Southern Pacific Company, 1907), p. 58.

25. One of the most popular visual artifacts of the period, postcards form a genre of tourist photography that, much like stereographs of the nineteenth century, have yet to be the subject of much scholarly analysis. Most of the scholarship is descriptive—listing and displaying samples of postcards in a variety of categories. Although these works show the scope of postcard artistry, they offer no cultural analysis. Another scholarship category involves personal reflections, combined with very brief historical accounts of the postcard's emergence. See Hal Morgan and Andreas Brown, *Prairie Fires and Paper Moons—The American Photographic Postcard: 1900–1920* (Boston: David R. Godine, 1981). Morgan and Brown's book includes a useful section on dating photographic postcards. George and Dorothy Miller provide slightly more historical analysis and description in *Picture Postcards in the United States, 1893–1918* (New York: Clarkson N. Potter, 1976). The best example of the postcard's cultural analysis focuses on the prevalence of racial stereotyping and xenophobic attitudes around the turn of the century. See Christraud M. Geary and Virginia-Lee Webb, eds., *Delivering Views: Distant Cultures in Early Postcards* (Washington, D.C.: Smithsonian Institution Press, 1998).

26. The women's behavior and posture during the shoot was not uncommon during this period. A photographer, Bert Bruce, staged mock holdups at the Wawona Tree—"complete with stage-frightened vacationers and bandits wielding bottles for guns"—sometime between 1880 and 1920. David Robertson claims that Bruce "made his living doing nothing but taking pictures of tourist parties coming through the Tunnel Tree" during such overdramatized moments. This particular image, however, is probably not a Bruce photograph. See Robertson, *West of Eden*, p. 105.

Even the Grizzly Giant endured intrusive tourist behavior, showing just how far visitors' transformation in the trees' presence had progressed. However, the distinguished tree's photography rarely if ever depicted these encounters. As Runte points out, park officials were highly concerned with its protection throughout the early twentieth century, because "illegal as opposed to legal vandalism had become . . . [a] problem." Their solution was to install a series of encircling fences, including

simple wooden ones. But by the late 1920s, such fences became more elaborate. One superintendent proposed the installation of a World War I-inspired "long triple-barbed wire" contraption strung low to the ground, camouflaged behind ferns and brush. Tourist photographers mostly ignored portraying Grizzly Giant amid such protection. See Runte, *Yosemite*, p. 164. The star attraction at Sequoia National Park, the General Sherman tree, inspired similar concerns and the installation of security props.

27. Although the Wawona Tree was the most popular sequoia for these kinds of postcard compositions, others attracted somewhat similar portrayals of tourist behavior. For example, a postcard with a 1917 postmark shows two men with arms defiantly crossed, leaning against the large bulk of the Massachusetts Tree. Accenting the tree's size, one of the men stands on the other's shoulders—but their impudent pose is the most noteworthy part of the composition, resembling that of other tourists in most wonder tree postcards and photographs. See Yosemite National Park Research Library, 12,395. Coast redwood postcards similarly focused on sequoia oddities and amused tourists. The Art-Ray Company (1946–1956) produced many of these materials, although likely there were earlier vendors. See Peter Johnstone, ed., *Giants in the Earth: The California Redwoods* (Berkeley, CA: Heyday Books, 2001), unpaginated portfolio section.

28. A minor example of the various formats that captured the distracted wonder tree tourist certainly included an early twentieth-century photograph—possibly later converted into a 1930 postcard—that showed a couple posing outside their car after having passed through the tunnel. Standing near a sign announcing the dimensions of the Wawona Tree, the male exuded a sense of composed confidence, unconcerned or uninterested with the arboreal wonder towering over and behind him. With his arm draped around the woman, he expressed an equal sense of control over his companion and his immediate surroundings. Reprinted on a recent postcard, "Yesterday & Today," *Yosemite National Park: The Interpretive Series*, #24045 Wawona Tunnel Tree (Pittsburg, CA: Impact, n.d.).

29. Hutchings, *In the Heart of the Sierras*, p. 227.

30. Gordon-Cummings, *Granite Crags*, pp. 307, 308, 309.

31. Their photography was so popular that some have been reproduced as late-twentieth-century retrospective postcards. See "A Fallen Monarch, California Big Trees," California Redwoods Post Cards, Golden Age of Post Cards Series A—#2 of 2, Olde America Antique, Susan Davis, Bozeman, MT (original publisher, Edward H. Mitchell, San Francisco, ca. 1907–1915).

32. Stephen Mather, *Report of the Director of the National Park Service to the Secretary of the Interior* (Washington, D.C.: Government Printing Office, 1917), 70. Auto log photograph between pp. 74 and 75.

33. Two postcard companies that printed these cavalry scenes were Pacific Novelty of San Francisco and Los Angeles and the Detroit Publishing Company. See "U.S. Cavalry on Fallen Monarch, Mariposa Big Tree Grove, California" (Yosemite National Park Research Library 21,361) and "Cavalry on Trunk of Sequoia, Merced Grove, California," ca. 1907–1915, reprinted by Olde America Antiques, California Redwoods Post Cards, Golden Age of Post Cards, Series A—#1 of 2, 1990 Susan Davis, Bozeman, MT.

34. Bell, "Some of California's Big Trees and Their Guardians," p. 495.

35. Sequoia and Kings Canyon National Parks Museum (SEKI), negative 2204, or see

William C. Tweed and Lary M. Dilsaver, *Sequoia Yesterdays: Centennial Photo History* (Three Rivers, CA: Sequoia Natural History Association, 1990), n.p. Multiple versions subsequent to the tree's 1917 planing exist in SEKI files 12606, 12607, and 12611.

36. Jakle's discussion essentially describes Bowron's, Marx's, and Rose's theory of covert culture. Finding "contrived attractions" as key, Jakle maintains that "since most tourists sought to reduce nature to familiar terms, most sought contrived attractions . . . [that] humanized nature, making the little understood and the potentially frightful, as well as the downright tiresome, more palpable for tourist consumption." See John A. Jakle, *The Tourist: Travel in Twentieth-Century North America* (Lincoln: Nebraska University Press, 1985), p. 67. For Eve fantasy, see Anonymous, "A Romance at South Dome," *Overland Monthly* ser. 2, 8 (July 1886): 64–65.

37. Jakle, *The Tourist*, p. 66; MacFadden, *Rambles in the Far West*, pp. 127, 128.

38. Unidentified artist, "California: The Home of the Big Tree," *Country Life in America* 5 (January 1904): backcover. It later resurfaced in a smaller ad in the same magazine, "Nature's Wonderland California" 6 (July 1904): 299. The comparison between the two landmarks was so compelling that a year later *Munsey's Magazine* invoked the two titanic objects by describing the Flatiron as "a curiosity to which people will come and stare as they do at cataracts and big caves and great trees and fat women and whatever else is abnormal." Edgar Saltus, "New York from the Flatiron," *Munsey's Magazine* 33 (July 1905): 390. Perry presents a similar interpretation of the ad in *Pacific Arcadia*, pp. 119–20.

39. Anonymous, *Big Trees of California*, Southern Pacific folder, issued April 15, 1909: 3–4. Peter J. Schmitt considers urban–natural comparisons differently, finding them more revelatory of urban dwellers' insecurities than boastful assertions. He examines Americans' impulse to "translate nature into urban terms" around the turn of the century in *Back to Nature: The Arcadian Myth in Urban America* (Baltimore: Johns Hopkins University Press, 1990/1969), p. xx. In a quickly emerging urban world, nature imagery invoked reassuring Arcadian spiritual ideals of beauty and serenity, which were at risk in a society "trying to cope with the pressures of urbanization" (p. xix). Schmitt argues that Americans subsequently attempted to offset urban scenes with those of nature to find some kind of spiritual or emotional balance within the urban world's harsher realities. Some of the results included "railroad posters [that] gave [nature lovers] a vision of rushing rivers and roaring waterfalls, of towering mountains and sprawling glaciers, of northern lakes and forests, which complemented city streets and crowded buildings." The promotion of sublimely opposed scenery was therefore "tailored to the emotional needs of an urban world," because it "enabled nature lovers to shut out [or maybe ignore] the undesirable and . . . refine the world into permanently beautiful form" (p. 153).

Such emotional denial is evident in boastful depictions of the Bohemian Club's Coast redwood camping excursions. These images offer a much earlier and more integrated example of urban–natural comparisons, the kind that Southern Pacific later incorporated into their big tree and California travel promotions. The elite group of muscular Christians, most of them highly successful entrepreneurs and commercial titans themselves, formed their own fraternity in the San Francisco area in the late 1800s. An 1880s Elim Grove campsite portrait shows the well-dressed and powerful group posing with one of the Northern Pacific's locomotives, whose

explosive steam christens the transportation giant's penetration of this ancient realm. As Perry convincingly maintains, "in this context . . . the camera considers these financial emperors and conquerors of the wilderness" as the trees' equal— "big men among Big Trees" (*Pacific Arcadia*, p. 125). More telling, however, is the disparity between the sequoias and urban technology, which is figured in the grove's naming. *Elim* is a backward spelling for "mile," the measure of the main track's distance from the aged grove. Tourism and transportation technologies were taking over the trees' territory, led by these unfazed corporate conductors, some of whom likely financed the new link. See Perry, *Pacific Arcadia*, pp. 123–26.

40. Anonymous, *Big Trees of California*, Southern Pacific folder, undated and unpaginated.

41. Anonymous, *Big Trees of California* (April 15, 1909): 3.

42. Anonymous, *Big Trees of California*, Southern Pacific booklet, issued July 25, 1904, unpaginated, but quotation located in the caption for an image titled, "'The Grizzly Giant,' Mariposa Grove." Other companies began to appropriate Grizzly Giant in their promotions as well, revealing even further the trees' transformation as tourist objects. For a 1901 ad, Kodak reproduced H. C. Tibbitts's Grizzly Giant photograph to bolster its claim that its camera was to others "as the Redwoods of California are to ordinary trees." Playing off the Wawona Tree's growing celebrity, Kalliodont toothpaste used a color illustration of the excavated wonder in the 1880s for one of its promotional flyers—the trees' great cavity, as Claire Perry has cleverly intuited, "a subtle reminder of the unpleasant consequences of neglecting the teeth." Somewhat as John Urry has argued of Niagara Falls, the big trees had reached such iconographic celebrity that they were "transformed by a variety of commercial and public interests," indicative of a tourist gaze "undergo[ing] immense changes." Their appearance had reached a point of familiarity that products, such as cameras and toothpaste, and ideas, such as leadership and endurance, could be associated with them that had nothing to do with trees or botany. Even more interesting is Kodak's usage of Grizzly Giant to encourage the consumption of its own appearance as a tourist site, or, rather, a depicted object. Indeed, with the ad Kodak used the Grizzly Giant to promote the continuance of the tree's own iconographic commodification, an appropriation of image and object similar to Hill's redwood panels and also Carleton Watkins's redwood-framed photographs, which he exhibited at the 1867 Paris International Exposition. See "The KODAK," *Country Life in America* 1 (November 1901): vi; Perry, *Pacific Arcadia*, p. 120; and John Urry, *The Tourist Gaze: Leisure and Travel in Contemporary Societies* (London: Sage, 1990), p. 62.

CHAPTER 8. THE NATIONAL EQUIVALENT

1. Its filming was grand and harrowing as well, with locations in Utah, Wyoming, Montana, Sequoia National Park, and Yuma, Arizona. As Garry Wills points out, Walsh supervised three camera teams, "one filming in 70mm, one in 35mm, and one with German speakers for foreign exhibition. Logistics, equipment failure, squabbling extras, drunks, and lecherous principals" all skyrocketed costs and contributed to the film's financial failure. See Wills, *John Wayne's America: The Politics of Celebrity* (New York: Simon & Schuster, 1997), p. 51.

2. Anonymous,, "Across the Editor's Desk," *Better Homes & Gardens* 14 (December 1935): 4; Anonymous, "Sequoia Wins Tree Vote," *Nature Magazine* 26 (July 1935): 196.

3. See Sequoia and Kings Canyon National Parks Museum (SEKI), File Code K, Box 256, File 14, Congressional Record for May 4, 1936, p. 6871.

4. See SEKI, File Code K, Box 256, File 14, letter to White dated May 5, 1936; and *Nature Magazine* 26 (July 1935): 196. Warren I. Susman provides more insight into Representative Wolcott's interest in stressing a tree's typicality. Citing examples from the development of the Gallup poll and New York's 1939 World's Fair, Susman contends that "nothing [was] more characteristic of the 1930s vision . . . than the concept of the typical or average." See Warren I. Susman, *Culture as History: The Transformation of American Society in the Twentieth Century* (New York: Pantheon Books, 1984/1973), p. 219. George Gallup created the American Institute of Public Opinion in 1935 and released polls that identified general American opinions, but its strongest expression came at the 1939 fair. Such a concept was the central focus of the fair, Susman argues, especially given the popularity of some of its contests (the search for the typical American boy) and exhibits (the popular film, *I'll Tell the World*, a saga of the typical American family facing economic hardship). See Chap. 11 in Susman, *Culture as History*, especially pp. 211–20.

5. The first significant naming ceremony occurred in 1923 with the naming of the Warren G. Harding tree. See Department of the Interior, *Report of the Director of the National Park Service to the Secretary of the Interior* (Washington, D.C.: Government Printing Office, 1923), pp. 68–69. Promotional materials and program for the Lee and Anthony ceremonies available at SEKI, File Code K, Box 257, File 10 and CD 4788.

6. Fern Gray, *And the Giants Were Named* (Three Rivers, CA: Sequoia Natural History Association, 1975), p. 4.

7. Walsh includes a fallen sequoia in *Trail*, in a scene where Coleman (Wayne) successfully slays the last of the hired guns sent to kill him. It is a visually stunning moment as he throws a knife at the villain while standing on top of the avenue created by the massive trunk. A scout trained by natives, Coleman knows how to survive and thus he victoriously stands on top of the sequoia. But Walsh quickly reestablishes the lesson of the trees' indomitable presence in the film's final scene where Wayne and Churchill reunite under trees that stand firmly upright.

8. Thomas West, "The Big Tree that Wouldn't Fall," *Nature Magazine* 18 (August 1931): 121.

9. C. A. Harwell, "The Fall of a Giant Sequoia," *Scientific Monthly* 40 (May 1935): 484.

10. Anonymous, "Ancient Sequoia Tree Falls in California Grove," *Science News Letter* 46 (July 29, 1944): 73.

11. See S. J. Holmes, "Two Generations of Redwoods," *Nature Magazine* 17 (April 1931): 242; Anonymous, "The Indestructible Redwood," *Literary Digest* 85 (May 16, 1925): 24–25; and Oliver A. Morris, "Giant Trees that Refuse to Die," *Travel* 71 (September 1938): 9–11, 48.

12. Morrow Mayo, "To See It Fall," *Harper's Magazine* 172 (May 1936): 710, 711.

13. Ibid., p. 712.

14. Ibid., p. 713; Roland Marchand, *Advertising the American Dream: Making Way for Modernity, 1920–1940* (Berkeley: University of California Press, 1985), pp. 324–33.

15. David Robertson, *West of Eden: A History of the Art and Literature of* Yosemite (Yosemite National Park: Yosemite Natural History Association and Wilderness Press, 1984), p. 136.

16. For analysis and information on Berlin's song, see Jonathan Spaulding, *Ansel Adams and the American Landscape* (Berkeley: University of California Press, 1995), p. 179; and Lynn Wenzel and Carol J. Binkowski, *I Hear America Singing: A Nostalgic Tour of Popular Sheet Music* (New York: Crown, 1989), p. 105. Woody Guthrie's critical 1940 response to Berlin's song, "This Land Is Your Land"—originally titled "God Blessed America"—parodied such optimism. After listing the redwoods as one of the significant landmarks bounding the nation's natural resources he questioned the inequity of oppressive humanmade boundaries. Reading signs saying "Private Property" and watching people stand in line at a Relief Office, Guthrie wondered "if God Blessed America for me." He changed the chorus line to "this land was made for you and me" when the song was released in the mid-to-late 1940s. See Dave Marsh and Harold Leventhal, eds., *Pastures of Plenty: A Self-Portrait, Woody Guthrie* (New York: HarperCollins, 1990), p. xxiv.

17. Richard Polenberg points out that participation in these acts of sacrifice, such as conserving rubber or maintaining victory gardens, was "imbued with broad significance" and "enhance[d] feelings of comradeship and well-being" among Americans. See Polenberg, *War and Society: The United States, 1941–1945* (Philadelphia: J.B. Lippincott, 1972), pp. 132, 133. For redwood references, see Weyerhaeuser advertisement, "Team-Mates in Defense," *American Forests* (September 1941): 435 (this image actually depicts a Douglas fir, but it was reprinted from an article celebrating the Coast redwoods published three years earlier—"Giant Redwoods that Refuse to Die"); Anonymous, "Saga of the Redwoods," *Popular Mechanics* 80 (November 1943): 28, 32; Anonymous, "Fiber from Redwood Bark is Wool Substitute," *Popular Mechanics* 77 (May 1942): 49; Anonymous, "Redwoods at War," *Business Week* 776 (July 15, 1944): 83.

18. David P. Peeler pairs Adams with Edward Weston as photographers who intentionally ignored the social scene during the dramatic 1930s, styling their approach as an "art of disengagement." See "The Art of Disengagement: Edward Weston and Ansel Adams," *Journal of American Studies* 27 (December 1993): 309–34; Spaulding, *Ansel Adams and the American Landscape,* p. 178.

19. Mary Street Alinder and Andrea Gray Stillman, eds., *Ansel Adams: Letters and Images, 1916–1984* (Boston: Little, Brown, 1988), pp. 109–10.

20. These were the years when some of Adams's most popular and cherished images of nature emerged. As Adams's cultural biographer Jonathan Spaulding has argued, during these years Adams began to

> portray . . . the landscape as vast, powerful, touched by the hand of God—all the qualities then being invoked as the nation geared up to join the global conflict. The images he made in these years were Adams fortissimo: rousing nationalistic choruses linking nature, spiritual inspiration, and national purpose.

See Spaulding, *Ansel Adams and the American Landscape,* p. 188.

21. Colin Westerbeck, "Ansel Adams: The Man and the Myth," in Michael Read, ed., *Ansel Adams, New Light: Essays on His Legacy and Legend* (San Francisco: Friends of Photography, 1993), pp. 11, 12.

22. Alinder and Stillman, *Ansel Adams,* p. 117.

23. Ansel Adams, *Ansel Adams: An Autobiography* (New York: Little, Brown, 1985), p. 260.
24. Mary Street Alinder, *Ansel Adams: A Biography* (New York: Henry Holt, 1996), pp. 188, 202; Spaulding, *Ansel Adams and the American Landscape*, p. 193.
25. Alinder and Stillman, *Ansel Adams*, p. 154.
26. Leslie Calmes, personal communication (February 8, 1999). Calmes, assistant archivist at the Center for Creative Photography in Tucson, AZ, claims that Adams never kept field notes.
27. Ansel Adams, "Problems of Interpretation of the Natural Scene," *Sierra Club Bulletin* 30 (December 1945): 47.
28. Adams seemed drawn to the roots and trunks of the big trees, photographing a close-up view of their striated, twining roots in *Sequoia Gigantea Roots* (ca. 1950, Center for Creative Photography, Tucson, AZ), and a bold redwood trunk, nearly stomping in the snow, in *Redwood Tree, Mariposa Grove, Winter* (ca. 1937, Center for Creative Photography). He included the last image and two others of the trees (*The Grizzly Giant* and *In the Mariposa Grove*—the latter whose composition differs from a similarly titled 1944 image) in a 1963 guidebook, but unfortunately he does not list their dates. The former's date may be 1947. These last two images are studies of the sequoias' lower trunks. See Virginia and Ansel Adams, *Illustrated Guide to Yosemite: The Valley, the Rim, and the Central Yosemite Sierra* (San Francisco: Sierra Club, 1963), pp. 94–96.
29. Rodney L. Brink, "Temples of Peace," *Christian Science Monitor* (April 1, 1944): 8, 9.
30. Frieda Knobloch, *The Culture of Wilderness: Agriculture as Colonization in the American West* (Chapel Hill: North Carolina University Press, 1996), pp. 37, 40.
31. Anonymous, "Fighting the Red Demon," *Nature Magazine* 34 (August–September 1941): 381–86; see Knobloch, *Culture of Wilderness*, Chap. 1, especially pp. 40–44. For a colorful example of the "red demon" motif, see Louis Hirshman's poster, "Stop and Get Your Free Fag Bag. Careless Matches Aid the Axis," in Christopher De Noon, *Posters of the WPA* (Los Angeles: Wheatley Press, 1987), p. 150. For other posters that equated foreign aggression with forest sabotage, see the illustrations in Alfred Runte, *Public Lands, Public Heritage: The National Forest Idea* (Niwot, CO: Roberts Rinehart, 1991), pp. 72–73.
32. "Old Sequoia" is not the only Disney short that includes the big trees. "Out of Scale" (1951), however, playfully references wonder-tree motifs. After infiltrating Donald Duck's backyard miniature railroad station and suburban complex, the twin chipmunks Chip and Dale upset Donald's control of the landscape, causing a runaway train and a large tree's catapulting—the latter of which Donald had targeted for removal because it was "out of scale." The tree lands upright on the small rail tracks, its trunk punched through by a fugitive trolley. Donald regains control of the errant train by mounting it and readies himself to attack the twins. As he steams toward them, Chip grabs a wooden sign that says, "Giant Redwood," and both he and Dale quickly place it above the tree's opening. Dale points to the sign and the trunk's hollow, saying in a high-pitched juvenile voice, "Giant redwood. See?" to Donald's elated distraction. The tree's size no longer a problem, Donald exults, "giant redwood! OK!" and charges the diminutive car through the opening. Given that the tree had originally been the twin chipmunks' home, "Out of Scale" wryly comments on Americans' valuing of nature's control and domestication, big-tree themes most strongly associated with the early twentieth century.

EPILOGUE

1. Anonymous, "American Redwood Trees Have Chinese Relatives," *Science News Letter* 51 (February 1, 1947): 79. For a description of its discovery and initial study, see Ralph W. Chaney, *Redwoods of the Past,* 3d ed. (San Francisco: Save-the-Redwoods League, 1990).

2. Newton B. Drury, "Zero Hour Approaches for Calaveras South Grove," *National Parks Magazine* 26 (January–March 1952): 33. President Bill Clinton completed their protection in April 2000 when he named thirty sequoia groves that remained unprotected Giant Sequoia National Monument.

3. See Julia Butterfly Hill, *The Legacy of Luna: The Story of a Tree, a Woman, and the Struggle to Save the Redwoods* (San Francisco: HarperSanFrancisco, 2000).

4. Susan R. Schrepfer's work certainly establishes the context on which such analysis could be based. *The Fight to Save the Redwoods: A History of Environmental Reform, 1917–1978* (Madison: Wisconsin University Press, 1983), focuses on the history of Coast redwoods' conservation activism, particularly the development and actions of the Save-the-Redwoods League. Another text worth consulting is John Evarts and Marjorie Popper, eds., *Coast Redwood: A Natural and Cultural History* (Los Olivos, CA: Cachuma Press, 2001).

5. For detailed analysis about Hill's involvement, see Carolyn de Vries, "Andrew P. Hill and the Big Basin, California's First State Park," *San Jose Studies* 2 (1976): 70–92; Carolyn de Vries, *Grand and Ancient Forest: The Story of Andrew P. Hill and Big Basin Redwood State Park* (Fresno, CA: Valley, 1978), and Victoria Thomas Olson, "Pioneer Conservationist A.P. Hill: 'He Saved the Redwoods,'" *American West* (September/October 1977): 32–40. Some of his photographs are included in Carrie Stevens Walter, "The Preservation of the Big Basin," *Overland Monthly* (October 1902): 354–61.

6. Given that the play's first presentation occurred in the California Redwood Park at Big Basin in 1922 [and later performed in Sequoia National Park on August 26 and 27 of the same year (Program, *Fourth Annual Presentations,* p. 22)], Ersa's run at Sequoia National Park was likely inspired by previous tree pageants sponsored by the Sempervirens Club in the late 1910s. In 1919 and 1920, two plays were produced at Big Basin—"The Soul of Sequoia: A Forest Play" (1919) and "The Sempervirens Forest Play" (1920). Fundraising problems ended that production's run in 1921. For a brief description of these plays, see Willie Yaryan, Denzil Verardo, and Jennie Verardo, *The Sempervirens Story: A Century of Preserving California's Ancient Redwood Forest, 1900–2000* (Los Altos, CA: Sempervirens Fund, 2000). "Ersa" program material located in SEKI archives at Sequoia National Park.

7. "Ersa of the Red Trees," pp. 7, 24. In 1952 Warner Brothers also attempted to incorporate preservation issues when it released *The Big Trees,* "a muscular adventure" of one man's conversion from exploitative lumberman to a type of community leader. Jim Fallon (played by Kirk Douglas) finances an illegal land grab of a sequoia grove, one reverently inhabited for generations by what *Newsweek* identified as a "thee-and-thou-ing religious sect" (A.W., "The Big Trees," *New York Times,* February 6, 1952, 24:2; and Anonymous, "New Films: The Big Trees," *Newsweek* (February 25, 1952): 100–102). Amid their protests, led by a woman temptingly named Eve (Alicia Chadwick), with whom Fallon falls in love, he

changes his ways and, according to the *New York Times*, "switches from dirty deeds to clean ideals and a good woman." Once fallen, he rehabilitates himself by dramatically stopping another lumberman from doing what he originally intended with his purchases—completely mining and thus permanently destroying the grove. Along with embarrassing dialogue that mocks the sequoias and women—including one scene where Fallon compares the tree's dimensions to Eve's and another where he remarks that Eve "is the first [gal] who asked me to come around and see her trees"—the film, an unchallenging examination of the resource conflicts of the McKinley era, ends up mostly invoking the big trees' religious atmosphere. A minor cultural artifact, *The Big Trees* is an unimaginative celebratory Western that rehashes familiar ideas about the trees' sacredness.

8. For a fascinating analysis of the film's exploration of female identity, see William Rothman, *The "I" of the Camera: Essays in Film Criticism, History, and Aesthetics* (New York: Cambridge University Press, 1988), Chap. 13.

9. Dan Auller, *Vertigo: The Making of a Hitchcock Classic* (New York: St. Martin's Press, 1988), p. 93.

10. John Steinbeck. *Travels with Charley—In Search of America* (New York: Penguin Books, 1986/1962), pp. 188–189, 190.

11. Ibid., pp. 188, 190, 191.

BIBLIOGRAPHY

Adams, Ansel. *Ansel Adams: An Autobiography.* New York: Little, Brown, 1985.
——. "Problems of Interpretation of the Natural Scene." *Sierra Club Bulletin* 30 (December 1945): 47–50.
Adams, Virginia and Ansel. *Illustrated Guide to Yosemite: The Valley, the Rim, and the Central Yosemite Sierra.* San Francisco: Sierra Club, 1963.
Alinder, Mary Street. *Ansel Adams: A Biography.* New York: Henry Holt, 1996.
Alinder, Mary Street, and Andrea Gray Stillman, eds. *Ansel Adams: Letters and Images, 1916–1984.* Boston: Little, Brown, 1988.
Allis, S. "As Seen in a Logging-Camp." *Overland Monthly* 36 (September 1900): 194–208.
American Paintings in the Metropolitan Museum of Art, Volume 2. New York: Metropolitan Museum of Art, 1985.
Anderson, Nancy K. "'The Kiss of Enterprise': The Western Landscape as Symbol and Resource." In *The West as America: Reinterpreting Images of the Frontier, 1820–1920,* edited by William H. Treuttner, 237–83. Washington, D.C.: Smithsonian Institution Press, 1991.
Anderson, Nancy K., and Linda Ferber, eds. *Albert Bierstadt: Art & Enterprise.* New York: Brooklyn Museum, 1990.
Andrews, Ralph W. *Photographers of the Frontier West: Their Lives and Their Works, 1875–1915.* Seattle, WA: Superior, 1965.
——. *"This Was Logging!" Selected Photographs of Darius Kinsey.* Seattle, WA: Superior, 1954.
Anonymous. "About Trees." *Putnam's Monthly* 6 (November 1855): 518–22.

Anonymous. "Across the Editor's Desk." *Better Homes & Gardens* 14 (December 1935): 4.

Anonymous. "American Redwood Trees Have Chinese Relatives." *Science News Letter* 51 (February 1, 1947): 79.

Anonymous. "Ancient Sequoia Tree Falls in California Grove." *Science News Letter* 46 (July 29, 1944): 73.

Anonymous. "Art Items." New York *Evening Post,* December 11, 1862, 2:4.

Anonymous. "The Big Trees of California." *Harper's Weekly* 2 (June 5, 1858): 357–58.

Anonymous. *Big Trees of California.* Southern Pacific booklet, issued July 25, 1904.

Anonymous. "California Redwood." San Francisco *Chronicle,* August 20, 1894, 4:3.

Anonymous. "California Scenery at the Paris Exposition." San Francisco *Evening Bulletin,* June 10, 1868, 3:4.

Anonymous. "A California Tree." *Daily Alta California,* June 10, 1853, 2:2.

Anonymous. "Californian Exhibits at the Fair." San Francisco *Chronicle,* April 23, 1893, 26:1–7 to 27:1–2.

Anonymous. "Californian Redwood as a Substitute for Steel." *American Architect and Building News* 82 (October 3, 1903): 5.

Anonymous. "California's Famous Big Trees." *Scientific American* n.s. 66 (February 13, 1892): 103–04.

Anonymous. "A Carpeted Saloon." In *A Treasury of the Sierra Nevada,* edited by Robert Leonard Reid, 204–06. Berkeley, CA: Wilderness Press, 1983.

Anonymous. "Charter Oak Place." Hartford *Daily Times,* September 1, 1858, 2:5.

Anonymous. "A Christmas Seed and a Spring Harvest in the Valley of the San Joaquin, California." *Sunset* 4 (February 1900): 127–61.

Anonymous. "Fiber from Redwood Bark Is Wool Substitute" *Popular Mechanics* 77 (May 1942): 49.

Anonymous. "Fighting the Red Demon." *Nature Magazine* 34 (August–September 1941): 381–86.

Anonymous. "Fine Arts. The Academy of Design." *New York Times,* April 13, 1874, 5:1–2.

Anonymous. "Fine Arts. Domestic Notes." New York *World,* November 26, 1875, 5:3.

Anonymous. "An Immense Tree." *Gleason's Pictorial Drawing-Room* 5 (October 1, 1853): 217.

Anonymous. "The Indestructible Redwood." *Literary Digest* 85 (May 16, 1925): 24–25.

Anonymous. "Mammoth Tree." *Gleason's Pictorial Drawing-Room Companion* 6 (March 11, 1854): 160.

Anonymous. "National Academy of Design." New York *Evening Post,* April 25, 1874, 1:1–2.

Anonymous. "New Films: *The Big Trees.*" *Newsweek* (February 25, 1952): 100–02.

Anonymous. "Redwood Logging in California." *Scientific American* n.s. 63 (July 26, 1890): 55.

Anonymous. "Redwoods at War." *Business Week* 776 (July 15, 1944): 83.

Anonymous. "A Romance at South Dome." *Overland Monthly* ser. 2(8) (July 1886): 57–74.

Anonymous. "The Royal Academy. Concluding Notice." *Art-Journal* 36 (August 1874): 225–29.

Anonymous. "Saga of the Redwoods." *Popular Mechanics* 80 (November 1943): 28–32.

Anonymous. "Sequoia Wins Tree Vote." *Nature Magazine* 26 (July 1935): 196.

Anonymous. "To the Big Trees." *Overland Monthly* 5 (November 1870): 397–403.

Anonymous. "The Valley of Grisly Bear." *Art-Journal* n.s. 9 (August 1, 1870): 252.

Anonymous. "Whitney's Geological Survey of California." *North American Review* 110 (January 1870): 229–32.

Auller, Dan. Vertigo: *The Making of a Hitchcock Classic*. New York: St. Martin's Press, 1988.

A. W. "The Big Trees." *New York Times,* February 6, 1952, 24:2.

Badger, Reid. *The Great American Fair: The World's Columbian Exposition & American Culture*. Chicago: Nelson Hall, 1979.

Baxter, Jean Taylor. "Burdens and Rewards: Some Issues for American Artists, 1865–1876." Ph.D. dissertation, University of Maryland, College Park, 1988.

Becker, Howard S., "Stereographs: Local, National, and International Art Worlds." In *Points of View: The Stereograph in America—A Cultural History,* edited by Edward W. Earle, 89–96. New York: Visual Studies Workshop Press, 1979.

Belasco, Warren James. *Americans on the Road: From Autocamp to Motel, 1910 to 1945*. Baltimore: Johns Hopkins University Press, 1979.

Bell, J. Franklin. "Some of California's Big Trees and Their Guardians." *Harper's Weekly* 41 (May 15, 1897): 495–96.

Billington, Ray Allen. *Land of Savagery, Land of Promise: The European Image of the American Frontier in the Nineteenth Century*. New York: W.W. Norton, 1981.

Blodgett, Peter J. "Visiting 'The Realm of Wonder': Yosemite and the Business of Tourism, 1855–1916." *California History* 69 (Summer 1990): 118–33.

Bohn, Dave. "Kinsey Photographer." *American West* 12 (May 1975): 16–27.

Bohn, Dave, and Rodolfo Petschek. *Kinsey Photographer: A Half Century of Negatives by Darius and Tabitha May Kinsey, Volume Two*. San Francisco: Prism Editions, 1978.

Boime, Albert. *The Magisterial Gaze: Manifest Destiny and American Landscape Painting, circa 1830–1865*. Washington, D.C.: Smithsonian Institution Press, 1991.

Boorstin, Daniel J. *The Image: A Guide to Pseudo-Events in America*. New York: Atheneum Press, 1972.

Bowron, Bernard, Leo Marx, and Arnold Rose. "Literature and Covert Culture." *American Quarterly* 9 (Winter 1957): 377–86.

Brink, Rodney L. "Temples of Peace." *Christian Science Monitor* (April 1, 1944): 8–9.

Britsch, Ralph A. *Bierstadt and Ludlow: Painter and Writer in the West*. Salt Lake City, UT: Brigham Young University Press, 1980.

Bromley, Isaac. "The Big Trees and the Yosemite." *Scribner's Monthly* 3 (January 1872): 261–77.

Brown, Abbie Farwell. "Notable Trees about Boston." *New England Magazine* n.s. 22 (July 1900): 503–23.

Bunnell, Lafayette Houghton. *Discovery of the Yosemite, and the Indian War of 1851, Which Led to that Event*. Chicago: Fleming H. Revell, 1880.

California State Library. *Carleton E. Watkins: A Listing of Photographs in the Collection of the California State Library*. Sacramento, CA: Author, 1984.

California World's Fair Commission. *Final Report of the California World's Fair Com-*

mission. Sacramento: State Office, A. J. Johnston, Superintendent State Printing, 1894.

California World's Fair Commission. *Literary and Other Exercises in the California State Building, World's Columbian Exposition, Chicago, 1893.* Chicago: Rand, Mc-Nally, 1893.

Carr, Gerald L. *Albert Bierstadt: An Exhibition of Forty Paintings.* New York: Alexander Gallery, 1983.

———. "Albert Bierstadt, Big Trees, and the British: A Log of Many Anglo-American Ties." *Arts Magazine* 60 (Summer 1986): 60–71.

Cawelti, John G. "America on Display: The World's Fairs of 1876, 1893, 1933." In *The Age of Industrialism in America: Essays in Social Structure and Cultural Values,* edited by Frederic Cople Jaher, 317–63. New York: Free Press, 1968.

Chaney, Ralph W. *Redwoods of the Past.* 3d ed. San Francisco: Save-the-Redwoods League, 1990.

Cikovsky, Nicolai, Jr. "'The Ravages of the Axe': The Meaning of the Tree Stump in Nineteenth-Century American Art." *Art Bulletin* 61 (December 1979): 611–26.

Clinton. "Bierstadt in His Studio." Utica *Morning Herald and Daily Gazette,* September 16, 1874, 2:4.

Cox, Thomas R., ed. *This Well-Wooded Land: Americans and Their Forests from Colonial Times to the Present.* Lincoln: Nebraska University Press, 1985.

Crary, Jonathan. *Techniques of the Observer: On Vision and Modernity in the Nineteenth Century.* Cambridge, MA: MIT University Press, 1990.

Cronon, William. *Changes in the Land: Indians, Colonists, and the Ecology of New England.* New York: Hill and Wang, 1983.

———. "The Trouble with Wilderness; or, Getting Back to the Wrong Nature." In *Uncommon Ground: Toward Reinventing Nature,* edited by William Cronon, 69–70. New York: W. W. Norton, 1995.

Curti, Merle. "America at the World Fairs, 1851–1893." *American Historical Review* 55 (July 1950): 833–56.

Daniels, Jonathan. "The Hour of Elation." In *America at War: The Home Front, 1941–1945,* edited by Richard Polenberg, 1–3. Englewood Cliffs, NJ: Prentice-Hall, 1968.

Darrah, William Culp. *Stereo Views: A History of Stereographs in America and Their Collection.* Gettysburg, PA: Times and News, 1964.

———. *The World of Stereographs.* Gettysburg, PA: Author, 1977.

Davenport, Russell. "The Promise of America." *American Mercury* 59 (September 1944): 263–69.

Davis, Keith, F. "'A Terrible Distinctness': Photography of the Civil War Era." In *Photography in Nineteenth-Century America,* edited by Martha Sandweiss, 131–79. New York: Harry N. Abrams, 1991.

Demars, Stanford E. *The Tourist in Yosemite, 1855–1985.* Salt Lake City: Utah University Press, 1991.

Department of the Interior. *Report of the Director of the National Park Service to the Secretary of the Interior.* Washington, D.C.: Government Printing Office, 1923.

De Vries, Carolyn. "Andrew P. Hill and the Big Basin, California's First State Park." *San Jose Studies* 2 (1976): 70–92.

———. *Grand and Ancient Forest: The Story of Andrew P. Hill and Big Basin Redwood State Park.* Fresno, CA: Valley, 1978.

Dickens, Charles. *The Life and Adventures of Martin Chuzzlewit*. London: Oxford University Press, 1959/1844.

Dimock, George. *Exploiting the View: Photographs of Yosemite & Mariposa by Carleton Watkins*. North Bennington, VT: Park-McCullough, 1984.

Donaldson, Christine Hunter. "The Centennial of 1876: The Exposition, and Culture for America." Ph.D. dissertation, Yale University, 1948.

Dreiser, Theodore. *The Titan*. New York: Horace Liveright, 1925/1914.

Driesbach, Janice T. *Direct from Nature: The Oil Sketches of Thomas Hill*. Yosemite National Park, CA: Yosemite Association, in association with Crocker Art Museum, Sacramento, CA, 1997.

Drury, Newton B. "Zero Hour Approaches for Calaveras South Grove." *National Parks Magazine* 26 (January–March 1952): 31–33.

Earle, Edward W., ed. *Points of View: The Stereograph in America—A Cultural History*. New York: Visual Studies Workshop Press, 1979.

———. "The Stereograph in America: Pictorial Antecedents and Cultural Perspectives." In *Points of View: The Stereograph in America—A Cultural History* (9–21). New York: Visual Studies Workshop Press, 1979.

Eddy, J. M. "Among the California Redwoods." *Harper's Weekly* 38 (January 6, 1894): 14.

Ellsworth, Rodney Sydes. *The Giant Sequoia: An Account of the History and Characteristics of the Big Trees of California*. Oakland, CA: J.D. Berger, 1924.

Emerson, Ralph Waldo. "Nature." In *Selected Writings of Ralph Waldo Emerson*, edited by William H. Gilman, 186–223. New York: New American Library, 1965.

Engbeck, Jr., Joseph H. *The Enduring Giants*. Sacramento: California Department of Parks and Recreation, 1973.

E. S. "The International Exhibition—VII. American Art." *The Nation* 23 (July 6, 1876): 6–7.

Evarts, John, and Marjorie Popper. *Coast Redwood: A Natural and Cultural History*. Los Olivos, CA: Cachuma Press, 2001.

Ewan, Joseph. "The Philadelphia Heritage: Plants and People." In *America's Garden Legacy: A Taste for Pleasure*, edited by George H. M. Lawrence, 1–18. Philadelphia: Pennsylvania Horticultural Society, 1978.

———. *William Lobb, Plant Hunter for Veitch and Messenger of the Big Tree (University of California Publications in Botany, Volume 67)*. Berkeley: University of California Press, 1973.

Farquhar, Francis P. "Camels in the Sketches of Edward Vischer." *California Historical Society Quarterly* 9 (December 1930): 332–35.

———. *Edward Vischer & His "Pictorial of California."* San Francisco: Grabhorn Press, 1932.

Finger, Charles Joseph. *Footloose in the West: Being the Account of a Journey to Colorado and California and Other Western States*. New York: William Morrow, 1932.

Fisher, Richard T. "The Big Trees of California." *World's Work* 3 (February 1902): 1714–23.

Foley, D. J. *Foley's Yosemite Souvenir Guide*. 12th ed. Yosemite, CA: Yosemite Falls Studio, 1912.

Fort, Ilene Susan, and Michael Quick. *American Art: A Catalogue of the Los Angeles County Museum of Art Collection*. Los Angeles: Los Angeles County Museum of Art, 1991.

Fowles, Jib. "Stereography and the Standardization of Vision." *Journal of American Culture* 17 (Summer 1994): 89–93.

Frank, Waldo. "Our America: 1942." *American Mercury* 54 (January 1942): 66–72.

Fry, Walter, and John R. White. *Big Trees*. Stanford, CA: Stanford University Press, 1930.

G. A. R. "The Art of America. Its Exhibits at Philadelphia." *New York Times,* June 13, 1876, 1:6, 2:1.

Geary, Christraud M., and Virginia-Lee Webb, eds. *Delivering Views: Distant Cultures in Early Postcards*. Washington, D.C.: Smithsonian Institution Press, 1998.

Gilbert, James. "A Contest of Cultures." *History Today* 42 (July 1992): 33–39.

Gordon-Cummings, Constance Frederica. *Granite Crags*. Edinburgh: W. Blackwood, 1884.

Grant, J. D. *Redwood Radio: A Reverie*. Berkeley: Save-the-Redwoods League, Library Building, University of California, n.d.

Gray, A. A. "Camels in California." *California Historical Society Quarterly* 9 (December 1930): 299–317.

Gray, Asa. "Mammoth Trees of California." *American Journal of Science and Arts* ser. 2 (18, no. 52) (July 1854): 286–87.

———. "On the Age of the Large Tree Recently Felled in California." *American Journal of Science and Arts* ser. 2 (17, no. 49) (January 1854): 440–45.

Gray, Fern. *And the Giants Were Named*. Three Rivers, CA: Sequoia Natural History Association, 1975.

Greeley, Horace. *An Overland Journey from New York to San Francisco in the Summer of 1859*. New York: Alfred A. Knopf, 1964/1860.

Green, Harvey. "Pasteboard Masks: The Stereograph in American Culture, 1865–1910." In *Points of View: The Stereograph in America—A Cultural History,* edited by Edward W. Earle, 109–15. New York: Visual Studies Workshop Press, 1979.

Greenwood, Grace. "Notes of Travel. Going into the Yosemite." *New York Times,* July 22, 1872, 5:1–4.

Grenbeaux, Pauline. "Before Yosemite Art Gallery: Watkins' Early Career." *California History* 57 (Fall 1978): 220–29.

Guild, Curtis. "From the Boston *Traveller*: The Charter Oak." Hartford *Daily Times,* August 26, 1856, 2:5.

Gunsky Frederic, ed. *Selected Writings by John Muir: South of Yosemite*. Garden City, NY: Natural History Press, 1968.

Hallock, Charles. "Life among the Loggers." *Harper's New Monthly Magazine* 20 (February 1860): 437–54.

Harte, Bret. *The Writings of Bret Harte, Vol. 4*. In the Carquinez Woods *and Other Tales*. Boston: Houghton Mifflin, 1912/1883.

Harwell, C. A. "The Fall of a Giant Sequoia." *Scientific Monthly* 40 (May 1935): 482–84.

Hawthorne, Nathaniel. *The Marble Faun*. New York: New American Library, 1961/1860.

Hendricks, Gordon. *Albert Bierstadt: Painter of the American West*. New York: Harrison House/Harry N. Abrams, 1988/1974.

Hewes, Jeremy Joan. *Redwoods: The World's Largest Trees*. New York: Smithmark, 1993.

Hickman, Paul, and Terence Pitts. *George Fiske: Yosemite Photographer*. Flagstaff, AZ: Northland Press, 1980.

Hill, Arthur. "Life in a Logging Camp." *Scribner's Magazine* 13 (June 1893): 694–715.

Hills, Patricia. *The American Frontier: Images and Myths*. New York: Whitney Museum of American Art, 1973.

Hittell, John S. *Yosemite: Its Wonders and Its Beauties*. San Francisco: Bancroft, 1868.

Holmes, Oliver Wendell. "Doings of the Sunbeam." *Atlantic Monthly* 12 (July 1863): 1–15.

Holmes, S. J. "Two Generations of Redwoods." *Nature Magazine* 17 (April 1931): 242.

Hood, Mary V. Jessup, and Robert Bartlett Haas. "Eadward Muybridge's Yosemite Valley Photographs, 1867–1872." *California Historical Society Quarterly* 42 (March 1963): 5–26.

Hoopes, Josiah. *The Book of Evergreens. A Practical Treatise on the Coniferae, or Cone-Bearing Plants*. New York: Orange Judd, 1868.

Hosley, William. *Colt: The Making of an American Legend*. Amherst: Massachusetts University Press, 1996.

Howells, William Dean. "A Sennight of the Centennial." *Atlantic Monthly* 38 (July 1876): 92–107.

Hulbert, William Davenport. "The Lumber-Jack and His Job." *The Outlook* 76 (April 2, 1904): 803–16.

Hutchings, James Mason. *In the Heart of the Sierras*. Oakland, CA: Old Cabin, Yo Semite Valley, and the Pacific Press, 1888.

Huth, Hans. *Nature and the American: Three Centuries of Changing Attitudes*. Berkeley: University of California Press, 1957.

Hyde, Anne F. "From Stagecoach to Packard Twin Six: Yosemite and the Changing Face of Tourism, 1880–1930." *California History* 69 (Summer 1990): 154–69.

Ingersoll, Ernest. "In a Redwood Logging Camp." *Harper's New Monthly Magazine* 66 (January 1883): 193–210.

Jakle, John A. *The Tourist: Travel in Twentieth-Century North America*. Lincoln: Nebraska University Press, 1985.

James, Henry. *Hawthorne*. Ithaca, NY: Cornell University Press, 1997/1879.

Johnston, Hank. *Railroads of the Yosemite Valley*. Los Angeles: Trans-Anglo Books, 1966.

———. *They Felled the Redwoods: A Saga of Flumes and Rails in the High Sierra*. 10th ed. Fish Camp, CA: Stauffer, 1996/1966.

———. *Thunder in the Mountains: The Life and Times of Madera Sugar Pine*. 2d ed. Corona del Mar, CA: Trans-Anglo Books, 1974/1973.

———. *The Whistles Blow No More: Railroad Logging in the Sierra Nevada, 1874–1942*. Glendale, CA: Trans-Anglo Books, 1984.

Johnstone, Peter, ed. *Giants in the Earth: The California Redwoods*. Berkeley, CA: Heyday Books, 2001.

Kammen, Michael. *Meadows of Memory: Images of Time and Tradition in American Art and Culture*. Austin: Texas University Press, 1989.

King, Clarence. *Mountaineering in the Sierra Nevada*. New York: W. W. Norton, 1871.

King, Thomas Starr. "A Vacation among the Sierras—No. 4. The Big Trees." *Boston Evening Transcript*, January 12, 1861, 1:1–3.

Kinsey, Joni Louise. *Thomas Moran and the Surveying of the American West*. Washington, D.C.: Smithsonian Institution Press, 1992.

Knobloch, Frieda. *The Culture of Wilderness: Agriculture as Colonization in the American West*. Chapel Hill: North Carolina University Press, 1996.

"The KODAK." *Country Life in America* 1 (November 1901): vi.

Krauss, Rosalind. "Photography's Discursive Spaces: Landscape/View." *Art Journal* 42 (Winter 1982): 311–19.

Kruska, Dennis G. *Sierra Nevada Big Trees: History of the Exhibitions, 1850–1903*. Los Angeles: Dawson's Book Shop, 1985.

Kurutz, Gary F., and K. D. Kurutz. *California Calls You: The Art of Promoting the Golden State, 1870 to 1940*. Sausalito, CA: Windgate Press, 2000.

Latimer, George Horace. "Trippers and Stoppers." *Saturday Evening Post* 194 (October 8, 1921): 20.

Levine, Lawrence W. *Highbrow/Lowbrow: The Emergence of Cultural Hierarchy in America*. Cambridge, MA: Harvard University Press, 1988.

Lindley, John. No title. *Gardeners' Chronicle* (December 24, 1853): 819–20.

Littel, Katherine Mather. *Chris Jorgensen: California Pioneer Artist*. Sonora, CA: Fine Arts Research, 1988.

Löfgren, Orvar. *On Holiday: A History of Vacationing*. Berkeley: University of California Press, 1999.

Lossing, Benson John. "American Historical Trees." *Harper's New Monthly Magazine* 24 (May 1862): 721–40.

Ludlow, Fitz Hugh. "Seven Weeks in the Great Yo-Semite." *Atlantic Monthly* 13 (June 1864): 739–54.

MacFadden, Henry Alexander. *Rambles in the Far West*. Holidaysburg, PA: Standard Printing House, 1906.

MacKenzie, George G. (Lewis Stornaway). *Yosemite! Where to Go & What to Do. A Plain Guide to the Yosemite Valley, the High Sierra, & and Big Trees*. San Francisco: C. A. Murdock, 1888.

Magoc, Chris J. *Yellowstone: The Creation and Selling of an American Landscape, 1870–1903*. Albuquerque: New Mexico University Press, 1999.

Mansfield, Howard. *In the Memory House*. Golden, CO: Fulcrum, 1993.

Marchand, Roland. *Advertising the American Dream: Making Way for Modernity, 1920–1940*. Berkeley: University of California Press, 1985.

Marder, William and Estelle. *Anthony: The Man, the Company, the Cameras*. Amesbury, MA: Pine Ridge, 1982.

Marsh, Dave, and Harold Leventhal, eds. *Pastures of Plenty: A Self-Portrait, Woody Guthrie*. New York: HarperCollins, 1990.

Marshall, Walter Gore. *Through America; or, Nine Months in the United States*. London: Sampson Low, Marston, Searle, & Rivington, 1882.

Mather, Stephen. *Report of the Director of the National Park Service to the Secretary of the Interior*. Washington, D.C.: Government Printing Office, 1917.

Mayo, Morrow. "To See It Fall." *Harper's Magazine* 172 (May 1936): 710–13.

McCabe, James D. *The Illustrated History of the Centennial Exhibition*. Philadelphia: National, 1876.

McGrath, Robert L. "The Tree and the Stump: Hieroglyphics of the Sacred Forest." *Journal of Forest History* 33 (April 1989): 60–69.

McGraw, Donald J. "The Tree that Crossed a Continent." *California History* 61 (Summer 1982): 120–39.

Melendy, Howard Brett. "One Hundred Years of the Redwood Lumber Industry, 1850–1950." Ph.D. dissertation, Stanford University, 1952.

Miller, George and Dorothy. *Picture Postcards in the United States, 1893–1918.* New York: Clarkson N. Potter, 1976.

Morford, Henry. *Morford's Scenery and Sensation Hand-Book of the Pacific Railroad and California.* New York: Chas. T. Dillingham, ca. 1870s.

Morgan, Hal and Andreas Brown. *Prairie Fires and Paper Moons—The American Photographic Postcard: 1900–1920.* Boston: David R. Godine, 1981.

Morris, Oliver A. "Giant Trees that Refuse to Die." *Travel* 71 (September 1938): 9–11, 48.

Morton, H. J. "The Yosemite Valley." *Philadelphia Photographer* 3 (December 1866): 376–79.

Muir, John. "On the Post-Glacial History of Sequoia Gigantea." *Proceedings of the American Association for the Advancement of Science* 25 (August 1876): 242–53.

———. *Our National Parks.* Madison: Wisconsin University Press, 1981/1901.

———, ed. *Picturesque California: The Rocky Mountains and the Pacific Slope.* Vol. 2. New York: J. Dewey, 1888.

Murray, Andrew. "Notes on Californian Trees." *Edinburgh New Philosophical Journal* n.s. 11, no. 2 (April 1860): 205–27.

Naef, Weston J. *Era of Exploration: The Rise of Landscape Photography in the American West, 1860–1885.* Boston: Albright-Knox Art Gallery and the Metropolitan Museum of Art, 1975.

———, ed. *In Focus: Carleton Watkins. Photographs from The J. Paul Getty Museum.* Los Angeles: J. Paul Getty Museum, 1997.

Nash, Roderick. *Wilderness and the American Mind.* New Haven, CT: Yale University Press, 1967.

Nelson, T. *The Yosemite Valley, and the Mammoth Trees and Geysers of California.* New York: T. Nelson and Sons, 1870.

Nickel, Douglas R. *Carleton Watkins: The Art of Perception.* New York: Harry N. Abrams, 1999.

Novak, Barbara. *Nature and Culture: American Landscape and Painting, 1825–1875.* New York: Oxford University Press, 1980.

Nye, David E. *Narratives and Spaces: Technology and the Construction of American Culture.* New York: Columbia University Press, 1997.

O'Connell, Jay. *Co-Operative Dreams: A History of the Kaweah Colony.* Van Nuys, CA: Raven River Press, 1999.

Ogden, Kate Nearpass. "Sublime Vistas and Scenic Backdrops: Nineteenth-Century Painters and Photographers at Yosemite." *California History* 69 (Summer 1990): 134–53.

Olmsted, Frederick Law. "The Yosemite Valley and the Mariposa Big Trees, A Preliminary Report (1865)." *Landscape Architecture* 43 (October 1952): 12–25.

Olson, Victoria Thomas. "Pioneer Conservationist A.P. Hill: 'He Saved the Redwoods.'" *American West* (September/October 1977): 32–40.

Oxley, J. Macdonald. "From Forest to Floor." *Cosmopolitan* 4 (December 1887): 312–22.

Pakenham, Thomas. *Meetings with Remarkable Trees.* New York: Random House, 1998.

Palmquist, Peter E. *Carleton E. Watkins: Photographs, 1861–1874.* San Francisco: Fraenkel Gallery, in association with Bedford Arts, 1989.

———. *Carleton E. Watkins: Photographer of the American West.* Albuquerque: New Mexico University Press, 1983.

———. "C.L. Pond: A Stereoscopic Gadabout Visits Yosemite." *Stereo World* 10 (January/February 1984): 18–20.

———. *Fine California Views: The Photographs of A.W. Ericson.* Eureka, CA: Interface California Corporation, 1975.

———, ed. *J.J. Reilly: A Stereoscopic Odyssey, 1838–1894.* Yuba City, CA: Community Memorial Museum, 1989.

———. *Lawrence & Houseworth/Thomas Houseworth & Co.: A Unique View of the West, 1860–1886.* Columbus, OH: National Stereographic Association, 1980.

———. *Return to El Dorado: A Century of California Stereographs.* Riverside: California Museum of Photography, 1986.

Peattie, Donald Culross. *A Natural History of Western Trees.* 3d ed. Boston: Houghton Mifflin, 1953.

Peeler, David P. "The Art of Disengagement: Edward Weston and Ansel Adams." *Journal of American Studies* 27 (December 1993): 309–34.

Perkins, Eli. "California's Big Trees." *New York Times,* June 17, 1877, 5:7.

Perl, Jed. "The Vertical Landscape: 'In the Redwood Forest Dense.'" *Art in America* 64 (January/February 1976): 59–63.

Perry, Claire. *Pacific Arcadia: Images of California, 1600–1915.* New York: Oxford University Press, 1999.

Pine, George W. *Two Wonders of the World. Yosemite, Mammoth Trees, and Bird's-Eye View of California.* New York: Herkimer, 1873.

Poetical Works of William Cullen Bryant. New York: D. Appleton, 1908.

Polenberg, Richard. *War and Society: The United States, 1941–1945.* Philadelphia: J.B. Lippincott, 1972.

Price, Sara Delavergne. "How the Big Tree Was Sent to Chicago." *Frank Leslie's Popular Monthly* 35 (June 1893): 728–34.

Prouty, Andrew Mason. *More Deadly than War! Pacific Coast Logging, 1827–1981.* New York: Garland, 1985.

Pyne, Stephen J. *How the Canyon Became Grand; A Short History.* New York: Viking, 1998.

Rand McNally & Co.'s Handbook of the World's Columbian Exposition. Chicago: Rand, McNally, 1893.

Report of the Acting Superintendent of the Yosemite National Park to the Secretary of the Interior. Washington, D.C.: Government Printing Office, 1912.

Report of the Acting Superintendent of the Yosemite National Park to the Secretary of the Interior. Washington, D.C.: Government Printing Office, 1913.

Report of the Director of the National Park Service to the Secretary of the Interior. Washington, D.C.: Government Printing Office, 1918.

Report of the Superintendent of the Yosemite National Park to the Secretary of the Interior. Washington, D.C.: Government Printing Office, 1915.

Ripley, Thomas Emerson. "Shakespeare in the Logging Camp." *American West* 4 (May 1967): 12–16.

Robertson, David. *West of Eden: A History of the Art and Literature of Yosemite.* Yosemite National Park, CA: Yosemite Natural History Association and Wilderness Press, 1984.

Rule, Amy, ed. *Carleton Watkins: Selected Texts and Bibliography*. Boston, MA: G.K. Hall, 1993.

Runte, Alfred. *National Parks: The American Experience.* 2d ed. Lincoln: Nebraska University Press, 1987.

———. *Public Lands, Public Heritage: The National Forest Idea*. Niwot, CO: Roberts Rinehart, 1991.

———. *Trains of Discovery: Western Railroads and the National Parks*. Flagstaff, AZ: Northland Press, 1984.

———. *Yosemite: The Embattled Wilderness*. Lincoln: Nebraska University Press, 1990.

Rupp, Rebecca. *Red Oaks & Black Birches: The Science and Lore of Trees*. Pownal, VT: Storey Communications, 1990.

Rydell, Robert W. *All the World's a Fair: Visions of Empire at American International Expositions, 1876–1916*. Chicago: Chicago University Press, 1984.

———. "The Culture of Imperial Abundance: World's Fairs in the Making of American Culture." In *Consuming Visions: Accumulation and Display of Goods in America, 1880–1920*, edited by Simon J. Bronner, 191–216. New York: W. W. Norton, 1989.

Saltus, Edgar. "New York from the Flatiron." *Munsey's Magazine* 33 (July 1905): 381–90.

Samuels, Gayle Brandow. *Enduring Roots: Encounters with Trees, History, and the American Landscape*. New Brunswick, NJ: Rutgers University Press, 1999.

Sargent, Shirley. *Galen Clark: Yosemite Guardian*. San Francisco: Sierra Club, 1964.

Schama, Simon. *Landscape and Memory*. New York: Vintage Books, 1995.

Schmitt, Peter J. *Back to Nature: The Arcadian Myth in Urban America*. Baltimore: Johns Hopkins University Press, 1990/1969.

Sears, John F. *Sacred Places: American Tourist Attractions in the Nineteenth Century*. New York: Oxford University Press, 1989.

Seemann, Berthold. "On the Mammoth-Tree of Upper California." *Annals and Magazine of Natural History*, ser. 3 (3, no. 15) (March 1859): 161–75.

Sequoia and Kings Canyon National Parks Museum (SEKI). File Code G, Box 1, File 3, July 24, 1923, Programme, *Fourth Annual Presentation, "Ersa of the Red Trees," Giant Forest*, Saturday July 4th, 1931, 8:00 P.M.

SEKI. File Code K, Box 256, File 14, Congressional Record for May 4, 1936, p. 6871.

SEKI. File Code K, Box 256, File 14, letter to Superintendent Col. John R. White, dated May 5, 1936.

Sexton, Nanette Margaret. "Carleton E. Watkins: Pioneer California Photographer (1829–1916): A Study in the Evolution of Photographic Style, During the First Decade of Wet Plate Photography." Ph.D. dissertation, Harvard University, 1982.

Shaffer, Marguerite S. *See America First: Tourism and National Identity, 1880–1940*. Washington, D.C.: Smithsonian Institution Press, 2001.

Shinn, Charles Howard. "The Great Sequoia." *Garden and Forest* 2 (December 25, 1889): 614–15.

Simon, Janice. "'Naked Wastes . . . Glorious Wood'": The Forest View of the White Mountains." *Historical New Hampshire* 54 (Fall/Winter 1999): 92–106.

Smillie, James D. "The Yosemite." In *Picturesque America*, Vol. I, edited by William Cullen Bryant, 464–95. New York: D. Appleton, 1872.

Smith, Henry Nash. *Mark Twain's Fable of Progress: Political and Economic Ideas in "A Connecticut Yankee."* New Brunswick, NJ: Rutgers University Press, 1964.

Southall, Thomas. "White Mountain Stereographs and the Development of a Collective Vision." In *Points of View: The Stereograph in America—A Cultural History,* edited by Edward W. Earle, 97–108. New York: Visual Studies Workshop Press, 1979.

Spaulding, Jonathan. *Ansel Adams and the American Landscape.* Berkeley: University of California Press, 1995.

Steinbeck, John. *Travels with Charley—In Search of America.* New York: Penguin Books, 1986/1962.

Strahan, Edward. *The Masterpieces of the Centennial International Exhibition.* Vol. 1. New York: Garland, 1977/1876–1878.

Susman, Warren I. "Commentary: Ritual Fairs." *Chicago History* 12 (Fall 1983): 4–7.

———. *Culture as History: The Transformation of American Society in the Twentieth Century.* New York: Pantheon Books, 1984/1973.

Sutter, Paul S. *Driven Wild: How the Fight against Automobiles Launched the Modern Wilderness Movement.* Seattle: Washington University Press, 2002.

Szarkowski, John, ed. *The Photographer and the American Landscape.* New York: Museum of Modern Art, 1963.

Taylor, Bayard. *New Pictures from California.* Oakland, CA: Biobooks, 1951/ca. 1860s.

Taylor, Benjamin F. *Between the Gates.* Chicago: S. C. Griggs, 1878.

Thoreau, Henry David. *The Maine Woods.* New York: Penguin Books, 1988/1864.

Trachtenberg, Alan. *Reading American Photographs: Images as History, Mathew Brady to Walker Evans.* New York: Hill and Wang, 1989.

Truman, Ben C. *History of the World's Fair.* Philadelphia: Syndicate, 1893.

Twain, Mark. *A Connecticut Yankee in King Arthur's Court.* New York: Bantam Books, 1982/1889.

Tweed, William. *The General Sherman Tree: The World's Largest Living Thing.* Three Rivers, CA: Sequoia Natural History Association, 1988.

———. *Kaweah Remembered: The Story of the Kaweah Colony and the Founding of Sequoia National Park.* Three Rivers, CA: Sequoia Natural History Association, 1986.

Tweed, William C., and Lary M. Dilsaver. *Challenge of the Big Trees.* Three Rivers, CA: Sequoia Natural History Association, 1990.

———. *Sequoia Yesterdays: Centennial Photo History.* Three Rivers, CA: Sequoia Natural History Association, 1990.

Urry, John. *The Tourist Gaze: Leisure and Travel in Contemporary Societies.* London: Sage, 1990.

Vermaas, Lori Ann. "The National Trees: Celebrating the Sequoias—Their Trunks, Roots, Stumps, Bark—and Their Depiction as Big Trees in America, 1852–1944." Ph.D. dissertation, University of Iowa, 2000.

Vischer, Eduard. "A Trip to the Mining Regions in the Spring of 1859: Preface" (translated by Ruth Frey Axe). *California Historical Society Quarterly* 11 (September 1932): 224–46 and (December 1932): 321–38.

Vischer, Edward. *The Forest Trees of California. Sequoia Gigantea. Calaveras Mammoth Tree Grove. Photographs, from the original drawings of Edward Vischer, with contributions from various sources.* San Francisco: Author, 1864.

———. *Missions of Upper California, 1872.* San Francisco: Joseph Winterburn, 1872.

———. *Pictorial of California.* San Francisco: Joseph Winterburn, 1870.

———. *Vischer's Views of California. The Mammoth Tree Grove and Its Avenues.* San Francisco: Author, 1862.

Walker, Andrew. "American Art & the Civil War." *American Art Review* 11 (September–October 1999): 126–31 and 207.

Wall, Louise Herrick. "Under the Far-West Greenwood Tree." *Atlantic Monthly* 71 (February 1893): 194–201.

Ward, John D. U. "Sequoias Colonize Britain." *Natural History* 59 (October 1950): 383.

Warren, James Perrin. "Contexts for Reading 'Song of the Redwood-Tree.'" In *Reading under the Sign of Nature: New Essays in Ecocriticism,* edited by John Tallmadge and Henry Harrington, 165–78. Salt Lake City: Utah University Press, 2000.

Weinstein, Robert A. "Ships and Timber." *American West* 16 (January/February 1979): 18–29.

Wells, A. J. *The Yosemite Valley and the Mariposa Grove of Big Trees of California.* San Francisco: Passenger Department, Southern Pacific Company, 1907.

Wenzel, Lynn, and Carol J. Binkowski. *I Hear America Singing: A Nostalgic Tour of Popular Sheet Music.* New York: Crown, 1989.

West, Thomas. "The Big Tree that Wouldn't Fall." *Nature Magazine* 18 (August 1931): 121.

Westerbeck, Colin. "Ansel Adams: The Man and the Myth." In *Ansel Adams, New Light: Essays on His Legacy and Legend,* edited by Michael Read, 9–15. San Francisco: Friends of Photography, 1993.

White, Stewart Edward. *Blazed Trail Stories and Stories of the Wild Life.* Garden City, NY: Doubleday, Doran, 1901 and 1902.

Whitman, Walt. "Song of the Broad-Axe." In *Leaves of Grass and Selected Prose,* edited by Lawrence Buell, 147–57. New York: Modern Library, 1980.

———. "Song of the Redwood-Tree." In *Leaves of Grass and Selected Prose,* edited by Lawrence Buell, 165–69. New York: Modern Library, 1980.

Whitney, J. D. *Geological Survey of California. The Yosemite Book: A Description of the Yosemite Valley and the Adjacent Region of the Sierra Nevada, and of the Big Trees of California.* New York: J. Bien, 1868.

———. *Geological Survey of California. The Yosemite Guide-Book: A Description of the Yosemite Valley and the Adjacent Region of the Sierra Nevada, and of the Big Trees of California.* 2d ed. Cambridge: Welch, Bigelow, 1870.

Willard, Dwight. *A Guide to the Sequoia Groves of California.* Yosemite National Park, CA: Yosemite Association, 2000.

Willey, D. A. "Logging in the Northwest." *Scientific American* 83 (December 29, 1900): 409–10.

Williams, Michael. *Americans & Their Forests: A Historical Geography.* New York: Cambridge University Press, 1989.

Willis, Nathaniel Parker. "The Mammoth Trees of California." *Hutchings' California Magazine* 3 (March 1859): 385–97.

Wills, Garry. *John Wayne's America: The Politics of Celebrity.* New York: Simon & Schuster, 1997.

Wilson, Richard Guy, Dianne H. Pilgrim, and Dickran Tashjian, eds. *The Machine Age in America, 1918–1941.* New York: Harry. N. Abrams, 1986.

Winslow, C. F. "Dr. C.F. Winslow's Letters from the Mountains. The 'Big Tree.'" *California Farmer and Journal of Useful Sciences* 2 (August 24, 1854): 58.

Withey, Lynne. *Grand Tours and Cook's Tours: A History of Leisure Travel, 1750 to 1915.* New York: William Morrow, 1997.

World's Columbian Exposition 1893: Official Catalogue, United States Government Building, Part XVI. Chicago: W. B. Conkey, 1893.

Yaryan, Willie, Denzil Verardo, and Jennie Verardo. *The Sempervirens Story: A Century of Preserving California's Ancient Redwood Forest, 1900–2000.* Los Altos, CA: Sempervirens Fund, 2000.

INDEX

Page numbers in boldface indicate illustrations.